CREATING THE FUTURE

# CREATING
# THE
# FUTURE

MICHAEL FALLON

COUNTERPOINT
BERKELEY

Library of Congress Cataloging-in-Publication Data

Fallon, Michael, 1966- author.
 Creating the future : art & Los Angeles in the 1970s / Michael Fallon.
   pages cm
   ISBN 978-1-61902-343-7 (hardback)
 1. Art and society--California--Los Angeles--History--20th century. 2. Art, American--California--Los Angeles--20th century--Themes, motives. I. Title.
 N72.S6F35 2014
 709.794'9409047--dc23

2014014415

ISBN 978-1-61902-343-7

Cover design by Maren Fox
Interior Design by Megan Jones Design

COUNTERPOINT
2560 Ninth Street, Suite 318
Berkeley, CA 94710
www.counterpointpress.com

Printed in the United States of America
Distributed by Publishers Group West

10 9 8 7 6 5 4 3 2 1

*For Nicole & Eleanor*

# CONTENTS

# Confusion, Uncertainty, and the Southern Californian Origins of Art's Postmodern Plurality

L OS ANGELES' EMERGENCE AS A NATIONAL ART capital in the mid-twentieth century owes as much to circumstance and timing as it does to the artists of the era. Beginning in the 1950s, after a half-century of intensive polish,[1] the far Western outpost region known as Southern California emerged as America's shining beacon of hope—a forward-looking, golden Shangri-La by the Pacific Ocean.

Los Angeles—which had grown by mid-century to become California's cultural and demographic capital—was at the time a city engrossed in its rise to the top. As the richest, healthiest, most admired urban area in the United States, the city embodied the "California Dream." By the 1960s, L.A. was where you went to find openness and warmth, fulfillment and happiness; it was where you could realize your dreams and be the person you were always meant to be. It was a place where great riches were attainable, and where eternal youth seemed possible. It was the home of Hollywood, of young, handsome politicians, of sexy and free-spirited rock gods and goddesses. In the popular media of the time—in films like *Gidget* and *Beach Blanket Bingo*, television shows like *77 Sunset Strip*, in Beach Boys songs and on album covers, and in countless magazine

picture profiles—Los Angeles was modern, hip, and far sexier than the American norm.

As a visual concept, L.A. had wide appeal. Iconically speaking, the city was associated with money, palm trees, glamorous movie stars, clear blue skies, and, above all else, sunshine. Its colors—molten gold, linen white, deep azure blue, and sparkling candy-apple red—were dazzling. Los Angeles evoked chrome and bright plastic and neon signs and freshly laid asphalt gleaming in the midday sun; it was the sleek ellipse of a surfboard hewn from space-age polyurethane. It was the racy "streamline," in the parlance of Tom Wolfe, of a '57 Chevy Bel Air, or it was the sweeping modernist arches over soon-to-be ubiquitous fast-food hamburger joints (or over the H.G. Wellsian Theme Building at LAX, as the city's vast international airport was known). The lingering image one had after leaving L.A. was of an endless river of steel and rubber churning and snaking through the city's wide valley passes and out across a vast and endlessly productive land basin.

As Los Angeles grew through the middle years of the last century, gaining confidence, stature, and notoriety, its culture naturally matured and spread into areas long deemed the territory of the Eastern establishment. This included literature, theater, dance, music, and visual art. L.A.'s first generation of noted visual artists—celebrated in recent years in the Jeff Bridges-narrated documentary *The Cool School* and in Hunter Drohojowska-Philp's widely praised book *Rebels in Paradise*—came to maturity right in the midst of California's colorful 1960s explosion of visual wish fulfillment. Like much of the rest of California's growing population, these artists—all intent on making a big splash in this exciting and new city—had come to L.A. from a variety of backgrounds and places. Wallace Berman, the oldest and initially most experienced artist of the group, was born in Staten Island but grew up in L.A. after his family moved to the Boyle Heights neighborhood during the 1930s. Berman's assemblage works heavily influenced the art of the era, and his first solo show took place at a new space, the Ferus Gallery, which opened in Los Angeles in 1957. Ed

Kienholz was born in eastern Washington State and, after settling in Los Angeles as a young man in the early 1950s, got involved in the local arts community and became one of the founders of the Ferus Gallery.[2] Billy Al Bengston, meanwhile, was born in Kansas City, eventually settling in Los Angeles in the late 1940s and attending the Otis Art Institute in the 1950s. His first solo show was mounted at the Ferus Gallery in 1958. Ed Ruscha was born in Omaha, Nebraska, and Larry Bell was born in Chicago, Illinois. Both moved to L.A. to attend the Chouinard Art Institute in the 1950s and both had their first solo shows at the Ferus Gallery in the early 1960s.[3] The others in the group—Ed Moses, Craig Kauffman, Robert Irwin, John Altoon, and Kenneth Price—were born in disparate locations around the Los Angeles area and came from a range of different upbringings before finding their ways to the Ferus Gallery.

Beyond the fact that they were all male and of white European backgrounds, there was little that connected the Ferus Gallery stable of artists beyond their collective sense of ambition and a confident belief in what they could accomplish in their new California home. As early as 1961, in fact, the Ferus Gallery began packaging their shows with the California experience in mind. Ken Price's exhibition announcement that year had a picture of the artist surfing at a local beach, arms stretched upward in a gesture of triumph. Billy Al Bengston's exhibition announcement in 1961, meanwhile, depicted the artist with his motorcycle. In 1963, Ed Ruscha made a key artistic breakthrough when he created his first artist's book for a Ferus exhibition. That the book was called *Twentysix Gasoline Stations* reveals how California's culture was influencing the Oklahoma native. In 1964, as the wider art world began to take notice of what was happening in Los Angeles, the Ferus Gallery mounted a group show of four of its artists (Moses, Irwin, Price, and Bengston) with a title that said everything about the local artistic mindset: "Studs."

The Ferus group's swagger had its clearest expression in the career of founder Walter Hopps. From the beginning, Hopps had provided a

strong artistic vision, if not business savvy,[4] to the enterprise. In 1962, Walter Hopps mounted the very first solo exhibition of a new, up-and-coming artist named Andy Warhol. Warhol's version of the emerging Pop Art Movement—slick images of consumer goods like Campbell's Soup cans—seemed particularly suited to the media-savvy and consumer-focused city. Shortly after the Warhol show, Hopps was curator, for the Pasadena Museum of California Art, of one of the earliest group exhibitions of Pop Art. Hopps would leave Ferus to become a full-time curator in Pasadena later that year, and in 1963 he would bring widespread art-world focus to L.A. by mounting the first retrospective of the influential French Dadaist Marcel Duchamp.[5] By the time Hopps was named curator of the American Pavilion of the 8th Saõ Paolo Bienal in 1965, where he would promote three of the Ferus cohort (Bell, Bengston, and Irwin), one thing was clear: Under the onslaught of Ferus's virile artistic energy and Hopps's groundbreaking work as a curator, the national and international art world could no longer ignore what was happening in Los Angeles.

THE LUSTER OF THE SOUTHERN CALIFORNIA DREAM, as reflected in the work of the Ferus Gallery and its artists, was so bright by the late 1960s it is difficult to pinpoint exactly when it all began to grow dim. Many people willingly overlooked the initial warning signs of social degradation in California—the Watts riots in 1965[6]; the Sunset Strip riots in the mid-1960s[7]; the closing of Pacific Ocean Park in 1967 and its fall into ruins amid the deteriorated Dogtown neighborhood of Venice; the rise of street gangs in Compton and East Los Angeles; the malaise regarding the corrupt administration of mayor Sam Yorty[8]; the mass student protests in Berkeley and elsewhere through the later 1960s and into the 1970s; the June 1968 murder of Democratic presidential candidate Bobby Kennedy by a young immigrant from suburban L.A.[9]; the senseless string of "Manson family" cult murders in 1969[10]; the state's rising divorce rates after the passage of the country's first no-fault divorce

law in 1969[11]; and an ever-increasing number of quality-of-life issues across the region in the late 1960s.[12]

By the early 1970s, it was clear that the California Dream had begun to spoil. As the British journalist Michael Davie would note in his book *California: The Vanishing Dream,* despite the state's wealth, sunshine, talent, and knowledge, "worldly happiness" was fleeting among its residents. "The economic and technological machine was grinding on," Davie wrote, "but fewer and fewer people thought that its whirrings were a prelude to a better future."[13] It didn't help that the Energy Crisis of 1973 and the resulting national recession hit California particularly hard, putting a significant amount of economic pressure on people who expected far better things from their home state. The growing stress of Californians in the 1970s was so dramatic, in fact, it would all but scuttle the state's sense of exceptionalism and throw into doubt the idea that it and its culture were worthy of the admiration it had received over the past thirty years.

As if to mirror California's slide from its pinnacle, the local art scene that revolved around the Ferus Gallery quickly fell into disarray. In 1966, meanwhile, one of the key Ferus artists, Ed Kienholz, mounted a controversial retrospective exhibition at the Los Angeles County Museum of Art (LACMA). The massive and stunning exhibition should have added to the artist's and the gallery's reputations, but instead it was somewhat derailed because of one sculpture, "Back Seat Dodge '38." Inspired by what Kienholz called his "miserable first experience of sex," it was found to be offensive by local authorities, forcing the museum to partially obscure its contents except to consenting adults. Other disappointments followed. In 1966, Walter Hopps was asked to step down from his position at the Pasadena Museum of California Art after just three years. The stated reason for this dismissal was Hopps's unconventional administrative style—as the museum's staff became increasingly frustrated with Hopps's comings and goings and lack of availability for administrative business.[14] In 1966, too, the main driver of L.A.'s growing art reputation, the

Ferus Gallery, closed its doors for financial reasons. The status that Los Angeles held as a national art market in the mid-1960s, built as it was around the Ferus-enabled propaganda of California's exceptionalism, was belied by an oil painting made by Ed Ruscha around this time. Called "The Los Angeles County Museum on Fire" (1965–68), it depicts an idealized and isolated image of the museum with one of its new William L. Pereira–designed buildings aflame and spewing smoke into the mustard-yellow sky.

A coda to the entire Ferus Gallery moment came in 1969, when John Altoon, the spirited and recklessly bohemian Abstract-Expressionist painter who had been a key component in establishing the group's and the city's muscular and macho art-world image, died of a heart attack. Even though the heyday had all but ended, Altoon's colleagues were shocked at his death. And while Altoon had long struggled with substance abuse, depression, paranoia, and even schizophrenia, the tragedy was clear: The artist was just forty-four at the time.

BY THE DAWN OF THE 1970S, L.A.'S BRIGHT MOMENT in the national cultural and artistic limelight had come to a near-complete end. Many commenters at the time, and since, thought of the collapse of the '60s art heyday in L.A. much as Edward Gibbon thought of the fall of the Roman Empire—as the harbinger of the barbaric, uncultured, ignorant, and backward era known as the Middle or Dark Ages. "There was a tremendous sense of betrayal in the L.A. art world," wrote a disappointed Peter Plagens of the local art scene in the late 1960s. "Los Angeles had established itself as the 'second city' of American art. But a funny thing happened on the way to the pantheon: The West Coast art scene hit the skids."[15]

Whether or not this was truth or hyperbole, the perceived end of L.A.'s art heyday did have dire consequences to artists and art professionals across the city. The market for art collapsed locally, causing stress on working artists and gallery owners. The Pasadena Museum of California Art was nearly shuttered because of financial problems.

Irving Blum, after a few aborted attempts to resurrect Ferus and then start his own gallery, eventually moved to New York. And the art magazine *Artforum* also left Los Angeles for New York, causing local artists to bemoan the fact that their efforts and exhibitions would be written about only in "cursory snippets"[16] or by "parochial" critics who worked for local newspapers.

Still, despite the real changes that occurred in L.A.'s art scene after the demise of the Ferus group, and the overwhelming perception that something special had forever passed, art did not end in Los Angeles. Instead, much as occurred after the collapse of the Roman Empire, life went on. Certainly the absence of a dominant cultural force meant—both in ancient Rome and modern L.A.—the emergence of something much murkier, less clearly defined, and more difficult to understand. However, just as historians more contemporary than Gibbon[17] have pointed out the flaw in painting a thousand-odd-year period of history with so broad and damning a brush, isn't it also possible that, by looking more closely and open-mindedly at the art that followed the collapse of Ferus, we may also learn a more subtle truth?

At the dawn of the 1970s the artists of L.A. were forced, because of the retrenchment of the California Dream, to adapt. Into the vast void left after the departure of the Ferus group stepped a whole slew of new artists, diverse groups, start-up galleries, unexpected movements, and new artistic directions perfectly suited to the unsettled times. That the light of these new artists and movements did not individually shine as brightly as the monoliths of the 1960s does not diminish the meaning or value of what was produced throughout Los Angeles during the decade that followed. In many ways, the art of L.A. in the 1970s forged a more intriguing, more sustainable path through the bleak wilderness that the Ferus artists had trailblazed a decade before. This generation of artists essentially helped create, through their more mundane struggles to survive and thrive in the midst of the scarcity of the 1970s, the future—for art in Los Angeles, for artists from all sorts of backgrounds, for artists in the many generations to come.

# A DEW Line for the Old Culture

*1971, the "Art and Technology" Exhibition,*
*and the End of L.A.'s Modernist Daydreams*

O F ALL THE WAYS TO EXPLAIN ART, ONE OF THE most intriguing was once suggested by Marshall McLuhan. "I think of art, at its most significant," wrote the scholar and critic in 1964, "as a DEW line, a Distant Early Warning system that can always be relied on to tell the old culture what is beginning to happen to it."[1]

Although somewhat outdated now, McLuhan's explanation is poignant because it captures two key truths about art. The first is that great art is, at its core, a provocative, upsetting, occasionally revolutionary thing. Each time an artist of significance sets foot in his studio, he convenes a war room against all the forces in the culture that stand in opposition. There are many examples of this—Picasso's response to the bombing of Guernica; the paint splatters in Jackson Pollock's Long Island studio; Joseph Beuys's strange ongoing personal relationship with fat and felt; Andy Warhol's "ah-ha" moment in a grocery store soup aisle; Richard Serra's mean splashes of molten lead. In each of these cases, something propelled the artists forward against the currents of their time, toward making something wholly new.

In addition to fomenting revolution, truly powerful art can also foreshadow, as McLuhan suggested, looming cultural sea changes. A

good example of this occurred in the fall of 1962. Two young and ambitious artists on the rise that year—the married couple Sonia Gechtoff and James Kelley—had just moved their painting studios from California, where they had been well-known, second-wave Abstract Expressionists, to the nation's art capital in New York. Earlier in the year, the two artists had appeared in a recent show at the Whitney Museum, and, afterward, they had each secured good representation at a local gallery. But then suddenly the rug was pulled out from underneath them.

As Gechtoff explained years later: "My husband and I were at the (Sidney) Janis Gallery," to see a group exhibition called "New Realists." Among the artists represented in the show were a number of young up-and-comers—Roy Lichtenstein, Wayne Thiebaud, Claes Oldenburg, Robert Indiana, and Andy Warhol—who all worked in a manner that had been dubbed Pop Art. "I looked at my husband," Gechtoff said of the moment, "and I said, 'You know what? This is the beginning of the end for people like us.' "

The problem was simple. As Abstract Expressionists, Gechtoff and Kelley were leading practitioners of a style of art whose time was passing. The culture, ever-changing, had moved on from one moment—the modernist era, when artists insisted on the primary importance of expressing individual emotive reality—to another moment that was more mired in the detritus of modern living. Gechtoff admitted she had never prepared for just such a moment. "I thought I could walk into any gallery," she said, "but I was wrong. We had a number of bad years then. A lot of us Abstract Expressionists felt the door close on us when Pop Art took off."[2]

THE DOOMSDAY MOMENT FOR EVERY ART MOVEMENT typically happens as it did for Gechtoff and Kelley's Abstract Expressionism. Because culture acts in much the same manner as an *Ouroboros,* whose head is each new generation of creators perpetually swallowing the outmoded and outdated tail, all art is eventually

doomed. And, through this brutal and unforgiving process, culture remains eternally refreshed.

Another good example of art acting as a Distant Early Warning to an important change in the culture occurred about a decade after Pop killed off Abstraction. On May 11, 1971, the "Art and Technology" exhibition opened in the new Hammer Wing of the Los Angeles County Museum of Art. The full project, planned by the museum's senior curator, Maurice Tuchman, and executed over four years leading up to the final exhibition, was meant to showcase the advancing curatorial power and cultural reach of L.A.'s new civic crown jewel—the coolly late-Modernist, William Pereira–designed facilities of LACMA, opened in 1965 and quickly deemed one of the top two or three museums in the country. The exhibition was also meant to embody a number of very hip currents bubbling up in the late 1960s, including a growing interest in scientific phenomena and technology and in the potential for art and artists to cross-pollinate with corporate commerce.

Tuchman, who came to LACMA in 1964 as a twenty-eight-year-old graduate of Columbia University and an acolyte of celebrated art historian Meyer Shapiro, had taken quickly to the enterprising spirit of his adopted home. "I had just moved to California," he told an interviewer in 1969, "a place where one is always conscious of the future."[3] Having adopted a flamboyant mien—including a "dandy's designer duds, Buffalo Bill mustache, long auburn hair, and habit of appearing . . . with interchangeable leggy blondes half a head taller than he"—Tuchman was considered a prize catch by the museum's trustees. He had also quickly gained his share of detractors. "He may look like a wunderkind to the museum," said an influential critic of the day, "but he'll never last. He loves Hollywood glamour. He should be a movie producer."[4]

Maurice Tuchman was, above all else, an ambitious man, and his choice to come west was a calculated one. In Los Angeles, Tuchman realized there was real potential to change the status quo. Throughout the 1960s, the city had exhibited a nearly unparalleled record of

innovation and excitement in its art scene. The Ferus Gallery had been
home to a strong alternative current of artistic thought and creative
energy. The L.A. artists of the 1960s had innovated new styles, pushed
the limits of nascent styles like Assemblage, Minimalism, and Pop Art,
and produced often stunningly realized, occasionally brilliant works
of art. Further, Ferus curator Walter Hopps was a key early champion
of Pop Art, famously giving a young artist named Andy Warhol his
first solo exhibition several months before he appeared in the fate-
ful group show that Gechtoff and Kelley saw at the Janis Gallery in
New York. Los Angeles in the 1960s had not only developed the first
national art market outside of New York, but it had remained a wide-
open art market where anyone with skill and ambition could make
their mark.

Whatever the exact motives behind Tuchman's concept, the final
exhibition of the "Art and Technology" project was widely antici-
pated, particularly in local circles. Proud civic leaders held up this
collaborative project, which connected seventy-six artists with forty
local corporations, as a particularly Angeleno way to go about the
business of creating cultural capital. Local press crowed loudly about
the project throughout its progress—starting with Tuchman's first
announcement of the project in the fall of 1968, continuing through
the appearance of many of its art works in the 1970 World's Fair in
Osaka, Japan (where 10,800,000 visitors came by the U.S. Pavilion
to see the art), and culminating in a series of hyperbolic writeups on
all stages of the exhibition. "It takes not one iota of chauvinism to
state categorically," wrote *Los Angeles Times* art critic Henry J. Seldis,
"that Maurice Tuchman's contribution to Expo '70 is the most signifi-
cant and forward-looking cultural project in a fair replete with supe-
rior examples of art and architecture."[5] "We are confronted with eye-
opening, mind-boggling, sometimes deliberately thought-destroying
experiences," wrote another reviewer after the full exhibition opened
at LACMA, "designed to bring us closer to perceptual reality than
most of us have ever come before."[6]

The pride that locals took in "Art and Technology" was in keeping with the city's ongoing campaign for attention and legitimacy. And why shouldn't the art of L.A. trumpet the virtues of its home? After the long expansion through the 1950s and '60s of the region's economic, social, and cultural life, wider acknowledgment of the state's status seemed overdue. In 1971, Los Angeles was aware it stood alone atop a precipice. It was the richest, healthiest, most envied urban area in the United States—with hordes of good-looking young people filling its streets and working its jobs, influential cultural figures sitting on the boards of its institutions, and depictions of its attractions and lifestyle splashed across movie and TV screens and filling the country's radio airwaves. As such, Los Angeles wanted other places at last to pay closer attention to what its creative people thought. In fact, the "Art and Technology" exhibition was all but perfectly designed to highlight the virtues of California—technological innovation, powerful business interests, and beautifully modern things. In a real way, this was an exhibition about a city that, through the backbreaking work of freeway-paving, through the hard effort of educating itself and developing a high-tech culture out of the desert, by virtue of its perceived health, beauty, and wealth, had somehow risen to be a major urban force in the country—indeed, in the world. The final exhibition in the "Art and Technology" project was to be a key moment in L.A.'s continuing artistic examination of its own significance and self-worth. "The exhibition's catalogue is not so much the narrative of a completed project," wrote art critic Peter Plagens a few years later in his book *Sunshine Muse*, "but an interim report on a hoped-for ongoing metamorphosis of modern art, centered in Los Angeles. Its candid and lengthy description/documentation of every attempted collaboration between the museum-matched artists and corporation admits to every artist's arrogance . . . as well as the easy alignment of artists with hard-core capitalism . . . ."[7] Even *Time* magazine could not keep from adding to the refrain, publishing its own glowing review. "The show is a revelation," exclaimed an anonymous beat writer. " 'Art and Technology's' real importance is as a catalyst

of a possible future. No Jerusalem has been founded among the white hygienic mills of Southern California, but the practical experience of 'Art and Technology' may very well point the way to future, and much easier collaborations."[8]

NOT EVERYONE GREETED TUCHMAN'S PLANNED ART-world putsch with enthusiasm. Despite the buzz about L.A.'s art throughout much of the previous decade, many members of the national art press, as well as the majority of major art collectors, museum curators, and other art experts, had pointedly ignored the goings-on out in Los Angeles. Some suggested that the stylistically diverse mishmash of artists out west was akin to the regionalist art of the 1930s, which turned indigenous sensibilities, subject matter, and materials into a populist art fad. (Mike Davis described the art of L.A. in the 1960s as the "avant-garde counterpart to the 'Endless Summer' depicted in Roger Corman movies . . . and the falsetto lyrics of Beach Boys' songs."[9]) For much of the twentieth century, in fact, Los Angeles itself had been dismissed, by people from New York and other older, Eastern cities, as a sprawlingly backward "Double Dubuque"—mainly because, ever since the 1920s, it had been settled by endless waves of immigrants from the Midwest and other rural parts of the country. Because of this strange reverse parochialism, the key early hero of L.A. art, Ed Kienholz, had been given only one solo show in New York as of 1971. "You might have a big reputation in L.A.," said John Baldessari, an artist of the generation that followed the Ferus group, "but you were small potatoes compared to New York. And those few [L.A.] artists who did get shows in New York got routinely trashed. Not because of the art, but just because they weren't suffering like New Yorkers suffered."[10] Even a rare California art collector from the time, Don Factor, agreed his home never got a fair shake: "There was always the complaint that New York is so insular and they don't believe anything goes on outside of New York. And that was true, to a large extent. They couldn't have cared less about what was happening on the West Coast . . . ."[11]

Perhaps as a result of long-standing bias, the "Art and Technology" exhibit was much less well received in the national art press than it was at home. "Unless there is a power failure in Southern California on Friday," Hilton Kramer wrote of the show in a *New York Times* review, "the much heralded 'Art and Technology' exhibition, representing a collaborative effort on the part of contemporary artists and major industrial corporations, will finally open to the public at the Los Angeles County Museum of Art."[12] Kramer's reference to a "power failure" was a small but telling dig at Los Angeles. The so-called Sylmar Earthquake had struck the region in February of 1971 and, while causing power outages, it had also killed sixty-five people, damaged two local hospitals, collapsed several freeway overpasses, forced the evacuation of 40,000 people, and caused more than a half-billion dollars in damage and countless disruption to the ongoing everyday business of Southern California. Yet across the country in places like New York, to people with little sympathy for this upstart city, the event simply encouraged what they thought were obvious questions: *Wherefore California? Why exactly had so many people moved to such a remote place? And what business did they have trying to compete with the real urban capitals of America?*

Kramer went on to write that while "Art and Technology" could "certainly claim its share of visual shocks and revelations . . . oddly enough, one doesn't come away from it with one's visual imagination very much enriched." Of the sixteen artists whose work was included in the exhibition, Kramer praised only six. These were: Newton Harrison, whose "tall vertical cylinders of delicate changing colored light [executed at Jet Propulsion Laboratory] afford[ed] one of the most beautiful and tranquil experiences in the show"; Rockne Krebs, whose work was constructed of "powerful laser lights, which, through the manipulation of various fool-the-eye devices, create an illusion of vast abstract vistas of space defined by an endless construction of colored lines"; Boyd Mefferd, whose "room of flashing strobe lights leaves an instantaneous series of head-splitting pictorial after-images floating in the

mind"; Claes Oldenburg, who created an "amusing . . . kinetic 'Giant Icebag,' which perform[ed] a twenty-minute programmed 'dance' on the museum's open-air plaza"; Robert Rauschenberg, who presented a "ingenious landscape of liquid mud, which erupt[ed] into little fountains and explosions and gurgling eddies"; and Robert Whitman, whose "room of mirrors and floating images of objects [was] . . . a bit of Magritte magnified . . . ."[13] Despite Kramer's appreciation of these six artists, he remained disappointed with how unimaginative, derivative, and regressive were the overall efforts. R.B. Kitaj's and Oyvind Fahlstrom's contributions in particular, he wrote, were simply "larger versions of their familiar styles," created with nothing new in mind. Overall, according to Kramer, old-fashioned ideas ruled the day in this exhibition purported to be about the newest, most futuristic thinking. "The heritage of Dada, Surrealism, and Constructivism, the newer modes of Pop and color Abstraction," he wrote, "still govern[ed] the minds of these artists, who have not yet found in the resources of advanced technology the inspiration to move beyond them."[14]

HILTON KRAMER'S DAMNING, EAST-COAST ART establishment response to "Art and Technology" was to be expected. It was in keeping, after all, with New York's long-standing bristling against the advancing culture of L.A. The initial local salvos against "Art and Technology," and against the prevailing local narratives being told about the rise of L.A.'s art, on the other hand, were something of a shock. They should not have been. Sometime before the final exhibition was even mounted, amid the tangle of local anticipation for the event, it was pointed out that though one woman, Channa Davis, had been invited to submit a proposal to participate, no female artists were to be included in the final exhibition. In due time, this one simple fact would open a floodgate of pent-up frustration and rebellious sentiment that would forever change the timbre of art in the city of Los Angeles. For now, in the lead-up to the final show during the spring and early summer of 1971, some local women met and founded the

Los Angeles Council of Women Artists. Its acronym, LACWA, made a pointed statement about the museum's exclusion of women not only from "Art and Technology," but from most of its galleries and shows up till then. In a piece published in the *Los Angeles Free Press* in June, a few weeks after Tuchman's show finally opened, the group declared: "The Art and Technology show has been heralded as 'the wave of the future.' If this is so, then we are most distressed to observe that there are no women in it . . . . Sixteen artists are represented in this invitational show—none are women."[15] And if this statement was not damning enough, the manifesto also pointed out that no black, Asian, or Chicano artists had been included in the show.

Over time, in fact, it became clear that many other local artist groups also did not care for the "Art and Technology" exhibition. This may have been a bit of sour grapes. Of the fourteen or so local artists (out of seventy-six total) who were invited to submit an application to the project, only two—Frederick Eversley and Newton Harrison— were among the twenty artists asked to complete their work and become part of the exhibition. The local resentment may have been more valid, if not for the fact that Tuchman had pointedly approached a range of local artists—including several of the famed Ferus Gallery stalwarts—but had been turned down flat. The stated reasons for most local artists' ambivalence and antipathy to "Art and Technology" were telling. Some of the invited artists failed to connect in satisfactory ways with the corporations they were interested in working with; others ran up against roadblocks in using the technologies they proposed to use. But most of the local artists who had been approached by Tuchman to be part of the project had simply been too suspicious to get involved. That is, the artists did not want to contribute to "Art and Technology" because they were wary of getting in bed with the region's most domi- nant arts institution.

*"Our discussions with artists were often strangely intense,"*
*Tuchman wrote in the exhibition catalogue, "and there*

*was more opposition on their part to the goals of Art and Technology than we had expected to encounter. I had, for example, a particularly emotional conversation with Robert Irwin, who told me that many artists resented certain aspects of the program as they understood it: they felt that it was unfair for the Museum to take possession of the works cre-ated; that the Museum was primarily interested in producing an exhibition, rather than in arbitrating the process of inter-action as an end in itself; that artists would be pressed by the Museum into making works for these reasons; and that they would not in fact be given access to experimental situations within companies which were not demonstrably related to the materials or processes of their past work.* "[16]

Additionally, as it turned out, artists were inspired at the time to take a stand against one of Tuchman's less well-known goals for "Art and Technology." By bringing artists and technological workers together, Tuchman thought it could help humanize the way companies use technology. In 1968, the writer Wylie Sypher had written, as Tuchman was aware,[17] of the state of "alienation" and "maladjust-ment" that technological workers were feeling at the time, and he had posited a potential solution to the problem. "The corporate job struc-ture," wrote Sypher, "run[s] counter to the positive nature of techno-logical endeavor, which is in nature a form of play and participation. The artist, who has maintained his traditional 'prerogative to use sci-ence and technique unofficially,' might become a catalyst toward the end of humanizing technique."[18]

Unfortunately, as "Art and Technology" would reveal, artists at the dawn of the 1970s were not interested in being any sort of catalyst for LACMA's affiliated corporate sponsors. And these attitudes would color many of Tuchman's interactions with artists, as well as many of their interactions with each other. For example, Donald Judd, who showed some initial interest in participating in the exhibition, simply

chose, once he understood what was going on with this exhibition, to fall out of touch with its curators. No one could reach or locate him after 1969. James Turrell's collaborative project with Robert Irwin—to work with the Garrett Aerospace Corporation's Life Sciences Department to explore aspects of perceptual psychology by regularly using anechoic (sensory deprivation) chambers—famously fell apart before the artists could produce any work for the show. Turrell's later comments about this failure suggested that a flaw at the conceptual core of "Art and Technology" had caused the project to go awry. "You could make this thing ["Art and Technology"] historically significant if you want[ed] to," Turrell said in September of 1970, after he had stopped working with Irwin. "I have the feeling that whatever is happening here is a symptom of something that's going on—but I think—I hope—it's going to be vastly overshadowed by the thrust of things going on independently."[19]

In other words, as scholar Anne Collins Goodyear would later explain, "The 'Art and Technology' exhibition was the product, and the victim, of a confluence of social, economic, and political factors that initially inspired, and ultimately curtailed, widespread support for projects linking art, science, and technology during the late 1960s and early 1970s."[20] That is, over the course of four years between the beginning of the "Art and Technology" project in 1967 and its exhibition in 1971 something in society had changed—the culture's values had shifted, a new spirit was ruling the land. People—especially those of a creative bent—had simply come to believe different things than before, so much so that the artists who at first had been open to the idea of using technology in their work now had come to fear and loathe it.

THERE WERE, OF COURSE, EXCEPTIONS TO THIS fearful response. Of all the artists who stuck with "Art and Technology" through the entire process and mounted their works in the U.S. Pavilion and in the final exhibition, Andy Warhol is perhaps the most emblematic. Still, the work he mounted in the final exhibition

also further explains why technology and artists were destined to come into conflict in L.A. in 1971.

Warhol, whose relationship with industrial printing technologies was a comfortable one, had arranged for his participation in "Art and Technology" to collaborate with Cowles Communications to make use of their new, three-dimensional (so-called "holographic") printing processes. But his project, according to the show's catalogue, unfortunately "came to issue in a startlingly literal way." For his final "Art and Technology" work, Warhol had printed, in 3-D, a repeating pattern of four photographed flowers on multiple panels that he then intended to mount on a twelve-by-twenty-five-foot curved wall. Atop the wall, Warhol also planned to install a rain machine that would drop a shimmering curtain of mist in front of the bright image.

Far from being a forward-thinking and creative collaboration between an artistic vision and corporate technologies, Warhol's installation eventually was dismissed as something far less successful. In its initial state, as mounted at the U.S. Pavilion at the Osaka Expo, the work was visually unremarkable. In fact, the project had been troubled in its execution from the beginning. "Virtually every stage in the assembling of the work was problematic," explained the show's catalogue. First, there was an issue regarding how best to mount the panels on the curved wall. The glue would not stick properly, and the panels popped and buckled in unsightly ways. Then the placement of panels was troublesome. Random distributions and horizontal arrangements did not work, and the only solution seemed to be fitting the panels vertically side by side and raising the wall off the ground. Next, the lighting of the work was extremely difficult. In order to disguise the unevenness of the edge of each panel, light could not fall directly on the panels, and it was tricky to get the light to fall on the water correctly without reflecting back on other, nearby works of art. And finally, there was the problem of scale. The flowers looked too small and ticky-tackyish when viewed from beyond the sheet of water, and the 3-D effect was completely lost on the viewer. "This was never resolved

satisfactorily," read the exhibition catalogue, "and it was determined
that in reconstructing the work for the Museum exhibition, each iden-
tical image [i.e., panel] would depict not [a pattern of] four but one
greatly enlarged flower."

That the corporate-friendly, technologically savvy Warhol would
have trouble executing his artistic vision for "Art and Technology"
highlighted the flaw at the heart of the show's concept: The exhibition
was out of step with the changing culture. Another very clear case
study of the failings of "Art and Technology" was in the participation
of the California-born artist Richard Serra.[21] In 1966, Serra, who was
eleven years younger than Warhol, had made a figurative and literal
splash with his early process-based sculptures made from molten lead
spattered against the wall of a studio or exhibition space. On the basis
of this experimental work, Tuchman invited the twenty-eight-year-
old Serra to participate in "Art and Technology," and Serra, who had
supported himself as a younger man by working in steel mills on the
West Coast, submitted a detailed proposal to collaborate with Kaiser
Steel, located nearly sixty miles east of Los Angeles. His intention was
to produce work he had already imagined—large, heavy, and precari-
ously balanced sculptures comprised of unwieldy slabs of metal—but
had lacked the resources or technical expertise to execute.

Other commenters have pointed out the twofold results of the "Art
and Technology" invitation to Serra. "Serra regarded the availability
of Kaiser's steel-producing plant as an opportunity basically to experi-
ment in huge scale," wrote curator Gail R. Scott in the show's cata-
logue. "In using the company's formidable scrap resources and men
and equipment, he did not attempt primarily to come away with a per-
manent or a transportable art work, but instead to learn what he could
in a few weeks' time about making sculpture comprising thousands
of tons, rather than pounds, of material."[22] During his short Kaiser
residency, then, Serra tried to create massive sculptures of stacked and
leaning layers of steel. By doing so, he moved closer to mastering the
use of steel in the monumental sculptures he had dreamed of making,

and in this sense the project was a success for the artist—helping him cultivate the techniques he would use, twenty or more years later, to fabricate his famed "torqued ellipses." Unfortunately, however, at the time of the "Art and Technology" exhibition Serra's technical expertise still lagged behind his ambition.

After his initial excitement over his collaboration with Kaiser, Serra's experiments stalled or failed completely all through 1970 and into early 1971, owing either to a flaw in their conception or an inability to get proper technical assistance to fabricate his concepts. Serra's final project for the "Art and Technology" exhibition was, by necessity, a drastically scaled back and visually less exciting work comprised of a steel plate partially buried in an incline in the museum's park grounds. There was nothing imposing or technically advanced about what he had accomplished for "Art and Technology," and, after the failure, Serra's attitude toward technology hardened. "Technology is not art—not invention," he said in 1970, when it was becoming increasingly clear his proposed project was not going to be successful. "It is a simultaneous hope and hoax . . . . Technology is what we do to the Black Panthers and the Vietnamese under the guise of advancement in a materialistic theology."[23]

Here was the Distant Early Warning at the heart of "Art and Technology." Serra's thinking reveals that, at the dawn of the 1970s, the wider cultural optimism and hope of the 1960s—for the potential of human endeavor to forge a better, more ideally beautiful, peaceful, and redeemed world—was at an end. And replacing the optimism of the previous generation was a general sense of suspicion, unease, and pessimism—about technology, about corporations, and about society's centers of power and influence. As a result of these changing attitudes, so did artistic concerns after 1970 increasingly turn inward, away from the wider good, and toward more esoteric and solipsistic practices and ideals.

Much of the cause of this shift of cultural and artistic perspective has been blamed on the Vietnam War, and on corporate support for

the technological innovations and industrial production that made that unjust war possible. In fact, several corporations contributing to "Art and Technology," including the Jet Propulsion Laboratory, the RAND Corporation, and Teledyne, were later publicly identified as being involved in Vietnam through their connection to the aerospace industry. And critic Max Kozloff later characterized Tuchman's corporate partners as "a rogue's gallery of the violence industries."[24] By the time the final exhibition opened in May of 1971, antiwar forces were gaining increasing traction in the culture. This was just a month removed from a massive gathering in Washington, D.C., that protested the Tet Offensive, the My Lai Massacre, the American invasion of Cambodia, and the killings at Kent State. Just five days after the exhibition's opening, an orchestrated protest took place at nineteen military bases around the country. And in June of 1971, the *New York Times* and *Washington Post* published the Pentagon Papers, further inflaming the public. All of these events contributed to increasingly negative feelings against LACMA's pro-technology exhibition as it remained on view through August.

IN ADDITION TO GIVING SOME ADVANCE WARNING regarding the culture's views about the war and technology, "Art and Technology" also seemed to warn observers about the limits of the California Dream. This was ironic, since at the time the state was the nation's most diverse, richest, most youthful, and most dynamic and innovative. Many of the rapid and transformative technological developments of the early 1970s originated, after all, in California.[25] At the same time, California was also among the first regions to struggle with the contradictory and paradoxical troubles and disparities that stem from the modern consumerist system that emerged in the 1970s. That is, California was ground zero of the behaviors and attitudes of the time that writer Tom Wolfe would eventually come to call the "Me Decade." In no other place during the 1970s were people more self-absorbed, internally preoccupied, and consumed with consumerism than in Los

Angeles. And Angelenos, who spent their lives on crowded freeways driving to increasingly distant jobs, were among the first groups in the country to wonder why they weren't any happier than they were.

By 1971, it was growing clear that Los Angeles, after its long run of success through the 1960s, had reached a ceiling. Increasing numbers of people were realizing that daily life in California—with its growing traffic congestion, worsening air quality, diminishing open space, and segmentation of neighborhoods and communities—belied the commonly spouted local P.R. In 1971, a poll revealed that half of all recent arrivals to the state were disillusioned about what they found in California and said they would leave the state if given the chance. That same year, migration to California dropped drastically—down 90 percent from the annual rate of 300,000 that entered the state during each year of the 1960s.

With all of these forces in the background, by the end of the run of "Art and Technology" the near-universal sentiment among local culturati suggested that the show was a poor reflection on L.A.'s art and culture. Art critic Peter Plagens, who was a local painter at the time, suggested that the exhibition was the "swan song of Sixties art"—a programmatic turning point toward a more mercenary, less easily defined era in art.[26] Meanwhile, as Mark Davis pointed out, after "Art and Technology" the "heroic moment of the Underground Los Angeles Culture" that held sway throughout the 1960s seemed to quickly pass. And Christopher Knight, who would later become the long-standing critic of record at the *Los Angeles Times*, suggested that after "Art and Technology" the "high-flying spirit of the 1960s" simply "crashed and burned," imploding into a "febrile, Popish regionalism" and a "morass of determined provincialism."[27]

"L.A. needs," wrote an exasperated Plagens in the wake of the "Art and Technology" show in 1972, "the cleansing of a great disaster or founding of a barricaded commune."[28] In "Art and Technology," then, we see signs of when certain American notions of Modernist art—what Jerry Saltz called the "single, canonical narrative"[29]—began

to lose traction. Ultimately, the rejection of industry-sponsored technology, coupled with the protests by various groups excluded from the show, pointed to the shift away from the high and comprehensive ideals of the final generation of artists who worked with Modernist assumptions in mind.

Art, just as McLuhan proclaimed, was submitting a Distant Early Warning to the Old Culture—of 1960s high-Modernist daydreamers and local hucksters selling the idea of the California desert mirage—concerning what was about to happen to it. If art was to be believed, the days ahead for California were likely to be murky ones indeed.

CHAPTER II.

# The Long March

*The Rise of Women Artists*

OR A LONG MOMENT, THE GATHERED CROWD was perfectly still. In their midst, a woman, dressed in nondescript black clothing, her black hair flying wild from her head, had stopped speaking. It was a pause meant for effect; the speaker knew, as any army officer or guerrilla leader knew, the intense power of certain breaths and pauses between words. She did not move for several moments, and the crowd was mesmerized, eager for more. When the woman began again, her rapid-fire speech, a product of her Chicago upbringing and lineage of twenty-three generations of rabbis, brought the crowd back to life.

This was Judy Chicago. It was early 1972 in Los Angeles. The gathered were mostly young artists and art students. The room was nothing special—white walls, a plain living space in the middle of a plain house, situated on a troubled block near the city's downtown—but the occasion was charged. Chicago, who was thirty-four, knew the import of the moment. She seemed to know the import of every moment. She leaned forward and unleashed.

"What do I want? Fuck it," Chicago said, her voice seething with pent-up resentment and rage. "I spent an hour going through this. First, I made it fifteen by fifteen, then twenty by twenty, then fifteen by fifteen. I couldn't get inside and connect with what I wanted. And independent of all these things, I thought, *what do I want?*" She leaned

forward, tightening her mouth to emphasize her words. The crowd
bristled with energy. Chicago was zapping them with the electricity of
possibility; she was letting them know that they could change a society
that had so long treated them as second-class. "I wanted fifteen by
fifteen, fuck, I thought, so I'm going to make it fifteen by fifteen. Every
decision is that kind of process, having to stop the outside world and
ask, 'What do I want? What do I want? What do I want?' "

Born Judy Cohen in Chicago, Illinois, Judy Chicago was a tiny
woman who always seemed larger. Her body was fit and compact,
built something like a bantamweight boxer's, and her head was often
cocked slightly to the side, as if caught in the middle of a throat clear-
ing. Despite her small stature, however, with her high cheekbones,
teardrop-shaped nose, exotic hair, and energetic bearing, Chicago
seemed to leap from every photograph. This was especially true when
she was photographed alongside men. In images of her from the mid-
1960s, working with three other men on a dry-ice installation, for
example, or in photos with her husbands and lovers, she jumps out
from the frame. Later, in photographs among other bright women,
after she had come to associate mostly with women, Chicago blended
in a bit more, seemed less feisty. Or, possibly, she just seemed as feisty
as those around her.

It said something about what was happening in the world, about
how far society had come in just a few short years, that Chicago
could so readily set other women alight. This had happened almost
by happenstance. After all, Chicago had missed the most significant
moment for local women artists up till then—the protest of the "Art
and Technology" exhibition at the Los Angeles County Museum of
Art—because she'd been away teaching in Fresno. But you couldn't
hold back a woman like Chicago for long, and, when she returned to
L.A. in the fall of 1971, she was quickly drawn into the fray.

IN THE CLASH BETWEEN THE PRIVILEGED OPPRESSORS
and the poverty-stricken oppressed, Mao Zedong once suggested it is

inevitable that the outmanned and overmatched will turn to unconventional tactics of warfare. "Guerrilla operations," wrote Mao in his 1937 book, *On Guerrilla Warfare*, "are but one . . . aspect of the revolutionary struggle . . . . When the invader pierces deep into the heart of the weaker country and occupies her territory in a cruel and oppressive manner, there is no doubt that conditions of terrain, climate, and society in general offer obstacles to his progress and may be used to advantage by those who oppose him. In guerrilla warfare we turn these advantages to the purpose of resisting and defeating the enemy."

It took some time for the women artists of L.A. in general, and Judy Chicago in particular, to learn the tactics that Mao suggested. In 1958, when a nineteen-year-old Judy Cohen had come to the city to attend UCLA on scholarship after she had been denied admission to the School of the Art Institute of Chicago, it had been a different era, and she had been a different person. While she was politically active, working for a time with a local chapter of the NAACP, she was surprised to discover how unfriendly the art world was toward women. "As I remember this period of my life," Chicago later wrote, "I realize there was a knowing and a not-knowing going on within me simultaneously. I was coming to recognize that there was a serious gap between the way I saw myself and the way I was seen by the world . . . . I tried to deny the significance of the gap, because I did not want to feel how alienated I really was as a woman who took herself seriously."[1]

Chicago's relationships with men in those years only added to the problem. In 1959, she met and fell in love with a lean and intense underachiever named Jerry Gerowitz, with whom she would have a contentious, on-and-off relationship for the next four years. The couple argued often—about his lack of career direction, their lack of money, his initial unwillingness to contribute to household upkeep, and his gambling binges. Over and over, the two broke off their relationship, then got back together, then broke it off again. By the fall of 1960, Chicago decided she had had enough of Gerowitz and separated from him. But then, as luck would have it, she was suddenly debilitated

by bleeding ulcers and needed Gerowitz to care for her for the next two years. Despite the couple's continued struggles, Chicago decided to marry Gerowitz in the spring of 1961, provided he agreed to make some necessary changes in his life. For a year, the relationship, and Chicago's life, was good. She graduated Phi Beta Kappa from UCLA in 1962, then entered graduate school and got work as a teaching assistant. The couple bought a house in Topanga Canyon, where she set up a studio in the garage. In 1963, however, on a gray and rainy day, Gerowitz drove his car off one of the windy roads leading to their home and was killed. Chicago was devastated, grieving intensely for the next year and a half, and coping in the only way she could. "I turned to my work as my refuge and salvation," she said.[2]

It was this renewed dedication to her art that propelled Chicago to complete her Master of Fine Arts degree at UCLA in 1964 and seek a career in an art market that was loath to accept her. Over the next five years, Chicago faced down near-constant insult from local males. She was told that women couldn't be artists. She was subjected to rude sexual advances by those in power. She coped with patronizing museum curators and lovers who expected her to "take care" of them. She was made to feel there was something "wrong" with her, just for being a woman.

Fortunately, Chicago did have some successes in those years, enough to convince her to keep going. Her paintings for her MFA exhibition in 1964—clean and geometric abstractions that hinted at sexual organs, attracted the attention of Robert Irwin. Shortly thereafter, at Irwin's invitation, Chicago became a fixture around Barney's Beanery, where the Ferus artists often congregated. Despite her rugged and sexy look (boots, cigars, jeans), or perhaps because of it, the highly macho Ferus boys had a hard time taking her seriously. "They spent most of their time," Chicago would later say, "talking about cars, motorcycles, women, and their 'joints' . . . . They made a lot of cracks about my being a woman and repeatedly stated that women couldn't be artists."[3] Undaunted, Chicago took an auto-body class—she was

the only woman in a class of 250 men—to learn how to spray paint on metal in order to make the slick art then in vogue because of the local "Finish Fetish." A work she made from that period, tellingly titled "Car Hood," had, in a nod to the Ferus aesthetic, a distinctly masculine quality, even as she added her own vagina-like hood ornament. Over the next year or so, Chicago worked to ingratiate herself with the Ferus boys. One night, she drunkenly told Billy Al Bengston how much she was inspired by his work, at which Bengston scoffed, bitterly calling her a "flash in the pan."[4] Eventually it dawned on Chicago that she would never be accepted as one of the boys. And by the time of her first local solo exhibition—at Rolf Nelson's gallery in 1966—her art, painted canvases stretched over plywood forms, had evolved away from the Ferus influence. "I'm finished with the kind of surface and craft preoccupation of the Ferus boys," Chicago said. "It's a dead end that leads to preciousness, and they're really fucked up by it."[5]

Despite her frustration, Chicago remained determined to establish herself as an artist in Los Angeles. Part of the problem, she decided, had been her assimilationist approach to her profession. "By the time I left school, I had incorporated many of the attitudes that had been brought to bear on me and my work," Chicago said of her output in those years. "I had begun to compensate for my situation as a woman by trying to continually prove that I was as tough as a man, and I had begun to change my work so that it would be accepted by men." Conditions in the local art market meant, however, that she would never be accepted on these terms. She was, like Mao, outmanned and overmatched by the dominant force in L.A.'s art community: Men. "I used to have dreams about being on a battlefield with bullets zinging across the field in front of me," she continued. "I felt that I had to get across, but I didn't know how, having never been trained for warfare. I was terrified. Finally, an anonymous hand reached out and helped me across the field safely. The dream symbolized my need to learn how to survive in the rough-and-tumble male world in order to become visible as an artist."[6]

At the very end of the 1960s, then, as the promise of the Ferus group was rapidly disintegrating, Chicago realized that her attempts to join in with the men—to act like them, drink and smoke like them, make art just like them—were not only doomed to failure, but that they were a denial of her own unique nature. This approach would also never result in her desired outcome: Supplanting the dominant culture with her new vision for art.[7] As a result, Chicago conceived of a more unconventional approach to art-world success. She vowed that, in order to achieve her victory, she would force herself to be true to her nature as a woman and only express ideas in her art that reflected her female experience. To launch this guerrilla campaign, Chicago decided to take the unusual step of rejecting the patrilinear names of her husband (Gerowitz) and father (Cohen). *But what to call herself?* She kicked around ideas, wondering what conditions of terrain, climate, and society in general could she use to her advantage. In time, she settled on a name that acknowledged her family roots and her Midwestern upbringing. She would call herself Judy Chicago, an artist without country, or rather, an artist in hostile territory who was now a country of one.

The switch did not happen immediately. The legal paperwork was convoluted, and it took time to create a body of work that fit with her new identity. But finally, in the fall of 1970, Chicago mounted a solo show of abstracted female forms at the gallery at California State University at Fullerton. On the wall of the gallery, the artist hung a revolutionary proclamation: "Judy Gerowitz hereby divests herself of all names imposed on her through male social dominance and freely chooses her own name, Judy Chicago."[8]

GUERRILLA WARFARE, EVEN IF ON THE SIDE OF HISTORY and justice, is effective only through long and sustained struggle. Chicago had yet to learn this, and she was immediately disappointed by the public response to her Fullerton exhibition and to her statement of independence. No one in the local art community seemed to know what to do with the points she was trying to make. As a result, Chicago

felt more alienated from the community than before, and she grew even more uncertain about the new direction for her art.

"If making art according to male standards had resulted in making my subject matter unintelligible," she wrote later of the Fullerton show, "perhaps looking at the work of women artists would give me clues about how to communicate my point of view." That is, from her failure in Fullerton Chicago realized she would have to go back to the beginning to learn how to expose, rather than cover up, the female-oriented content in her art. She also realized she couldn't do this important inward work in Los Angeles, "where the values of male artists pervaded the environment—values that asserted form over content, protection over exposure, toughness over vulnerability."[9] Chicago decided then to retreat from the battle—take a "Long March," so to speak—and recollect her energy and revise her thinking before making future incursions in the L.A. art community. Chicago met with the head of the art department at California State University at Fresno, a school located in California's Central Valley more than two hundred miles north of Los Angeles. And this was how, in the late summer of 1970, she found herself packing up and driving north into the dusty and remote center of California to teach art.

THE STANDARD NARRATIVE ABOUT THE EXPLOSION of L.A. art in the late 1950s and 1960s, and about the heroically groundbreaking "Cool School" artists of the era who for the first time put the city on the cultural map, tends to overlook a critical detail. In those years growing numbers of women artists had been making Los Angeles their home base. Though an estimate of the exact number at the time is impossible to come by, in hindsight we can see that numerous women had been trying to establish themselves in Los Angeles in the years before 1970. In addition to Chicago, the list includes such notables as Joyce Kozloff, Sheila de Bretteville, Betye Saar, Miriam Schapiro, Bruria Finkel, Gilah Hirsch, Wanda Westcoast, June Wayne, Channa Horwitz, Judy Reidel, Janice Lester, and many others.

Despite their numbers, and despite their obvious skill and drive, women were all but excluded from the galleries and museums of L.A. during the 1950s and '60s. Frustrated by the entrenched institutional hostility of the local art market, some of these women turned to alternative methods of establishing themselves as artists. One such method was to meet in support groups—called, in the parlance of the time, "consciousness-raising" groups. Here, the women artists of L.A. began plotting the actions that they hoped would change the landscape that had been laid out in front of them.

In the early 1970s, three particular initiatives that developed out of the underground group discussions would make Los Angeles an epicenter of a nascent national Feminist Art Movement. The first of these was almost preordained, as it targeted the most obvious and glaring example of bias against women by the local art establishment—the exclusionary practices of LACMA. How it happened was this: In the fall of 1969, a group of local women artists had been convened by Joyce Kozloff, an artist from the East Coast who had recently come to Los Angeles with her art historian husband Max Kozloff. "We were invited to a faculty party at the home of Allan Kaprow," Joyce said many years later. "And I didn't know many people there, so this woman [Phyllis Stein] started talking to me with this young child, who was there as a faculty wife . . . . And that is how the group began." The group's first meeting took place in an apartment in Ocean Park. "It was a small apartment," Kozloff continued. "Everyone was crowded around in the living room and standing. We went around the room and everyone introduced themselves . . . . The group mostly felt around to get a sense of what everyone wanted to do."[10]

The group—which eventually became the Los Angeles Council of Women Artists (LACWA)—was comprised of a regular rotating crew of about sixty-five women artists and an expanded list of about 250 members. Among the list were such active local artists as Bruria Finkel, designer Sheila de Bretteville, musician Vicki Hodgetts, artist Channa Horwitz (née Davis), and documentary filmmaker Judy Reidel. The

group chose subjects for discussion on meeting nights, and out of the larger group they formed consciousness groups. "Within a couple of months," said Kozloff, "I was totally radicalized. I was angry all the time . . . . But I think that happened to a lot of women." In time, two near-unanimous concerns emerged among the group. The first was education: The artists saw feminist teaching as a key to gaining a foot-hold of respect in the art world. And the second was just sitting there, a fat and complacent target.

"When LACMA decided to do an exhibition on art and technol-ogy," explained artist and curator Bruria Finkel, "it created a tremen-dous upset among the women because there were no women in the show whatsoever . . . . It was clear that women needed to do some-thing."[11] "We, as a larger group, decided to tackle the Los Angeles County Museum [of Art]," said Joyce Kozloff. "[It] was a very big project, and a lot of money and a lot of time had gone into it. On the cover of the catalog was a grid of faces, and they were all men . . . . The women were absolutely enraged."[12]

If the women artists of L.A. found one thing about the "Art and Technology" program particularly galling beyond the nearly obscene scope and expense of the enterprise, it was that the show's cura-tor, Maurice Tuchman, loudly claimed to have looked far and wide for the most exceptional artists working at the time. This, as every women in the group knew, was not true: Some accomplished females had been excluded from "Art and Technology" from the get-go. Not only was no single woman artist included in the final exhibition, only one female artist was ever invited to submit a proposal.[13] In light of the widespread upset in the group, LACWA paused to ask a cru-cial question: Was it by design that women had been shut out of the exhibition, or was there some other explanation? "We went to the museum," Kozloff explained, "and we counted all the works on the walls. Then, another day we went to the library and looked through all the catalogues of previous shows . . . . The statistics couldn't have been worse."[14]

Further incensed by the hard statistical evidence of exclusion now staring them in the face, the group determined that they should publicize what they considered the blatant discrimination by LACMA. To do this, LACWA considered a wide range of ideas and suggestions for their next steps. What followed out of these discussions was such a flurry of activity that it's difficult to pin down the order, and full scope, of what finally occurred. There were protest rallies, press conferences, and public documents. There were demands and threats of litigation against the museum. "The women in the group weren't only artists," said Kozloff. "They were filmmakers and journalists, so we had a lot of media-savvy people in the group. When we had the press conference there was a lot of media there and it got covered. It was on the radio, it was in the newspapers. I think it was on the evening news. It was embarrassing for them. They were taken by surprise."[15] In one protest rally, a group of women gathered in the courtyard outside the museum dressed in pink Western dresses, pink vests, cowboy hats, and black, Lone Ranger–style masks. They shouted slogans and made a ruckus. The media took notice. In another protest, the women wore dark clothing and masks with the face of Maurice Tuchman, the exhibition's chief curator, on them. They held black and pink balloons on which they had printed the words, "WHERE ARE THE WOMEN AND MINORITIES?"

By mid-June, one of LACWA's committees had finished a critical document. Called the "LOS ANGELES COUNCIL OF WOMAN ARTISTS REPORT," they sent it to the local media, and on June 15 it appeared verbatim in the *Los Angeles Free Press*.[16] The same day, LACWA held a press conference at the Greater Los Angeles Press Club to raise the public cry accusing the museum of discriminating against women artists. The actions of the women of LACWA were, as the group intended, shocking to the establishment. This was guerrilla warfare, after all. It was revolution. "That was the first action in the Los Angeles art world," by feminist artists, according to Joyce Kozloff, "at that museum, around that show."[17]

Among the key points of LACWA's report were a number of state-ments about the blatant statistical biases against women artists (as well as against artists of color) in the curatorial practices of LACMA, some strongly worded suggestions that the only moral path was for the museum to change its ways, and a twelve-point proposal for how it could, in practice, end the current discrimination against women even as it educated the public about "the contributions of women to the arts in the past and opportunities for women now and in the future."[18] The document ended by stating the hope that LACMA would negotiate with LACWA regarding its twelve points, and, for good measure, the group added it was prepared to take the museum to court in order to force the museum to treat women fairly.

While the museum ultimately acquiesced on only one of the demands, agreeing to organize and mount a large retrospective exhibi-tion of women's art,[19] LACWA's decision to attack the highest ech-elons of art in L.A.—at the exact moment it was celebrating its highest achievement—opened a lot of eyes around the region and country. "I think the bottom line really was the clarifying of the ideas that our women's movement had,"[20] said Bruria Finkel. "We became women-identified," said Kozloff of the experience, "and we had a very strong support system. It was a moment of such optimism and enthusiasm and energy. We thought we could change the world."[21]

AT THE SAME TIME THAT THE LACWA INCURSION WAS being planned against the Los Angeles County Museum of Art, Judy Chicago was mustering her own guerrilla force of women artists in distant Fresno. Chicago had arrived at California State University at Fresno in the fall previous to the "Art and Technology" show with, in addition to her personal artistic goals, a momentous agenda in mind. Before the fall semester began, she went to the college's Art Department chair and told him she wanted to try something different. "He was very sympathetic toward my plan to offer a class for women only," said Chicago, "and we discussed the fact that a great many

young women entered the beginning art classes and few emerged from the schools into professional life. He agreed with me that something should be done about that, and he seemed to understand my desire to give back some of my own acquired knowledge to younger women."[22]

Because of the deep implications of what she intended to do at the college, Chicago repeatedly stressed, in those first weeks, that her primary interest was in helping young women become artists. But Chicago was not being completely open about her intentions; she had much deeper goals in mind. "I suspected," said Chicago, "from my own struggles, that the reason women had trouble realizing themselves as artists was related to their conditioning as women. I had found that society's definition of me as a woman was in conflict with my own sense of personhood . . . . Due to my own determination, I had been able to stand up to this conflict and to function in the face of it. If my situation was similar to other women's, then my struggle was a metaphor for the struggle out of role conditioning that a woman would have to make if she were to realize herself."[23] Knowing that for this process to work it would take a great amount of focused time, Chicago planned for the course to last a full year and to be held in an independent studio away from the campus. Having the students take charge of fixing up their own workspace, with tools and physical exertion, would teach them that they could "take care of themselves." Keeping the class off campus would help the women avoid the intimidating presence of men and let them learn how to speak out and assert their ideas. "It's not that the men did anything overt to cause the women to retreat," Chicago explained. "Rather, their presence reminded the women of society's tacit and all-pervasive instruction that they should not be too aggressive, so that the men's egos would not be threatened. This ever-present command seemed to be lifted only when men were not around."[24]

Chicago posted signs in the halls of the Art Department that invited female students to a meeting about a potential class for anyone who wanted to become a professional artist. Chicago held the first class

meeting of fifteen women art students at the beginning of the term, and what she witnessed at first frightened her. Gathered in the home of one of the students, nervous and uncertain as they waited for Chicago to set things in motion, the young women chitchatted about clothes and boyfriends and other "superficial" topics. Chicago waited for the conversation to turn around to more pertinent subjects—to art, school, books, something intellectual—and when it did not she began to doubt her idea. "I couldn't believe it," she said. "I had been with art students before. There was generally some discussion about something having to do with art or the arts in general." She wondered exactly what she had gotten herself into. "This was just like high school," she thought. "I didn't want to be identified with women like these . . . 'chicks,' who concerned themselves with trivial issues . . . . I didn't know what to do. I wanted to escape."[25] But Chicago forced herself to stand her ground, and, in that instant, she made a decision that would become the "most important step" that she ever took in her work with young women artists. She decided that she should, then and always, reveal exactly how she felt. So Chicago simply said to them: "You are boring the hell out of me. You're supposed to be art students. Art students talk about art and books and movies and ideas. You're not talking about anything."[26] The stunned silence that followed was so complete that Chicago was sure she had derailed the class before it had had a chance to get started. But then, out of the silence, one soft voice spoke up: "Well, maybe the reason we don't talk about anything is that nobody ever asked us what we thought."

Chicago was convinced—no one had ever demanded that these women strive to reach their potential. They had lived lives in which they were not expected to do the "serious talking," and in which they were supposed to go along with the men. Ultimately, Chicago learned that when women made demands of each other, and expected an exchange of ideas and thoughts from each other, they could begin normalizing their status in the arts. By design, Chicago's art class was different from a standard course in the field. Rather than teaching form,

techniques, or the history of art, she forced the students to become aware of their own patterns of thinking. She asked them to make art out of their day-to-day experiences, and not from the academic concerns that dominated their other classes. "I felt like it was important," she said, "for them to understand and be able to cope with their circumstances, instead of simply feeling, when they came up against cultural pressure, that there was 'something wrong' with them."[27]

As the fall term wore on, just as Chicago intended, the students became aware above all else of their status as women in the culture. And this knowledge was galvanizing. Of the fifteen students who participated in Chicago's course, several—including Suzanne Lacy, Faith Wilding, Vanalyne Green, and Karen LeCocq—continued onto prominent artistic careers.[28] "It was a tremendously affirming experience to be with all women," said Suzanne Lacy years later, "to have such a charismatic woman role model in Judy. We talked a lot about role models. I think it organized people's psyches in a different way and allowed them to move forward with a lot more courage."[29]

AS HER FIRST SEMESTER AT CALIFORNIA STATE University at Fresno neared an end, Judy Chicago took stock of what had been accomplished in her Feminist Art course. While she was proud her students were on their way to producing powerful work that she thought might rock the art establishment, she realized she was in a bind. She was having trouble handling all of the feelings the program brought up in her. "I didn't want my students to see my fears," said Chicago, "and become anxious about exposing what was clearly the raw material for an openly female-oriented art, as I felt that they were dependent upon me for support and strength. I had my own anxieties about exposure to deal with. I felt overwhelmed by the level of responsibility that had somehow implicitly come to rest with me, just by the fact of this class and the permission the women in it felt. I couldn't 'pass the buck.' I was the person responsible for providing that permission, and that was a terrifying feeling."[30]

As the program progressed and students dealt with their compli-
cated feelings, Chicago's classroom was increasingly riddled with stu-
dent "crying jags, depressions, and self-deprecating remarks." After a
few of Chicago's students performed at an art seminar at the University
of California in Berkeley in December, 1970, Chicago decided to
inform students of a change in policy designed to establish some men-
tal and emotional space between them and her. "I told them that I
wasn't going to relate to them any more primarily on an emotional
level," said Chicago. "Up until that time, we had been spending more
energy dealing with personal problems than making art. I suggested
that they begin to rely on each other for emotional raps, setting them
up either regularly or on the basis of individual needs. I told them that
henceforward I was going to relate to them almost entirely on the basis
of work."[31] Chicago released the students to become their own support
system, and, after a few fits and starts, soon it became clear, according
to Chicago, "that our 'class' was transforming itself into a community
. . . based on the students' needs as well as mine."[32]

Despite these changes, Chicago remained confused and anxious in
Fresno, so she turned to the only person she knew who could help, her
colleague Miriam "Mimi" Schapiro, a painter who had just started
teaching at the California Institute of the Arts (CalArts) near L.A. "I
have to talk to you," Chicago told Schapiro. "You are the only woman
I can talk to. All of these things are happening in my class, and if I
don't talk to you, I won't be able to handle them."[33]

To Schapiro, Chicago relayed all of her fears about the students
and their issues, and about the level of responsibility she was struggling
with. Schapiro was supportive and reassuring, agreeing that the two
should work together in a "partnership" and planning visits to Fresno
to observe students at work and lecture at the college. "Judy and I spent
a lot of time together talking about the problems of teaching," said
Schapiro of her visits. "She was involved in restructuring the school
situation and breaking down the role barriers between teacher and stu-
dent." Schapiro was also impressed with Chicago's students' work—by

the expression of feeling, the use of autobiographical material, and the way they developed "new definitions of female iconography."[34] She gave valuable criticism to the students, something that Chicago never had felt proficient at, and the students quickly embraced her.

Chicago, witnessing Schapiro's rapport with the students, became increasingly convinced that she, while good at organizational tasks and at conceiving and conducting a big project, was not good at dealing with more petty concerns. She simply did not have the patience or energy for that kind of responsibility. Though there are several, conflicting stories about how and when the idea originated, by March of 1971, as Schapiro continued to visit Fresno and work with Chicago's students, the two had begun planning to move what they were now calling the Feminist Art Program to CalArts for the fall term in 1971. While some, but not all, of Chicago's Fresno students would make the move south, for all intents and purposes Chicago spent the rest of the spring term in Fresno winding down her involvement with the college and plotting her return to the great battlefields of L.A.[35]

AS THE FALL OF 1971 APPROACHED, IT WAS BECOMING increasingly clear to the women artists of L.A. that their moment was at hand. June Wayne was a formidable local artist who, despite a distinguished career that spanned back nearly to World War II, was still relatively uncelebrated by the wider art community.[36] In the fall of 1971, Wayne began teaching a series of courses to young women artists that she called the "Joan of Art" seminars. In the classes, Wayne covered topics related to being a professional artist and preached the importance of always giving back to the female community of artists. Her impact on the artists of Los Angeles was significant. As Faith Wilding wrote in 1977, most of Wayne's former students claimed she had made a huge difference in their professional lives and careers, and that, in fact, "it had been the turning point for some of them in making the step from amateur to professional."[37] Meanwhile, the Los Angeles Council of Women Artists, fresh from their surprising coup

at the County Museum that summer, continued to gather and connect women artists from across the region.

The fierce and independent Chicago, however, on her return to L.A. was dismissive of the new group, thinking it was too big and passive to be effective in the battle against the status quo. Chicago preferred the idea of a select group of strong women who would be the core of a "coherent female community."[38] For her, the key to this feminist future was pushing her vision for a "Feminist Art School." Therefore, even as the "Joan of Art" seminars began taking off at June Wayne's studio in 1971, Chicago was working hard to relaunch her program in L.A.

Judy Chicago and Miriam Schapiro established the Feminist Art Program with a flourish at CalArts that fall, as evident in the fact that, out of the institute's two hundred enrolled female students, sixty had applied to be part of the program (twenty-five were accepted). The program at CalArts was an expanded version of the concept that Chicago had pioneered in Fresno. In addition to female-centered studio courses, the program offered team-taught courses on art as well as female art history taught exclusively by women for women only. What's more, the designer Sheila Levrant de Bretteville was developing, in collaboration with Chicago and Schapiro, a feminist program in design at CalArts. The Women's Design Program would be a one-year program that focused on a full study of art processes, group consciousness raising, performance workshops, and a study of feminist literature.

Timing was a key to CalArts' advancement of a comprehensive new feminist educational program. While the school's history went back to 1961, when the Disney brothers merged the L.A. Conservatory of Music (f. 1883) and the Chouinard Art Institute (f. 1921) to create a comprehensive arts institute, CalArts had only just reached its new permanent campus in Valencia in the fall of 1971.[39] The new place was full of a kind of raw and untethered energy. Grounds were unplanted and mostly sand, which blew around the campus and annoyed everyone. When the administration finally got around to installing plants, most

of them died. One prominent figure on campus that year was a young acting student named Paul Reubens. He was known for his penchant for dressing up like Carmen Miranda and dancing through the school's corridors.[40] The campus's manic energy was infectious. Space was tight and amenities were few (the bathrooms were particularly poorly cared for), but those were just problems to solve with elegant solutions.

A case in point: That fall, two enterprising design instructors, Peter de Bretteville and Toby Cowan, created a modular kit for students to use as cheap dorm furniture. Called the "Metamorphokit," it was a Bauhaus-inspired conglomeration of chromed steel tubes, Formica-laminated panels, plywood storage boxes, and plastic storage bins that yielded a simple bed, work table, and cabinet-like structure (the plastic boxes functioned as drawers when placed in the plywood boxes). The dimensions and fit of the elements were coordinated so students could rearrange them to suit various needs or space configurations. The instructors gave a kit to each of their students on the first day of class and made their first creative assignment to assemble it. They encouraged students to think creatively about how best to arrange the furniture so that the kit met their needs.

Consider the excitement in one student's impression of what school was like on the first day of classes in 1972, as documented in the School of Design's 1972 publication *Networks 1*: "I was assigned to a white concrete block room with a walk-in closet, large sliding-glass windows, and a stack of yellow and vermilion wooden boxes, bent metal tubing, wood panels, a bag of nuts and bolts . . . . I just wanted to sleep, but in order to do that I had to put my bed together . . . . Sue built a small table. I made a kitchen area, and we used whatever was left over to build a monumental bookcase-desk combination . . . . It's very satisfying to make the furniture do what I want."[41]

THE ATMOSPHERE OF OPEN CREATIVITY AT CALARTS was particularly empowering to women, and the young women who enrolled in Chicago and Schapiro's Feminist Art Program during its

first year were markedly ambitious and driven. In order to harness all the energy and talent, Chicago and Schapiro planned carefully, sketching out the activities of the first term and laying the groundwork for a project that would become the third great genius stroke of L.A.'s Feminist-Art *annus mirabilis.*

Because many of the new campus's facilities were not yet complete or fully functioning, the two instructors took the students out of the classroom as often as they could. Forced to be innovative in unfamiliar surroundings, students rose to the occasion and mounted some daring performative works. One early major Feminist Art Program project, for example, was a sequence of performances called "Site/Moment: Route 126" that occurred on a single day along the highway that ran from the CalArts campus to Ventura. The events began with a group action, led by Suzanne Lacy, to create a sculpture on site from the discarded husk of a car. It ended with the women watching artist Nancy Youdelman slowly walk out into the ocean, seemingly to her own watery death.[42]

The highway was a fitting metaphor for not only the life experiences of these young female artists, but also for the Feminist Art Program itself. There was a sense, even in the program's first year of existence, that the projects and instruction were leading toward something big. What that something could have been was uncertain at the onset of the program, though the seed for it had already been suggested in a lecture that art historian, and close friend of Chicago's, Dr. Paula Harper had given to the fledgling Feminist Art Program back in August. According to notes Chicago made of the lecture in her journal, Harper had suggested to the students that they make a house. "We'll rent it for a couple of months & 'do' it," read the record of Harper's pitch, "i.e., paint, plant, decorate, etc., doing It [sic] in the most 'feminine' way possible, incorporating work by Calif. women artists where it's appropriate—buying hand-painted China, crocheted, embroidered, etc., pieces—everything that is 'feminine, i.e., trivial' in the eyes of society. Then we'll show it."[43]

Sometime early in that first semester, as the Feminist Art Program remained homeless on the still-unfinished campus at CalArts, Harper's speech echoed in the minds of the Feminist Art Program's coordinators. While the original concept was meant to "honor the house as traditionally the art of women," in the hands of Chicago and Schapiro the concept grew somewhat more complex and ambitious. Chicago, for instance, wanted to examine the house as "a place of imprisonment of women," and both Chicago and Schapiro agreed the project should "challenge gender stereotypes and raise consciousness of ways in which women's creativity was marginalized and repressed."[44]

Uncertainty reigned for a time in the program and at the school in late 1971. When a dance student at the school was raped in her dorm room, the confidence and ambition of the Feminist Art students, as well as of many of their female peers, suffered. Chicago and Schapiro took the opportunity to join the dance school dean, Bella Lewitzky, in organizing a campus-wide meeting about rape. Chicago also collaborated with other artists on campus to create performances and other art works about the female experience in light of the rape. By the time that a site was found for the program's capstone project—a dilapidated mansion on Mariposa Street near downtown that was slated for demolition—Chicago was optimistic despite the anxiety on campus. "The ideas for rooms are phenomenal & it seems like it will work out well," Chicago wrote in her journal. "Everyone's very excited & ideas range from a quilted bedroom to the bedroom for Léa, from Colette's *Chéri*."[45]

The Mariposa house's owner had agreed to let the Feminist Art Program use the space for three months, and on a bright morning in early November, Chicago and Schapiro set loose their twenty-one students in the house's seventeen dilapidated, vandalized rooms with mops, brooms, saws, ladders, hammers, and nails. The students' assignment was to renovate the house and turn its rooms into workable installation and performance spaces. The project, which became known as "Womanhouse," almost did not survive that initial month,

as the students were frustrated at having to work harder than they expected at a dirty and unpleasant job. They complained, broke down, and even accused Chicago and Schapiro of being unfair and dictatorial in their demands. But somehow they survived, learning not only a whole slate of physical skills but also that they could survive almost anything.

"Womanhouse" opened with art and performances on January 30, 1972, and remained on display for a month. The spaces included numerous spectacles and housed several now-iconic works and installations. The student Robbin Schiff produced the "Nightmare Bathroom," in which a female body was embedded in a blocky, coffin-like bathtub. Someone had painted the kitchen and dining room completely pink, down to the fixtures and household items on the shelves, and Judy Chicago had made the "Menstruation Bathroom," in which an expanse of white and pristine tile and fixtures was broken only by a trash bin overflowing with bloody feminine napkins. Performances of Faith Wilding's one-person rumination "Waiting," and Chicago's two-person performance "Cock and Cunt Play" were also widely praised.

Throughout the run of "Womanhouse" during February of 1972, interest in the project remained high across the region and around the country. During its monthlong run, an estimated nine to ten thousand visitors came to the space, many of whom were young women who took the artists' works to heart. "It makes me feel proud, a kind of pride in what women can do," said a female engineer who was quick to call herself a "non-artist." "I think everyone that sees it has to realize that women are not poor-imitation men. You know they have something specific to say and something special to do. It's very nice. It'd be interesting if more men could come see it."[46] The famous feminist writer Anaïs Nin visited, as did a cohort of feminist activists from Southern California and beyond.[47] The art world itself—including figures like art historian Linda Nochlin and even Maurice Tuchman, late of the "Art & Technology" controversy[48]—also took interest, as did the local and national media.[49]

As was evident in the impassioned speech she gave to the gathered crowd that night at the house, Chicago found in "Womanhouse" a perfect venue for her frenetic energy and particular brand of leadership. She gave inspirational talks, directed performance pieces, and coordinated various student activities. When asked what had been her goals for "Womanhouse," Chicago suggested that it was all about the potential for being a place of action, where women could make things happen. "It synthesized all female activities and the invisible achievements of women," she said. Then, she added, simply, "I want to change the world."[50]

From the moment "Womanhouse" opened, then, the project was laden with a sense of its important, groundbreaking nature. The struggle involved in completing the project was, of course, all but forgotten. On the project's last weekend, overflow crowds attended, with many imploring Chicago, Schapiro, and the students to keep "Womanhouse" open. But the group, exhausted by the attention and worn out from the work, was glad to close their project down, even as they were proud of their accomplishment. Chicago herself was effusive in her journal. "It really marks the beginning of female art . . . ," she wrote. "In a few years, things will be more open & women will be able to be more subtle and sophisticated and then my work, I hope, will be appreciated."[51]

As to whether the male-dominated art community of Los Angeles would agree with Chicago, and willingly accept the legitimacy of the new power on the block in coming years, remained to be seen.

# CHAPTER III.

# *Viva Mi Raza!*

## *The Rise of Chicano Artists*

REVOLUTION WAS CLEARLY IN THE AIR OF smoke-choked Los Angeles at the end of the 1960s. About the same time that the women artists of Los Angeles were rising up against the powers-that-be, another very determined group was beginning its own rebellion. By the early 1970s, American Latinos, especially those of Mexican origin, had become fed up with the discrimination, marginalization, inequality, and even brutality they faced at the hands of the mostly white, Anglo-Protestant majority. For much of the twentieth century, generation after generation of young American Latinos had been barred from the American Dream—a good education, a well-paying job, a safe neighborhood, access to the justice system, and so on. Moreover, even as Latinos were force-fed the idea that it was important to become part of the American "mainstream," their significant cultural and historical contributions in places like California, New Mexico, Nevada, Texas, and Arizona were downplayed and ignored by the dominant (white) culture.

In many ways, Southern California was ground zero for white bias against American Latinos. "Los Angeles matured at least in part," suggested history professor and author William Deverell, "by covering up places, people, and histories that those in power found unsettling. Los Angeles became a self-conscious 'City of the Future,' by whitewashing an adobe past, even an adobe present and adobe future . . . . [It was] a

way by which white Angelenos created distance (cultural or personal) between themselves and the Mexican past and the Mexican people in their midst."[1] The barrier constructed between whites and Latinos was not accidental. In fact, the city's early city leaders and boosters made it a core local value. In a 1930s brochure advertising its virtues to curious Midwesterners, Southern California was touted as the place where "Anglo Saxon civilization must climax in the generations to come . . . . [And] the Los Angeles of Tomorrow will be the center of this climax."[2] As a result, Latino neighborhoods were deliberately separated from white ones through the force of local convention and planning practices, as well as through occasional violence. "In Los Angeles," wrote Chicano Studies professor Carlos Francisco Jackson, "de facto segregation plagued communities of color."[3] The ultimate result was a century-long perpetuation of an exploitable underclass. Mexican-American adults were given few work opportunities, and Mexican-American students were given little chance by local schools and often placed in classes for kids with learning disabilities or mental retardation. "This practice," suggested Jackson, "perpetuated the status of Mexican Americans as a source of readily available, cheap labor."[4]

Starting in the 1950s and 1960s, frustrated Mexican-American activists found inspiration from the nationalist liberation movements that had overthrown unjust and exploitative colonial systems in Africa and Asia. As a result, the so-called "Chicano"[5] Movement—called simply *El Movimiento*—began to agitate for critical societal change through a range of activities. In the 1940s and '50s, for instance, World War II veteran Dr. Hector P. Garcia fought to protect the rights of Latinos, serving on the U.S. Commission on Civil Rights and founding an advocacy group to support Hispanic veterans. In the 1960s and '70s, Reies López Tijerina led a land grant movement to regain control of his people's ancestral lands in the American Southwest. In 1962, Cesar Chavez founded the National Farm Workers Association to fight for the rights and working conditions of Mexican American farm workers. In 1968, what would become the most prominent

civil rights organization in the Mexican American community—the Mexican American Legal Defense and Educational Fund (MALDEF)— was founded, taking on a host of important tasks for the community, including political advocacy and the training of community leaders.

Because of the wide array of issues facing a widely dispersed and varied Chicano community, *El Movimiento,* like the Feminist Movement, recognized the need to create evocative visual symbols and imagery to help focus and rally the people to the cause. This led to the establishment, by the end of the 1960s, of a correspondingly radical-ized Chicano Art Movement. The artists of the Chicano Art Movement often felt their foremost task was to represent the community's self-image. "In an effort to ensure that the imagery and content accurately reflected the community," wrote the scholar Carlos Francisco Jackson, "Chicano artists often entered into dialogue with community members about their culture and social conditions."[6] As a result, the Chicano Art Movement was often a critical tool during the 1970s in leading *la raza* (that is, "the race," as many in the movement took to calling themselves) to some critical community victories.

CONSIDERING THE OVERLAP BETWEEN SOUTHERN California's rising status as an alternative American art capital and the growing political and social consciousness of the large Latino popula-tion that called the region home, it was almost inevitable that much of the activities of the Chicano Art Movement would be centered there. Leaders of both the Chicano Movement and Chicano Art Movement in Los Angeles and San Diego were very aware of the local history of segregation of Latinos by the white majority. And Chicano artists were profoundly influenced by their lives spent growing up in—or at least intimately aware of life in—the *barrios,* or Spanish-speaking Latino neighborhoods, of the American Southwest. It was in the barrios of Southern California, then, that much of the inspiration for the Chicano Art Movement would first take hold and begin to develop its own par-ticular aesthetic and visual language.

The American barrios of the mid-twentieth century were, in general, marginalized and isolated places. Often situated on the edges of the wealthier, "whiter" parts of local society, these neighborhoods were, in the minds of the majority population, enclaves of crime and poverty that were better ignored. Often the barrios were tantamount to ethnic enclaves—akin to the ghettos of old Europe that isolated local Jewish populations—with long histories of marginalization, unequal access to social or other services, and other stifling barriers to fulfillment and participation in the mainstream. As a result of the dominant culture's treatment of the inhabitants of these neighborhoods, the barrio developed a particular and complex culture. As the urban planning scholar David R. Diaz put it, the barrio represented for many Chicanos both oppression and opposition, both a "zone of segregation and repression" as well as "the reaffirmation of culture, a defense of space, an ethnically bounded sanctuary, and the spiritual zone of Chicana/o and Mexicana/o identity."[7]

For expressive artists in the barrio, the facts of daily living exerted a strong influence on their art. "With their complicated conjuncture of internal and external forces," suggested the historian Raul Homero Villa, "the barrios of Los Angeles and other California cities have been real and rhetorical locations from which, and about which, to enact ideological expressive critiques of domination." The Chicano artists, writers, activists, and other creatives typically have found inspiration in their surroundings to question the "larger landscapes of power through the political culture of their expressive works."[8] By the 1950s and '60s, several unique artistic and aesthetic forms began to emerge from the barrio. Most visible and widespread, perhaps, was the Chicano take on the local car culture of Southern California. In the years following World War II, white kids across Los Angeles had built an entire culture from their tricked-out hot rods and loud muscle cars. As a result, the kids of the barrio answered with their own appropriately elaborate car culture: that of the "lowrider." Whereas the hot rods of Southern California were souped up to ride loud and race fast, exemplifying

the easy and excessive consumption and wealth of white America and reveling in the bluster of America's great technological Space Age,[9] the Chicano answers to the hot rod were built to ride close to the ground and cruise through streets as slowly as possible. And although both cultures reveled in decorating their cars with expensive custom paint jobs using metal flake or pearl flake paint, clear coats, pinstripes, flames, and other decorations, the lowrider aesthetic replaced the hot rod's "streamline" with a Latinesque sensibility exemplified by gaudy sun visors, baroque fender skirts and bug deflectors, gold or chrome spoke wheels or rims, and any sort of trapping that would signify a lack of hurry.

Closely related to the lowrider phenomenon was a set of personal lifestyle and fashion choices that developed in the barrio around the same time. Known as *pachuquismo*, it was described by Beatrice Griffith in her 1948 book-length sociological study of the Mexican American experience in California, *American Me*. Of the "estimated four hundred thousand persons of Mexican ancestry living in Los Angeles County," Griffith wrote, there was "a small group of teen-age boys and girls who by virtue of certain characteristics of dress and behavior have become a group apart from the normal Mexican population . . . . Who are those Mexican-American boys and girls known as Pachucos? What are the forces in the industrial area around Los Angeles that have created a lost generation? What do these underprivileged youth find when, at the age of fourteen or fifteen, they enter 'the fount of life'? They find conflicts so perplexing and so full of contradictions that they often shun the responsibilities of both cultures—that of their parents and that of America—and create their own world of 'Pachuquismo.' "[10] According to Griffith, the physical and aesthetic characteristics of the pachuco grew out of "rich but shallow" soil. "They," the pachucos, wrote Griffith, "are nourished neither by deep tradition nor age-old mores. Rather, they are nourished by an intense vitality, individualism, frustration, and rebellion. In creating a hybrid culture that is neither American nor Mexican, these youths have taken full advantage of their freedom of choice, and

their choices have sometimes been unfortunate ones. They have created their own language, Pachucano talk; their own style of dress; their own folklore and behavior patterns. They have developed a neighborhood group spirit . . . thus creating the so-called gangs."[11] Griffith went on to describe the lives of young people who joined the pachuco gangs of the Southern California barrios of the 1940s. Born and raised in the overcrowded shacks and tenements of the barrio, Mexican American kids typically took to the streets to find both peace from their home life and a modicum of social support. In the fifty or so gangs that Griffith observed, kids found activities ranging from athletic competition with other gangs to intense fighting. "Why do Pachucos feud among themselves," Griffith wondered, "often with violence, resulting in serious injuries and death? As one older boy explained it, 'These kids are all full of animal mad. That's why they fight each other. They can't fight the cops or the gabachos, their enemies, so to get the mad from their blood they fight each other.' "[12] Considering the massive immigration of Mexicans to the Los Angeles area between the 1940s and 1980s,[13] and the resulting social pressure of the increasingly crowded barrios, it's easy to see how the local gangs grew to define, by the early 1970s, what the Chicano barrio experience was about. Back in 1948, Griffith had noted that, as part of gang culture, the pachucos had numerous ink tattoos on his fingers and arms, and they spent much of their time marking, in ink and chalk, their "names and signs . . . around the town on street cars, tunnels, billboards, and buildings, even on police phone boxes." Such public "scratch marks"[14] were not new; graffiti, after all, had been found in very ancient urban settlements in Ephesus, Rome, and Pompeii. However, Mexican American youths of the barrios of Southern California, who sought to leave their mark on the blighted landscape that they inhabited in the middle part of the twentieth century, raised an ancient practice to unexpected new heights.

Understanding how graffiti became an important cultural practice in the Southern California barrios in the 1960s and '70s requires a bit of local historical knowledge. After the so-called Zoot Suit Riots of

June 3, 1943—in which young pachucos, after being vilified and tar-
geted in the press and among community leaders and politicians, were
hunted out and attacked by (mostly) white servicemen stationed in the
L.A. area at the time[15]—the tone of Chicano gang practices changed. By
the late 1940s, the gangs hardened under the pressure of conflict with
territorial rivals, with authorities, and with the violence of the Zoot
Suit Riots. The gangs grew bolder and more visible in the community,
and they transformed to something at once darker and more treach-
erous and yet somehow more appealing to increasingly marginalized
Chicano youths—adding ritualized "street baptism" for its members,
adapting codes of honor and loyalty to each other and their territory,
and taking on increasing numbers of criminal activities.

Concurrent to the evolution of gang culture in the barrios, mean-
while, a Bronx machine shop proprietor, frustrated with the awkward
aerosol cans of the era, had invented a new, reliable "crimp-on valve"
that allowed better control of the spray flow. By the later 1950s, these
new low-pressure aerosol cans were increasingly common and used for
all manner of products, including paint. In the 1960s, the barrio gangs
of Los Angeles and elsewhere discovered the new aerosol spray paints
for use in their marking activities. According to scholars, the gangs of
this era "fought other gangs and they sprayed their graffiti all over the
place,"[16] creating a Babel-like profusion of words and images and mes-
sages. "Walls containing multiple layers of graffiti form a palimpsest
surface," wrote Jerry and Sally Romotsky, "where many inscriptions
provide a history of local street activities."[17] Most of the erased and
overlayered walls show a struggle, by various groups over spans of sev-
eral years, to claim ownership of the territory. Whatever their purpose,
the markings of Chicano gangs, which seemed to many older Mexican
Americans and most of the mainstream culture like angry and con-
founding hieroglyphs, were, by the later 1960s, nearly ubiquitous on
the walls of city buildings, on suburban playground walls, under free-
way overpasses, in flood control channels—namely, almost any public
space in Los Angeles within reach of the spray cans.

Despite that the markings were relatively indecipherable to non-gang members, the distinctive aesthetic of Chicano gang graffiti expressed clear sentiments to mainstream society. According to Susan A. Phillips's history on L.A.-gang and hip-hop graffiti, *Wallbangin': Graffiti and Gangs in L.A.*, the graffiti of L.A. in the 1960s and 1970s was a means of communication that spoke of the hybrid cultural status of many of the young gang members making the marks. These gang members were "people stuck in the spots betwixt and between cultures," wrote Phillips, people who "may be part of things but seem to belong nowhere." This "hybridity," she suggested, "creates new social forms within the 'layered conception of the modern world,' balancing modernity and tradition."[18] That is, whereas the Chicano gang graffiti often appeared to an outsider to be composed of cryptic and ugly symbols and words, to young residents of the barrio it was a tool to express layered political and social opinions, to share ideas about the confounding nature of modern Chicano experience and the redemptive power of indigenous Chicano heritage and cultural, and, in the aggregate, to establish a clear counter-narrative to the assumed understanding of Chicano life in the barrios. As anthropologist Nestor Garcia Canclini explained in 1995: "Graffiti is a syncretic and transcultural medium. Some graffiti fuse word and image with a discontinuous style: the crowding together of diverse authors' signs on a single wall is like an artisanal version of the fragmented and incongruent."[19] In the clear aesthetic choices made by each graffiti "artist"—the unique calligraphy styles, the choices of expressive content, the nuances of line and form and expressive mood, and the refined and delineated messages—graffiti not only was a tool of resistance and challenge, reclamation and empowerment for young Chicanos, but, increasingly, it was becoming something else altogether: A street-based, community-centered, expressive art form.[20]

## THE CULTURE OF THE BARRIO, AND ITS EXPRESSIVE

manifestations on the streets and walls of Southern California, somewhat explains how one Chicano community in San Diego, Barrio

Logan, realized through art an early and critical public victory against the white political establishment of the early 1970s. Named for an Illinois Congressman who worked in vain to bring the transcontinental railroad to San Diego in the 1870s, Logan Heights was a neighborhood situated just south of the city's downtown. In 1910, the neighborhood saw an influx of people fleeing the effects of the Mexican Revolution, and shortly afterward it was rechristened Barrio Logan. Early on, Barrio Logan was a pleasant community with a population of about twenty thousand residents that stretched from the south part of a busy downtown to a beach on the northern shore of San Diego Bay. But this heyday would not last. When the U.S. Navy moved into San Diego in the 1930s, it requisitioned stretches of the shoreline, cutting off the barrio's access to the water—a fact that drove some residents away from the area. During World War II, new zoning laws encouraged the building of auto junkyards in the flatlands near the shore. An all-too-familiar sense of alienation and malaise settled over the barrio. In 1963, city planners added to the mess by running the new Interstate Highway 5 through the heart of the community, splitting it into two parts and further eroding its sense of cohesion. In 1969, the construction of the San Diego Coronado Bay Bridge added ugly pylons to the local landscape and covered much of the community with a depressing concrete "roof." By the 1970s, Barrio Logan's population had fallen to just five thousand.

Despite the decline, the rising self-awareness and sense of self-determination fostered by *El Movimiento* spurred attempts to revive Barrio Logan. In 1967, community leaders made a bold demand of the city: That it designate the otherwise blighted 1.8-acre swath of land underneath the pylons of the Coronado Bay Bridge as a new neighborhood park. After two years of intense discussion, the state of California agreed in June of 1969 to the community's demands and would lease the land to the City of San Diego for its conversion to a community recreational area. Barrio Logan leaders celebrated their rare victory, though of course, based on the community's past dealings

with the establishment, they should have known it would not be that easy. In fact, despite the state's directive, leaders in San Diego had no real intention to develop the park, as Logan Barrio's community leaders would discover.

Early in the morning on April 22, 1970, Mario Solis, a Logan Barrio resident who was on his way to classes at nearby San Diego City College, noticed several bulldozers parked in the three-acre lot located adjacent to the presumed park plot. When he asked some of the assembled work crew what was going on, he was shocked to discover that they were preparing to grade the land in order to build a new California Highway Patrol station.[21] As the bulldozers began rolling out, Solis acted quickly, running door-to-door to spread the news. A small crowd of community members gathered at the work site, and Solis continued on to the college to alert students in his Chicano Studies class. Some students ran to join the crowd that was gathering underneath the freeway pylons, while others gathered to print up fliers to distribute around campus and the immediate area around the college. Word quickly spread across Barrio Logan, and the crowd grew. At noon that day, some local high school students walked out of their classes and joined the congregation. Some members of the gathering created a human chain around the bulldozers. Other group members had gotten hold of gardening tools, and they began furiously digging up the plot of land under the bridge to plant cactuses and flowers.[22] Faced with a growing and increasingly motivated crowd, the Highway Patrol commander present at the site ordered the construction to stop. And suddenly, without any forethought or planning, the community members of Logan Barrio were now occupying the land underneath Interstate Highway 5 and the Coronado Bay Bridge.

That evening, about 250 of the demonstrators met with San Diego city leaders at a local community center. At the meeting, a leader of the Barrio's Community Action Council accused the state of having deceived the community regarding what was planned for the land in question. Officials hedged in their response. According to the state

records, the land that local residents wanted for a park actually belonged to the California Highway Patrol, and, according to a representative of the state's department of transportation, who attended the meeting, it was ultimately up to the City of San Diego to decide if it wanted to negotiate with community members regarding converting the land into a park. At some point, Mario Solis rose up and proclaimed that demonstrators would return the following morning at 7:30 a.m. The next evening, at another community meeting—this time with more city officials[23]—more angry voices vowed that the community would not give up the fight for a park. Toward the end of the meeting, portentously, a locally based mural artist by the name of Salvador Torres rose and spoke. In his speech, he expressed for the first time his vision of having local Chicano painters and sculptors turn the blighted swath of land beneath the tangle of bridge pylons, "into things of beauty, reflecting the Mexican-American culture." In response, some of the younger people at the meeting began stomping their feet. One of them, a student from San Diego State University, shouted "Viva la raza!" at the officials. "We gave you our culture of a thousand years," the student continued. "What have you given us? A social system that makes us beggars and police who make us afraid. We've got the land and we are going to work it. We are going to get that park. We no longer talk about asking. We have the park."[24]

The occupation of what was now being called Chicano People's Park (later shortened to Chicano Park) continued as city officials deliberated. Youth organizations from other parts of California—Santa Barbara and Los Angeles, for instance—heard of the growing carnival atmosphere and traveled to the spot to participate in the protest. Women from the Barrio Logan community cooked meals for the demonstrators, and other community members brought more plants, seeds, and fertilizers for the growing garden. Victory for Barrio Logan, when it finally came, was somewhat anticlimactic. On May 1, an assistant city manager for San Diego announced that the city had reached an agreement with the state of California to make a land

exchange—meaning, the plot of land under the Coronado Bay Bridge could become a park and the state would offer up another plot of land for the city's new highway patrol station. The only stipulation by the state was that the plot of land had to be cleared of demonstrators before the official negotiations could begin. On May 3, after twelve days of occupation, the Barrio Logan protestors reluctantly vacated the site, making sure that they stationed between five and ten people on the sidewalks surrounding the land at all times. From here, however, things slowed down.

On July 2, a formal agreement between the city and state was signed over the transfer of the park land, but by March of the next year no actual construction or development had taken place on the park site. Impatient younger members of Barrio Logan began raising questions of city leaders, who fortunately relayed good news. A site had been found for the patrol station, and, a few weeks later, everything finally lined up. On April 26, 1971, the California State Assembly unanimously passed a bill that granted a thirty-year lease to the 4.5-acre plot of land under the Logan Barrio freeway overpasses for a park that would include play areas, open grass, child-care services, and a community center for adult education, health and social services, and even employment counseling. Governor Ronald Reagan signed the bill into law on May 23, 1971, and community members finally rejoiced. And yet this still was only the beginning of the true impact of Chicano Park.

AFTER ACCOMPLISHING THE NEARLY IMPOSSIBLE feat of forcing an ambivalent city to give up land for a community park, the leaders of Barrio Logan, in collaboration with local representatives of the nascent Chicano Art Movement, did something truly, lastingly revolutionary: They turned the park into a showcase for the culture of the barrio and of the Chicano people of California. Back in the late 1960s, artists of the nascent Chicano Art Movement, seeking to find a mode of expression that would be meaningful and empowering to Mexican Americans, couldn't help but notice what was happening

on the walls of the barrios of Southern California. The spread of graffiti made a powerful cultural statement for Chicanos wishing to speak up against a hostile world. At the same time, as Chicano artists well knew, wall murals had been a part of Mexican and Mexican American culture for much of the past century, particularly in the works of the great Modernist artists—Orozco, Rivera, and Siqueiros—who led the Mexican Mural Movement of the '20s and '30s. These artists' murals were heroically scaled, and imbued with nationalistic, social, and political messages intended to speak to Mexican audiences, so it made sense that Chicano artists working during the U.S. political upheaval of the 1960s and 1970s would look to *Los Tres Grandes* for a blueprint of how to create culturally and politically empowering art.[25]

Starting in the late 1960s, Chicano artists from San Diego and Los Angeles, inspired by the wider Chicano Movement, had begun to form local artist collectives. These collectives organized exhibitions of members' art work, conducted community and art workshops, published broadsides, posters, and literary publications, organized street and protest activities, and, perhaps more visibly to the community at large, they started painting murals. By the early 1970s, San Diego was home to collectives like Los Artistas de los Barnos, Los Toltecas en Aztlán, and El Congreso de Artistas Chicanos en Aztlán, and Los Angeles boasted groups like Asco (founded in 1971), the collective Los Four (1973), and the East Los Streetscapers (1975).[26] Because of the presence of these collectives, the idea to paint murals in the unused spaces under the bridges and on the freeway pylons at the site of Chicano Park had come up when barrio leaders first asked the city to create the park.

Salvador Torres, the artist and activist who spoke passionately at the Barrio Logan rallies, had been a member of three Chicano artist collectives in San Diego. He came to his position of leadership in the local arts community honestly. Though born in El Paso, Torres arrived in San Diego with his family at a young age. As a studio arts student at San Diego City College, he met and befriended the artist Victor

Ochoa and artist/poet Jose Montoya. In the late 1950s, Torres followed Montoya up north to the California College of Arts and Crafts in Oakland, from which both graduated in the early 1960s.[27] Torres spent six years as an art instructor at the College before falling seriously ill and returning home to San Diego to be treated for tuberculosis. After his release from the hospital around 1969, Torres returned to his old home in Barrio Logan and was heartbroken and enraged by the distress and depression afflicting his community.

After his indignation and anger subsided, Torres slowly accepted the reality of the offending freeway overpass, and, in time, he developed another view of it—as a place rife with artistic possibility. In his spare time, Torres began sketching the spaces and shapes created by the pylons and the understructure, and he soon took to imagining the colorful art that might exist in these spaces. Out of this, Torres conceived, in 1969, the Chicano Park Monumental Public Mural Program, before there was any inkling that the park might become a reality.

After the community began making its push to create Chicano Park, Torres quietly began seeking the formal and official consent for organizing a project in the space under the San Diego Coronado Island Bridge by meeting city and transportation officials. The idea was, in Torres's mind, that giving the community an opportunity to express themselves created a chance for Barrio Logan to "speak truth to power" and break down longstanding barriers of communication and understanding. Negotiations over the Chicano Park Monumental Public Mural Program overlapped with the community's struggle to wrest control of the land. Complicating the mural discussion in particular was the city's struggle to deal with the increasingly rampant street graffiti and its associated gang activity; meaning, Torres had to overcome the pushback from the community and political leaders, whose focus on expanding graffiti removal efforts and abatement programs clouded their views of the value of community-driven wall mural projects. It was difficult for many to accept that wall markings of any sort could have a socially redeeming quality or be viewed as

art, and a decision on Torres's proposed Chicano Park Monumental Public Mural Program proposal was avoided year after year. Still, the momentum for the program did not die out, continuing instead to gain steam even as the community won the right, in 1971, to create the Chicano Park.

AS WAS CLEAR IN THE STRUGGLE TO CREATE CHICANO Park, a core value of the Chicano Art Movement was its focus on connecting and empowering Chicanos by honoring the traditions and culture of the barrios and the community's wider history. However, just as the fight for Chicano rights took place on multiple battlefronts, community-focused art in the Chicano communities of Southern California was not solely limited to public spaces. In fact, at the same time that Chicano Park was coming into being, another very complementary movement was taking place around the cities of Southern California. The need for the creation of Chicano cultural centers ultimately arose in Southern California, wrote arts scholar Philip Brookman, "from a recognized need for such a facility that was organized and administered by Chicanos, through which their own expressions could be explored."[28] Eva Sperling Cockcroft, a renowned muralist and art educator, concurred, adding that what Chicanos craved was creative and expressive autonomy, which only their own space could offer. "The shift away from integrationism and reformism toward empowerment and radicalism," wrote Cockcroft, "touched a vibrant chord in many people . . . . People everywhere sought to establish their sense of selfhood, their cultural identity, their own image, their own heritage. People wanted to control their own media, their own schools, their own lives."[29] Such centers would also right a local historical wrong. "The works of Chicanos and other minority groups," suggested history professor Kristen Guzmán, "had faced exclusion from major public arts institutions and private galleries. Such an exclusionary attitude on the part of public entities was especially troubling because they were, in theory, charged with the duty of

representing the populations in and around their communities."[30] The artist Roberto Gutierrez expressed the frustrations of many Chicano artists at the time when he called the situation "a catch-22. You had to have name recognition to get into a gallery," said Gutierrez, "and vice versa. The beauty of [Chicano art centers] . . . was that they gave Latino artists visibility."[31]

Starting in the late 1960s, Chicano artists began to take action. "Artists and cultural workers," wrote Guzmán, "many of them also involved with social justice and civil rights organizing, pulled together what resources they could and created sites of artistic production."[32] Though these art centers, studios, and galleries were often understaffed or staffed by untrained volunteers, and generally lacked money and resources, by avoiding the strictures of other established mainstream art centers and museums and focusing, according to Carlos Francisco Jackson, "on those subjects denied by the public museum's homogenized narrative and history of the United States,"[33] these cultural centers ultimately provided Chicanos a means for continuing to steer how their culture and history was perceived by the wider society.

In 1970, for instance, the San Francisco–area artist collective called MALAF (Mexican American Liberation Art Front) opened the Galeria de la Raza, a gallery and cultural center dedicated to Chicano art and artists that was, and still is, situated in San Francisco's Mission District. The revolutionary intent of MALAF's Galeria de la Raza is clear in some of MALAF's rhetoric of the time. "The Revolucion is now 1968 and we are still struggling," the artists of MALAF wrote in a 1969 manifesto. "This is the quiet battle, the battle within one's mind. These artists confronted the Anglo system; what it was, what it is, and what it will be are some of the questions they asked themselves. Then came the difficult question, What am I? *Quien soy yo?* Finally after years of demoralization and constant 'hang-ups' they emerged as Chicanos. They were free. They had returned to humanity."[34] Other Chicano cultural centers and galleries that were founded around the same time included the Mechicano Art Center, founded in Los Angeles in 1969;

the Centro de Artistas Chicanos in Sacramento, founded in 1972; and Brocha del Valle in Fresno, founded in 1974. "It was an alternative to the system that existed at the time," said the MALAF artist Raul Yanez of the Galeria de la Raza and other Chicano centers years later. "Museums were not exhibiting Chicanos, galleries were not exhibiting Chicanos, so we felt we had to take our destiny in our own hands."[35]

Salvador Torres had been a member of MALAF before his illness forced him back to San Diego, and many of his organizing efforts there were no doubt inspired by his time in the group. In addition to spearheading efforts to create the Chicano Park Monumental Public Mural Program, Torres had a hand in establishing the first major Chicano art center at a spot located less than three miles north of Chicano Park in San Diego's Balboa Park, the city's famous and historic urban cultural park located just north of its downtown. The need for such a space came out of a realization similar to MALAF's, "that cultural self-determination was the only way to preserve and develop the ideologies and contributions of San Diego's native population [i.e., Chicanos]."[36] Providing much of the fodder for this notion were the nearby institutions of higher education—San Diego State University, San Diego City College, and the University of California, San Diego—which at the time all had growing Chicano Studies programs and vibrant student movements. Out of these schools came a number of trained and politically radicalized Chicano activists and artists who were getting jobs teaching in local high schools and university art programs and beginning to ask how their work could be more relevant to young people from their own cultural backgrounds.

"This was a very key time in San Diego," the Chicano poet Alurista explained. "In 1967 and 1968 (at San Diego State) we had already started an organization. The name of our organization was MAYA, the Mexican American Youth Association. Its primary objective was the recruitment and retention of Chicano students and the perpetuation of Chicano culture and history. That can be said to be the triggering event, the coming together, the emergence of the Chicano student movement

in San Diego."[37] Fortuitously, Salvador Torres had met the poet Alurista at San Diego State University shortly after his return to the city in the late 1960s.[38] Through Alurista, Torres became connected with local artists Guillermo Aranda, Mario Acevedo, and Jose Montoya[39]—all of whom would have a hand, along with his old friend Victor Ochoa, in laying the groundwork for a vibrant new cultural center in San Diego.

The actual establishment of the Centro Cultural de la Raza at Balboa Park in San Diego took even more effort than did Chicano Park. In the later part of 1968, Salvador Torres had gained permission from the San Diego Parks and Recreation Department to use an abandoned building located on the edge of Balboa Park as a studio. At the time, Torres needed a large space that was cheap in order to produce several large portable murals on canvas. The Ford Building at Balboa Park had originally been built for the Ford Motor Company to use as a temporary assembly plant and display showcase for its cars during the 1935–6 California Pacific International Exposition. After the exposition, the building had remained essentially empty, with the exception of the war years when it was used as a technical school for aircraft workers. This was true despite a near-constant string of proposals for the building's use that did not last or pan out.[40] In 1968, the 45,000-square-foot Ford Building went well beyond Torres's needs—so much so that, once he had permission to use the space, he invited numerous other local artists to join him. The list included Aranda, Ruben de Anda, Leticia de Baca, the Aguilar sisters, Tomas Casteneda, Mario Acevedo, Luis Espinoza, Ricardo Gonzalez, Antonio Rivas, a folkloric dance group called the Enriques, his friend Alurista, and a women's singing group called Trio Moreno.[41] By the middle of 1969, the Ford Building had become home to myriad artistic activities by San Diego–based Chicano artists, including regular artist studios, exhibitions, workshops, musical and dance rehearsals and performances, meetings, and even a rudimentary silkscreening facility.

The slow-growing awareness for the need to create a more formal and solid organization to protect and preserve this burgeoning

community art space was what led to the founding in 1969, by Torres and others, of Los Toltecas en Aztlán. From there, the push to establish a community art center at the Ford Building truly got underway. Incidentally, this push matched the excitement of what was happening in the wider Chicano Movement itself. Throughout California and the Southwestern part of the United States, the organizational capacity of local Chicano groups was expanding rapidly, leading to the first-ever National Chicano Youth Conference in Denver in March that year.[42] Los Toltecas drew up bylaws, and the group's forty-plus members drew up a formal petition to establish a Centro Cultural de la Raza at the Ford Building. "In order to make this Centro one where artists create, where workshops are conducted, and where people of San Diego breathe the spirit of the Chicano people of Aztlán," they wrote, "we . . . propose that the city seek sufficient funds to aid us in the task that confronts our Mexican community today: building a center where the culture and history of our Chicano people can find a place under the sun that bronzed our skins and our hearts."[43]

BEMUSED CITY LEADERS IN SAN DIEGO DELIBERATING on the proposals concerning Chicano Park and the Centro Cultural de la Raza in 1970 likely didn't realize they weren't alone in their confusion. Similar monumental convenings over creating community spaces for Chicano artists were taking place in other cities across Southern California. One of the most important of these was at first only a modest idea, conceived of in a Boyle Heights garage by a Catholic nun in tandem with a small coterie of Chicano printmakers. In 1970, Sister Karen Boccalero, along with fellow print artists Carlos Bueno, Antonio Ibañez, and Frank Hernandez, set up a small printmaking shop with a particular vision in mind: To create community-focused artist prints that would foment the ongoing political revolution that leaders of the Chicano Movement envisioned at the time. The idea was so successful, ultimately, that it led to the founding of an independent, community-supported art center for printmaking called Self Help Graphics.

At the time, Boyle Heights, along with much of the economically distressed, ethnically segregated, and politically marginalized area just east of downtown Los Angeles, was alive with the charged working-class political activism that increasingly mixed with the emerging militancy and pride of *El Movimiento*. Young activists from the region were involved in a variety of causes, including: the United Farm Workers, La Alianza Federal de las Mercedes (which campaigned for Chicano land reclamation in New Mexico), several pushes for political self-determination, and the widespread school walkouts (known as the "East L.A. Brownouts") that were intended to address the ongoing educational disparities affecting the city's Hispanic students. "The inferior educational conditions in Eastside public schools were reflected in a 50 percent dropout rate among Chicana/o students," wrote Kristen Guzmán. "In 1968, thousands of Chicana/o students walked out of these schools, effectively shutting them down; in doing so they shocked the school board and empowered a generation of youth with a new understanding of their own identity, history, and power."[44] The Brownouts were a catalyst for a large part of the Chicano population of the East L.A. region, as well as a number of politically minded Chicano artists such as Harry Gamboa, Jr., Patssi Valdez, and Moctesuma Esparza. "Their participation in the East L.A. Brownouts," wrote Kristen Guzmán of these young artists, "gave them the experience of being part of the Chicano civil rights movement and a political consciousness would shape their later contributions to a Chicano arts movement."[45]

The key to Self Help Graphics' establishment and eventual success was Carmen (Karen) Boccalero. Born in 1933 in Arizona to a family of Italian descent, Karen had moved with her family in the 1940s to Boyle Heights, then an ethnically diverse section of Los Angeles. Karen received formal training as an artist at Immaculate Heart College in Los Angeles with Sister Corita Kent, herself an artist and political activist whose peace posters gained acclaim in the 1960s. From Sister Corita, Karen learned both a progressive sociopolitical outlook and how to pull prints, a skill she further developed at Philadelphia's Taylor Art

School. The inaugural program of the early Self Help Graphics space—located initially in the garage behind the home where Sister Karen lived with other nuns from her order—was a batik and silkscreening class for local artists, which culminated in an exhibition of their work. In the fall of 1972, Sister Karen and Self Help Graphics got a major shot in the arm in the form of a onetime $10,000 donation, from the Sisters of St. Francis, to pay rent on a 2,000-square-foot space located on the third floor of a building just off of Exposition Park. In 1979, the center would move to an even larger space in a building owned by the Archdiocese of Los Angeles. The Church's continuing support of Sister Karen's work was evident in the fact that it required the art center to pay only one dollar per year in rent.

From the start, Sister Karen, who became the center's longtime director, focused on two main objectives for Self Help. First, the center would provide training and studio space for printmakers connected to the artist community of East L.A. Second, it would offer families and children of the surrounding community significant cultural experiences that would instill a sense of cultural pride. Self Help Graphics' particular dream, according to a letter that Sister Karen wrote to the Campaign for Human Development in Washington, D.C., was, by training artists in printmaking and sending them to local elementary schools to teach, to be a force for social and political change and the nexus for an artistic revolution. By design, the center demanded that Chicano artists take creative control over the production and exhibition of their work. In this way, Self Help Graphics empowered the artists and strengthened the ethnic pride of Chicanos in Los Angeles.

Artists who participated at Self Help Graphics came to see themselves not only as artists, but also as community resources, teachers, and cultural "instigators." "The group of artists that came together at Self Help during the early 1970s," wrote Kristen Guzmán, "believed that East L.A., an area besieged by poverty and crime, had the potential for cultural and economic transformation. As Sister Karen envisioned this change, she wrote, 'One of the greatest impacts that the

Chicano community is making in the greater Los Angeles area is [in] art. It is through art and artists that we, the Chicano community, are now giving a viable image of who we are, our culture, our ideas, our dreams.' "[46] Through the 1970s, dozens of Chicano, and non-Chicano, artists participated in programs and exhibitions at Self Help. Among their accomplishments was the refashioning of traditional Mexican cultural events, such as the Day of the Dead festivals, and offering them to interested members of L.A.'s diverse wider community. Self Help Graphics, with its particular focus on printmaking and the particular touch of Sister Karen Boccalero, made a significant contribution to the culture and politics of both East Los Angeles and the greater L.A. region. "She put the arts scene in East Los Angeles on the map," said museum director Bolton Colburn some years later. "She helped to cultivate Chicano art."[47]

A FEW HOURS' DRIVE FROM BOYLE HEIGHTS DOWN Interstate Highway 5, the struggle continued in San Diego to establish a mural program at Chicano Park and to create a vital new community art center for Chicanos in Balboa Park. In the spring of 1970, Los Toltecas en Aztlán sent their proposal to San Diego's City Council, Mayor Frank Curran, and to Chicano groups around the state, asking for support of the plan to create El Centro Cultural de la Raza in the Ford Building, and the group followed up by carrying signs to a city council meeting. Just as with Chicano Park, however, the city had other ideas, and the Ford Building was already being considered for a new aerospace museum. When city officials demanded that the group leave the site, however, the artists refused. "[Luis Espinoza and Salvador Torres] actually confronted the police," Victor Ochoa recalled some years later. "They reacted by exploding," said historian Philip Brookman, "and telling the police that we needed a centro cultural that did something for our people."[48]

While the Toltecas dug in, writing letters and refusing to be evicted, it soon became clear that city was determined to take charge of the

Ford Building, and the group realized that a compromise might be the only chance for a resolution. If the city could find the Chicano artists another site at Balboa Park for the Centro, they offered, then and only then would it vacate the Ford Building. The city offered an abandoned concrete water tank that had been built at the time of the 1915 San Diego Exposition, and in early November, 1970, the Toltecas agreed to the offer, provided the city make certain repairs to the building. On January 28, 1971, a final agreement was struck by the city to lease the water tank building for one dollar a year. And City Manager Walter Hahn approved the deal, saying, "We believe that the San Diego heritage indicates the opportunity of a Latin-American cultural center to promote the authentic history of the community."[49] The Toltecas moved into the new building in May, and on July 11, 1971, they held opening ceremonies for the Centro de la Raza that attracted a reported five hundred community members. The occasion was marked with speeches, dance and musical performances, and an art exhibition. Guillermo Aranda spoke perhaps the most memorable words of the ceremonies when he stood and said, "We are here to teach and learn. Children and young Chicanos are our focus. La familia shall be strengthened through all our creative efforts.[50] Alurista himself concluded the ceremonies by saying, "We have a nation to build and our struggle must be collective."[51]

In 1973, after four years of negotiations with the San Diego Coronado Bridge Authority, Salvador Torres finally realized his dream to use art to enliven and beautify the dull, gray concrete surfaces of the bridge pylons and freeway on-ramps around Chicano Park. His Chicano Park Public Monumental Mural Program was approved by the city with the only stipulation that artists not drill into the concrete surfaces of the pylons, as drilling would break the clear sealer on the concrete, thus allowing moisture to reach the reinforcing iron and wires embedded in the pylon, eventually creating rust and endangering the structural system of the bridges and overpasses. Here's how Torres described the first day of actual mural painting, as local artists

began work with assistance from members of the Barrio Logan community: "The paints were all laid out. And there's this gigantic wall there, and all of us just looking at this wall. So we pour out the paint, took some rollers, and attacked the wall with the rollers. We put color everywhere. There was at least two or three hundred people there, that all of a sudden were all over the walls. It was done spontaneously. We exploded on the walls. Any sense of control had been lost with the large number of participants involved."[52]

Not everyone agreed with Torres's loose, anything-goes approach to creating the first batch of murals at the park. Some of Torres's fellow artists felt that the murals projects had not been designed with enough serious intent and had been conceptually watered down by the involvement of so many nonartists. But Torres's approach to creating a "mural environment"[53] at the park had what scholars deemed an important social-political function. According to art historian Oscar Vasquez, "performative" mural environments that were created through a process involving public speeches, concerts, poetry readings, recreated Aztec dances, and the like functioned as "symbolic recolonization or reterritorialization of the site where they are located."[54] In other words, the effort to establish and then decorate a place like Chicano Park was, as the scholar Jo-Anne Berelowitz put it, a struggle by Chicanos "for territory, for representation, for the constitution of an expressive ideological-aesthetic language, for the recreation of a mythic homeland, for a space in which Chicano citizens of this border zone could articulate their experience and their self-understanding."[55]

In this struggle to locate a symbolic homeland, of course, the Chicano Art Movement of the early 1970s was quite separate—despite some similarities in tactics and artistic approach—from the Feminist Art Movement that was going on almost concurrently. Whereas much of what Judy Chicago and others focused on in the early years of the decade was creating a common visual language that could address the desires, fears, and professional aspirations of women (and women artists) in light of decades of repression, El Movimiento was concerned

with an entire race's existence and well-being. Naturally, the Chicano Art Movement involved a wider range of ages, classes, and segments of the community—young and old, intellectuals and labor classes, urban and rural, and so on—than did the Feminist Movement. And because of the particular goals of the Chicano Movement and its artistic wing, numerous Chicano organizations and institutions proliferated across Southern California as the 1970s progressed. That is, by 1974, the Los Angeles region was home to five other art centers/galleries,[56] six artist groups,[57] and seven Chicano theaters. Some of these centers and institutions came together peacefully and naturally; others only after some amount of struggle. And while not all were on the same page regarding the proper way to fight a dignified battle with the dominant culture, they all were aligned in the basic ideology of the struggle.

Perhaps in response to the criticisms of his approach to creating the murals at Chicano Park, after the first phase of the mural painting was complete Torres led a core group of artists from Las Toltecas, as well as from El Congreso de Artistas Chicanos en Aztlán, back to the site again and again over the next year to refine and complete the works of art. As a result, by the end of 1974 Torres had managed the creation of a series of murals—begun by community collaboration and refined by the community's best artists—that explored Chicano nationalism with a range of spontaneously and energetically applied and beautifully refined images. The murals at Chicano Park, the prints pulled at Self Help Graphics, the workshops and exhibitions held at Centro Cultural de la Raza—by fostering community participation in the spaces of the community, engaging community members in focusing on the community's own well-being and beautification, and reclaiming the public space for the community—raised La Raza up from its marginalized circumstances and revealed the community's true nature to the world. As a result, by the mid-1970s the Chicano Art Movement in Southern California had given local Chicanos, in these new spaces and environments, their first, hopeful glimpses of a better, more openly expressive future.

# A Laminar Flow at the Edges

*Or, Anger and Dissent in the early 1970s Art Scene*

REVOLUTIONS COME IN MANY GUISES. BEYOND the wide-ranging, culture-changing rebellions fomented by vast cohorts like the women artists of Los Angeles and the Chicano people, there were examples of single individuals who, pushed to their psychological limits by injustice or intolerance or some other opposing force, became their own private revolutionaries.

A good explanation of how this works can be found in Polish journalist Ryszard Kapuściński's account of the Islamic Revolution that took place in Iran in 1979. "All books about all revolutions begin with a chapter that describes the decay of tottering authority or the misery and sufferings of the people," Kapuściński wrote. "They should begin with a psychological chapter—one that shows how a harassed, terrified man suddenly breaks his terror, stops being afraid. This unusual process—sometimes accomplished in an instant, like a shock—demands to be illuminated. Man gets rid of fear and feels free. Without that, there would be no revolution."[1] During the bitter power struggle between the sitting Shah of Iran and opposition forces led by exiled religious leader Ayatollah Ruhollah Khomeini, crowds took to the street to voice their rising frustration and dissent. In one particular moment, a policeman approached a man at the edge of the crowd and ordered him to go home. Based on experience, Kapuściński explained, the shouts of the policeman should have made the desperate man cower and flee, but the

man did not run. And as a result when the policeman stopped shouting, the crowd stood defiant. "We don't know whether the policeman and the man on the edge of the crowd already realize what has happened," wrote Kapuściński. "The man has stopped being afraid—and this is precisely the beginning of the revolution. Here it starts."[2]

For individual artists living and working in Los Angeles at the beginning of the 1970s, the confusion and uncertainty of the local art world was somewhat distressing. The great Ferus moment had collapsed. The first great generation of Los Angeles' Modernist art heroes had also become its last, and local art observers, critics, and young artists were at a loss. Of course, in such an atmosphere of anxiety it makes sense, as Kapuściński predicted, that some individual artists in L.A. were pushed past the point of being afraid. That is, amid the cultural confusion and social tumult that enveloped L.A., several individual artists—three in particular—stood quietly and defiantly at the edges of the crowd. These were artists who, each in his own way, had realized he had nothing to lose and everything to gain by embracing his own personal revolution.

Each of the three artists rejected, that is, affiliation with an art movement or "-ism" or any sort of artistic cohort, choosing instead to work independently and outside the mainstream. Each also imbued his art—either by choice or by virtue of point of view—with an incisive, cutting, and almost hermetic and off-putting quality. This independence, ultimately, would be of great benefit to each of their personal visions of art, but at the same time their approach also undermined any potential financial viability—at least in the short term. Still, in a time of reduced attention on local art, and a dampened local art market, this hardly mattered—everyone was struggling. In fact, ironically enough, all three of these artists' seeming ambivalence toward the uncertain Los Angeles art market of the early 1970s would eventually become a distinct career advantage.

Despite their surface similarities, John Baldessari, James Turrell, and Chris Burden were all distinct from each other and from other

artists of their time. Each pursued his own kind of personal rebellion from the edges of the art scene. A closer look at their work at this time—and in particular at one or two seminal works made in the early 1970s—reveals much about the tensions, anxieties, and despair of L.A. artists. And it reveals how each of these three rose above the conditions of the time by breaking free of the fear and rebelling against the chaos.

## 1. "Cremation Project" (1970) — John Baldessari

On July 24, 1970, a relatively unknown Southern Californian artist named John Baldessari gathered up the mass of paintings that filled his studio in the San Diego area—upwards of 120 of them, the exact number was never recorded—and, after documenting them by taking slide photos of each, he and five of his close friends used their bare hands, feet, axes, and other tools to rip and break up the paintings into "bite-sized chunks."[3] Baldessari then placed the pieces into three large cardboard boxes and three plastic bins, loaded the bins into his Ford Econoline van, and drove them to the Cypress View Mortuary where a sympathetic crematorium operator had agreed to burn the paintings to ashes. The entire process, which the artist called the "Cremation Project," was documented by a photographer friend of his named David Wing. Afterward, Baldessari collected the ashes, took them back to his studio, and, two weeks later, announced the end of his paintings in the local paper—the *San Diego Union*—just as you might publish an obituary of a loved one. The announcement read, at least in part, as an affidavit, announcing the demise of "all the works of art done by Baldessari between May 1953 and March 1966 in his possession as of the day of the cremation."[4]

Understanding how John Baldessari could have reached such a state in his artistic career—a state in which he could destroy thirteen years' worth of art with his own hands —is akin to understanding the mindset of a man who would refuse to turn away from an enraged policeman. No doubt he was frustrated to the point of being beyond fear of consequences. "An artist was like a social pariah in

those years,"[5] he said. At the time, he had been working, in his words, "under the most provincial of circumstances"[6] in National City, a suburb of San Diego. Baldessari had begun making paintings after receiving a bachelor's degree in art from San Diego State University in 1953. (He received a master's degree in 1957.) His painting style had been somewhat loose, somewhat variable—sometimes a more poetic and literate version of the Pop Art that was so dominant in those years, other times a knock-off of established art styles ranging from Dada to Cézanne. But whatever it was, it was definitely not considered a match to the testosterone-fueled aesthetic that dominated the art market of Southern California in the 1960s. Baldessari's paintings also hit none of the high notes of the high Modernist Expressionists like Jackson Pollock and Barnett Newman, who still loomed large in the national imagination. In other words, Baldessari's painting failed to sell and failed to capture the imagination of any sort of public.

Still, for thirteen years Baldessari worked diligently at art, supporting himself by teaching at San Diego–area high schools and colleges. Despite all his efforts, very few of his paintings ever left the confines of his studio, and the ones that did were most often given away. Through the years, the paintings piled up—against walls, on floors, in every corner of his studio—until, at last, he began to feel "that he was drowning" in them.[7] Then, one day in 1966, Baldessari woke up and realized he hated—indeed that he "loathed"—being a painter. He had come to reject the idea that he should strive to become a great artist—if even there were such a thing—as glorified by the New York art scene or, locally, the Ferus gang. From that point on, he stopped painting and began focusing on the raw essence of art-making: the idea. "I stopped trying to be an artist as I understood it," he would later explain, "and just attempted to talk to people in a language they understood . . . . Rather than paint realistically and aspire to the conditions of a photograph, why not just use the photograph or a text? I thought I would do all that on canvas so that the canvas would be an art signal."[8]

As a result of this shift in his outlook, Baldessari began experimenting to discover whether or not painting was, as he had been taught, the only valid art form. He began employing photography, text, and other non-painterly elements in his art, and, as the decade wore to a close, he became convinced he was on the right track. In 1969, Baldessari began a series of works that played with the very idea of what it meant to "create" art by removing himself from the art-making process. Called the "Commissioned Paintings," they began with photographs, taken by the artist, of a hand pointing to a series of everyday objects. Baldessari then commissioned several local amateur artists to make paintings of his photographs, and he exhibited them with a statement about their authorship written onto the canvases. In another experiment, for an exhibition that same year at the Stadtischen Museum in Leverkusen, Germany, called "Konzeption-Conception," Baldessari submitted a series of simple notes on cards. Included in the series was one card on which he had written, tellingly enough: "The world has too much art—I have made too many objects—what to do?" He provided his answer at the bottom of the same card: "Burn all my paintings, etc., done in the past few years. Have them cremated in a mortuary. Pay all fees, receive all documents. Have event recorded at County Recorder's. Send out announcements? Or should it be a private affair? Keep ashes in urn."[9]

Buoyed by the results of his non-painterly efforts, and looking to make a fresh start as an artist, in December of 1969 Baldessari held a one-day studio sale. In the aftermath of the sale, he decided to make good on the idea he had written on the card for the Stadtischen Museum exhibition. "I used to follow cultural standards about what was allowable in art," he recalled later. "Then I decided that I was going to make up my own rules." Still, it was in no way an easy decision for Baldessari to wipe out such a massive amount of creative output. "There was a lot of doubt and anxiety," he said. "It's like a death or a mercy killing."[10] Despite his internal conflict, Baldessari held fast to the idea that the act of burning his art was not as important as

putting in motion his changed approach toward art. "I breathed a sigh of relief when the crematory door slammed shut. I felt liberated."[11]

HAD BALDESSARI BEEN A BETTER-KNOWN ARTIST AT the time, his act of artistic immolation might have resulted in widespread consternation in the art world. On one hand, it flew in the face of the dominant ideal of the time—of the heroic, expressive genius who has power to create, improve, and reshape the world through his creative efforts.[12] On the other hand, on a superficial level, it was not a particularly unique action. Many artists through the centuries have edited or expunged their output, destroying art works they do not want to be associated with or that they found inconvenient to their later careers. In 1967, Agnes Martin sought out and destroyed many of the biomorphic abstractions she'd made during the 1950s. In 1954, a twenty-four-year-old Jasper Johns destroyed all the art in his possession just prior to setting off in a new direction. Robert Rauschenberg threw a host of art works in the Arno River in 1952 after an art critic suggested he should. Even Claude Monet shredded at least thirty water lily paintings before a 1909 exhibition.[13] But make no mistake, as an underappreciated, highly frustrated, and rebellious artist at a certain point in his career and stuck in a certain time and place, Baldessari used the "Cremation Project" both as a means of disowning an unfulfilling chapter of his career and life and of ideologically challenging the long-standing Modernist hegemony of painting in favor of the new Conceptualist moment in art.

In the months following the "Cremation Project," Baldessari seemed aware of the import of the work. In a letter that he sent to one prominent curator shortly afterward, he wrote, "I really think it is my best piece to date."[14] After the cremation, Baldessari kept some remnants of the paintings' ashes in a book-shaped urn, on which he had inscribed the words, "John Baldessari May 1953–March 1966." He also used the ashes in several additional works of art. For his photograph "A Potential Print" (1970), he sprinkled some of the ashes in

a corner and impressed them with a footprint. An accompanying text description of the work explained that the footprint was a play on words, referencing the idea of a "print" as well as an old superstition about death.[15] Baldessari also took some of the cremated paintings' ashes and baked them into a batch of cookies, of which he is rumored to be the only person to partake.

Whatever the ultimate meaning and impact of the "Cremation Project," by the summer of 1970 the thirty-nine-year-old John Baldessari, freed from the artistic mire that long threatened to drown him, returned to his empty studio a liberated but still somewhat uncertain artist. Or at least this is what is revealed in the work he made in the months and years that followed. Baldessari's conceptual works between late 1970 and early 1972 reveal an artist searching for self-definition, an understanding of who he is and why he does what he does. For instance, in a spare, black-and-white art video from 1971 called "I Am Making Art," Baldessari stands before a video camera, backed by a blank wall devoid of any kind of visual flourish. For eighteen solid minutes in this spare setting, he pantomimes a succession of random and abstract gestures while repeating over and over in a dull monotone, "I am making art." While rudimentary in execution, the video is still somehow surprisingly affecting. On one hand it is a grainy, desperate display of willful self-definition—as if the artist is trying to reassure himself he is doing something of cultural import. But on the other it is a defiantly subversive political gesture, as if the act of boldly defining his art is what makes the artist an artist. The work is the struggle of an artist in flux, exposing himself to a possibly hostile world—all writ large in a grainy, murky, small-screen art film.

More tentative exercises in artistic self-definition followed. In 1971, Baldessari made a film called "Police Drawing" that documented a performance he called the "Police Drawing Project." For this effort, Baldessari walked into a classroom full of art students he did not know, set up a video camera, and then left the room. A few moments later a police artist entered and, soliciting students' testimony, sketched a

likeness of the absent Baldessari. In 1972, meanwhile, Baldessari made the one-off film "Teaching a Plant the Alphabet," which shows precisely what the title suggests. And he made the film "Inventory," in which, for thirty minutes, the camera simply shows a succession of small, random objects that the artist has moved into the picture-frame. The simplistic and reductive quality of all of these films, combined with their Conceptual feeling-out of the nature of perception, of visual images, of language, and of how the creativity of the artist interacts with all of these, makes of these films a perfect record of a time of transition in Baldessari's career.

The experiments could have continued ad infinitum, leading Baldessari deeper and deeper into (perhaps) a dead end, if he had not taken a sharp turn in a film made sometime in the second half of 1972. Whereas the tentative and searching nature of his earliest Conceptual videos reveals an artist engaged in an effort to define the purpose of his art, Baldessari's expressive approach suddenly matured and grew much more subtle in a thirteen-minute film titled "Baldessari Sings Sol LeWitt" (1972). This work has many of the same features of his earlier films—it's grainy, low-lit, black-and-white, and devoid of any props or sets—but the lack of slickness here feels just right, and, in fact, from the start of the film Baldessari seems much more self-confident and self-aware, his purpose clear from the get-go. In the film, Baldessari sings, in a warbly voice, each of Sol LeWitt's thirty-five manifesto-like statements about Conceptual Art set to the tune of stodgy popular songs like "Camptown Races" and "Some Enchanted Evening." It's a simple and low-tech idea, of course, but through Baldessari's ironically muted approach we are transported to realms of thought, mystery, and humor that rise far above the more tendentious video works he had made up to that time.

A full understanding of the great distance that Baldessari traveled between July, 1970, when he performed the "Cremation Project," and the later part of 1972, when he sang Sol LeWitt, requires a bit of background information. In 1967, in the June issue of *Artforum*, LeWitt,

a New York painter and sculptor who had gained some notoriety for his Minimalist images that employed cubes and other geometric forms, wrote an essay titled "Paragraphs on Conceptual Art." "In Conceptual art the idea or concept is the most important aspect of the work," LeWitt explained in his essay. "When an artist uses a Conceptual form of art, it means that all of the planning and decisions are made beforehand and the execution is a perfunctory affair. *The idea becomes a machine that makes the art* [emphasis mine]." This last sentiment seemed, in looking back, to have been particularly influential on the development of art in the early 1970s, as well as a particular focus of Baldessari's video piece. The essay continued with similar descriptions—Conceptual Art's freedom from the skills of the craftsman, its intentional emotional dryness, its reliance on the process of conception and realization, its rejection of subjectivity in favor of careful planning, and so on—for nearly two thousand words. "This kind of art is not theoretical or illustrative of theories," he wrote. "It is intuitive, it is involved with all types of mental processes and it is purposeless." The essay was so thick with generalized prescriptions and so lacking of any clarifying examples or other more reader-friendly information, that LeWitt must've felt it necessary to follow up with a stripped down, manifesto-like distillation of his ideas. Called "Sentences on Conceptual Art," this text appeared in the relatively obscure art journals *0-9* in New York and *Art-Language*, no. 1, in England in May, 1969.[16]

The gist of what LeWitt was driving at, in his statements as well as in his work, was to point out the disparity between how language operates and how objects and actions exist in the world. Knowing this basic fact makes some of his thirty-five statements—such as, "A work of art may be understood as a conductor from the artist's mind to the viewer's. But it may never reach the viewer, or it may never leave the artist's mind," or, "Once the idea of the piece is established in the artist's mind and the final form is decided, the process is carried out blindly. There are many side effects that the artist cannot imagine . . ."—much less abstruse than they appear to be at first glance.

Both of LeWitt's texts—his "Paragraphs on Conceptual Art" and "Sentences on Conceptual Art"—were in essence intended to plant a firm flag for his generation of artists in a zone well outside that of Abstract Expressionism, which still held near-complete sway in academic circles, and Pop Art, which was the dominant market trend as the 1960s wound to a close. LeWitt was also grappling with the limitations of the Minimalist movement that he was a part of at the time, by suggesting a expansive way of thinking about how such art existed in the world even as such art remained spare and, well, minimal. "Unlike some strict Minimalists," wrote Michael Kimmelman of his work some years later, "Mr. LeWitt was not interested in industrial materials. He was focused on systems and concepts—volume, transparency, sequences, variations, stasis, irregularity, and so on—which he expressed in words that might or might not be translated into actual sculptures or photographs or drawings. To him, ideas were what counted."[17]

LeWitt's statements on Conceptual Art rippled throughout the art world for the next several years. More conservative art critics in New York at the time, clinging to the tenuous final remnants of the fast-fading Modernist era, "regularly savaged"[18] LeWitt's ideas, and assumed the concepts would result in art that was "arcane and inert." Yet in the years that immediately followed, a number of artists and other forward thinkers embraced the potential for creative explosion that they saw in LeWitt's statements and ran with them. In 1968, for example, Lawrence Weiner was inspired to give up his practice of making physical art work and presented his own, succinct Conceptual Art–focused "Declaration of Intent," which had just three stipulations: "1. The artist may construct the piece. 2. The piece may be fabricated. 3. The piece need not be built. Each being equal and consistent with the intent of the artist the decision as to condition rests with the receiver upon the occasion of receivership."[19] LeWitt's prescriptions would continue to influence art production through the decades that followed.

In Los Angeles in the late 1960s, meanwhile, the local, Minimalist-based "Light and Space" movement—as expressed in Robert Irwin's

disks, Peter Alexander's colored resin blocks, Larry Bell's carefully crafted glass boxes, and so on—had all but run its course, opening up a large gap into which any young, avant-garde artist could step. For this handful of noteworthy artists, LeWitt's statements offered a clear glimpse at some alternative art-making strategies and philosophies. By the time that Baldessari was refining his own particular approach to Conceptualism, in the aftermath of his "Cremation Project" in 1971 and 1972, a certain brand of Conceptual Art had begun to proliferate in the local art market that seemed, on the surface, dry and self-important and overly serious. On the other hand, when looked at more deeply and intently, the work of such artists as Bruce Nauman, Al Ruppersberg, Douglas Huebler, even former Ferus artist Ed Ruscha, was infused with a deadpan sense of humor behind its flat affect. In 1972, Baldessari was absorbing all of these notions and approaches, and, in the process, opening up the local potential for Conceptual Art to befuddle, confuse, mystify, and amuse. Baldessari began his 1972 film based on LeWitt's famous sentences with a somewhat tongue-in-cheek, if completely deadpan, dedication: "I think that these sentences have been hidden too long in the pages of exhibition catalogues. [Perhaps] my singing them for you will bring these sentences to a much larger public." From there, Baldessari got even goofier. "In this case," wrote curator Russell Ferguson of the artist's performance in singing LeWitt's statements, "Baldessari splits language from written form, . . . embracing a simple didactic structure that is contracted from within . . . . 'Baldessari Sings LeWitt' is shot in grainy black-and-white. The camera never moves. The artist sits in a black metal folding chair in front of a cinder-block wall. Everything connotes great seriousness." All of this, of course, is fully in line with public expectations about the nascent field of Conceptual Art—as a way of working that lacks soul, humor, energy, and depth of feeling, and Baldessari is content to play along with these expectations "right up until [he] begins to sing, that is, when two incongruent registers are forced into juxtaposition."[20]

By forcing the overladen words of LeWitt's sentences on Conceptual Art into the melodies of well-known popular tunes that he himself sings (quite poorly), Baldessari at once explodes the entire notion of what the art of ideas can be, even as he thumbs his nose at the idea that any high prophet of art—even a wholly avant-garde one—can ever truly encapsulate all that art can be, or not be, in a list of simple sentences. And he performs these gently subversive acts even as he clearly brands his work with a particularly L.A. sensibility—in the use of video, in the deployment of pop culture (which Conceptual artists tended to sneer at as non-art), and in the artist's own dry humor and very cool reserve. In "Baldessari Sings Sol LeWitt," then, the artist has become like the man on the edge of the crowd, unafraid to tell truth to power—in this case the East Coast art world mavens who would presume to force one particular view on everyone else. That is, in 1972, Baldessari was unafraid to tweak a few noses regarding the presumption that anyone could dictate what mattered in art to anyone else.

What his fellow artists might have thought of Baldessari's gently seditious and seriously humorous artistic rebellion between 1970 and 1972, which culminated in his video "Baldessari Sings Sol LeWitt," is uncertain. What is certain, however, is that the LeWitt video had at least one clear and beneficial effect—it gained him as much immediate widespread attention as anything he had done up to that time. "One of Baldessari's most ambitious and risky efforts," was how Helene Winer described the project in the March 1973 issue of *Art in America.* "What initially presents itself as humorous gradually becomes a struggle to convey LeWitt's statements through this arbitrary means." Baldessari's own personal revolution, it seemed, was at last striking pay dirt.

### 2. "Burning Bridges" (1971) — James Turrell

Around the same time that John Baldessari was undergoing his transformation from a more conventional painter to a fearlessly funny purveyor of subversive ideas, another L.A. artist was going through his own revolution. This revolution, however, would lead him to reject, in

one fiery moment, the art-world strictures of the time, eventually setting him on a path that led directly out of the local art market.

Though twelve years younger than Baldessari, James Turrell emerged into the local art consciousness at roughly the same time—at the apex moment of the Ferus Gallery and its staple of artists. Born in Pasadena in 1943, Turrell grew up in a comfortably middle-class Quaker household to intellectual and somewhat rigid parents. From the age of six, Turrell was urged by his grandmother to "go inside and greet the light" at Quaker meetings,[21] a fact that would have a great bearing on his later artistic career. Turrell's mother, Margaret Hodges Turrell, was trained (but never practiced) as a medical doctor and served in the Peace Corps in Malawi. His father, Archibald Turrell, was an aeronautical engineer who became, later in life, an educator and junior college president. Though Archibald died while Turrell was still a boy, the father continued to influence his son through books he had written and engineering tools he had left behind. "You often react to a strong parent," Turrell later said. "So, when my father was alive, I had no interest in aviation, no interest in that side of things whatsoever. What I did was build boats. I made them out of wood, and he helped and supported me financially in my projects, but he was an older father at the time, so I didn't have quite that same relationship with him that other children around me had with their fathers. It was only after my father's death that I became interested in aircraft and flying."[22]

Turrell was an excellent student and a well-rounded boy and young man. He participated in sports and scouting, earned honors, served as senior class president, and eventually was named "Boy of the Year" in Pasadena for 1960.[23] He developed unique intellectual interests at a young age. He was "drawn to Asian cultures" and studied Japanese traditions and Eastern philosophies. He also was attracted to the desert landscape of the American West. In college, Turrell studied painting and made gray abstractions influenced by Turner, Constable, and Monet. In art history classes, Turrell was impressed with Rothko and Seurat. He studied sculpture as well, most notably with ceramic

sculptor John Mason, who gave him insights about "what it means to be an artist."[24] Turrell later would recall a formative experience he had during college. In 1963, he attended a John Cage concert, where he had his eyes "opened" by Cage's seminal composition "4' 33"," in which performers are instructed to remain silent for the prescribed length of time. "I was impressed by the quality of the statement," Turrell later recalled. "I didn't really understand it, but I knew it was important."[25] Turrell graduated from Pomona College with a degree in perceptual psychology in the spring of 1965, and then entered the new art program at the University of California in Irvine in the fall of 1965. It was at this school that Turrell's life as a straight-and-narrow honor student and scout suddenly changed.

Turrell stayed at UC Irvine for a semester and a half, ultimately failing to complete his graduate education at the school. While there, Turrell studied with some up-and-coming members of the local avant-garde—Tony DeLap, John McCracken, David Gray—and with art writer John Coplans and curator Walter Hopps, late of the Ferus Gallery, who was at the time the director of the Pasadena Museum of California Art. What caused him to leave UC Irvine is somewhat unclear—in his words, he simply felt "it was time to stop becoming an artist and start being one"— though it is clear that his interest in art had evolved wildly from his days of being interested in the Impressionists and Mark Rothko. During his brief stay at the school, Turrell began to deploy a novel medium in his work. "My first attempts to use light as space were in 1965 and 1966," said Turrell, "using gas to create flat flames. I used hydrazine and different mildly explosive gases in a large-diameter burner with a very small honeycomb interior. The flow of gas that was achieved was quite laminar, and the speeds were the same in the center as out toward the edges. The friction was similar across the entire flow of gas, so I was able to achieve very flat flames. These were the first pieces that I made with light, and actually they were quite beautiful. But I had trouble controlling them. There was much too great attention to the hardware, although the flames were tremendously beautiful and exciting."[26]

In November of 1966, after Turrell had left UC Irvine, he rented the Mendota Block—a 5,000-square-foot commercial building built in 1913 that had most recently been the cut-rate Mendota Hotel. Located at the corner of Hill and Main Streets in Ocean Park, across the street from the Sunlight Thrift Store and kitty-corner from a ramshackle dry cleaner, the back part of the building was used by Turrell as living quarters, while the two rooms on the ground floor near the front of the building became studio spaces.[27] Over his time at the Mendota Block, the surrounding neighborhood of Ocean Park became, quietly and sporadically, a small hub for a significant number of artists. Sam Francis had moved there some time in the early 1960s, followed by artists such as Tony Berlant, William Wegman, Richard Diebenkorn in 1967,[28] and even, in 1973, John Baldessari. "The whole area was ghetto," Baldessari would say some years later. "In the living room of the house I rented on 3rd Street, there was a motor block sitting there that someone had been repairing, so I had to get that hauled out of there. Many artists were working on Main Street, from Jim Turrell to Diebenkorn, because it was so cheap and rundown. And the Dogtown skaters all hung out at the surf shop and parking lot next door."[29]

At the Mendota Block building, Turrell sealed off his studio rooms from the outside world by constructing walls over the windows, smoothing the walls with plaster, sound-deadening the ceilings, and painting the walls, ceilings, and floors a uniform color of white. The resulting spaces were ideal for his ongoing experiments with light and his attempts to create "subtle perceptual situations that encouraged viewers to tap into their own visual capacities."[30] Having abandoned his use of flame, Turrell turned to experimenting with a high-intensity film projector to create lighting effects and visual illusions. Making use of projections of white or colored light in darkened rooms, Turrell was able to create the illusion of solid-like forms that were actually made of light[31] or that created strong and resonant fields of light on flat walls.[32] For a 1966 work called "Afrum-Proto," for example, Turrell

used a quartz halogen lamp to project what appeared to be a three-dimensional light cube in the corner of a dark room.

Turrell's interest in perception came from the rich visual texture—the sunlight, low horizons, open land, and big skies—of Southern California, as well as from his college study of experimental psychology. Turrell explained that this work was meant to get "at the root of perceptual reality,"[33] and he focused on these experiments through 1967 and 1968. Eventually, he took to building a secondary (false) wall in his studio rooms that would leave a slit at one or more of its edges. By backlighting the false wall with colored fluorescent lights that would shine through the slits, Turrell could completely dissolve a visitor's sense of the actual dimensions of the room and create other mystifying perceptual puzzles.

TURRELL'S ATTEMPTS TO ESTABLISH HIMSELF AS AN artist in those years were complicated by his particular views of art. Turrell's experiences building boats—a fine and strenuous wood-based craft form—put him not only at odds with his father, but also with the hot-rod aesthetic that undergirded the approach of many of the Cool School artists. With his particular interest in craft, and the uniquely deliberate way that he went about making art works, Turrell just seemed out of sync with the vast majority of local artists.

One clear exception, of course, was Baldessari, who was, right about the same time, abandoning painting and asking similar questions as Turrell. Although Turrell used fire in his early works, he never put the flame to any art works, moving instead toward the eschewal of physical materials to make art. His intention was to be direct and as "perceptual as possible" with his art. "A lot of artists are involved in the Cargo Cult," was how Turrell put it. "That is, they collect a lot of tools and things with which to make art, and often the tools and the things that are collected are paid more attention to than what's made with them. And in the same way, artists get involved with making studios, and put great effort into the making of studios rather than

into the art that goes out of the studio."[34] For Turrell, there was purity in refusing to make art objects, slick or otherwise, and this was at the heart of his artistic rebellion. "I made studios," said Turrell. "[And those] really became my art."

It being difficult to make a living by creating "studios," Turrell struggled in the late 1960s in his attempts to establish a viable career as an artist. At the same time, however, Turrell's peculiar views allowed him both to stand out as a uniquely self-propelling artist and to (somewhat) ignore the constraints of the local marketplace. In 1967, at age twenty-four, Turrell was given—by his old UC Irvine professor John Coplans—a solo exhibition called "Installations, Drawings" at the Pasadena Museum of California Art. In the exhibition catalogue, which was published in *Artforum*, Coplans called Turrell "one of the most interesting artists on the California scene."[35] In the summer of 1968, the famed artist Jasper Johns saw Turrell's work in L.A. and arranged for the young artist to visit Leo Castelli's Gallery in New York. While a show never materialized at Castelli's Gallery because of the limitations of its space, Castelli helped arrange for an exhibition (and a pre-exhibition stipend) at Arnold Glimcher's Pace Gallery. This exhibition, too, failed to come to fruition.

The reasons for Turrell's failure with Pace were more complicated. Essentially, it came down to a conflict between Turrell's desire to continue evolving his art and the gallery's wish to commodify work that Turrell had already perfected. Glimcher had offered significant financial support for Turrell to create a new body of work in 1969 that would be similar to the projection works he had already showed the gallery. But Turrell, loath to stand still, pushed forward to create a new series he called the "Mendota Stoppages." These were studio-specific works that cut apertures through the "fabric" of the Mendota Block building—a fact that later got him in hot water with the landlord—to create certain light effects. When Arnold Glimcher saw them in summer of 1969, he was immediately bewildered. "The gallery people took one look at the work and said, 'We don't know how to sell this,' "

Turrell said later. "Now at the time Pace was doing well selling Bob Irwin's paintings and Larry Bell's pieces, and they had sort of taken me on because of Larry and Bob. The projector things they thought they could sell, but the new things, no. So suddenly the gallery that had given me the impetus to go on and work ahead was saying, in effect, 'We don't want your next show, we want your last one. In fact we won't take your new work, but we'll take your old work.' I was old enough to know what that meant and young enough to say, 'Screw it, I'm not doing that.' "[36] Whatever the cause, at the end of a long year of work, in the red-hot summer of 1969, Turrell suddenly found himself exiled from the New York art market,[37] saddled with a reputation for contentiousness, and in debt—to the tune of $13,500—to the Pace Gallery.[38]

Turrell later explained he wasn't trying to be difficult at this formative stage in his career. Rather, he insisted, he was at the time simply "unconcerned about mundane success"[39] and more focused on the development of his aesthetic. Ironically, the reputation of aloofness played to Turrell's advantage by enhancing his reputation among some in the art crowd, who interpreted his stances as admirable idealism. In the summer of 1969, stories of what Turrell had done had circulated so much that Newsweek dispatched an arts writer, Douglas Davis, to investigate. Davis spoke to a "gallery official" and gained little insight. "The only coherent statement I got from him [the gallery official]," Davis wrote, "was that he [Turrell] didn't want people to see his works in a context where they could be considered eligible for possession." In the end, Davis seemed grudgingly impressed by the young artist's positions. "Turrell resists all attempts by the outside world to pigeonhole him in any way," wrote Davis. "He resists even the term 'artist,' together with the binding ties that the term inspires."[40] In 1970, author and curator Willoughby Sharp took note of Turrell in an article Arts Magazine called "New Directions in Southern California Sculpture," writing that rumors of "experiments with these and other projects, coupled with Turrell's refusal to show after invitations from Nick

Wilder and Leo Castelli, and vague reports of works with natural light constructed in the walls of his studio have made him a heroic figure for a younger generation of Los Angeles artists."[41] Critic Elizabeth Baker would follow up a year later in Art News, suggesting that Turrell's "sharp white light creations" were "legendary."[42]

Despite his rising underground notoriety, Turrell increasingly struggled to make ends meet as the end of the decade closed in. And the failure of his Pace Gallery show was not the only crisis James Turrell struggled with. In the summer of 1969, Turrell ended a year's worth of close collaborative work with Robert Irwin that was supposed to lead to a large project for the "Art and Technology" exhibition. It was a decision that Turrell publicly downplayed at the time—"I don't know that anything really startling came out of the whole thing," he told LACMA that summer. "I sometimes feel I've found some things out, but they don't apply to anyone else unless they come to them in the same way."[43] The collaboration had come about in the summer of 1968, about the time of Turrell's discussions with the Pace Gallery, when he had begun spending time with the well-established, former Ferus Gallery artist Irwin. The two artists had been featured by curator John Coplans in exhibitions at the Pasadena Museum of California Art, and, at the time, Irwin was increasingly moving away from work he did for Ferus toward an investigation of light phenomena and perception—so the two artists had much in common. Their dialogue, from the start, was intense. Turrell provided Irwin, according to Lawrence Weschler, with "a great deal of intellectual background" for the elder artist's intensive investigations, and Irwin provided his advice and support based on his long experience as an artist. Irwin, who had begun working with Maurice Tuchman on the "Art and Technology" exhibit in early 1968, invited the younger Turrell to collaborate with him. In November of that year, Tuchman arranged for the two artists to work with the Garrett Aerospace Corporation, which was developing the environmental control systems for NASA's manned space flight program, and its laboratory head, Dr. Ed Wortz. After some preliminary

uncertainty, the three men discovered interest in essentially the same thing: How man perceived his environment. After many hours of discussion over the next several months, the artists drifted into experiments using anechoic chambers, ganzfelds, alpha conditioning, and the like. In November of 1968, the artists drew up an exhibition agreement with LACMA, and by January they were planning to create an experimental combined Ganzfeld-anechoic chamber for the museum. Turrell seemed enthusiastic about the collaboration, writing up the proposals, even discussing with Irwin plans for continuing this work after the "Art and Technology" exhibit had run. Unfortunately, in August, as the artists were being asked by Tuchman to begin translating their investigations into art—and around the same time that Turrell's exhibition with the Pace Gallery was falling through—the younger artist suddenly and without explanation dropped out of the project. Neither of the artists would appear in the "Art and Technology" exhibitions, though their work would be extensively documented in the exhibition's catalogue.[44]

Perhaps to preserve his focus in the midst of all this turmoil, Turrell continued his work at the Mendota Block. He enjoyed the "skyspaces" he had cut in the roof of the building, and the way he had turned the Mendota Block into a "sensorium for light," but then he had to deal with the fallout when his landlord found out about this and made him repair the "damage."[45] "The owner actually begged me to buy it [the Mendota Block], for $30,000," Turrell said many years later, "but I didn't have the money."[46] Money, in fact, was increasingly tight for the artist after the summer of 1969. Despite his idealistic focus on the quality of his investigations over marketplace concerns, Turrell was forced to find a way to survive and continue producing his work. Around 1970, Turrell discovered he could support himself, ironically enough, by restoring antique cars and vintage aircraft.[47] Also, around this time, Turrell, perhaps belatedly seeking a connection to his father, became attracted to the sky, and he earned a pilot's license. In time, this interest would become significant to Turrell's work and career,

but in the spring of 1970, his newfound aerial focus led to Turrell's choreographing a piece with artist/neighbor Sam Francis. Francis had been a pilot during World War II, and he and Turrell designed, first by flying their own planes, then hiring a skywriting firm to execute the work with colored smoke trails, what they termed a "sky sculpture."

IT'S DIFFICULT TO PINPOINT EXACTLY WHEN TURRELL'S tumultuous progression as an artist led to his own private artistic revolution. Turrell remained steadfastly true to his developing vision through the many twists and complications of the early part of his career; however, by the early 1970s, it was clear that it was growing critical to take steps to ensure his survival as a working artist. In the fall of 1971, Turrell chose to enter the graduate program in art at the Claremont Graduate School, where he could continue to support himself (and his Ocean Park studio) by teaching classes. Once in place, in the very first week of his teaching, Turrell continued his tendency to push the limits of his art. In a performance art piece that he, tellingly, called "Burning Bridges" (1971), the artist placed road flares and aluminum reflectors into alcoves behind the columns of a campus building. Once he lit the flares, it created a strong illusion that the building had caught on fire. "It was so effective," Turrell said later, "that the fire department was called out."[48] As the fire department descended on the campus, Turrell left Roland Reiss, the head of the graduate art program, to deal with the fallout as he rushed off to join his students at another performance. In many ways, this work—a one-off event that was part of a larger class performance project and not really in line with Turrell's continuing artistic development—was not a particularly noteworthy part of the artist's oeuvre. "I think we were all interested in seeing how our ideas would extend into different types of art," Turrell said of "Burning Bridges." "They were things that made life amusing."[49] At the same time, "Burning Bridges" encapsulated all of the rebellious attitudes of Turrell's creations in those years. By virtue of its very title and its Baldessari-like employment of fire, as well as by

virtue of the artist's cavalier attitude about the fuss, "Burning Bridges" was about much more than light, performance, his new campus, and the class he was teaching. It was a work that revealed an artist so deeply engaged with his own critical evolution that little else mattered.

Over the next few years, the bridge burning continued for Turrell. In the early 1970s, as he completed a master's degree in art, Turrell increasingly focused on what he called "skyspaces." These were enclosed spaces that allowed a few people in to view sky phenomena. In 1972, Turrell was visited at his Mendota Block studio by the Count Panza di Biumo, an "adventurous Italian art collector"[50] who commissioned the young artist to create a skyspace, along with several other works, at his palazzo in Verese, Italy. The resulting work, called "Lunette" (1974), was Turrell's first commissioned work and key to his developing interest in the sky.

Around the same time that Count Panza was opening up some international vistas for Turrell, the artist lost an important part of what kept him grounded in Los Angeles. In 1974, after more than eight years, he lost his space at the Mendota Block. "It was purchased by a consortium in a real estate investment trust," Turrell would later explain, "of which Barbra Streisand was the majority owner." The trust also bought up the building where Sam Francis and Richard Diebenkorn had studios. "They evicted us all . . . they evicted a good portion of the Los Angeles art community, it was really quite a thing. Everybody had to go and get new studios."[51] And, of course, losing the Mendota Block space meant much more to Turrell than losing just his studio; he also lost "a great deal of work," wrote Craig Adcock. "He lost the walls and apertures that he has spent so much time shaping."[52] Turrell, as usual, downplayed the closing of his Mendota studio: "I had a good run of it,"[53] he said of the space he had developed and honed as his major art practice for eight years. Of course, it helped that Turrell's loss was somewhat assuaged by the announcement, that same year, that he had been awarded a major Guggenheim Fellowship.

As a result, his moorings lost, his bridges burnt, his graduate degree and some measure of financial stability at last secured, Turrell made perhaps his most radical turn yet. In 1975, Turrell purchased a Helio Courier H-295 five-seater, single-prop airplane and took to the air, essentially permanently leaving behind his Southern California home. Turrell made the most of his freedom, using his trips to provide the direction for the next stage of his career. "I liked to land my plane out in the desert, in open fields, in dry-lake beds, in all kinds of remote areas," Turrell said of his early sojourns across the desert landscape. "Each of the places I saw from the air generated thoughts for pieces. It was a process that could have gone on forever."[54] In time, that is, Turrell's searches across the desert would lead him to discover, in northern Arizona, a dormant volcanic crater, and the discovery would change everything.

### 3. "Shoot" (1971) — Chris Burden

If John Baldessari and James Turrell were isolated men forced by their desperate circumstances in the early 1970s to a state of revolutionary fearlessness, then Chris Burden was a martyr-in-waiting. In Kapuściński's account of the Iranian Revolution, after the man faces down the angry policeman, the policeman reports to his commander, who then sends in riflemen. These riflemen take positions on nearby rooftops, and, when the crowd refuses to disperse, they shoot. After the panic has died down, and the families come to collect the dead who remain behind, it is the martyr-in-waiting who has taken note of all that has occurred. He has seen and as a result he has begun, then and there, to devise his own radical response to the matter at hand, a response that will eventually make him a martyr to the cause.

Chris Burden had been born in Boston, Massachusetts, in 1946, in fairly privileged circumstances. His father was an engineer, and his mother had a master's degree in biology, and as he was growing up the family lived mostly in France and Italy. In these places the younger Burden, a privileged outsider, tooled around on a motor scooter

observing the local sights and sounds. But then, at age twelve, Burden suffered a bad accident on the island of Elba—he nearly severed a foot and, supposedly, had to undergo an emergency operation without anesthesia—that affected his outlook on life and led him, during a long convalescence, to take up photography.

After his family returned to Massachusetts, Burden couldn't help but feel like an outsider among his own people. During the summer between his junior and senior years in high school, a restless Burden took a Greyhound bus cross-country to La Jolla, California, so he could study at the Scripps Institution of Oceanography on a grant from the National Science Foundation. There, in the sunshine and laid-back lifestyle of Southern California, the teenager felt normal for the first time in awhile. "I had my first taco," he said many years later, "and I learned how to drive a motorcycle. The room I rented was right on La Jolla Shores beach, and the surfers wanted a place to store their surfboards. Their dads were in the air force and had brought back Honda motorcycles . . . . So the deal with these surfer guys was that if I let them store their surfboards in my room, then they'd let me teach myself how to drive their motorcyles."[55] During his entire stay in La Jolla, in fact, Burden never actually connected with the scientists he was supposed work with. Instead, he tooled around the coast on borrowed motorcycles, took photographs, and lived the grand and carefree life he had left back on Elba when he was twelve years old.

Burden's California residency eventually drew to a close, and the young man realized that once he was home he would have to face bigger questions: *Where would he go to college? What would he eventually do in life?* He could not, after all, expect to tool around on motorbikes forever, taking photographs and avoiding all responsibility. With these concerns weighing on his mind, Burden arranged a ride back to Massachusetts with a few friends, and, while driving out of Southern California on the original Route 66 (known locally as Foothill Boulevard), he passed by the quaint suburban-L.A. campus of Pomona College. Then and there he decided that he would arrange

an interview with the school. As a result, a year later, the young high school graduate returned to Southern California to attend college.

To put his parents' minds at ease, Burden started at Pomona College as a pre-architecture student. "You took art courses, physics, and advanced algebra concurrently," Burden later explained of his chosen major. "The physics and algebra courses, especially the physics courses, were really hard at Pomona. So right away I started drifting towards art, because you'd have to spend forty hours a week on the math. It didn't seem interesting at all, and a lot of the physics was over my head. I really liked making things."[56] In his sophomore year at Pomona College, after working a summer in an architectural office back in Boston where he was "the lowest of the gofers," Burden returned to school having come to a conclusion. "I decided to become a sculptor," he said. "I didn't want to be a pre-architecture student anymore. I wanted to become an artist, and specifically I wanted to become a sculptor. And [art department chair Nick Cikovsky] said to me, 'Oh, I don't know. It's bad enough to be a painter, but a sculptor, you're just committing financial suicide.' He used those very words: 'financial suicide.' And I went, 'Huh, well, we'll see about that.' "[57] Burden graduated with a bachelor's from Pomona College in 1968, then attended graduate school in art at UC Irvine. He started out studying sculpture but quickly shifted to performance art, mainly because, Burden later explained, he did not have much money to purchase sculpting materials.[58] He received an MFA degree in 1971 after performing, between April 26–30, 1971, a thesis work called "Five Day Locker Piece" (1971), which gave a good measure of what sort of artist Burden had become by age twenty-five. "I was locked in locker No.5 for five consecutive days and did not leave the locker during this time," said Burden in a formal statement. "The locker measurements were two feet high, two feet wide, three feet deep. I stopped eating several days prior to entry, thereby eliminating the problem of solid waste. The locker directly above me contained five gallons of bottled water; the locker below me contained an empty five-gallon bottle."[59]

Burden's performance, much to the artist's surprise, caused a small-scale sensation on the Irvine campus. "I thought this piece was going to be an isolation thing," Burden explained in a 1974 lecture at the Rhode Island School of Design, "but it turned into this strange sort of public confessional where people were coming all the time to talk to me . . . . The university's a pretty big place and people who weren't interested in art, specifically, came over just to see this guy locked in a locker. I think that the further away you were from this, the more strange it seemed, and I noticed that when people actually came to talk with me, they were reassured in a way."[60] In time, the furor over the performance captured the attention of campus police, who were uncertain what they should do, and the Dean of Fine Arts at the school, who reportedly was on the verge of panic. "There was a debate about whether or not they should try to pry me out with crowbars," Burden continued. "And there was nothing I could do. Just toward the end I got panicky myself. I started getting that weird feeling that a REAL crazy was going to come and do something to me. There were periods of time when I was alone and I knew my vulnerability might inspire someone to do something crazy. But that was only toward the end."[61]

Buoyed by the notice his locker piece had received, the new graduate set to work on developing his art career. To accomplish the delicate act of transitioning from student to artist, Burden knew that he would need to develop evocative, discomfiting, perhaps unforgettable performance ideas, prepare carefully for the actual performances, and be sure that he pulled them off well. The fact that they would only be seen by a handful of people would not hinder him, but would create an aura of mystery about him and grow his legend—or so he hoped. That summer, he was offered two chances to perform for the public in two different art galleries. The first opportunity would be a three-day performance in Kansas City. The second would be a one-off event at the F Space in nearby Santa Ana. With all the weight of his future career on his shoulders, Burden pondered long and hard how he could, with his next performance, create a burning memory that people would talk

about for the ages. What he did not know, however, was one of these performances would not only be successful in raising his art-world star, but it also would forever alter his life, define his career, and indelibly change the art world in California and beyond.

ALTHOUGH BURDEN HAS OFTEN DENIED THAT THE national and international events of the time influenced the shape of his early performances, the circumstantial evidence is fairly compelling. This was an era, after all, in which the public was increasingly turning its attention toward the brutal military quagmire of Vietnam, and, in light of the fight over the Pentagon Papers, was increasingly scrutinizing the government's ongoing attempts to hide the truth of America's role overseas. Even before the end of the 1960s, in the aftermath of the Chicago Eight trial and with the general dispersing of the loud, youth-oriented protest movements, distrust of the government and of the corporate and industrial power structures that dominated the culture had been at a high. "Make war on the machines," wrote '60s counterculture leader Abbie Hoffman in 1971, just before he went "underground" to escape trumped-up drug charges against him. "And in particular the sterile machines of corporate death and the robots that guard them."[62] If anything, Burden's first two public performances after his graduation from UC Irvine seemed to stem directly from the zeitgeist.

In Kansas City in early November, for instance, Burden conceived of a three-day performance called "You'll Never See My Face in Kansas City" (1971). According to Burden's description of the work, over the course of this residency he wore a ski mask at all times whenever he moved around the city. The act of concealing his face from everyone in the city not only evoked shady criminality—a natural assumption in an era increasingly aware of the rising urban crime rates that came as a result of a fraying social fabric—but it also captured the paranoid and reclusive spirit of the times, in which more and more radical protesters from the previous decade were going underground to continue

battling the power structure from a safe remove. For good measure, as if to emphasize this sense of paranoia and menace, for three hours during his gallery performance at the Morgan Gallery Burden sat unmoving behind a panel that hid his neck and head and kept his identity obscured from gallery visitors.

Burden's investigation into the deep vein of menace that existed in the culture went even further with the performance that followed—and it was this willingness to go deeper that would make his next performance instantly iconic. About the events that occurred on November 19, 1971, at the F Space in Santa Ana, Burden has tended to stick to dry, almost banal facts. In a letter written to the editors of the art magazine *Avalanche* prior to the performance, Burden explained simply: "I will be shot with a rifle at 7:45 p.m."[63] His write-up of the events after the fact was just as dry: "At 7:45 p.m. I was shot in the left arm by a friend. The bullet was a copper jacket 22 long rifle. My friend was standing about fifteen feet from me."[64] Even years afterward, Burden usually avoided most embellishments or explanations of the performance. "The bullet went into my arm and went out the other side," he recalled in 2008. "It was really disgusting, and there was a smoking hole in my arm."[65]

The only real records of the performance that exist today are two short and crude recordings—a shaky eight-second film clip taken by a friend and a distorted sound recording made by the artist himself. In the sound clip, we can hear Burden discussing certain logistics with his assistant in the moments leading up to the performance. "You know where you're going to do this, Bruce? Right there? I'm going to stand here," says Burden. After some muffled talk, the assistant asks, "Are you ready?" And seconds later, there is a loud, echoing crack. In the film clip, we see flickering images of the young artist, wearing a plain white T-shirt, standing at one side of a smallish, white-walled gallery with his left arm held downward but slightly away from his body. After a man moves into view, raises a rifle, and shoots, Burden concusses slightly. There is smoke, and as if reeling from a blow Burden staggers

slightly forward before catching himself and walking back toward the shooter. Before reaching his friend, he grabs his left arm with his right hand and takes a peek down at it, as if to make sure what he thought would happen actually happened.

Despite his recitation of dry facts there are a few hints that Burden was responding to outward concerns when he conceived of "Shoot," as this performance was called. Some years later, when interviewed by a fellow media-savvy artist, Burden talked about the influence of the war on this work. "Vietnam had a lot to do with 'Shoot,' " Burden told Doug Aitken. "It was about the difference between how people reacted to soldiers being shot in Vietnam and how they reacted to fictional people being shot on commercial TV. There were guys my age getting shot up in Vietnam, you know? . . . So what does it mean not to avoid being shot, that is, by staying home or avoiding the war, but to face it head on? I was trying to question what it means to face that dragon."[66] No matter how he explained "Shoot," however, the extreme act of having himself shot became a defining moment in Burden's career. To the wider public, the action seemed inexplicable, if not entirely deranged, and became an instant one-liner about the extreme lengths that artists often resort to in their work. Even some inside members of the art world wondered if Burden did not expect too much of the audience, forcing them into the position of viewing actions of an intensity and tension that they had not signed up for. Burden's public stances at the time about this work were, when they were not rote recitations of fact, often rife with a showman-like bravura. "Art doesn't have a purpose. It's a free spot in society, where you can do anything," Burden said in 1974, both in response to the criticisms about his seeming recklessness and in evocation of the then-dwindling revolutionary spirit of the era. Still, contrary to popular assumptions, Burden was never reckless about "Shoot." In his performances he never intended to put his life at risk or cause irreparable harm to himself. Leading up to "Shoot," for instance, Burden practiced with his assistant for two weeks, making sure that both he and the shooter were comfortable with what they intended to

do. In addition, Burden purposely chose not to perform the piece on the UC Irvine campus since he realized it would cause conflict with the campus police. He instead chose to hold the performance at a small gallery space, inviting only a small group of friends to watch it both to contain the immediate shock and to, as much as possible, ensure everyone's safety. Critic Kristine Stiles points to these facts as evidence that Burden "responsibly performed the piece [under] ethical conditions."[67]

Whatever the response, one marked bit of fallout from "Shoot" was that, at the end of 1971, word about Burden was finally out, and the twenty-five-year-old artist found himself suddenly famous (or infamous) among the nation's art observers. It was a mixed blessing. While plenty of the onlookers wanted to know—in the manner of gawkers at an accident scene—what Burden would do next, many established critics and art-world figures had a hard time getting past a basic reductive formula: This crazy artist would go to any length to turn his body into art.[68] For his part, Burden turned the newfound fascination with him and his art to delve deeper into his explorations of human fear, of risk, and of danger. That is, each successive work after "Shoot" seemed designed to test the limits of his, and his audiences', endurance, strength, flexibility, and tolerance for risk and pain.

In "Deadman" (1972), Burden lay down in the middle of La Cienega Boulevard beneath a tarpaulin as though he were a corpse. It was November 12 at 8 p.m. "Two flares were placed near me to alert cars," Burden said. "Just before the flares extinguished, a police car arrived."[69] In "Bed Piece" (1972), Burden stayed in a bed in the Market Street Program gallery in Venice, California, for twenty-two straight days. And so on it went, each performance intent on outdoing the last. Burden hung himself upside down and naked over a basketball court ("Movie on the Way Down," 1973); he crawled naked through broken glass on a local ten-second TV spot ("Through the Night Softly," 1973); and he had himself—or gave the illusion of having himself—electrocuted ("Doorway to Heaven," 1973), cut ("Back to You," 1974), and drowned ("Velvet Water," 1974).

This was all very radical stuff, and somewhat difficult to witness, as it all seemed to be a compulsive flirting with injury and death. As a result, to many in the art world of the time Burden seemed an other-worldly figure, something of a shamanistic psychopomp for the modern world. Death seemed to be the specter that hovered over audience reactions to Burden's performances. "Chris Burden," wrote critic Ken Johnson in a much later assessment of his work, "took the idea of death very seriously. In a way Burden was the inverse of [environmental artist] Smithson. He ventured into a wilderness not of nature but of the mind. Many of his works are harrowing just to think about . . . . How far from the human—from the apparatus of socialized consciousness, that is—can you get without dying? Normally we can't conceive what it's like to be dead. Would it be to dissolve into nothingness or into some kind of universal consciousness, as if the universe were itself an unthinkably immense intelligence? Maybe in getting so close to death, Burden was hoping for a glimpse of the great beyond."[70]

While informed by these very human concerns, Burden's performances were certainly about much more than death—not that he elaborated on this much. Beyond his dry, reductive descriptions of his performances, Burden has always remained self-consciously oblique regarding the intentions of his work. "When I did the performance 'Shoot' in 1971, I knew I was making art in a way that few others were," Burden said very recently in an interview. Rather than the work being solely about death, or how far an artist could go in risking personal harm for his work, Burden explained, "The question for myself would have been, 'Have I been shot?' Obviously, the wound was more serious than that, but as you can see, I was trying to find where the edge was . . . . There are always two sides to a coin. Society is usually fixated on only one side of the coin. For example, being shot is considered by society to be a bad thing and to be avoided at all costs. Sometimes it is of some interest to flip the coin and face the dragon head-on."[71] In the face of such artistic defiance, many critics were put off, of course. Some dismissed his performances, while others found them simply

repellent or nauseating. Robert Horvitz, writing in *Artforum* in May 1976, said of Burden's work: "Like most reductivist art, his work is under-articulated. That is, the information presented is so limited that one set of facts may suggest—indeed, may encourage—a number of conflicting interpretations and offer no means of determining which were intended by the artist. . . . Inaccessibly private responses, feelings, and insights are woven into its basic structure. Nor can one distinguish between those qualities that are specifically attributable to the work from those that are ambient or latent in the environment."[72]

Despite the antipathy, Burden's performances were so widely observed that they took on a life beyond the artist, helping create a new art genre, "endurance art," and influencing a generation of imitators—some noteworthy, most forgettable—and giving him a formidable reputation even beyond art circles. Burden was so widely known by 1973 that Norman Mailer referenced his work in his essay and book on graffiti art that year, *The Faith of Graffiti*. Mailer held up Burden as an example of the Romantic, civilized artist in contrast to the more primitive impulses that guided graffiti artists. A few years later, David Bowie sang about Burden and his work "Trans-fixed" (1974) in his song "Joe the Lion," and Burden's performance "Shoot" provided the inspiration for Laurie Anderson's 1976 song "It's Not the Bullet that Kills You (It's the Hole)."[73]

For an artist who seemed so intent on killing or perhaps just maiming himself, Chris Burden was, by the middle of the 1970s, doing a pretty good job at forging his own defiant way into history.

# Not an Energy Crisis

*L.A.'s Explosion in Conceptual and Performance Art*

### Part 1. Catalytic Converters: Concepts in L.A. Art ca. 1970–1973

A full understanding of the impetus behind the various art rebellions that hit L.A. in the first years of the 1970s is not possible without stepping back a bit to the last year of the previous decade. In 1969, the world, as well as its culture, was in a dramatic state of flux. This was a year of monumental, history-changing events—the Stonewall Riots, the Moon Landing, the Manson Family murders, Chappaquiddick, a fiery Cuyahoga River, nationalism in Northern Ireland, My Lai, Woodstock, Altamont—and the cultural production of Europe and the United States reflected the spirit of the times. Artists of all sorts reflected the unrest and confusion—1969 was the year, after all, that Led Zeppelin's first album announced the emergence of a loud and raw new musical genre, heavy metal, and that *Hair* and *Oh! Calcutta!* challenged the tastes of stodgy New York theater audiences with nudity and frank sexual themes. At movie theaters, young people flocked to see the edgy and controversial films of the nascent "New Hollywood": *Easy Rider, Midnight Cowboy,* and *Butch Cassidy and the Sundance Kid.* Philip Roth published his seminal first novel, *Portnoy's Complaint,* and Kurt Vonnegut published the groundbreaking (and heartbreaking) *Slaughterhouse-Five.* For the young generation that was emerging in 1969, the times were so tumultuous and full of change and possibility that almost anyone could make history at any

moment. "Our program," said poet, activist, and White Panther Party founder John Sinclair, "is cultural revolution through a total assault on culture, which makes use of every tool, every energy, and every media we can get our collective hands on . . . our culture, our art, our music, our books, our posters, our clothing, the way our hair grows long, the way we smoke dope and fuck and eat and sleep—it is all one message, and the message is freedom."[1]

In the art world, a number of young artists sought to assault the culture—and specifically the commodification and long-standing formalism of current-day art—through a variety of alternative and revolutionary strategies and approaches. A full summary of all of these new and adventurous avant-garde movements and moments would be impossible, were it not for one fact: In 1969, in the quaint and somewhat sleepy Swiss river town of Bern (pop. ca. 160,000), at a drab *kunsthalle* built in 1918, the then-unheralded director of the facility, Harald Szeemann, mounted an exhibition of even less-heralded European and American art that was later deemed "instant history, a radical moment."[2] Given the unwieldy title "Live in Your Head: When Attitudes Become Form: Works, Concepts, Processes, Situations, Information"—but more often referred to by the shorthand version, "When Attitudes Become Form"—this exhibition has, over the years, gained a near-mythical reputation. And this was despite the fact that it was wholly a low-key affair, drawing only a small crowd of locals who were unprepared to digest what they were seeing. "Puzzlement was understandable," wrote Holland Cotter on the occasion of a recent reenactment of the original exhibition at the Prada Foundation in Venice. "It brought together some of the most adventurous young European and American avant-gardists of the day, exponents of post-Pop, post-Minimalist, supposedly anti-market trends like Conceptual and Process art [as well as Arte Povera and Land Art]. It presented them at a high moment of political and cultural turmoil internationally, and in what has been perceived as a radically loosened-up exhibition format, with art created communally, spontaneously, on the spot."[3]

The work that Szeemann collected, by nearly seventy artists from around the globe, filled his art center and a nearby annex. Remarkably enough, Szeemann conceived of the show, organized it, and mounted it all without a travel budget, without the advantage of the contemporary international travel industry, and without the time-saving capabilities of the Internet. The result, however, was stunning—a pitch-perfect encapsulation of the most radical, alternative, and groundbreaking visions of what art could be at the time, and a perfect art-world response to an unsettled and revolutionary year. "The show wasn't quite sculpture," according to Cotter, "and certainly wasn't painting. Its mediums included ice, fire, broken glass, lead, leather, felt, fluorescent tubing, peas, charcoal, and margarine. Ropes snaked through rooms; electric wires wound down a staircase. Nothing was framed or on pedestals or behind stanchions, and visitors trampled on work, though it was hard to tell where the art ended and the damage began."[4] Much of the art was deliberately inscrutable, intending to confront art-world tastes and confound expectations of the time. A work by American Michael Heizer, for example, was comprised of the craters he had punched into the pavement outside the museum using a wrecking ball. American Lawrence Weiner's contribution to the show was to remove a three-foot square of plaster from one of the walls. "That's all," he told a bemused journalist. "That's it . . . . If you feel you don't need it, you don't need it. I'm not going to force it on you, or try to convince you."[5] English sculptor Richard Long, meanwhile, simply went on a three-day hike in the Swiss Mountains. Szeemann's intention, in his words, was to let the artists "take over the institution."[6] It is perhaps a telling indication of Szeemann's genius that many of the artists included in the show, who were then relatively unknown, were later deemed visionary giants of the era: Walter De Maria, Bruce Nauman, Sol LeWitt, Richard Serra, Joseph Beuys, Joseph Kosuth, and so on.

The immediate response and eventual fallout from Szeemann's daring exhibition unfortunately was not good for the curator. Local

public reaction to "When Attitudes Become Form" was wildly nega-
tive, and newspaper headlines in and around Bern—"When Platitudes
Become Form," "Sabotage in the Art Temple," "Is Art Finally Dead?"
"Stupidity . . ."[7]—belittled the event. Two Swiss artists protested the
show by burning their military uniforms. Another group of artists
dumped a mound of horse manure in front of the kunsthalle and stuck
a sign in it. Then there were the newspaper cartoons: One showed
Szeemann apparently planning his next exhibition at a junk shop;
another showed a garbage truck driving away from the kunsthalle
while a man runs after it, shouting, "No! No! You're taking away the
show!" Most serious to the career of the curator Szeemann, who was
already under the scrutiny of the kunsthalle's board for not showing
enough Swiss artists, was the criticism he received from his unhappy
staff, who were upset by the number of foreign artists he featured.
Under such pressure and scrutiny, Szeemann resigned shortly after
"When Attitudes Become Form" closed.

Despite the controversy and the negative fallout from local audi-
ences and the people he worked for, Szeemann ultimately succeeded
in one way: His exhibition caught the attention of the art world. The
status and fame of this one exhibition, in fact, has persisted to the
present day. "Ever since 1969, everyone—critics, historians, philoso-
phers, etc.—has cited this exhibition as a milestone," wrote an arts
journalist recently in *The Art Newspaper*. "Included in the key refer-
ence book, *Die Kunst der Ausstellung* (Insel Verlag, 1991), together
with shows such as the Wiener Secession of 1902, the Armory Show
of 1913, and the first edition of Documenta, Szeemann's exhibition
became an icon, a myth, a sort of Atlantis in the fabulous geography
of modern and contemporary art, and the subject of hundreds of PhD
theses."[8] The renown of "When Attitudes Become Form" is so lasting
that curator Philippe Vergne referenced the title in his epic 2003 exhi-
bition (on globalism), "How Latitudes Become Forms," at the Walker
Art Center in Minneapolis, and, in 2013, the curator Germano Celant,
well aware that few people in the art world actually saw Szeemann's

original exhibition, reconstructed "When Attitudes Become Form" at the Prada Foundation in Venice.

THE INTERESTS OF YOUNG ARTISTS IN LOS ANGELES in the early 1970s dovetailed neatly with the revolution that Szeemann meant to start with "When Attitudes Become Form." It helped that a number of young and singular California-based artists—Bruce Nauman and Stephen Kaltenbach of Northern California, Ed Kienholz of L.A., and a young unknown L.A. artist named Allen Ruppersberg— were included in the exhibition. It also helped that, in the void left by the end of the Cool School, and with the disjointed and somewhat troubled nature of the times, local art was growing stylistically dispa- rate and divergent. This is to be expected. When there was no obvious center anywhere—in politics, in society, in the culture—it makes sense that the creators of culture would reflect that uncenteredness.

Still, there were a few common strands of thought or artistic prac- tice that a number of young L.A. artists found compelling. Most of the young artists who came of age after the end of the Ferus Gallery, perhaps anticipating the coming era of scarcity and economic retrench- ment, rejected commercialism, commodification, and formalism in their art. For them, the art object, which had for so long in the twen- tieth century been the dominant relic of artistic practice, suddenly was deemed outmoded, distasteful, and gauche. The rejection of object- making and disdain for art commodification of course left few practi- cal ways for artists to still express themselves. And this is why so many artists in L.A. at the time flocked to the new and developing genres of experimental art that Szeeman helped make fashionable—namely Conceptual Art and its close cousin Performance Art.

Performance Art as an artistic practice has an indeterminate origin and an unclear definition. "Performance Art is an essentially contested concept," suggested professor Marvin Carlson. "Any single definition of it implies the recognition of rival uses. As concepts like 'democ- racy' or 'art,' it implies productive disagreement with itself."[9] As a

contemporary art-world practice, Performance Art developed in the 1960s, alongside Conceptualism, out of the ongoing impulse to reject traditional art forms such as painting and sculpture. Most relevant to American artists, in the 1940s and 1950s many American abstract painters sought to make their work a sort of free performance. That is, the canvas was seen by artists and critics of the time as "an arena in which to act," and paintings were seen as the remnants of the artist's actions in his/her studio. After the end of the Abstract-Expressionist heyday, these notions of an abstract art made from "action" were picked up and developed by artists of the Fluxus movement of the late 1950s and 1960s, and several Fluxus artists—George Maciunas, Joseph Beuys, Yoko Ono, Dick Higgins, George Brecht, and others— took the lead in creating performative art events and making concept-based non-art objects throughout the early and mid-1960s.

By the late 1960s, the idea of what comprised Performance Art had been somewhat codified. Essentially, Performance Art involved a performer or artist, whose task was to create an ephemeral and authentic experience for an audience that could not be repeated, captured, or bought/sold. (Conceptual Art, meanwhile, was similar in that it was not focused on the object, but, as LeWitt explained, on the idea.) In general, Performance Art became a dramatic form that employs certain theatrical conventions—an actual live performance that is staged for an audience—while eschewing many of the basic assumptions regarding theatrical performances. Performance Art often ignores or seeks to subvert audience expectations. It does often include action and spoken word, but this is usually presented as a direct form of communication between artist and audience. In general, Performance artists avoid formal linear narratives with simple meanings or messages, refuse to create fictional "characters" and any staged interactions, and prefer to challenge audiences to think in new and unconventional ways particularly in regards to their ideas about art, artists, themselves, and the greater society. (Conceptual artists similarly confound art-viewer expectations by eschewing the making of aesthetically pleasing art objects).

Beyond the buzz over "When Attitudes Become Form," two events were key catalysts in spreading Conceptual and Performance Art practices in Los Angeles in the 1970s. The first occurred in 1967, when the New York–based artist Allan Kaprow—who was famed for his invention, back in the 1950s, of the multidisciplinary, performative spectacles that he called "Happenings"—was commissioned by the Pasadena Museum of California Art, as part of a mid-career retrospective, to produce a multi-site Happening called "Fluids." For this work, the well-traveled and in-demand Kaprow directed teams of workers for three days in October to build walled, rectangular structures out of cinder block–sized chunks of ice. Each of the completely enclosed structures were about seventy feet in length, ten feet wide, and seven feet high. The work was complicated and progressed in unique ways, depending often the specific conditions and rate of melting at each site. In a lot next to a McDonald's in Pasadena, for example, the work took on the rhythms of fast-food counter and kitchen workers. At a site next to a children's center in Temple City, the work mimicked the energy of children at play. According to Kaprow's biographer Jeff Kelley, "Fluids" was composed of "constantly changing states: of matter, of weather, of place, of scale, of mind, of work, of temperature, of dissolution, of memory, and, once or twice in the smoggy-red late afternoon light, of grace."[10] "Fluids" was a perfectly fitting work for the evolving L.A. art world at the time, and, incidentally, it was also a revealing metaphor for the state of Kaprow's career.

Kaprow had begun working as an artist in New York in the early 1950s, right in the thick of the Abstract-Expressionist era. Having studied art history at New York University and Columbia, and having earned a degree in art at the Hans Hoffman School of Fine Arts in 1949, Kaprow naturally started off his career as an abstract painter. But quickly he found himself investigating what the ultimate definition of "action" might be in art. In 1953, Kaprow began teaching at Rutgers University, where an impressive cohort of innovative and daring avant-garde artists/teachers/students—including Roy Lichtenstein, Lucas

Samaras, George Segal, Robert Watts, Robert Whitman, and Geoffrey Hendricks—had gathered. These artists taught, studied, exhibited, and brainstormed together, developing notions that became points of origin for Pop Art, Fluxus, art environments, and Performance Art. In 1957, Kaprow attended, along with a number of his artist cohort at the time, classes in musical composition taught by John Cage at the New School for Social Research, and he took to heart Cage's creative detachment, his celebration of chance phenomena in his work, and his constant drive to experiment. After his experiences with Cage, Kaprow's ideas developed rapidly.[11]

In 1958, Kaprow's investigations led him to create his first "public environment" at the cooperative Hansa Gallery, which at the time was seen as a venue for work rebelling against the dominant New York School. Also in 1958, Kaprow created his first public "Happening," at the campus chapel of Douglass College in New Brunswick, New Jersey. Called "Communication," it was essentially a mock public lecture that involved overlapping tape recordings of nonsensical sounds along with physical objects—placards, banners, tin cans, bells, bouncing rubber balls, a flashing red light bulb—that were manipulated by the audience through cues from Kaprow. "No one knew precisely what had happened," wrote Jeff Kelley of this seminal moment, "but clearly something had. No one knew what it meant, but it seemed deliberate enough to mean something."[12] For Kaprow, the event signaled that by carefully "scoring" an experiential "composition" and employing the randomness of audience interaction he had found a dynamic new, radical, performative style of art that he could make all his own.

As the 1950s ended, Kaprow continued pondering the aesthetic concepts that underscored his Happenings, particularly in relation to other artistic currents of the time. By design, Happenings had no structured beginning, middle, or end, and there was no hierarchical distinction between artist and viewer. It was the viewer's reaction that decided the art piece, making each Happening a unique experience that could not be replicated. Performers were encouraged to take advantage of unplanned

occurrences during Happenings even as they acted out, within a preset structure, fantasies based on universal, real-life desires and concerns. Happenings minimized the actual creation of artifact and treated art as something no longer confined to a gallery or museum, existing only as an event. By 1963, Kaprow had become the presumed spokesman for an exploding form of quasi-ritualistic art performance, and he began receiving invitations to speak and teach around the country. Because of this, as the 1960s progressed the artist's outlook turned away from the New York art world toward the cultural "hinterlands" and eventually to the far West Coast. The remoteness of some of the locations Kaprow visited pushed him to ask more urgent questions regarding modern living and to investigate headier themes like domestic conflict, product packaging, media messaging, systemic waste and entropy, human relations, labor issues, technological change, and so on.

Ironically, even as Kaprow worked to make his Happenings more grounded and responsive to the times, the idea of the Happening became increasingly mythologized in the culture at large—associated with popular media images of the Beats and other mid-century avant-gardists, and applied to everything from youth gatherings to television commercials and everything in between. By the late 1960s, according to Jeff Kelley, "Happenings were bigger as rumors than they had ever been as events." Much of Kaprow's lecture time on college campuses in those years were then "spent dispelling his own mythology (so he could get on with his work)."[13] Toward the end of the 1960s, in fact, the term "Happenings" had acquired so much cultural baggage that Kaprow stopped using it altogether, applying the more neutral, less exalted term "activities" for the events he conducted. By the time he got to Pasadena in 1967, then, his work was on the one hand a highly experimental and radicalized form of art, and on the other hand it was strangely traditional—in how it explored human behavior, societal and cultural interaction and exchange, and the basic formulas of storytelling.

After the completion of "Fluids" in Pasadena, between the spring of 1967 and the fall of 1969 Kaprow continued his itinerant life.

He was constantly traveling between his home in Long Island and Berkeley, where he co-directed an experimental education program for teens, and he also somehow fit in projects in Chicago, St. Louis, Albany, Austin, La Jolla, and several locations in Europe. During this same period, having become distant with his former colleagues in and around New York, and having realized the damaging effect of his absences on his family, Kaprow began to search for a new job. His experience at the Pasadena Museum of California Art, and his work with Southern Californians on the various parts of "Fluids," must have made him believe California had potential to support his work. In 1968, after making inquiries, Kaprow sat down to talk with officials from the University of California, San Diego, and the yet-to-be-completed California Institute of the Arts about his moving out West. After determining that CalArts' new provost, theater director and avant-garde theorist Herbert Blau, shared many of his ideas about progressive education, Kaprow accepted a job at the new school as an art professor and assistant dean.

And this is how, right in the midst of the momentous summer of 1969, Kaprow found himself moving from his Long Island home to the far-off reaches of Southern California to start his career anew.

WHAT KAPROW FOUND IN LOS ANGELES AT CALARTS must have been discouraging. Because the campus in Valencia was still under construction, Kaprow and the school's students attended classes in Burbank's Villa Cabrini. And although Kaprow and new dean Paul Brach were given carte blanche to hire a number of cutting-edge artists to teach at the school when it opened,[14] CalArts was hindered by the "curious and not always harmonious" conflict between founder Walt Disney's vision and the visions of the teaching-artists actually working to get the school up and running.[15] Whereas Walt Disney and his brother Roy had worked to create an ambitious art school model that brought various disciplines together in close proximity as a kind of "bold, yet naive" arts-based utopian paradise—"a kind of 'whistle

while you work' Bauhaus"—what the assembled educators had in mind was somewhat more provocative and "scruffier."[16] Because of this, the students who came to CalArts were nothing like the well-mannered and nattily dressed young men and women the Disneys envisioned for the school. For the most part, students carried themselves with a kind of hedonistic-Maoist-countercultural aplomb, and they occasionally shocked the school's trustees by skinny-dipping or sunbathing in the near nude. And of course nothing in the original Disney vision came close to the Marxist and feminist agendas that were obvious among much of the faculty from the start.

Despite the conflicting visions for CalArts, the prevailing atmosphere at the school, at its kickoff in 1970, was one of very high expectations, and Allan Kaprow was a catalyst for much of this spirit. It started during the school's first semester, on the Burbank campus, when provost Blau asked Kaprow to stage a Happening with students that would function as a P.R. event for the new school. Although Kaprow had all but ceased coordinating spectacles at the time, he agreed to develop a big event, particularly since he saw it as an opportunity to engage his new students from the start of their experience at the school. The resulting Happening, called "Publicity," took place on October 6, 1970. Starting in the lunchroom at the Burbank campus, Kaprow spoke on the occasion about the idealistic spirit of the times—not only as evinced by the opening of the new school, but in the recent music festival at Woodstock and the first Earth Day, which had taken place the previous spring. Kaprow shared with the students the basic concepts he had developed for the event, then he led them onto several yellow school buses for a trip to Vasquez Rocks, a picturesque site, located about twenty miles to the north, that had often appeared as the setting of films and television shows.

Once there, the students split into work groups. Kaprow, as was his usual practice, gave few directions and let the students figure out for themselves how to accomplish the rough ideas and tasks he had outlined. Some groups of students spread out among the rocks and began to build ramshackle sculptural structures. Other groups competed

with each other to document the goings on with the new Sony video Portapaks they had brought along. In time, a group of renegade students arrived in a pickup truck, and, in a scene reminiscent of a Wild West bushwhacking, challenged the structure of the event, as well as the event coordinator's authority, by trying to set fire to some leftover lumber. While most of the gathered students remained unaware of the drama, a frustrated Kaprow drove them away. Eventually, as dusk began to fall and rangers prepared to close the park, student energy slackened and the Happening ended without further incident.

As Kaprow's first full year of instruction at CalArts continued, the challenges mounted. A bit past halfway through the year, in February of 1971, the 6.6-magnitude Sylmar earthquake struck, killing sixty-five people and causing damage to buildings and freeways across a wide swath of Southern California. In Burbank, at the Villa Cabrini campus, several buildings were seriously damaged, forcing the school's administration to relocate students early to the unfinished campus in Valencia. As a result of the turmoil, in the fall of 1971 Kaprow organized a performative work called "Scales" that referenced the particular conditions at the school. For this event Kaprow had six cinder blocks delivered to campus, and, as a metaphor for the challenges his students faced in the new space and new school, he directed six people to drag the blocks up and down stairwells and into still-unfamiliar halls and rooms of the building.

Through his efforts to infuse the first years of instruction at the California Institute of Arts with the performative spirit of his Happenings, and through his work as assistant dean to steer the school's particular educational direction, Kaprow exerted a powerful influence on the new school. In keeping with his artistic approach, Kaprow's pedagogical style was loose and participatory. Kaprow illuminated his philosophies regarding teaching in a series of articles he wrote between 1969 and 1974 called "The Education of the Un-Artist." Essentially, Kaprow saw the need to address the increasingly blurred boundaries between art and its environment, in which everything was imitating

everything else. Copying and playing, then, were the cornerstones of Kaprow's classroom curriculum. "He tended to do events," said the future Performance artist Suzanne Lacy, who was an early student of Kaprow's at CalArts and in the Women's Design Program at the time, "or encourage us to do events or activities, and then we would sit around and reflect on them." There were no traditional "crits," just a kind of follow-up "reflection." With Allan, "you would do a work and you would talk about an experience," Lacy continued, "and your experience could be, 'I was afraid when I was on the freeway in the middle of the night,' or it could be, 'It made me think about when I was a kid' . . . . Allan said he got some of this from feminist practices, including consciousness raising. The reflection was each person talking about what they thought and felt during the experience of the work."[17] That Kaprow was also, as Lacy suggested, quite comfortable with other avant-garde approaches to art-making and teaching—including the strategies, philosophies, and artistic approach of the remarkably strong feminist contingent that had been established at CalArts—was critical to the school's success. "The feminists came in full force with Judy and Mimi's program," said Lacy. "So there was feminist every-thing, and there was sort of this layer over other kinds of classes . . . . A lot of feminists gravitated toward Allan."[18]

Still, Kaprow's most lasting contribution to the school, and by extension the future direction of art in Los Angeles, may have been a decision that he was not really responsible for. Although Kaprow took some credit in later years for the hiring of John Baldessari, it was more likely the work of the dean of the department, Paul Brach,[19] who had known the artist at the University of California in San Diego and recognized his experimental sensibilities. Whatever the case, the arrival of John Baldessari at CalArts was the eventual key to everything, even though at the beginning the laconic, brilliant, plotting Baldessari was far overshadowed at CalArts by the likes of Miriam Schapiro and Judy Chicago, who were breaking ground in feminist education, the ener-getic Easterner Kaprow, and several other of the campus's new hires.

From the start, Baldessari, who had only recently completed the incineration of the bulk of thirteen years' worth of his art, had big plans. "John was this low-key, bemused man in a two-bit junior college in San Diego," said Paul Brach of Baldessari a few years later, "acting as though he was the absolute center of the international art world. He was projecting these clumsy snapshots on photo emulsion on canvas and having a sign painter letter the description underneath. I wanted someone who could open the students up to what the critic Harold Rosenberg called the 'de-definition' of art."[20] John Baldessari was in many ways the polar opposite to the cerebral and relaxed Kaprow. He approached teaching by inhabiting it alongside his art. "I don't make a great deal of separation between communication by teaching and communication by the work I do," said Baldessari. "I find it very much the same."[21] In this approach, Baldessari was particularly influenced both by the American poet William Carlos Williams, whose interest in ordinary things is reflected in his bare-bones language, and by the ideas of Austrian philosopher Ludwig Wittgenstein, who argued for a reevaluation of language and its uses in more everyday terms. While Kaprow believed that it was critical to act meaningfully in the space you inhabited, Baldessari believed that the most meaningful art was to be found in spaces where you least expected to find it. Whereas Kaprow was intent to let students go under a loose classroom structure, then hash over how they felt about the work, Baldessari had no qualms about directing his students, often employing them in his films and other projects. Like Kaprow, Baldessari would often take his students outside of the classroom. But unlike the politically, socially engaged Kaprow, Baldessari was pointedly playful with his students, pushing the limits of what constituted an artistic journey. Often he had a student throw a dart at a map of L.A. to determine their end destination—as a result, the class visited the Forest Lawn Cemetery, the Hollywood Wax Museum, and the Farmers Market, among other places, where activities and images were recorded by still and video cameras supplied by CalArts. In time, the teacher–student relationship in Baldessari's

classes resembled a counselor organizing field trips, skits, and craft projects for his charges at a high-powered summer camp.[22]

This irreverent approach to teaching, of course, corresponded to the playful questioning Baldessari was doing with his own work. In 1972–73, for instance, he made "The Artist Hitting Various Objects with a Golf Club" (1972–73), in which, as the title suggested, he took repeated whacks at things he found at a city dump. "I love the idea that in a world of things for use, of doing just gratuitous things," Baldessari said. "And to make people stumble a bit."[23] Baldessari pushed his students to look beyond the confines of the art world. For example, a young student named Matt Mullican, in 1973, worked on a project called "Details from an Imaginary Universe," in which snipped images from comic books presented a childish view of reality. Student David Salle, also in 1973, took domestic photos of women, one of whom was his own mother. And a part-time (or unregistered) student named Ilene Segalove made a video series called "The Mom Tapes," in which she filmed her conversations with her chatty mother.

In sum, Baldessari "tended to be a little more concerned with the question of art [than Kaprow]," said Suzanne Lacy. "Allan had a very easy relationship with student mentoring. He was a big pedagogue, but he wasn't a big authoritarian. He wasn't authoritarian at all . . . . But if you were in a Baldessari class, and I know this more from the people he taught who were colleagues of mine, you would be talking much more about positioning, because Baldessari was moving into the art world from a distanced perspective of being a West Coast guy, whereas Kaprow was bringing quite a bit of his ability from the art world with him from New York. Kaprow was pretty perplexed about his relationship to the art world, but Baldessari and Baldessari's students were thinking about how to be in the art world."[24]

UNDER THE INFLUENCE OF KAPROW AND BALDESSARI and several other of its early instructors, the California Institute of Arts became a center of educational innovation and cross-disciplinary

give-and-take, as well as a nexus for the latest avant-garde art strategies that had been concretized by Szeemann's "When Attitudes Become Form" exhibition. Kaprow's presence had contributed to the school's reputation almost from the get-go, but Baldessari's reputation as an important new and innovative artistic and educational thinker grew quickly as well. As a result, CalArts attracted students from around the country, as a growing number of young, hopeful artists were intrigued by the cutting edge approaches of the new school located in the hills outside L.A. A *New York Times* art reporter visiting the campus in its early years described the CalArts vibe: "It's alive with all kinds of artistic experiments and ideas. The art department just doesn't sit there—it moves."[25] "During those early years at CalArts," said John Baldessari later, "there was the feeling that everything was possible, not only at CalArts but in art; it was a great moment."[26]

Baldessari's mounting importance to the development of the art of Southern California in the early 1970s stemmed mainly from his particular approach to teaching. He framed his course at CalArts as a "post-studio art" course, basing it on the notion, he explained, that "there is a certain kind of work one could do that didn't require a studio. It's work that is done in one's head. The artists could be the facilitator of the work; executing it was another matter."[27] Baldessari had taken the term "post-studio" from Carl Andre.[28] "I thought about calling it Conceptual Art," Baldessari said, "but that seemed too narrow and too prescribed . . . . [post-studio] seemed to be more broadly inclusive, that it would just sort of indicate people not daubing away at canvases or chipping away at stone, that there might be some other kind of class situation."[29] Baldessari's idea attracted a number of young acolytes at the school and also influenced the art of some local professionals. Even the young local Conceptual artist Allen Ruppersberg seemed influenced by what was going on up in Valencia. "It was the period of post-studio work and I, like others," he said, speaking of his activities in the wake of "When Attitudes Become Form," "was interested in

getting away from the obsession with the studio and works that were only seen in galleries and museums."[30]

Beyond his innovative approach to teaching, Baldessari played a critical role in the continued development of new art in L.A. by connecting the new school and its students to another nexus of similarly forward cutting-edge art-making practices and pedagogy located some sixty miles to the southeast: the Claremont Graduate School. Baldessari, along with some of his earliest CalArts students, had long been careful observers of the activities of the Claremont Graduate School of Art. "In my VW bus," Baldessari said, "I would load students up and take them out to Claremont." His early students, like Matt Mullican, would remember going to Claremont a "bunch of times," adding, "It was a long trip."[31] Among the reasons that Claremont became such a nexus for cutting-edge art activities was Mowry Baden, a professor of sculpture who was a catalyst of innovation at the graduate program. Gallery director Helene Winer was also instrumental in mounting a series of shows that showcased many of the most notable avant-garde artists in L.A.—at a time when almost no other local art venue would show their work. This list included Baldessari (1970), Jack Goldstein (1971), Bas Jan Ader and William Leavitt (1972), Hirokazu Kosaka, Wolfgang Stoerchle, Chris Burden (1972), David Antin (1972), Allen Ruppersberg (1972), and James Turrell (1973). Winer also mounted, in 1973, a widely viewed showcase of cutting-edge Conceptual and other avant-garde artists that included Baldessari, Eleanor Antin, Joseph Kosuth, Sol LeWitt, and Lawrence Weiner, among others.

As Baldessari's ideas gained more currency through the 1970s, more and more talented young artists in Los Angeles naturally embraced the general shift in attitude from solitary contemplation of form and aesthetic decision-making to a thoughtful, Conceptual-based, outward engagement with the world. Considering all of this artistic experimentation at CalArts and elsewhere, it was increasingly clear that John Baldessari's views—that it was critical to turn away from the studio and its associations and toward engagement with the world—represented

the forward path in art. And while the idea that Los Angeles could be that important to the development of avant-garde art was still, in the early 1970s, confounding to some observers, it nevertheless was happening. "Art in L.A. [had long been] about making objects that were beautiful and that you put on the wall. Decoration," said Japanese-born Hirokazu Kosaka of his adoptive city. "[But] all of a sudden there was space, a small space, for a different kind of work that dealt with more important issues."[32]

### Part 2. In search of the miraculous: An Explosion of Conceptualism and Performance in Los Angeles, 1973–75

With the educational impetus of Allan Kaprow and John Baldessari and the expanded synergy of the art program at the Claremont Graduate School connecting local artists and pushing them to focus on a more direct, less object-oriented sort of art, Los Angeles experienced an explosion of cutting-edge artistic production after 1973. For the next several years, the output of new Conceptual and Performance artists expanded and evolved dramatically, heading off into several compelling directions at once. And though this dazzling flurry of activity is difficult to account for in a comprehensive way, we can see in retrospect that there were three clear lines of inquiry that seemed to drive local experimental artists through these years.

Two of the new directions in local art practice after 1973 developed out of John Baldessari's post-studio art course. One direction, which was much more drily Conceptual, reflected Baldessari's particular penchant for insouciant picture-making and subversive humor. The other direction, which was much more confounding and stressful to all involved, interpreted Baldessari's ideas and practices through the particular filters of the era. Edginess and stress were to be expected among L.A.'s Conceptual and Performance artists. Around the Los Angeles region and across the country there was a growing sense that the good life California and America had long promised—the life of two cars and a garage, of stable and dependable factory jobs, of chickens in

the pot and money in the bank—was coming to an abrupt close. It's difficult to pinpoint exactly when the California Dream in particular turned dark. As *Time* magazine suggested a few years later in 1977, "Californians differ[ed] over when the dream fizzled." The "California of the '60s, a mystical land of abundance and affluence," the magazine suggested, was widely believed to have "vanished some time in the 1970s."[33] What is clear is that between 1969 and 1973 Californians were forced to cope with a perfect storm of disappointments: The Manson Family murders, the rise of street gangs around the urban core, the loss of 180,000 jobs in the once-vibrant aeronautics industry, the Sylmar earthquake, chronic drought conditions that stretched the local water system to near-disaster, rising divorce rates in the state, increasing awareness of local environmental degradation and pollution problems, and so on. And whatever the initial source of the local malaise and disillusionment, the OPEC oil embargo of 1973 brought California to an even darker crossroads.

Between October of 1973, the month the embargo began, and January 1974, world oil prices quadrupled as oil reserves were strained. As a result, beginning in November of that year the economy of the United States was plunged into a sharp recession that would last until March of 1975.[34] In Southern California, where the entire economy and most people's lifestyles were reliant on the automobile[35] and the propped-up national oil economy, the gas shortage struck particularly hard. All spring and summer of 1974, local press reports told of long, traffic-jamming queues at service stations, fights breaking out at pumps, and the forced closings of stations from lack of petroleum to sell. After state officials implemented gas rationing, commuters were only further enraged. The economic aftershocks that followed the gas crunch doubled California's unemployment rate—from around 5 percent to over 10 percent.[36] Because of these troubles, for the first time in nearly a century, migration to California slowed to a near standstill.[37] Though the state would remain the most populous in the country, by 1975 the idea that California was the place you wanted to be—as the

*Beverly Hillbillies* TV show theme song had told us throughout the 1960s—was forever lost.

The new sense of malaise that settled over the region was thick and surprisingly resonant, coloring artists' work, affecting their output, and directing how they would choose to interact with the art world, audiences, and each other. In 1973 and the years that followed, artists expressed their own discontent with the time and place in a variety of ways, some poignant, and some quite angry and upsetting. In fact, much L.A. art in those years was imbued with a distinct sense of loss, uncertainty, and even, at its extreme, doom. "Artists who defined the early 1970s in Los Angeles," wrote art historian Thomas Crow, "tended to function under the sign of their own disappearance."[38]

For Conceptual and Performance-minded artists of Los Angeles in the 1970s who considered the former ideal of the artist—as a maker of objects, as a presence in the studio—increasingly untenable, the idea of removing the artist from the art became, for a time, something of a local *idée fixe*. "In the early 1970s," wrote David Salle, an early student of Baldessari's at CalArts, "nobody wanted to have a style, they just wanted to do things, to stay loose and close to the experience. Especially in Southern California, having a big-time signature style was the art world equivalent of going corporate at a time when the counterculture was making its last stand."[39] For his part, Baldessari was straightforward about the intention of his class: "I basically wanted a class where people weren't standing at an easel painting away," he said, "and that it would be about an idea of something and that idea could be done anywhere."[40]

Because of Baldessari's ideas, artists were simultaneously freed and wracked with self-doubt. "All roads artistic were headed in the direction of minimizing the personal," Salle continued. "To someone from Mars this might have seemed like a strange development; isn't that what artists do? But art, or painting anyway, had become the hiding place for a lot of bogus-feeling personality exhibitionism, and serious-minded people who wanted to be artists needed to find a way to escape

the prison of sensibility and the trivializing narcissism it implied."[41] While this puzzling path along which certain L.A. artists traveled in the 1970s befuddled a large part of the public at the time, it also led, ultimately, to some energetic and highly inventive Conceptual works that expanded what art could be.

In 1971, Chris Burden had kicked off his career with the terrifying and intense "Five Day Locker Piece." A year later, Jack Goldstein— one of Baldessari's current students at CalArts and an artist who would make his mark at the Pomona College Art Museum during its heyday—staged a performance on a hillside near the CalArts campus that sounds shocking even today. The performance involved Goldstein burying himself overnight outside—essentially disappearing from life, the only indication of his existence being a stethoscope amplified over loudspeakers (or connected to a blinking light, depending on the account) to track the beating of his heart. Appropriately enough, Allen Ruppersberg also adopted Harry Houdini as an artistic alter ego in a series of performances in 1973 that explored, somewhat obsessively, the concepts of escape and disappearance. In 1972, Ruppersberg also created "Where's Al?," an installation at the Pomona College Art Museum that included 160 small color snapshots of fleeting, unidentified figures doing ordinary things and 110 typewritten cards that recorded dialogues of people trying to find an elusive character named Al.[42] The dialogues never really add up to a complete narrative, though they do tell a story about the inconsistency and uncertainty of any modern life—as if to ask, as Goldstein and Burden did, what exactly is the position of the artist in relationship to his or her art.

Artists, particularly those working in L.A. in the 1970s, often lived a frugal and peripatetic life, and Ruppersberg, originally from Ohio, was used to moving frequently from apartment to apartment, and from artist studio to artist studio—in effect having no presence in the world. "We were outcasts," said Hirokazu Kosaka of the growing cohort of Performance and Conceptual artists in L.A. at the time.

"We were complete outcasts, . . . not known by anyone."[43] Kosaka himself investigated his own moral nature and inevitable disappearance when he lay under an electric blanket covered by a mound of dirt up to his neck for a performance in Pomona in 1973. That the effort to withdraw artistically and to seek the erasure of the artist's presence would lead to increasingly risky self-abnegation in the work of California's Conceptual artists between 1973 and 1975 seems preordained. "Concealing or removing the body from the view," suggested Crow, "becomes the equal and opposite requirement to putting it on conspicuous display. That negation of self carried potentially dire real-world connotations."[44] Indeed, the apogee of artistless art—that is, of the artist's attempts to remove all trace of his presence from the art—was yet to come in L.A. And one person in particular would come to epitomize the ominous, semi-metaphysical investigation of post-object and (post-artist) art in L.A.: Bas (short for Bastian) Jan Ader.

Born in the Netherlands in 1942, Ader had grown up under a dark cloud. Not only was his country, and all of Europe, devastated after the war, but his father had been shot by German occupiers in 1944 for harboring Jewish refugees. An understandably troubled and rebellious student, as a young man Ader failed out of art school at the Gerrit Rietveld Academy in Amsterdam, where he was known for using only one piece of paper for an entire semester, constantly erasing his drawings and starting over. At nineteen, Ader hitchhiked to Morocco, then signed on as a deckhand on a yacht headed to America. After a long spell at sea, he ended up in Los Angeles and essentially never left—first completing a BFA in 1965 at the Otis College of Art and Design, then a master's degree from the Claremont graduate school in 1967. Ader's work was Conceptual in nature, but often mired in his own deeply romantic, often tragic, personal-life struggles. One of his most famous works, a film called "I'm too sad to tell you" (1971), is comprised of a single, close-up, three-and-a-half-minute shot of Ader crying. The sense of pain and suffering evident on the artist's face, even as it is wholly

and realistically human, is nearly excruciating to watch. In "Fall I," a short early, black-and-white 16-mm film from 1970, meanwhile, Ader is shown seated on a chair perched atop the crown of the roof of his home in suburban Claremont. A few seconds in, the video shows the artist tumbling from his chair in slow motion, then rolling down the roof onto a porch overhang and falling over the edge into some bushes below (his shoe poignantly flying off his foot just before he lands). "I took that film and Bill Leavitt shot stills of it," said Ader's wife and artistic collaborator at the time, Mary Sue Anderson. "Bastian would never make sketches or do anything physically in preparation for a work of art . . . . His process was simply to think, and then do. That's part of the reason he didn't do very many pieces because he really thoroughly thought them out before he'd even start. And once he started to make the work of art, we shot it and it was done."[45]

As the 1970s progressed, Ader's art traveled into increasingly personal realms—his drive to depict his own fragility and desperation and the inevitability of failure, falling, and death. The real-world connotations in Bas Jan Ader's quest to face the darkness—in the city, in humanity, in his own tormented soul—is a perfect example of the dark roads traveled by L.A.'s growing pool of Conceptual and Performance artists. Eventually, Ader's investigations would culminate in an epic, multi-part artwork that had its beginnings in Los Angeles. Called "In search of the miraculous," its first stage, which was subtitled "(One night in Los Angeles)," was launched as an installation at the Claire Copley Gallery in Los Angeles in 1975. For this event, Ader brought in a choir, comprised mostly of students from the classes he taught in the UC Irvine art department, to sing sea shanties around an upright piano. "The signal song of the group was 'A Life on the Ocean Wave,' written in the 1830s by Epes Sargeant and Henry Russell."[46] The lyrics to the song extol the virtues of a life on the treacherous sea: "A life on the ocean wave! A home on the rolling deep!" Ader's students sang. "Where the scattered waters rave, and the winds their revels keep! . . . Like an eagle caged I pine, on this dull unchanging shore.

Oh give me the flashing brine! The spray and the tempest roar!" The song title would be significant in the second stage of "In search of the miraculous" as well, as the lyrics suggested the name for Ader's boat: *Ocean Wave*.

On the walls of the gallery, meanwhile, Ader displayed a series of eighteen inscribed photographs. In the first of these photos, he is depicted walking along the side of the Santa Monica Freeway sometime late in the afternoon. Though he is clearly visible in the image, his features are lost in the late-day shadows. Along the bottom of the image he has scrawled the words "yeh Ive been searchin." In keeping with the spirit of local Conceptual Art, the seemingly heavy sentiment of the scrawled words are lyrics from a popular song—the Coasters' "I've Been Searchin'." Thomas Crow took pains to describe the way Ader uses lyrics of this song in his essay for the *Under the Big Black Sun* exhibition catalogue. "Ader took the song from the top and got as far as the beginning of the second verse," Crow wrote. "As rendered across the first eight prints, the inscribed lines follow the lead voice [i.e., each line is one inscription]:

> *"Yeah I've been searchin'*
> *I've been searchin'*
> *Oh yeah, searchin' every which way*
> *Oh yeah, searchin'*
> *I'm searchin'*
> *Searchin' every which way*
> *But I'm like that Northwest Mountie*
> *You know I'll bring her home someday*

"Then the background chorus comes to the fore over the next two images:

> *"Gonna find her*
> *Gonna find her*

"The lead voice returns for the final eight:

*"Well now if I have to swim a river / you know I will*
*And if I have to climb a mountain / you know I will*
*And if she's hiding up on Blueberry Hill*
*Am I gonna find her child*
*You know I will 'cause I've been searchin'*
*Oh yeah searchin' my goodness*
*Searchin' every which way, but I'm like that / Northwest Mountie*
*You know I'll bring her in someday."*[47]

In each image that corresponds with each line of the song, we see the artist moving about the city as the evening light grows increasingly dim. With each successive image, the figure of Ader is increasingly difficult to make out. In several, taken on one of the city's hilltop vistas, he has all but disappeared from view even as the city around him has become brighter and more visible. In the last image, taken on a local beach as the first light of dawn begins to appear, the artist has reappeared in the dim morning light, a lonely figure out of a Caspar David Friedrich painting walking in the distant middle ground along the water of the Pacific Ocean. At the bottom of the image are the words "you know I'll bring her in someday." " 'One Night in Los Angeles,' " Thomas Crow concludes, "calls upon the motifs and crepuscular cinematography that typified [the film noir] genre, but that modern point of reference does little to deflate the self-seriousness of a medievalizing spiritual quest (as in Chandler's chivalric 'Down these mean streets a man must go who is not himself mean, who is neither tarnished nor afraid.')"[48]

In Ader's "In search of the miraculous" then, we sense that Ader, one of the underappreciated avant-garde artists of Los Angeles—one of Kosaka's "outsiders" and Crow's "medievalizing" questers—has become cornered on all sides by an insurmountable Conceptual dead end. Basically, for Ader, and others like Goldstein and Burden, there were a limited number of ways to explore the removal of the artist as a presence in his or her art (and in the world) before you crossed an

uncrossable line. Two performances in particular, still several years away, would bear this out. One performance in Chicago, by an L.A. artist often noted for his high daring and seemingly limitless capacity for pain and discomfort, would brush right up against his own oblivion before he was finally pulled away from it. The other performance, by Ader himself, would ultimately turn out to be an oblivion in every way imaginable.

NOT EVERY AVANT-GARDE ARTIST IN L.A. IN THOSE years was drawn by the trend toward nihilism and self-abnegation. In 1973 and 1974, a number of Conceptual and Performance artists sought other avenues of inquiry to drive their production. In this, there were two other clear and productive avenues to pursue—namely, the non–self-destructive post-studio practices of John Baldessari and the social and communal focus of Allan Kaprow. Indeed, the two artists' approaches soon became the two main directions—each somewhat in opposition to the other—of L.A.'s most experimental artists.

By 1974, after working together for three years, it must have become clear to both Kaprow and Baldessari that their approach to art-making, and their ideas about what art should be, were somewhat in conflict. Whereas Baldessari's approach was hermetic and cerebral, Kaprow's was rooted in the world and connected to wider community forces. Whereas Baldessari's work was idiosyncratic, inventive, and innovative, Kaprow's work was far more based on convention and consensus than anything else—his Happenings, after all, were by and large meant to be collaborative works, while Baldessari's works celebrated, essentially, the eccentricities of the single creative mind. And while John Baldessari and Allan Kaprow were friends and colleagues, connected by an interest in the latest approaches to art-making—Conceptualism, Performance, Video Art, and so on—the temperaments of the two men were markedly different from each other. In a 1973 television show called *You Call That Art?* that appeared on the Los Angeles TV station KCET,[49] the wily, fast-talking, liberated Eastern artist Kaprow

interviewed the laconic, bull-like artist Baldessari about his latest work and its new directions. The results were a fascinating bit of inside baseball—two obscure artists talking about the obscure art they make—that must have confused much of the local television audience. And while the banter between the two is somewhat polished, as they look at projections of some of Baldessari's earliest video performances there are some tellingly stilted back-and-forths. "You're actually using two other people's material—the songwriter and Sol LeWitt's," Kaprow says in discussing a screening of "Baldessari Sings LeWitt." ("That's true," Baldessari says softly.) "And everybody knows that in most songs that set poetry or statements to music, the meaning of the words is largely lost." To which Baldessari grunts, then stammers a bit before Kaprow prattles onward about humor. "I like the fact that you can't sing," Kaprow finally adds a few moments later, and Baldessari laughs briefly before changing the subject.

That Kaprow was realizing the limits to Baldessari's use of video as a performative medium became clear a year or so later, in an essay—called "Video Art: Old Wine, New Bottle"—he published in *Artforum* in 1974. "The use of television as an art medium," wrote Kaprow, "is generally considered experimental. In the sense that it was rarely thought of that way by artists before the Sixties, it must be granted a certain novelty. But so far, in my opinion, it is only marginally experimental. The hardware is new, to art at least, but the Conceptual framework and esthetic attitudes around most video as an art are quite tame."[50] In Kaprow's view, the problem was that most video art was simply a convenient form of recording of a performative event. "I'm thinking of tapes by (New York–based Performance artist Vito) Acconci, (New York–based Performance artist) Joan Jonas, and (German-born, Los Angeles–based Performance artists) Wolfgang Stoerchle—most of them are just more or less adequate recordings of the performances or are compositions of 'special effects' that could have been done just as well or better as film . . . . Video is simply cheaper and faster." In cases when artists used video for other purposes

in their art—such as in closed-circuit, instant-feedback experiments, or assembling multiple monitors to create environments—Kaprow was still dissatisfied. "Intriguing as these works are, they are also discouraging," he wrote. "The level of critical thought in them, their built-in assumptions about people, . . . and the constant reliance on the glitter of the machines to carry the fantasy strike me as simpleminded and sentimental."[51] Though Kaprow does not mention the work of Baldessari by name, it is clear that his view of the medium and its role in the development of post-object art has taken a sour turn in general. "There is the utopian conviction, the last one with its roots in progressive education, that if people are given a privileged place and some sophisticated toys to play with, they will naturally do something enlightening, when in fact they usually don't," Kaprow says before adding some sharp and crotchety disdain for the already proliferating clichés of video art in conclusion. "We succumb to the glow of the cathode-ray tube while our minds go dead."[52]

Whatever the two artists thought of each other, however, they each had their own independent pool of followers and acolytes who began, after 1974, to spread out across the local art landscape. On one hand, there were the artists drawn to Baldessari's drily ironic and self-aware brand of Conceptual picture-making. Beyond the shocking self-burial of Jack Goldstein, Baldessari's post-studio workshop was often focused on answering pressing questions about the meaning and function of art in the more non-commercial and anti-materialist art market of the time. And Baldessari's approach—of removing excessive trappings of individual style in favor of the individual idea—revealed itself to be an important development. "John's work in the 1970s," wrote Salle, "was almost immediately influential and has remained resonant for several generations. It provided a template for putting things (images, ideas) together using directed energy."[53] The hallmarks of the Baldessari style in art and his influence as a teacher became, over time, very clearly recognizable: stylistic coolness and lack of affect; an ironic outlook that frames images and associations; a malleability or

interchangeability in how parts combine into a whole; and a precise and somewhat simplified visual language. "First, there is the aesthetic, followed by the mechanics (how a piece is put together), which in turn become integrated into the aesthetic but in a slightly different way," Salle continued. "What the aesthetic of John's work accomplished was to give the everyday-Joe artist a way to embrace and lavish a little love on the everyday-Joe visual culture that is around us all the time . . . . Part of John's legacy is the elevation of the generic and unheroic, the vernacular of everywhere and nowhere."[54]

After 1975, many of Baldessari's earliest students—including Salle, James Welling, Jack Goldstein, Barbara Bloom, Matt Mullican, and Tony Brauntuch—eventually emerged as new art stars in a renewed art market. Much of the art that these artists had produced had moved on somewhat from the purist ideals that Baldessari's investigations tended to espouse, ranging into realms of representation and Pop Art that the teacher had somewhat come to reject. Still, as they often were the first to admit, it was always Baldessari that guided what they produced. "Of course," said Jack Goldstein years later, "a lot of our sensibility had its genesis at CalArts in the work and influence of Baldessari, who for a long time had been appropriating images from movies . . . . In that sense John Baldessari was the father of us all."[55]

At the same time that Baldessari's approach was driving the production of dematerialized art in the mid-1970s, Kaprow's idealistic and community-oriented Conceptualism was also bearing important artistic fruit across Los Angeles. Kaprow's ideas about performance and its connection to "art–life practice" would be a strong influence on the developing identities of younger artists like Suzanne Lacy. "Allan's formalism," she said, "was supportive to my own inclinations in that direction . . . . Because he was working so closely with many of us feminists, Allan's work gave us an aesthetic foundation for the move into 'life' that we were looking for. He gave us a historical rationale."[56] From Kaprow, Lacy and other Feminist Art students at CalArts gained an exposure to international trends in Performance and Conceptual

art. At the time, the Feminist Art focus was single-minded, limited somewhat to how women were going to break into the art world, make an impact on it, or change it. The connection to Kaprow gave them an opportunity to focus on something wider. "To investigate the border between art and life," Lacy later wrote, "was a theoretical substratum for Feminist artists wishing to unite art, the condition of women's lives, and social change. If art could be an articulation of real time and images collapsed into a frame of daily life, as Kaprow argued, then political art need not be simply an art of symbolic action, but might include actual action. Although 1970s Feminist artists, including Judy Chicago, drew on a long tradition of art in the service of social change, the challenge was," and here is where Kaprow's influence was truly freeing to artists, "to develop this not only in terms of morality [i.e., art in the service of social "good"] but in terms of current aesthetics."[57]

SUZANNE LACY'S CONNECTION TO BOTH ALLAN Kaprow, from whom she learned to refine her aesthetics, and to Judy Chicago, whom she worked with first at the program at California State University at Fresno, was particularly significant to the development of performance art in L.A. later in the decade. "I thought of them, humorously," said Lacy of her two mentors, "as the passionate mother (Chicago) and the affectionate, distant father (Kaprow)."[58] Even before the splintering of alternative art practices in the mid-1970s, Chicago and her early Feminist Art students had realized, early on, the potential of Performance Art in the service to their art-world cause. "One of the most important discoveries of the year," Chicago said of her experience in Fresno in 1970s, "was that informal performance provided the women with a way of reaching subject matter for art-making . . . . The most powerful work of the first year of the (Feminist Art) program was the performances."[59] In the months following the widely celebrated success of Womanhouse, Judy Chicago continued working with students on innovative non-objective, politically provocative projects, many of which happened to be performative. On June

6, 1972, Chicago and three students (Suzanne Lacy, Sandra Orgel, and Aviva Rahmani) presented, at the studio of the young sculptor Guy Dill, a particularly stirring and deeply angrily political performance that was intended to decry the violence of rape, incest, sexist conditioning, and social oppression—topics that were commonly raised in the Feminist Art Program at CalArts. Called "Ablutions" (1972), the work was a series of duets and solo acts by the various performers. First, a woman methodically, ritualistically wound some gauze around a seated naked woman. Then, another woman nailed raw beef kidneys in a line across several gallery walls. Two naked women bathed themselves in steel tubs that contained hundreds of eggs, blood, and clay—the shells of eggs littering the floor—while a tape played the testimony of women who had been raped. "I felt so hopeless all I could do was lie there and cry,"[60] the tape intoned, while two more clothed women took ropes and wrapped them, in web-like patterns, around the various performers, around the steel tubs, and to the nails holding the kidneys to the walls.

"Ablutions," in many ways, was a clarion call meant to demonstrate several important things. With its depth of political anger, as well as the sheer amount of its spectacle, "Ablutions" proved that the local Feminist Art Movement would continue to play a vital role in the art world and in the society at large. The work also pushed the scope of local Feminist Art dialogue—at once sharply depicting the female experience, even as it involved others in the discomfort and sense of shame and entanglement of the performers. "In 'Ablutions' the women are united by their joined protests against their victimization," wrote the critic Meiling Cheng in a typical response to this work. "The raw beef kidneys, the blood-drenched female body, and the cocooned figure all condemn patriarchal society's abusive sexism—the vicious violence of rape . . . . [Still,] 'Ablutions' demands social justice as an appropriate response to its performance."[61] And finally, as Kaprow likely would have approved, the performance was a call to action to change the culture of rape and violence that affected the lives of so many women.

In the year that followed the "Womanhouse" project and the presentation of "Ablutions," the Feminist Art Program at CalArts continued to grow and develop. The MFA students in CalArts' program were exposed to the full spectrum of recent avant-garde activities in art and encouraged to explore any and all contemporary currents in Conceptual, experimental, Performance, and mixed-media art. A local "openness and lack of professional constraints," which was in opposition with New York where Performance Art was constrained by the dominant examples of the Happening and the dance scene, gave these young artists' efforts some much-needed juice. A New York–based critic, visiting California for a Feminist Art conference around this time, noted that East Coast Feminist Art was showing its age, especially in comparison to the "funky displays" of West Coast artists.[62] In time, L.A.'s experimental aspirations helped foster the nascent artistic careers of a number of early graduates of CalArts' Feminist Arts Program, including: Nancy Buchanan, Karen LeCoq, Mira Shor, Beth Bachenheimer, Robin Mitchell, Judy Huddleston, Nancy Youdelman, Paula Longendyke, Susan Mogul, and Faith Wilding, among others.

One particularly influential concept that emerged out of the Feminist Art Movement in L.A. in the very early 1970s was the idea of a space fully owned, run, and operated by women artists, where almost any sort of artistic idea, concept, or performance was acceptable and encouraged. Almost immediately after "Womanhouse" closed in the late winter of 1971, calls were made across Los Angeles to establish a more permanent so-called "room of one's own." The mainstream art world, after all, was still keeping its doors shut to the young women artists of the time. Complicating matters, however, was the fact that, by the fall of 1972, Judy Chicago and Miriam Schapiro were growing increasingly at odds with each other. Much of the rift, in retrospect, seems to be professional jealousy, as well as a semi-generational gap (Schapiro was more than a decade older than Chicago and seemed acutely aware of the fact). Partially because of her soured relations with Schapiro, Chicago resigned from CalArts after the spring term in

1974, and in the summer of 1974 she founded, in collaboration with Sheila Levrant de Bretteville and a young art historian named Arlene Raven, the Feminist Studio Workshop (FSW). This enterprise, which would reject what they considered to be the confinement of the primarily male institution where they had all met (CalArts), was designed to be even more politically active than the Feminist Art Program.

Opened in September of 1973 in the living room of de Bretteville's house, the Feminist Studio Workshop was an independent school for women artists that would teach art-making skills and help them develop their own identity and sensibility as women. The central idea of the school was akin to the idea of Conceptual and Performance artists like Kaprow, Sol LeWitt, and Baldessari: That art should not be separated from other activities, and that members of the workshop should combine their consciousness-raising activities, their activism, and their art-making. All that remained was to find a site for the workshop—a space that would be part school, part gathering space, and part gallery. And in November of 1973, the group found it in an unlikely place, right under their noses—at the site of the old Chouinard Art Institute near MacArthur Park.

The Feminist Studio Workshop called its new space the Woman's Building, after a building created for the 1893 Chicago World's Fair.[63] In addition to running workshops, the group intended to sublet spaces in the building to other affinity groups: feminist theater companies[64]; a feminist bookstore and press; performance groups; a coffee shop; a local chapter of the National Organization for Women; and three art galleries. Before the building could be fully opened to the public, however, the women of the Feminist Studio Workshop needed to lead a massive renovation effort. For this, Chicago and others called in many favors to mobilize an army of hundreds of women and men to build walls, scrape and paint ceilings, sand floors and fixtures, paint signage, and generally make the spaces ready to accommodate the influx of young women. Ironically, the Woman's Building would lose its lease on the old Chouinard Building just a year later. But again, with the help

of the community, the workshop would regroup and quickly reconfig-
ure itself in a new building on North Spring Street near Chinatown,
ensuring it remained an active and an important part of the ongoing
development of experimental art in Los Angeles. That effort, which
was even more intensive, not only redeployed its army of volunteer
painters, builders, and movers, but also involved a fundraising concert
called "Building Women" that featured Lily Tomlin, Meg Christian,
Holly Near, Margi Adam, Cris Williamson, and the New Miss Alice
Stone Ladies' Society Orchestra.

Finally, in December 1975 the Woman's Building (and Feminist
Studio Workshop) opened its vast new warehouse space. In time, the
entire three floors (and 18,000 square feet) of the space were filled with
artistic activities, including a full-scale gallery program (with seven
separate gallery spaces), an annual Women's Writers Series of lec-
tures, the Women's Graphic Center, the L.A. Women's Video Center,
the Center for Art Historical Research, spaces for the screening of
films and videos, a lecture hall, halls for music and dance recitals and
fundraising events, and two profit-making enterprises to strengthen
its financial base—artist studio spaces that were for rent and a full-
service design studio. It's not surprising, considering the diverse activi-
ties at the Woman's Building, that it nurtured a wide array of high-
energy collaborative projects, art-making groups, and artistic activity.
Performance art groups such as Mother Art, Feminist Art Workers,
The Waitresses, and Sisters Of Survival emerged from the space, as did
Ariadne: A Social Art Network and the Lesbian Art Project and many
other emerging artists, exhibitions, projects, and artist groups. The
Woman's Building even published, starting in 1978, its own monthly
newsletter, called *Spinning Off*, that included a wide array of news
about cultural, political, and social events.

Not surprisingly, as a result of all of this activity the careers of sev-
eral important women Performance artists began to blossom. Suzanne
Lacy in particular emerged with a series of increasingly provocative
political works on issues related to the rights and condition of women.

The culmination of this may have been her seminal "Three Weeks in May" (1977). Using a wall map of the L.A. region, Lacy marked all reported rape cases that occurred in the area over three weeks in the titular month of May. Another work that Lacy became well known for in 1977 was "In Mourning and Rage." Created in collaboration with Leslie Labowitz-Starus, the work was intended to protest the lack of adequate response to the victims of the Hillside Strangler of that year. Framed as a political rally, it began at the Woman's Building, proceeded to the steps of City Hall, and, by making a series of demands from the city, drew attention to the issue of local violence against women.

The Feminist artists' strategy of separatism, in the safe confines of the Woman's Building, had a marked effect on the development of radicalized, female-centered art in Los Angeles in the 1970s. Basically, it allowed local women artists to make and exhibit work about their bodies, sexuality, and lives that was thought to be inappropriate for mainstream galleries and museums of the time. As a result, throughout the second half of the 1970s, the Woman's Building hosted a number of mesmerizing and powerful performances and experimental acts by women artists, including Nancy Buchanan, Barbara Smith, Martha Rosler, Rachel Rosenthal, and the members of performance groups like the Feminist Art Workers and Mother Art. As the decade wore on, the Woman's Building continued to be a catalyst for an explosive array of more generalized but increasingly radical political Performance Art events, projects, and interventions by artists across the region. Among the new practitioners of Performance Art in the 1970s who added to and were influenced by the local brand of politically and socially savvy Conceptual and Performance art were young artists and artist groups such as: the Kipper Kids, David Lamelas, the L.A. Free Music Society, Bob & Bob, Joan Jonas, and Lowell Darling.

By mid-decade, the sheer diversity and range of performance art activities in Los Angeles was stunning to behold. Throughout the 1970s, CalArts student Matt Mullican continued his investigations into

performance by making a series involving a stick figure named Glen(n), whom the artist set about trying to prove was "real." That Mullican pushed local investigations of being and non-being (in relation to art) to an extreme is evident in his performative visit to a cadaver at the Yale University School of Medicine to ponder what being dead does to a non–drawing-based person. In 1973, John M. White presented his "Watts Performances and Installations" at the Watts Community Housing Corporation. Filling a small gallery with a tangle of materials that resembled the aftermath of a riot, White gave his politically incendiary and angry, but also personally resonant, performance to small audiences in the space. Also in 1973, Jeffrey Vallance's very first performance, a political tour de force called "L.A. City Hall Frisbee Throwing Spectacular," was a sillier version of Suzanne Lacy's and Leslie Labowitz-Starus's "In Mourning and Rage" from several years later. In 1974, Claudia Chapline opened the Institute for Dance and Experimental Art in Santa Monica. The institute became known for its blend of multimedia art that meshed dance, Performance Art, fiber sculpture, Assemblage, Installation, and healing. All of this activity of course added to the ongoing mesmerizing and powerful performances by women—Nancy Buchanan, Paulia, Oliverso, Barbara Smith, and so on—at the new Women's Space in the Woman's Building and around the region. In time, the performances by L.A. artists had grown so extensive and wide-ranging that it seemed they would eventually push the culture toward important political and social changes for the benefit of all.

## Part 3: The End of Miracles

While the socially conscious, political-minded Performance Art of Los Angeles would continue to develop through the 1970s, the original, self-abnegating impulse of early Performance Art in the city would quickly run its course and, because of two shocking Performance-oriented works, eventually come to an abrupt dead end. As the 1970s progressed, two of the chief investigators of this impulse in L.A.

art—Chris Burden and Bas Jan Ader—developed their art practice in eerily similar ways and, in 1975, almost came to the same tragic result. It makes sense that the artists were so similar. Both Ader and Burden were, thanks to early formative traumas, outsiders in their surroundings. Whereas Ader coped every day with the burden of losing a heroic father to Nazi firing squads, Burden was somewhat haunted by the physical ordeal he endured as a boy when he nearly lost his foot. To some degree, both Ader and Burden were driven throughout their artistic careers—either consciously or subconsciously—by the need to investigate their traumas, to reenact them somewhat as a way of understanding them or perhaps purging them from their creative minds. Also, not surprisingly, their work often mirrored the same concerns.

Most remarkably, for instance, Ader was supposedly contemplating in 1971, after making his "Fall" films, a performance that would have likely made a huge splash at the time. "He came up with the sensational concept to shoot himself in the leg with a hand gun," said Rene Daalder, a Dutch filmmaker who came to America about the same time as Ader and later made a documentary film about him. "But at the last minute, the project was preempted by a student from Irvine College [sic; Daalder is referring here to Burden, who had been a student at UC Irvine] who famously had himself shot in the arm."[65] A good deal of Ader's work was influenced by Christian iconography, particularly that depicting the suffering of Christ. This was, of course, the same source for Burden's seminal 1974 performance "Trans-fixed," in which he had himself literally crucified on the back of a VW Bug. In return, at least one Burden work predicted the performance that Bas Jan Ader would ultimately become best known for. In 1973, Burden posted a note in the L.A. gallery Newspace, which had scheduled an exhibition of his work, saying that he planned to walk from San Felipe in Baja California southward for two weeks—the duration of the gallery "exhibition." In actuality, Burden, carrying only water with him, left San Felipe in a small kayak and paddled south to a remote beach

where he stayed, in the scorching sun, for eleven days, before declaring the performance's end and paddling back to town.

"It was really more about isolation than anything else," said Burden years later, echoing sentiments that were at the core of Ader's art. "It was about being gone."[66] In fact, both artists' quests to be "gone" would drive them to the extreme limit of what not only art could be, but what a human being could endure in service to their art. Chris Burden's "Doomed" would, in many ways, be a capstone moment in his ongoing push to erase the artist from the art. It would also be the last Performance Art work in which he would put himself in any sort of self-peril or danger. Performed in April of 1975 at the invitation of the Museum of Contemporary Art in Chicago, which had organized a large survey of Conceptual Art work of the time, "Doomed" was an endurance test that went far beyond his others in several important ways. Burden well knew that the violence and sensationalism of his art was what had made him almost instantly famous as a young artist in 1971. "Even I talk about them [the more sensational of his performances] more," he told the reporter in Chicago, "because they're . . . well, easier to explain."[67] In reality, however, by the mid-1970s Burden had become less interested in sensationalism and more interested in making art that explored deeper issues.

To perform "Doomed," Burden entered the gallery at the Museum of Contemporary Art at about twenty minutes after 8 p.m. on April 11 amid a slight carnival atmosphere. Avoiding looking at the audience of more than four hundred viewers, he set an industrial-style clock that had been affixed to the wall to the hour of midnight, and he lay down beneath a large sheet of glass that had been propped up against the gallery wall. On the floor, he moved his hands to his sides and fixed his gaze at the ceiling. (He could not see the clock.) After a pregnant silence of about ten minutes, during which Burden did not do much beyond blinking his eyes, the crowd broke into applause and whistles. Burden still did not move, and for the next two hours whenever audience members approached where Burden lay, museum attendants

kept them away. Later that night, when the crowd had dwindled and Burden had still not moved, the atmosphere in the gallery changed. "It's a really strange sense here right now," the museum's publicist, Alene Valkanas, told the newspaper reporter. "There are about forty people left, and they're all very quiet. Burden doesn't move. It was more like a circus before; but now it's more like a shrine . . . very mysterious and beautiful."[68] The reporter filed a story on Burden's performance, but couldn't take his mind off Burden's odd behavior, wondering what exactly he planned to do, worrying about the chance that someone would become frustrated, break the glass, and put the artist at risk of physical harm. At 1:15 a.m., when the reporter called the publicist to check in, Burden was still under the glass. The reporter drove back to the gallery, and still Burden had not moved, even though only a few museum guards and a TV reporter were the only audience left. "He doesn't move except for what look like isometric flexings," Valkanas said. "He flexes his fingers sometimes, and once in a while you can see his toes flexing."[69] The reporter left just after 2 a.m. When he called the museum the next day, Burden still had not moved.

The next time the reporter checked in was Sunday, at about 2:30 p.m., and still Burden had not moved. The performance had now lasted more than forty-two hours, and museum officials were consulting doctors about the health risks that Burden was facing. "A urologist said no one could go more than perhaps forty-eight hours without urinating and not risk uremic poisoning," the reporter wrote, noting that Burden had not had anything to drink for nearly two days and so was also risking dehydration. The performance finally ended about 6 p.m. The museum had decided around that time to place a pitcher of water next to his head and see if he would drink from it. "We felt a moral obligation not to interfere with Burden's intentions," Alene Valkanas said, "but we felt we couldn't stand by and allow him to do serious physical harm to himself. There was a possibility he was in such a deep trance that he didn't have control over his will."[70] The moment the gallery guard put the pitcher down, Burden got up from the floor, walked into

the next room, returned with a hammer and an envelope, and smashed the clock, stopping it at the forty-five-hour mark. Only upon opening the envelope did anyone understand the mechanism that drove the performance. On a sheet of paper, Burden had written the three main elements of the work: The clock, the glass, and himself. The performance would continue, he wrote, until someone on the museum's staff acted on one of the three elements. (By offering him water, they had inadvertently done so, thus ending it.) Burden said that he had been prepared to stay in his position indefinitely. "The responsibility for ending the piece rested with the museum staff," he said, "but they were always unaware of this crucial aspect." ("My God . . . ," responded Valkanas. "And we thought the rules of the piece required us to do nothing.")[71]

"I thought perhaps the piece would last several hours," Burden continued. "I thought maybe they'd come up and say, okay, Chris, it's 2 a.m. and everybody's gone home and the guards are on overtime and we have to close up. That would have ended the piece . . . . On the first night, when I realized they weren't going to stop the piece, I was pleased and impressed that they had placed the integrity of the piece ahead of the institutional requirements of the museum. On the second night, I thought, my God, don't they care anything at all about me? Are they going to leave me here to die?"[72] As the culmination of Burden's efforts to remove the artist and his own will from the work—relying instead wholly upon the actions of the museum—"Doomed" marked a point of no return in Burden's career as a Performance artist. According to the art critic Peter Schjeldahl, the artist never again undertook a public action that imperiled himself. "It wouldn't have made sense," Schjeldahl wrote. " 'Doomed' unmasked the absurdity of the conventions by which, through assuming the role of viewers, we are both blocked and immunized from ethical responsibility."[73]

Even if Burden had not had a change of heart about his approach to art after his harrowing experiences in the gallery of the Chicago Museum of Contemporary Art in April of 1975, events later on that summer might have convinced him. To follow up his photographic

exploration of Los Angeles from around the time of Burden's frighten-
ing performance in Chicago, "In search of the Miraculous (One Night
in Los Angeles)," Bas Jan Ader had conceived of a daring second act of
what was to be a three-part work that would mark an important moment
in his artistic career.[74] What happened during part two of Ader's mag-
num opus, however, all but ended the ongoing question of how far one
should strive to go in removing the artist from the equation. It also set
the tone for an entire new generation of young L.A. artists, who emerged
after 1975 and were bent on grappling with the nature of the times.

ON JULY 9, 1975, BAS JAN ADER WOULD CLIMB INTO A
small (twelve and a half feet), used Guppy 13 sailboat—called *Ocean
Wave*—intending to travel alone from Chatham, Cape Cod, across
the Atlantic Ocean to the south coast of Britain or north coast of his
native Holland. In the lead-up to this daring Conceptual work, Ader's
friends and loved ones had noted two distinct facts about the artist.
On the one hand, he seemed intently focused on the preparations for
his solo trip. After buying the boat in early June, Ader had taken it
to a professional shipyard to be modified. Though the Guppy 13 was
built to be something of a high-performance vessel, Ader had the rig-
ging strengthened, the washboards reinforced with extra fiberglass,
and so on. He carefully outfitted the boat with lightweight provisions
that would be less prone to get wet or spoil over the several-month
voyage. At the same time, however, some of his friends noted that
Ader seemed upset, or under some strain. One of his students, Jane
Reynolds, spoke with him by phone during his trip preparations, not-
ing that he "sounded sad, as if he were saying goodbye forever."[75] She
thought this mostly had to do with his distress over a languishing art
career. Another friend, the gallerist and dealer Claire Copley, thought
Ader was suffering more from the strain of carrying on an affair, since
1973, with a mistress with whom he spent half of every week. It was
a situation that his close friends like Copley and the fellow Dutch-
born artist Ger van Elk observed was too much for Ader to handle,

as he struggled to make a choice, "loving both equally, not wanting to hurt either."[76] Another possible source for this dismay, which had really been lifelong, was over the lingering despair for his lost father. In fact, the concept and scope of Ader's performance in "In search of the miraculous" may have been in tribute to his family, or conceived as a memorializing of some sort. After all, in family lore, the elder Ader had made a similar sort of trip when he was at the same age—thirty-three—as Ader was in 1975. Pressed by wanderlust, Ader's father had ridden a bicycle from Holland to Palestine, suffering setbacks, injuries, and even several near-death experiences before reaching his goal.

Still, one woman who was as close to him as anyone, his wife Mary Sue Anderson Ader, was fully confident that her husband knew what he was doing. "I don't think that he expected not to make it," said Mary Sue. "He didn't leave any long letter about what I was supposed to do. I never had a doubt in my mind that he wouldn't make it."[77] Mary Sue was Ader's collaborator on "In search of the miraculous," as well as on many of the artist's other works. Ironically, when Mary Sue Anderson had first met Ader ten years earlier at the Otis Art Institute in Pasadena, he was a twenty-three-year-old émigré from Holland who had just arrived in Los Angeles on a sailboat crew. "He was a little rough around the edges," Anderson said. "He had a rope belt and a full beard. He looked really Romantic and very adventurous."[78]

In mid-June of 1975, the couple departed California in their Mercedes, with the boat hitched behind. After a stop in Syracuse to visit some of Mary Sue's family, they continued on to Massachusetts, where Ader quickly got ready to sail. "There is some color film shot by Mary Sue Ader of her husband at work," wrote a biographer. "[The] mast is yet to be set, still separate from the yacht after the cross-country drive. The cockpit is strewn with materials. Ader is seen making adjustments to his self-steering device."[79] Among the items he strategically arranged around the boat's cabin were two months' worth of food, three months' worth of water, a Primus stove for cooking, a small battery-powered radio receiver,[80] an old-fashioned sextant, and a transponder that

would, in an emergency, alert any airplanes flying overhead of his position. In one photo taken as his boat is towed out of the harbor in Chatham on Cape Cod, Ader is shown sitting on the gunwales of his small yellow boat, working to unfurl the jib; the rough stenciled letters "OCEAN WAVE" are visible on the side of the boat. He is dressed all in blue, as was his habit in those days, a half-inflated life preserver around his neck and black Wayfarers protecting his eyes. His hair is a tangle of youthful brown-blond under the summer sun, and he appears contentedly focused on his task.

At 2 p.m. on July 9, Ader released the towline, and he turned the *Ocean Wave* to the open sea. Mary Sue, who planned to rendezvous with her husband by traveling to Holland in August, had noted the time in her diary. She remained convinced, like most of his friends and loved ones, that Ader had every intention of carrying through on the journey. "Bastian thought of that sail," said Mary Sue, "as a statement, and as an artwork, but it was also very definitely an adventure and pitting himself against time and against nature. And seeing if he could be the winner, so to speak."[81] However, in the aftermath of his departure, many people began to ask questions about his intentions. A few people in the art world suggested that Ader had run away to start yet another life. Another rumor that circulated, later confirmed by Ader's wife, was that he had told his friend and colleague James Turrell that he thought it would be interesting if he disappeared for three years before returning.[82] A few months after Bas Jan had failed to return to teach his classes at UC Irvine, someone opened his locker at the school and found an odd book stashed there that he must have been reading in the lead-up to "In search of the miraculous." Called *The Strange Last Voyage of Donald Crowhurst*, it told the true story of a sailor who, in his desperation to win an around-the-world sailing race, had forged his logbooks before he descended deep into psychological instability before throwing himself overboard to drown. In his recovered onboard diary, Crowhurst revealed that, during his fraudulent trip, he had rejected Einstein's Theory of Relativity and created his

own theory of the universe.[83] This was an unusual book for Ader to be reading before setting off on his own perilous ocean voyage, and the information added further grist to the rumor mill.

The first sign of trouble came when Bas Jan Ader did not arrive in Holland by the end of August. While Mary Sue contented herself with the knowledge that there was still time for the artist to appear, it was the latest date his wife could stay overseas before jeopardizing her job and she reluctantly returned home. During the fall, there was still no word from the artist, and Mary Sue grew worried. Because he had carried a signaling device with him, Mary Sue, along with Ader's brother Erik, contacted a number of national embassies and asked them to alert their passenger airplanes to watch for any kind of signal. Mary Sue returned to Holland for the Christmas season in 1975, her hope dwindling. And after the holidays, she returned to California feeling distressed. "An old sailor told us that he might possibly survive beyond the three months," she said, "that would've been November [1975] or something like that. But that didn't happen, unfortunately."[84]

In June of 1976, almost a year after Ader had set sail, Mary Sue Anderson Ader was informed that the *Ocean Wave* had been found in April, capsized off the coast of Ireland, by a Spanish troller in an area that was known by fishing boats. When Anderson was unable to pick up the boat after several months, the fishing captain claimed it as salvage and put it in a shed. By the time Anderson was able to get to Spain, the boat had been stolen off the captain's land. "That was of course unnerving," Anderson said. Frantically, she tried to collect as much information about the state of the boat from anyone else who had seen it, but details were sketchy. Because there was damage to the washboards attached to Ader's lifeline, Spanish naval authorities told Mary Sue and Erik Ader that an "explosion" had occurred on board. When Erik asked if there were any visible scorch marks, naval authorities said no, leading him to believe that his brother had been knocked overboard, perhaps violently, thus ripping the boards from their casing.[85] An Interpol investigation, meanwhile, also turned up nothing.

Her husband, it seemed, had just vanished. "A lot of people, since he was lost at sea, have talked with me about the possibility of his having disappeared," said Anderson years later. "In my mind that's not possible . . . . [But] there's never been a year without somebody saying something like that. When I first heard that was what people thought, I was so angry and heartbroken, but then I began to realize that it was part of the mystery and part of the romance of the work and that it should be left that way."[86]

Modern interpretations of Ader's performance seem to agree with Mary Sue Ader. "It is possible to read Ader's death as an inextricable part of 'In search of the miraculous,' " wrote the biographer Alexander Dumbadze, "as a condition of the work, not, it would seem, by choice but by fate: a chance occurrence that forever altered the interpretive possibilities of the piece and the reception of Ader's practice. A tragic end such as his is unprecedented in the history of contemporary art . . . . Ader's life, his intentions, shifted the journey from just a sail (a part of life) to something symbolic (a part of art)."[87] In this aspect of "In search of the miraculous"—in the artist crossing a line between using death, and its possibility, as a subject in art and actually dying in the course of making art—Ader made the ultimate statement about death and erasure in an era and place, 1970s Los Angeles, that had been increasingly fixated on such subjects. In his dying, then, the Christlike Ader freed the local art world from its zero-sum, dead-end investigation of a dark and ultimately disturbing subject. Because of this, after 1976 or so the avant-garde artists of L.A. moved on. It was Ader who, with his death, redeemed Performance Art so that it could carry on with its investigations of politics, society, personal identity, and other subjects into the next decade.

Still, the repercussions of Ader's death went far beyond the limited concerns of the avant-garde art world of the 1970s. After Mary Sue Anderson Ader went to court and had her husband declared dead—lost at sea—in 1979, she never completely came to terms with her husband's disappearance. From a documentary film made a few years ago

we can see that several rooms in her house in Southern California are filled with Ader's artistic trappings, left nearly untouched—dusty and riddled with rodents—since the time of his disappearance. She herself also seems lost at sea, nervous and joking somewhat about how people suggest she may be depressed. "To me, it was a really beautiful piece," Mary Sue says of the one work of art that has defined much of the last forty years of her life. "His idea was pitting himself against nature and natural forces, and spiritual forces, and this was very spiritual on one level."[88] Her voice, tired and uncertain, falls off at this moment, and Mary Sue stares off into a middle distance, transported many miles away by a distant reverie.

# "Devil With a Hammer and Hell With a Torch"

*How L.A.'s Street Culture Inspired a New "Lowbrow" Art Movement*

S INCE THE 1950S, LOS ANGELES HAS LARGELY been defined by one particular object: The car. In the early 1950s, during the widespread movement of (mostly white) affluent urban Americans to the sprawling suburbs of Greater Southern California, the car culture of L.A. mushroomed. By the 1970s Angelenos had, mostly willingly, given their lives over to a refined local car culture—parking lots, billboards, strip malls, service stations, car dealerships, drive-thru food joints, car washes, instant oil change shops, roads, and freeways.

The influence of the car on California (and of California on the development of car culture) had early origins, back nearly to the dawn of the automobile age. As Americans in general, and Californians in particular, gained mobility and affluence in the 1920s, households began purchasing additional cars. Alfred P. Sloan, then head of the General Motors Corporation, took note of this trend and realized an opportunity to upsell to customers hungry for more appealing automobiles—with personalized colors and other enticing design elements. In the 1920s, Sloan lured to Detroit a Los Angeles–based industrial designer named Harley Earl who had been constructing, out of his

family's old carriage factory, elaborately customized and expensively adorned cars for Hollywood elites like Tom Mix and Fatty Arbuckle. Sloan brought a very Southern Californian sensibility with him to Detroit. This was at the dawning of the Hollywood dream factory, and L.A. in those days, wrote author and artist C.R. Stecyk, "was populated by those who daily witnessed fantasy as reality. Movie crews were constantly working in the streets, where they could be readily observed making the present the historical past of imagined future. The locals enthusiastically sought out eccentric behavior and bizarre product as a matter of course."[1] Sloan's designs for General Motors focused on providing car owners a sense of the early glitz and glamour of Hollywood, and he made popular many design features that lasted through the middle of the century: chrome detailing, two-tone paint schemes, wraparound windshields, the hardtop, tail fins. With Sloan in its employ, General Motors thrived and its cars became a symbol of America's twentieth-century values: Freedom, progress, power, wealth, and excess.

Because of the particular layout of the Los Angeles metropolitan era—in which a succession of small communities built on a Midwestern main-street model were connected by a growing network of roads and highways, and because of explosive population growth across the region in the years leading up to and during the Great Depression, the automobile became the region's only viable form of transportation. At the same time, Southern California's relative affluence meant cars were attainable to a wide swath of the population. It's telling that, during a decade that the population of L.A. more than doubled—from just under 600,000 in 1920 to more than 1.2 million in 1930—the city's number of cars would see an even greater increase—from 161,846 cars registered in Los Angeles County in 1920 to 806,264 cars registered in 1930.[2] Because of this rapid increase in car ownership, and the sudden freedom the car provided, the culture around the car quickly took on a particular local flavor. In the early 1930s, for example, young male car owners began joining car clubs to learn and share their skills in

upgrading, redesigning, and driving their own custom cars as fast as they possibly could. Some of the car club's names were revealing of local attitudes: the Tornadoes of Santa Ana, the 90 M.P.H. Club of Los Angeles, the Road Runners of Huntington Beach, the Sidewinders of Glendale, the Throttlers of Hollywood, and so on. These kids did everything they could think of to provide as much speed as possible to their their cars—including stripping them of all superfluous metal to make them lighter, adding bodywork touches, and "hopping up" their engines. Southern California provided these "hop up" enthusiasts[3] several natural advantages for their hobby. The mild California weather allowed them to race their cars year round, and the geography gave them plenty of isolated and relatively safe places to race close by, including the dry lake beds in the Antelope Valley of the Mojave Desert—especially Muroc Dry Lake, Harper Dry Lake, and El Mirage Dry Lake.

Car culture in Southern California, of course, went well beyond mere racing. In L.A., cars were conveyances for getting to work and traversing the city's growing system of freeways and streets, a daily task that grew more complicated and involved as the twentieth century progressed. In the years after World War II, Los Angeles went through another period of explosive growth as ex-GIs from around the country who had been stationed in or around the region returned in droves after the war. They bought up housing, got good jobs in a booming local economy, and generally sought the trappings of the good life, American style. And, to a large degree, this included cars. Lots of cars. In 1940, the same year that L.A. opened its first urban expressway—the Arroyo Seco Parkway between downtown and Pasadena—the number of registered vehicles in the entire state was a stunning 2.8 million,[4] or almost 10 percent of the roughly 30 million[5] cars registered in the United States at the time (the state's population, meanwhile, was about 7 million, or just over 5 percent of the nation's population of 132 million). In the midst of this car explosion after the war, the old "hop up" culture rapidly developed from a do-it-yourself,

back-street (or remote dry lake) activity into a complex and lucrative local industry. By the early 1950s, the newly dubbed "hot rod" industry of Los Angeles includes scores of tuning and engine building shops, body shops, upholsterers, paint shops, pin stripers, and other businesses.

Out of this new hot rod industry, an entire culture and mythology developed. The Kustom Kulture—as the culture of hot rods came to be known—was about charisma and fun, about attracting girls, about style and sex and speed. Cars, for Southern California teenagers of the era, were a main extension of one's self-image. They were an expression of one's sexual identity and social status, an outlet for creative expression, and a compelling object of desire. The Hollywood image factory was all too willing to promote this culture and these values in an extended series of lurid B movies geared toward young boys and girls in California and around the country: *Hot Rod Girl* (1956), *Teenage Thunder* (1957), *Hot Car Girl* (1958), *Young and Wild* (1958), *Hot Rod Gang* (1958), and *Hot Rod Hullabaloo* (1966). By the later 1950s and 1960s, any young (male) Angeleno who didn't have suitably customized car might just as well not exist.

THE ARTISTS OF LOS ANGELES WERE FAR FROM IMMUNE to the lure of Kustom Kulture. "The car was the key," said Ferus artist Robert Irwin of his youth growing up in L.A., "the pivotal item in the whole ballgame. Everything was wrapped around the car. The car was your home away from home. And you put months and months into getting it just right. Everything was thought out in terms of who you were, how you saw yourself, what your identity was."[6] Irwin and many of his fellow Ferus artists were in fact enthusiastic embracers of California's car culture. In high school, Irwin had worked on cars and was deeply immersed, as was just about every teenager at the time, in keeping up his custom cars, cruising down the local boulevards, hanging out at drive-in theaters and car hops, driving girls to dances. "The first car I wanted was a '32 roadster," said Irwin. When his father

wouldn't loan him the $100 down payment, Irwin said, it was "the biggest disappointment of my life up till that point. It may be till this day the biggest disappointment. I don't think I've ever had a bigger one."[7] Later, when he was a few years older, Irwin was able to purchase a '39 Ford, which he sweated over endlessly. "I finally got that car finished," he said. "I had twenty coats of ruby-red maroon on the dash, and I had this great finish outside. The car was absolutely hunky-dory. Twenty coats of ruby-red, let me tell you, to paint the dash: that means taking everything out, all the instruments and everything, painting it, building up these coats very slowly, spraying the lacquer. It was just a very exaggerated thing . . . but I finally got it into that condition. I had a very good gig going, 'cause the car was in very cherry shape, which of course was very important to the whole scene."[8]

The cultural status of the automobile loomed so large in mid-century L.A. that it seems, in retrospect, something of a no-brainer that the car would inspire its emerging generation of artists. According to the critic Edward Allington, a number of artists who, like Irwin, grew up in California credited their "experiences with customizing cars or motorcycles as being more important than any formal art training they later received."[9] The Angeleno birthright of speed, freedom, and wide-open vistas—all fostered by the local influence of the car—revealed itself in the city's first home-grown art movement. The artists of the Cool School of the 1960s internalized the automobile's muscularity of form and were dazzled by the polished and sparkling finish of custom automobile paint jobs and the way that cars caught and reflected the local surfeit of light. The artists of this generation were widely noted for using, in much of their art, smooth and carefully modulated materials that removed all traces of the artist's hand from the work. The surfaces in these "L.A. Look" artists' paintings and sculptures, wrote Craig Adcock, were "intended to be locations for light over and above the other physical aspects of the object, and the care they lavished on finish was really about the interaction of light and material. In and of

itself, the craftsmanship focused on perception: it emphasized the infinitely thin moment when light reflects off surfaces and returns to the visual apparatus of the viewer."[10]

"What the involvement with cars, motorcycles, and planes gave to these artists," suggested art critic Edward Allington, "was the desire, the will, and the discipline of going that extra distance to seek perfection. There was a kind of Pacific Rim Zen in these activities—changed from its Japanese origins, modified in the bright post-war California sun. The quiet contemplation of lacquer during the tea ceremony converted into a meticulous concern for paint surfaces and car parts, into a contemplation of the infinite qualities of light as a metaphysic peculiar to the West coast."[11] Much of the developing local aesthetic goes back to Robert Irwin. In the mid-1960s, Irwin had asked an independent fabricator named Jack Brogan, who had done work for the local automotive and aeronautic industries, to help him develop a concept he had for a particular type of abstract painting. The resulting works were highly polished, convex discs that Irwin sprayed, with Brogan's help, with a smooth, luminous coat of paint—not unlike the "cherry" finish on a gleaming hot rod—and mounted on an arm that made the art seem to hover under strategically placed incandescent lights about twenty inches away from the wall. These works were, especially to his artistic peers, a revelation—a purely L.A.-based response to the creeping Minimalism that was current back East at the time—and many set out to achieve similar effects. After 1965, Brogan's skills were so in demand by local artists that he started a formal business as an "art fabricator." "Brogan's diverse technical experience," wrote art critic Peter Frank many years later, "allowed him to think across the boundaries of material and process, to grasp the properties of new substances and methods, and to address challenges with a wide technical repertory [as a] . . . problem solver impelled by curiosity . . . . Jack's spirit was one of the intangible things that drove L.A.'s aesthetic in the 1960s and '70s—and his handiwork was one of the tangibles. He was and remains equal to the exploratory drive of his friends."[12]

Under the spell of the car, and with the technical assistance of Brogan, artists like Larry Bell, Craig Kauffman, Peter Alexander, De Wain Valentine, Helen Pashgian, and John McCracken employed, in the late 1960s and early 1970s, materials such as plastic, polyester resin, acrylic, fiberglass, stainless steel, and coated glass to make their work. As a mass, these works effectively established a clear local aesthetic that often featured, above all else, smooth, precise, and delicately polished surface finish. The look of this art was one of elegant simplicity and preciousness that at once seemed to rival old-world art materials like bronze and marble, and also to mock them. In time, this aesthetic dominated much of the art of the later 1960s—as was remarked upon at the time. "Although the west-coast concern for plastic and high-finish was probably related to the general 'plastic' quality of Los Angeles," suggested Elizabeth Baker in 1971, "to such things as the hot-rod aesthetic and ambient glitz of Hollywood lifestyle, it also had philosophical implications that went beyond what can be explained in terms of the ubiquity of synthetic materials. There was plenty of plastic and glitz in other parts of the country, and the simple availability of exotic polymers in a town geared toward high-tech industries is an inadequate explanation for why the finish-fetish aesthetic developed in Los Angeles and not somewhere else."[13]

So alluring was this new "L.A. Look" that even the great maverick James Turrell was affected, citing his experience building boats and restoring classic automobiles and airplanes as "central to his development as an artist"—although he was always quick to point out that he never participated in any kind of "hot rod aesthetic." In the late 1960s and early 1970s, Turrell earned his living restoring vintage cars and planes. "This work was an important corollary to his art," wrote Craig Adcock, "particularly in terms of going the distance required to get an extra few degrees of perfection in the restoration," which the artist found "comparable to expending the extra amounts of energy required to get the walls and other physical components of his work to disappear so that light could be sent." In other words, it was the

"craftsmanship" and "artfulness" that Turrell learned from car restoration that "was fundamental to the art."[14]

Of course, not everyone was as enchanted by the developing car-based aesthetic. A number of critics and art observers from outside Southern California—especially those embedded in the national art market that still was headquartered in New York—somewhat dismissed the L.A. art of this era, deeming it less serious and more craft-oriented than New York–based Minimalism of the time, to the point of becoming akin to folk art. Irwin and others disagreed with this assessment. "As far as I'm concerned," Irwin said, "a folk art is when you take a utilitarian object, something you use every day and you give it overlays of your own personality, what you feel and so forth. You enhance it with your life."[15] New York–based critics also raised objections to its "overly niggling attention to surface perfection,"[16] even going so far as to coin a disdainful sobriquet for the work: "Finish Fetish." The reaction encapsulated the struggles that Los Angeles artists had confronted up to that point, and would continue to face, to gain national respect for work produced on the "wrong coast." But through all the arguments, the criticisms, and dismissals, Irwin remained a staunchly confident figure, ready and able to defend and justify, in both commonsense and art-critical terms, not only why the local aesthetic was wholly valid, but also why the local car culture itself was worthy of art-world respect.

Irwin argued this contention at the time with anyone who disagreed. In fact, Irwin recalled, at one point a "head honcho" art critic was visiting L.A., "and he was upset because Billy Al Bengston was racing motorcycles at the time. This critic just dismissed that out of hand as a superficial, suicidal self-indulgence." The critic, whom Irwin refused to name, was a Marxist, and prone to thinking he was "real involved with the people." But, according to Irwin, he was hardly connected to the world at all. "We got going and ended up arguing about folk art," Irwin said. "He was talking about pot-making and weaving and everything, and my feeling was that that was all historical art but not folk art. As far as I'm concerned, . . . a folk art in the current period of time would more

appropriately be in the area of something like a motorcycle. I mean, a motorcycle can be a lot more than just a machine that runs along; it can be a whole description of a personality and an aesthetic."[17] To prove his point, Irwin looked in the newspaper and found an ad by a guy who was selling a hot rod and a motorcycle, and he drove the critic out to see the young man's work. "Here's this kid," Irwin said:

> "He's selling a hot rod and he's got another he's working on. He's selling a '32 coupe, and he's got a '29 roadster in the garage. The '32 he was getting rid of was an absolute cherry. But what was more interesting, and which I was able to show this critic, was that here was this '29, absolutely dismantled, I mean completely apart, and the kid was making decisions about the frame, whether or not he was going to cad plate certain bolts or whether he was going to buff grind them, or whether he was just going to leave them raw as they were. He was insulating and soundproofing the doors, all kinds of things that no one would ever know or see unless they were truly a sophisticate in the area. But, I mean, real aesthetic decisions, truly aesthetic decisions. Here was a kid who wouldn't know art from schmart, but you couldn't talk about a more real aesthetic activity than what he was doing, how he was carefully weighing: What was the attitude of this whole thing? What exactly? How should it look? What was the relationship in terms of its machinery, its social bearing, everything? I mean, all these things were being weighed in terms of the aesthetics of how the thing should look. It was a perfect example."[18]

Yet the critic would have none of it, refusing to accept Irwin's argument. "Simply denied it," Irwin said, "not important, unreal, untrue, doesn't happen, doesn't exist."[19]

THE BIASES OF NEW YORK ART CRITICS NOTWITHSTANDING, L.A.–based artists like Robert Irwin were not the only intellectuals

who took note of the car culture. In a long essay called "The Kandy-Kolored Tangerine-Flake Streamline Baby," that the East Coast–based new journalist Tom Wolfe wrote for *Esquire* in 1963, the author marveled at the Californian penchant for cars and at the aesthetic of local car customizers. Describing the ever-present "luxurious baroque Streamline," Wolfe described features like tail fins, pinstriping, and other gaudy modifications. "The streamline is baroque abstract or baroque modern or whatever you want to call it," Wolfe wrote. "Looked at from a baroque standard of beauty . . . [the streamline touches] are an inspiration, if you will, a wonderful fantasy extension of the curved line, and since the car in America is half fantasy anyway, a kind of baroque extension of the ego."[20]

Wolfe's admiration for California's car-based aesthetics was as unlikely as it was accidental. At the time, Wolfe had been working as an unknown, thirty-two-year-old feature writer for the *New York Herald Tribune*. During an extended newspaper strike in 1962-63, however, Wolfe became desperate for some income, and, having recently written about a custom car show, he pitched a story to *Esquire* about the growing trend of car customizing. Editors at the magazine took a chance on the story, sending Wolfe on his first visit to Southern California, the epicenter of the car customizing subculture at the time.

In the piece that resulted, Wolfe focused particular attention on George Barris, the biggest name in California car customizing, "who grew up completely absorbed in this teen-age world of car, who pursued the pure flame and its forms with such devotion that he emerged an artist. It was like Tiepolo emerging from the studios of Venice, where the rounded Grecian haunted of the murals on the Palladian domes hung in the atmosphere like clouds. Except that Barris emerged from the auto-body shops of Los Angeles."[21] Wolfe visited Barris's studio in North Hollywood, which was called Kustom City. "The place looks like any other body shop at first, but pretty soon you realize you're in a gallery," Wolfe enthused, as if he were discovering the Sistine Chapel for the first time. "This place is full of cars such as you have never seen

before. Half of them will never touch the road. They're put on trucks and trailers and carted all over the country to be exhibited at hot-rod and custom-car shows . . . . They're full of big, powerful, hopped-up chrome-plated motors . . . but it's like one of these Picasso or Miro rugs. You don't walk on the damn things. You hang them on the wall. It's the same thing with Barris's cars. In effect, they're sculpture."[22] Interestingly, as happened with Harley Earl in the 1920s, Barris was invited by Detroit automakers in the 1950s to consult on car designs. His basic take—that the cars of the time weren't "streamlined and sexy enough"—was rejected out of hand, making Barris, according to Wolfe, "like Rene Magritte or somebody going on the payroll of Continental Cars to do great ideas of Western man."

The same treatment was accorded to another subject of Wolfe's survey, the Kustom Kulture hot-rod designer and graphic artist Ed "Big Daddy" Roth. As Wolfe described it, Roth was the Kustom Kulture's "Salvador Dali of the movement" and "a Surrealist in his designs, a showman by temperament, a prankster."[23] Roth was, according to Wolfe, the epitome of California's rebellious spirit and teenage ethos. He was a brilliant designer but also a bohemian who showed up at car shows, as the famously patrician Easterner Wolfe noted, in a T-shirt. In Wolfe's view, the *enfant terrible* Roth's particular contribution to the growing aesthetic of the Kustom Kulture was to combine a personal insouciance and a talent for caricature and parody with solidly innovative hot rod design and custom car painting. Earlier in his career, Wolfe pointed out, Roth had created a series of big-eyed, large-mouthed, voracious monster-like figures—the most famous being, perhaps, a Disney parody named Rat Fink. These figures were so distinctive they found their way onto T-shirts and car decals and were turned into popular figurines and plastic scale models. But Roth's ultimate genius was in how he put all of this production together as one "package," bringing T-shirts, decals, and toys along with his car designs to car shows around the country. Still, this highly commercial approach by Roth did not diminish the innovative, even revolutionary nature of his car designs.

"Big Daddy" Roth was, in fact, the first prominent Kustom Kulture designer to eschew the existing design of cars coming from Detroit in order to invent his own car forms. To do this, Roth would, using a basic frame and chassis, sculpt the body of his cars out of plaster that would then be used to make a fiberglass mold.[24] In 1959, Roth rolled out one of his earliest such designs, a car called "Outlaw" that was, according to one local artist and car enthusiast, "utterly unlike any car before or since."[25] The success of Outlaw encouraged Roth to create—working as an independent artist in his workshop and using "low buck, backyard methods"—one new, completely original, custom hot rod design each year. "Some of the best-remembered Roth hot rods include "the Beatnik Bandit (1960), the Road Agent (1961), the Orbitron (1964), and the twin V8-powered Mysterion (1963)."[26] By the mid-1960s, Roth's designs—the cars, the illustrations, the toys, and T-shirts—had turned him into something of a cultural icon. His work was collected across the U.S., as well as by people in Japan, Europe, Australia, and Scandanavia. *Time* magazine went so far as to dub him the "supply sergeant to the Hells Angels."[27] He was commissioned to create custom cars for television shows like *The Addams Family*, and Mattel's new toy line, Hot Wheels, in 1968 included Roth's Beatnick Bandit as one of the first sixteen diecast toy cars it produced.

In retrospect, Wolfe could have also dug deeper during his swing to the West Coast. Though they were the most prominent car customizers and designers of the time, Barris and Roth were two among a large fraternity. Other members of the Kustom Kulture club included Von Dutch (aka Kenneth Howard)—whose knack for fanciful pinstriping, flames, and other car design was also a significant contribution to the aesthetic—as well as Ron Turner, Lyle Fisk, Stanley Miller (Mouse), Sam Barris (the brother of George), and a younger artist, and protege of Ed Roth, named Robert Williams. If Wolfe had had a bit more foresight, in fact, he might have seen that Williams's wide-ranging art and eclectic artistic production would, in just a few short years, serve as a crucial linchpin in local art. Robert Williams, in fact, would

become perhaps the key figure in helping connect various forces in the California culture of the streets, and this connection would, in time, turn the car-centered Kustom Kulture into something bigger, more wide-reaching, and influential than anyone could have imagined.

IN THE HANDS OF THE MASTER DESIGNERS OF THE Kustom Kulture, it's clear from the descriptions of Wolfe and Robert Irwin, the car had been somewhat transformed into an important cultural relic. This explains why, despite the eventual dissolution of the Cool School and its "Finish Fetish" aesthetic, the car continued to influence the outlook of the artists of Los Angeles.

Even after the collapse of the Ferus group, when concept, performance, and other experimental strategies were poised to overshadow car-based investigations into abstract forms, many L.A. artists brought the car into their work in less idealized ways. Some used the item as a relic that carried a host of associations and meanings that could provide a backdrop for their Conceptual investigations. In this, the new generation of artists did not have to search for referents, as several Ferus artists had already provided some critical signposts. Most notable was the example that Ferus group doyen and original gallery founder Ed Kienholz offered in a work he created and famously (or infamously) exhibited in 1966. Kienholz, perhaps the most rebellious and thought provoking of the Ferus group, was, according to one later critic, "a local hero, known for wrestling with tough social issues" in his gritty and rough-hewn assemblage work. Since Kienholz's art did not conform, according to one critic, "to conventional standards of beauty,"[28] it was often simultaneously applauded and decried. Ironically, both of these takes on his work came to a head in one particular moment, during the run of Kienholz's groundbreaking and massive solo retrospective exhibition at the L.A. County Museum of Art in the spring of 1966.

Organized and curated by Maurice Tuchman, Kienholz's 1966 exhibition garnered attention even before it opened. On one hand, it

was the first such solo respective of a Los Angeles–based artist that
LACMA had ever mounted. And on the other hand, it garnered the
immediate scrutiny of an opportunistic county supervisor named
Warren Dorn, who found one of the works to be displayed "revolting,
pornographic, and blasphemous"[29] and threatened to withhold financ-
ing for the museum unless the tableau was removed from view. At the
time, Dorn, a Republican, had his sights set on running for Governor of
California against the incumbent Democrat Pat Brown and was look-
ing for ways to have his name featured more in the press.[30] The work
in question was a tableau-style installation called "Back Seat Dodge
'38" (1964), which was meant to portray Kienholz's real-life experi-
ences growing up as a kid amidst the nascent car culture of Southern
California.

As the artist told the story, the work referred to one evening in his
seventeen-year-old life when he borrowed his dad's '38 Dodge to go to
a dance. "This girl was out there, and I enticed her into the car," said
Kienholz. "We got some beer and pulled off in the tules someplace and
did intimate and erotic things all over her, and we sat there and drank
beer and had a nice time . . . . And I couldn't remember her name later.
I thought, what a crazy situation—to be that intimate with a person
and not know who they are. It just seemed wrong to me in a way. And
then I got to thinking about back seats and Dodges and the kind of a
world where kids are really forced into a cramped space in—maybe
even a fear situation, certainly a furtive situation. Like what a miser-
able first experience of sex most kids go through. I mean, the back
seats of cars."[31] To capture his conflicted emotions, Kienholz included
in his tableau a cast-plaster female figure, sprawled and disheveled
on the Dodge's back seat, legs splayed, bra and slip removed, and
pinned underneath a heaving, vaguely male figure made of ghost-
like chicken-wire mesh. At the time of his retrospective at LACMA,
Kienholz was nonplussed by the fuss, particularly since the sexuality in
it was, at most, an implied thing. And though the sculpture remained
in the show, because of Dorn's protests it was placed behind a barrier

warning visitors of the offensive nature of the work and blocking the tableau from younger visitors. The controversy over this work was so pronounced, more than 200 people, ironically enough, lined up to see the work the day the show opened.

Beyond Kienholz, the automobile also found its way, at least as an oblique concept, into the work of fellow Ferus artist Ed Ruscha. In 1963, Ruscha published his first artist's book, a thin, cheaply produced (and affordably priced) volume called *Twentysix Gasoline Stations*. The book was comprised of exactly what the title suggested: a series of twenty-six black-and-white photos of gasoline stations—all real stations that Ed Ruscha knew from his own travels. Ruscha's approach was completely deadpan, unelaborated, even rather slipshoddily realized. The stations are depicted just as they are, not as aesthetically appealing objects, which is of course somewhat the point. "I think it's one of the best ways of just laying down facts of what is out there," Ruscha said of his approach in this book. "I didn't want to be allegorical or mystical or anything like that . . . . I had this vision that I was being a great reporter when I did the gas stations. I drove back to Oklahoma all the time, five or six times a year. And I felt there was so much wasteland between L.A. and Oklahoma City that somebody had to bring in the news to the city."[32] Ruscha would continue making similar artist books on a range of topics through the decade, returning often to depict subjects that conceptually were linked to California's car culture—parking lots, local apartment buildings, the buildings on a stretch of Sunset Boulevard in West Hollywood (aka the Sunset Strip, which was a prime spot for cruising), all as though viewed from the vantage point of a car.

Ruscha's use of California's car culture as a background referent to his Conceptual artist books was a strong influence on the generation of experimental artists that followed in the 1970s. The most compelling example of this can be seen in Chris Burden, whose work occasionally made use of cars or referred to California's particular car culture. In several instances, the shocking quality of his work was enhanced

by the strangely mundane presence of cars. After his 1972 arrest for lying down on La Cienega Boulevard for "Deadman," Burden would two years later go a step further in using the car as a symbolic concept for one of his most notorious pieces, "Trans-Fixed" (1974). On April 23, at a warehouse space on Speedway Avenue in Venice, a Volkswagen Beetle was pushed out of the warehouse doorway with its engine running. Burden, lying face up and shirtless on the back of the car, remained still while assistants (reportedly) hammered nails into his hand as if he were being crucified. After revving the car's engine for two minutes, the assistants pushed the car back into the garage and closed the door. It's also worth noting that the car was so important to Burden as a concept that the first major non-performance work of his career, made in 1975 after his work "Doomed" convinced him to change gears, was called "B-Car." This was a lightweight vehicle, created by the artist in much the same manner as "Big Daddy" Roth, that he described as being able to travel 100 miles per hour and achieve a fuel efficiency of 100 miles per gallon.

As the example of Burden shows, the car was such a loaded symbol in the local culture it seemed almost natural for avant-garde artists who wanted to shock or confront audiences to make use of them. The young feminist artist Suzanne Lacy knew this in 1972 when she created her "Car Renovation." The work, part installational sculpture, part performance, took place in the "Site/Moment: Route 126" series of performance works that Judy Chicago had organized in her CalArts Feminist Art class that year. In fact, the various performances that occurred during "Site/Moment: Route 126," taken as a whole, could be seen as an exploration of the Feminist relationship to local car culture. Route 126 is, for Southern California at least, a somewhat remote highway that cut through the dusty hills that surround Valencia. Near the highway in 1972, amid the rocks and scrub plants and dirt, Lacy found an old, 1930s-era convertible, long ago wrecked, abandoned, and left to the elements. Lacy's idea was to resuscitate the vehicle, so she directed her peers to paint the car's exterior completely

pink, to paint the interior a velvety red, and to add two large eyes, two mouths (on either side of the body of the car)—one open, with a tongue sticking out, the other shimmering with pink lipstick and sporting a flowing beard. "Static in its plasticity," wrote Meiling Cheng of "Car Renovation," "[it] is nevertheless enlivened by its allegorical performativity. Lacy and her participants . . . reappropriat[e] a color [pink] that connotes lightweight, ladylike delicacy, and parodically en/genders their auto installation as female—or, at least, as feminine or female-like. Their collective artwork thus becomes a Feminist allegory, a monument to a group of women's curative labor."[33]

Though somewhat fanciful and perhaps easily overlooked, "Car Restoration" is, in referencing the ideals of the local car culture and twisting them for her own Feminist purposes, actually quite subversive. Lacy's work from its very beginnings tended to focus on sociocultural forces that operate on women and exposed and challenged the established power structures from the Feminist point of view. "Lacy tackles her experiences of otherness and challenges her sexualized subjugation," wrote Cheng. "By virtue of her political resolve and activist practice, I regard Lacy's Feminist performances in L.A. as redressive measures against some deep-seated problems that have plagued the city's multicentric and polarized cultural environments."[34] Lacy's "Car Renovation" is a good example of her Kaprow-like approach to taking the stuff of life, such as the omnipresent car, and transforming it into a fancifully provocative sculpture. As a result of Lacy's interventions, according to Cheng:

> "The wrecked convertible in 'Car Renovation' is at once raw material and rhetorical device. As I read it, the convertible's initial damaged state relates it to other disenfranchised subjects, with whom Lacy feels an emotional and ethical bond. Lacy and her participants further feminize their joint artwork in a culturally intelligible code, hence turning it into a metonymy for women in general. If we consider that a car is also

*conventionally addressed as a 'she,' the women artists' effort in embalming a dead convertible amounts to a Feminist intervention, which sarcastically quotes the melodramatic motif of rescuing a damsel-in-distress only to protest against the abandonment of a much-abused vehicle in a roadside open grave. Their actual attempt to salvage the car therefore hints at the symbolic redemption of all women."[35]*

In sum, then, "Car Renovation" is a highly political act, which pokes fun at the patriarchy that has only denied the power and self-identity of an entire gender deemed to be too weak or stupid to participate in the ubiquitous car culture.

REVOLUTIONARY STANCES INVOLVING THE MID-CENTURY car culture of L.A. were not limited to avant-garde artists. One of the most prominent figures of the very Kustom Kulture that was driving the ongoing evolution of California's car culture turned out to be just as hell-bent on rebellion as any Feminist or Conceptual artist—though it would take a number of years before this became clear. Robert Williams, born in 1943 in Albuquerque and raised in deep-South Montgomery, Alabama, was an unlikely revolutionary. While growing up, Williams's father ran "The Parkmore," a drive-in restaurant frequented by local hot-rodders. On weekends, his father would race one of his large array of stock cars at an oval track at the local fairgrounds, and, when Williams was just twelve, his father gave him his first car, a 1934 Ford five-window coupe. Unfortunately, Williams's idyllic boyhood was not meant to last, and when his parents separated and he returned to Albuquerque with his mother, the boy's troubles began. Lifted from his moorings, Williams failed ninth grade and began skipping school, spending most of his time out on the Albuquerque streets simultaneously avoiding and embracing the criminality of the local "pachuco" street gangs. By the time he was a junior his grades and truancy had gotten so bad he was removed from the school system.

Williams, who had become dedicated to the local hot rod culture
of Albuquerque, got by doing mostly odd jobs like truck driver, fork-
lift operator, and carnival concessionaire. His life was rapidly nearing
a dead end, but Williams had other ideas about his destiny. After a
grandfather's death, Williams got a small inheritance and took pause
to think: "Well, I'm running around with people on drugs," he said,
in recounting this moment years later, "people I know are going
to Santa Fe prison, and I'm going to end up there. My life's going
nowhere—I've got to get away . . . ."[36] Though Williams failed miser-
ably at school, there was one subject that he had always excelled in:
Art. "Toward the end of his high school career," wrote a biographer
in 1994, "[Williams] began to avoid all other subjects and attend only
art class for months at a time. To be sure, he had other interests—the
normal teenage panoply of movies, comic books, hot rods, motorcy-
cles, rock 'n' roll music, cheeseburgers, and girls—but these all became
absorbed in his passion for art."[37]

Like many Americans with similar passions in the middle part of
the last century, Williams, upon the end of his school career, sought
out the best possible place to pursue his bliss. And this was how he
ended up, in 1963, moving to Southern California, land of cars, surf,
girls, and sun. As it happens, the move to California was fortuitous for
the hopeful young artist who had never fit in well in the strictures of
formalized schooling or the tight social values of the 1950s. California,
at the time, was known for its openness, optimism, and seemingly
endless growth and expansion. The state had Hollywood, glamour,
gleaming new highways, style, and sophistication. "Los Angeles is the
world capital of the concept of technique," Williams would later say
of his adopted home. "One reason for this attitude can be traced to the
Hollywood movie industry . . . . From the '40s onward the Hollywood
motion picture industry relied almost exclusively upon their slick-
ness of production . . . [and] this emphasis on technique pervades all
aspects of California's culture, to the point where lifestyle has replaced
philosophy." Even more than any of the Hollywood stuff, Williams

was also aware that California was ground zero for the car culture that he loved. "It's wrong to blame all of this [lifestyle stuff] on the motion picture industry," said Williams. "In fact, the movie business is not, as commonly assumed, the most important economic force in Los Angeles County, not by a long way. The biggest business of all is motor vehicles. Every citizen of Los Angeles owns at least one automobile, which he uses to drive immense distances for work and pleasure. Sales, service, and other support industries for these vehicles probably occupy the majority of the population."[38]

The California that Williams happily settled into was a mobile, car-centric culture. It was also a state flush with cash, and this meant that its education system was expansive and affordable. In particular, the state's system of government-funded junior colleges cost just seven dollars per semester and, critical for a student like Williams, did not require a high school diploma to attend. Williams entered Los Angeles Community College, studying art and earning straight A's for the first time in his life. In fact, the experience transformed his life, not only because he suddenly was excelling in school but also because he met his lifelong love there, Suzanne Chorna.

Robert and Suzanne married just two months after meeting, and for a brief time Williams supported the couple by drawing cartoons for the school paper. Eventually, he was forced to leave school and find a job that would bring in more money. For six months, Williams worked doing pasteup for a karate journal. This job didn't work out when Williams's penchant for creating lavishly detailed drawings for the journal meant he was constantly late in completing the layout. After another six-month stint at another job—designing containers for the Weyerhaeuser Corporation—ended in his termination, Williams was growing increasingly desperate. He briefly attended classes at the Chouinard Art Institute but felt very out of place—"I guess I wasn't Disney material," he said later.[39] Then Williams found himself at the local employment office, ready to take anything that would support his family, and here he was greeted by a remarkable stroke of fortune:

Exactly one art-oriented job was open, but it was one that the office had had trouble filling. Every artist who had checked the position, they said, had come back to the office shortly afterward, "shaking his head and saying that he didn't believe he wanted the job, which consisted of drawing hot rods and motorcycles for a large, goateed beatnik character by the name of Ed 'Big Daddy' Roth."[40] At the time, Roth was something of a heroic figure in the local car culture and hot rod underground. To Williams, working for a figure like Roth was easily several steps up from working for some corporation. It was a "real artist's job" where he wouldn't have to wear a coat and tie, and, what's more, the salary was three times anything that he'd received for work up to this point in his life. Sure, it was far from an ideal situation— for instance, Roth promptly issued Williams a small pistol for protection[41]—but given that Williams would get to focus on creating art for Roth (T-shirts, illustrations, ads in Roth's various publishing projects, etc.), he couldn't really complain.

Williams worked for Roth Studios for five years, honing his commercial art skills and style, gaining deep knowledge about the hot rod subculture and other California street sensibilities, and immersing himself in an artistic culture that was both underground and subversive as well as populist and commercial. Williams later explained:

> "Roth Studios was extremely bohemian, an extremely free environment to work in. Everyone there played a part in it and there was so much energy that you were induced to be functional and productive. I was the art director, but I did a little bit of everything. Every day I would go out back and see what work was being done on the car shows. I would talk to Ed often . . . . Sometimes I'd help him sculpt things. He'd be working on a car and say, 'What do you think about this?' I'd say, 'Well, why don't you smooth that out?' So we all had a little input. Ed would go through the mail and see a letter from some kid that would say, 'Would you draw me this?' or, 'Could

*I have a shirt of this?' and Ed would take these fucking goofy things that kids drew and say, 'Hey, clear this up, this might be a good idea.' So I'd clean it up and it would end up on a T-shirt or a decal . . . . Let me tell you, it was a psychedelic think-tank heaven; you just couldn't be far out enough. I had to sit there and come up with the most impractical, flipped-out fucking notions in the world, and I was getting paid to do it, which was just unbelievable."*[42]

Eventually, happy as he was to find an expressive niche for himself as well as a decent paycheck, Williams would leave Roth. But this made sense. The open atmosphere promoted by Roth eventually would grate on even the most bohemian of sorts. "There was a continual flow of hot rodders and bikers coming in there from all over the country," Williams said later. "There was always a stream of odd people, but Tom Wolfe and a lot of very intelligent people came in there, too, and balanced out this very unusual world. Famous rock stars were in there all the time, writers, motion picture stars, producers—it was just a continual panoply of interesting characters coming in and out of there, and Roth was like a sponge just sucking it all back up."[43] Roth, who, according to Williams, was six-five, 280 pounds, and had a black belt in karate, had always run around with a rowdy crowd of unsavory characters. "He was big and had no fear of anyone," said Williams, "because if the chips were down he could just reach over and break your neck."[44] Williams, who had learned back in Albuquerque to avoid such people, warned his boss of the risks, but Roth seemed taken by the romance of the rough life these people led. Meanwhile, for Williams, though the atmosphere was exciting it wasn't always conducive to working. Sometimes "it was just like a carnival," Williams said. "You got to see the trash and the jetsam that followed him [Roth] home—really hot bitches and fast-talking guys, just a bunch of fucking goofballs that got sucked up in his slipstream. They were coming to bask in the bohemian automotive glow. They hoped some of the aura

would wipe off on them, and everyone working there would see these idiots coming in to be part of this thing."[45]

The other reason for Williams to leave Roth's employ was a growing professional confidence and ambition. As Kustom Kulture stalwarts like Roth moved further and further into the raw and unsavory aspects of the L.A. street life, they moved away from their roots in the car customizing culture and into deeper and deeper psychedelic-fueled mannerism. This in turn put a wedge between the car customizing crowd and the artists and intellectuals who celebrated them. "There was," wrote critic Edward Allington some years later, "only a short period when the Artists and the Hot Rodders had something in common, a period from the late '50s to the early '60s. After this the Artists and the Kar Kustomizers went their separate ways: one following a tight philosophical approach expressed with minimal means, the other moving towards a wild, Baroque extravagance with giddy displays of skill and decoration that has now almost atrophied into a tradition—which is exactly what one would expect to happen to a folk art."[46]

This included Williams, who, with all his talent, saw himself doing much more than producing ads for Roth. During the late 1960s, while Williams still worked for Ed Roth, he had developed a regular practice as a painter. These works, which he called "Super Cartoon" paintings, employed a somewhat Pop Art sensibility while using meticulous and time-consuming, Old Master-like painting techniques, including the use of varnishes, handmade paints, and so on. Several of these paintings took Williams over a year to complete. Many of these "Super Cartoon" paintings explored lurid subjects—sex, violence, psychedelia, and the like—that came out of several other of Williams's artistic interests of the time.[47] An important early painting was his "Ernestine and the Venus of Polyethlene" (1968). With its wild and dream-like swirl of bold colors and its raw sexual subject matter, the painting is heavily indebted to the psychedelic movement of the time. What takes the painting beyond that style, however, is Williams's sheer dedication

to the craft of painting and to the ocular impact of the imagery and forms he is inventing.

Even after moving on, Williams never regretted working for the erratic Big Daddy. "Roth is the one who laid on the barbwire for the whole culture to cross over his back," Williams said some years later. "It all eventually ended with him losing his business and his wife divorcing him, letting this poor guy go down the drain. He went out of business in the 1970s and . . . was totally forgotten. I heard people make very ugly, derogatory remarks about him. I had to step into a couple of conversations and say, 'You're wrong. Ed Roth was a real fucking hero. He's on par with Wild Bill Hickock and Buffalo Bill Cody. He's just an incredible person.' "[48] Still, there's no denying the fact that Williams himself had, smartly and fortuitously, moved on from Roth Studios before having to suffer any ill effects.

In 1969, Williams left Roth Studios began working to build a client base for his paintings. To make ends meet, in the meantime, Williams also connected with a psychedelic art movement that was burgeoning in San Francisco and in connection with a thriving rock 'n' roll scene. Artists like Victor Moscoso, Rick Griffin, and others made money creating rock posters for Bay Area concert promoters like Bill Graham, and Williams, who did not wish to leave his home in Hollywood, worked on the periphery of this industry. When the psychedelic era began to peter out a few years later, Williams, who had also continued working on comic strips ever since his days at Los Angeles Community College and had even done some comics work for Ed Roth,[49] saw opportunity in working with the so-called "underground" comic artists such as R. Crumb, Rick Griffin, Victor Moscoso, Art Spiegelman, S. Clay Wilson, and so on. Williams sent some samples of his work to Robert Crumb, the founder of *Zap Comix*, and began producing works to include in their publications that revealed a talent for the raunchy, vulgar, and anti-establishment subject matter and imagery of underground comics.

Meanwhile, Williams continued developing his painting style— drawing on a wide range of influences to produce ever more edgily

compelling works. For the second Monterey Pop Festival in 1968, Robert Williams painted a psychedelic work called "In the Land of Retinal Delights," in which a heavily distorted central figure, whose face sprawls outward into an eye that takes up about a third of the painting's surface, is lost among mountains of fancily colored, plasticky gewgaws, trinkets, and other odd and random shapes—all of which combine to create a traditional *horror vacui*, as well as the impression that we, the viewers, are the ones experiencing these (perhaps drug-induced) visions. Williams was certain it would make a splash at the event, but the festival was unfortunately cancelled—so the artist instead displayed it at a local museum, the Cars of the Stars Museum.

In 1969, Williams created the trickster-like, very anti-heroic, insectoid comic character Coochy Cooty for an edition of *Zap Comix*, and, in 1970, he released his own comic book, *Coochy Cooty Men's Comics*. From these publications, and from his association with the Zap collective, Williams's reputation steadily began to grow among an audience perfectly poised to receive what he had to say and reveal. For the fourth issue of *Zap Comix*, which was released in August of 1969, the collective attempted, with Williams's tacit involvement, "to severely test the norm with this issue and to actually try to produce the most extremely disgusting periodical imaginable. We wanted to push people's buttons."[50] The issue in fact caused a firestorm of anti-obscenity charges and court trials, all of which culminated in a March 1973 decision against the publication. Williams was chastened, along with the rest of his underground comic cohorts, and also suddenly galvanized to ponder what it was he wanted out of art. Williams's dedicated deployment of "inappropriate" or otherwise overlooked subject matter, themes, and imagery not only was due to his involvement in the underground comics movement, but it had also been common in the work of Kustom Kulture artists like Ed Roth and Von Dutch—and so it was part of Williams's artistic DNA. "Racers aren't a sentimental lot," wrote the writer and street artist C.R. Stecyk. "Ed Roth himself said: 'When racers are working on their cars it's the real thing. There

are no laws, no brainwashing, no everlasting truths, and no thought restrictions. The world of the garage is their sanctuary of artistic control. Imagination is the limit and speed is the need. Everything else is irrelevant.' "[51]

Some of Williams's acrylic paintings of this era, such as "Devil With a Hammer and Hell With a Torch" (1973), would typify his style through much of the decade—highly illustrative, somewhat cinematic, stylistically and compositionally very similar to underground comics, but deceptive in its seeming simplicity. This small painting is a tableau of scenes—a man working on the fender of a car in a garage, a slick and hopped-up lowrider zooming through a mountain highway, a trophy car at a car show, a parking lot tussle over a hot rod that's had its fender dented in, and various other small elements and images—but it is also a bravura work of artistry. The scope of the narration in the images, the way it tells the whole story of the Kustom Kulture in all its facets—from grunt work, to the attendant cultural contention, to trophies at car shows—and the way it depicts the shine and excitement of the car culture through faux chrome lettering and various shiny flowing chrome decorative borders, all of these elements reveal Williams's skill and artistry. "The Pachuco Cross" (1976), meanwhile, was another good indication of the layers of influence that played on Williams as he made his work. A typically small oil painting (twenty-four-by-nineteen inches) on canvas, it depicts a man, looking strung out with bloody hash marks on his arms, stooping over a prostrate figure in an alley next to a vintage 1940s car. A woman, her hair in a bouffant hairdo, looking like an aged bobby-soxer, grabs his wrist, which holds a tire iron. From the tire iron emanates a strange, glowing vision surrounded by a ring of fire—as if the iron were an acid-fueled slide projector. Among the various, green-and-yellow glowing images embedded in the circular apparition is a central hand holding a "pachuco" cross, so-called because it was a symbol common to the Latino gangs that Williams had been familiar with in his youth. In this one image, Williams effectively taps into various indigenous cultures,

both of the street and beyond—psychedelic art, the Kustom Kulture, Chicano gang imagery, and the noirish vibe of Hollywood B-movies.

From his point of origins in the hot rod customizing Kustom Kulture, his brief involvement in the psychedelic movement in art, and from his newfound and growing fame as an underground comic, Williams began to slowly transform and deepen his artistic output. This should have come as no surprise. Just as Robert Irwin would clash with the highfalutin art intelligentsia of New York in the 1960s, Williams would work hard to find some sort of middle ground between the pull of the low-common-denominator tastes of the public against his own growing notions of artistic legitimacy. As the critic Dave Hickey would later explain, the psychedelic art moment of the time was, in its anti-academic stance, in line with a host of other anti-academic styles going back to the seventeenth century: Rococo, Art Nouveau, the Pre-Raphaelites, even Pop Art. "In general," wrote Hickey, "we might say that these anti-academic styles prioritize complexity over simplicity, pattern over form, repetition over composition, feminine over masculine, curvilinear over rectilinear, and the fractal, the differential, and the chaotic over Euclidean order. They celebrate the idea of space over the idea of volume, the space before the object over the volume within it. They elevate concepts of externalized consciousness over constructions of the alienated self. They are literally and figuratively 'outside' styles. Decorative and demotic, they resist institutional appropriation and always have."[52]

That Williams was slowly moving toward his own artistic revolution is clear not only in Dave Hickey's assessment of his work, but also in Williams's own later writing. Twenty years after painting "In the Land of Retinal Delights," Williams would publish a somewhat groundbreaking essay titled "Rubberneck Manifesto." In the essay, Williams acknowledged various definitions of art—Nietzsche's "product of pure ego," Schopenhauer's "device of pleasure," Tolstoy's "propaganda," Oscar Wilde's "more real than reality"—before suggesting his own take. "The purest form of art is to give way to simple visual

interest," he wrote. "To look at what you find yourself driven to see. Higher notions of art tend to confine art with lofty moral restrictions. When art is passed off as a quasi-religion which can only be administered and interpreted by a special-order of priestly elites, the system invariably stifled imagination—even when the art is as liberal as blobs, slashes, and spatters . . . . When all predetermined prejudices are momentarily set aside and you are one of the many at the scene of the horrible accident your libido will do the looking. Something dead in the street commands more measured units of visual investigation than 100 Mona Lisas. It isn't what you like; it's what the fuck you want to see!"[53] Throughout the 1970s, then, the fact that Williams continued to soak in a range of influences—the art and culture that came from the streets of Southern California—was critical.

TOM WOLFE, IF HE HAD MET ROBERT WILLIAMS DURING his sojourn to California to investigate its car culture in the 1970s, would likely have admired the artist's syncretic character—that is, his ability to connect and bridge different styles and influences and cultures while still remaining true to his own particular vision of art. Wolfe would have also enjoyed Williams's highly refined and dedicated approach to making art that was distinctive and answerable only to his own particular impulse and interests. And though there is no record of Wolfe ever having come across Williams's work, the author, after finding success with his essay on California's car culture, would be commissioned often over the next decade to write about the culture of California. The state, after all, was at the time deemed the most forward and "far out" of any region of the country. In these assignments, Wolfe tended to be attracted to the state's penchant for merging and connecting diverse cultural influences.

This characteristic was perhaps natural for a place that resided at the edge of the continent, faced a vast ocean, was connected to the distant lands of Asia, and whose population came from many far-off places—the American Midwest and East, Mexico and other places in

Latin America, Asia, and so on. Whatever the reason, in the 1970s Los
Angeles was home to advancing pockets of cultural activity, many of
which were connected to the churning local streets and its indigenous
street-based cultures. The presence and growing influence of graffiti
has already been remarked upon. Though mostly a clandestine activ-
ity in its origins, after the first gallery exhibitions of the form—such as
the Pomona College Art Museum's May, 1970, exhibition "Chicano
Graffiti: The signatures and symbols of Mexican-American youth
taken in Los Angeles barrios"—and upon the growing connection of
the graffiti form to the local mural movement, the aesthetic and ide-
ology of street writing slowly began to saturate local visual culture.
One of the first signs of the widespread diffusion of the graffiti look
and attitude could be found in one particular and peculiar Southern
Californian cultural milieu that existed side-by-side with Chicano
gang culture in the streets of certain beachside communities. That is,
in L.A., the local surfing culture and its adjunct, a nascent skateboard-
ing culture, began in the 1970s to exhibit its own, graffiti-influenced
visual culture.

In 1971, three men—the artist and writer Craig Stecyk, surfboard
designer Jeff Ho, and surfer Skip Engblom—founded a small surf shop
in Venice called Zephyr Productions that would exert an enormous
cultural influence in its mere five years of existence. Though surfing was
not something that took place on the streets, the Zephyr Productions
Surf Shop quickly became part of the fabric of the streets of Venice.
Located on Main Street, very close to numerous local hot rod fab-
rication shops, the tangle of local artist studios, and in the very turf
where numerous Chicano gangs operated, Zephyr Productions was
aesthetically influenced by various street sensibilities. In particular, Jeff
Ho's wild and innovative surfboard designs borrowed from the graf-
fiti that was widespread on the local streets and mixed that energy
with the streamline aesthetic of the hot rod culture and the pinstriping
styles of Kustom Kulture masters like Von Dutch. Furthermore, from
its very opening, Zephyr Productions, seeing the energy and potential

marketing appeal of some of the local surf-rat kids, determined to sponsor a competitive surf team—called the Zephyr Competition Team (aka the Z-Boys)—that also helped influence a burgeoning L.A. youth aesthetic. Because the team was comprised of a horde of eerily talented athletes—eventually eleven boys and one girl—who happened to be all under the age of sixteen, it soaked up influences like a sponge and co-opted them to make them into something distinctly Californian. And, in turn, young teens across Southern California quickly adopted the style of the Z-Boys.

Because the Zephyr team surfed each morning in and among the dangerous pilings of the old, broken-down Pacific Ocean Park piers off of Santa Monica beach, they developed a unique style of surfing that relied on agility and a technique that employed quick cutbacks and other sorts of energetic moves. Each day, after the tides rolled out and waves were no longer high enough, members of the team would bum around the surf shop, running odd errands, flirting with customers, and idly toying with skateboards to practice their surfing moves. Skateboarding, which had been popular for a few years in the early 1960s, partially as an offshoot of the larger fad of surfing, had fallen somewhat out of popularity by the time the Zephyr Competition Team had been formed. As fortune would have it, however, a man named Frank Nasworthy had recently made an important discovery. Nasworthy, who had moved to California in 1971 because he wanted to surf, struck on the idea of replacing the traditional hard metal or clay wheels that skateboards had long used with new, smooth-riding, road-gripping polyurethane wheels. When the Z-Boys took up skate-boarding, they used new boards from the Cadillac Wheels Company (Nasworthy's company) that allowed them to mimic their own surf-ing experience out on the local pavement. "So with the progress of the polyurethane wheels," said one skateboarder of the era, "that just totally stoked me; you could do so much more on a skateboard, surf moves, especially; you could carve your turns and stuff without sliding, that changed everything a lot."[54]

Adding to the Z-Boys' particular interest in, and development of, the newly repopularized pastime of skateboarding was one particular feature of the local landscape around their home in Venice, a rough-and-tumble area that was known locally as "Dogtown." Several Dogtown schools close to the Zephyr Productions Surf Shop had parking lots or playgrounds that were enclosed by sloped, four- or five-foot-high berms that had been paved over with a smooth coat of asphalt. Using their new boards, the Z-Boys quickly learned that they could use these slopes in much the same way that they used the waves around the Pacific Ocean Park pier. Craig Stecyk recorded the rapid development of the slashing, twisting technique of the Z-Boys skaters and published his photos in 1975 in *Skateboarder Magazine*, which had folded after skateboarding's first wave of popularity had crashed in the 1960s but had been recently revived. To young kids around the country, the photos—of long-haired, wiry, otherwise ordinary-looking boys doing absolutely amazing things with their boards and their bodies—were revelatory, and soon this ragtag bunch of California kids were the idols of young teen and preteen kids around the country. "The Dogtown cult became known far and wide," wrote Craig Stecyk, "and millions of other kids were inspired by the aforementioned magazine to emulate not only the D.T. skate style, but also a perceived approach to authority and life."[55]

CALIFORNIA'S MANY CONTRIBUTIONS TO THE CULTURE of the 1960s and '70s, though very often borne out of street sensibilities, had several important common traits. On one hand, all of these movements—Kustom Kulture, graffiti, underground comics, psychedelic art, and the rest—were in one way or another reacting to the constantly moving, ever-expanding, relentless, and unavoidable city of Los Angeles that surrounded them. On the other hand, however, the movements were also a cultural push against the larger, fine art world of the East Coast that seemed—in the esoteric proclamations of artists like LeWitt and the stance of critics like Kozloff—disconnected

completely from life that took place on city streets and alleys and play-grounds and parking lots. "Art in the past sixty years has avoided," wrote Craig Stecyk, "the obvious appeal to the eye in favor of a more cultivated lean towards intellectual appreciation of texture, volume, and size. We live in an age of cold domineering art that screams of profundity, but says nothing. Anyone who can produce something big, obtrusive, rough, and impractical has fulfilled all the requirements needed to become a master artist; consequently, a large segment of the society with little or no skills has joined the ranks of the art world."[56]

The cultural movements that percolated up from the streets of L.A. in the 1970s had in common that they were made without any sort of pretext. They developed, after all, not by virtue of an ideology or an art magazine dictate, but out of a public need for life-affirming culture and aesthetics. That of course didn't mean that there weren't outside influences seeking to capitalize on such cultural developments. California, after all, was from its very origins a place that attracted the strike-it-rich entrepreneurial type. In the case of the rise of modern skateboarding, there first had been Frank Nasworthy and the Zephyr Competition Team. Then what followed was an army of product developers, promoters, publishers, and other copycats who took the cultural movement to hitherto unimagined heights—in terms of both economic impact, sales, and cultural influence.

In the second half of the 1970s, then, after the California street-based style of skateboarding had exploded into a nationwide trend, local entrepreneurs began pushing several other of California's street-based subcultures. In 1977, Mario Madrid founded a magazine called *Lowrider*, which was intended to promote Chicano culture in general, and in particular, according to a later publisher, "the automobile and the pretty ladies" that went together "hand in hand"[57] with the aesthetic and lifestyle of the Chicano custom car subculture of L.A. "I've always seen lowriders as a work of art because the creativity that goes into them is phenomenal," said Alberto Lopez, who would take over the magazine in the 1980s. At the height of its popularity, *Lowrider*

had a circulation of more than 200,000, with readers not only in L.A. but in the "Midwest, [on] the East Coast, and in markets as far-flung as Japan and Australia."[58]

Also in 1977, a California-based graphic artist named Steve Samiof and his photographer girlfriend Melanie Nissen teamed with a French poet who was living in L.A. named Claude Bessy (whose pen name was "Kickboy," after a Jamaican dub artist) and his animation-artist girl-friend Philomena Winstanley. Together they founded a large-format, tabloid-like "fanzine" called *Slash*. Focused on the small but growing punk music scene centered around Hollywood, *Slash* quickly gained a reputation for its irreverent and provocative takes on the music indus-try and for its celebration of newly emerging bands like The Damned, The Screamers, Nervous Gender, The Germs, and X. By the time the magazine imploded several years later, in 1980, when its coterie of founders scattered to pursue other interests,[59] one of its employees, Bob Biggs, had already founded a more lasting adjunct business—Slash Records—to put out the music of some of the bands the magazine was covering. The label's albums, like the magazine, had their own particu-lar aesthetic—both in terms of the musical acts it brought to light[60] and the artists it put on its album covers. Among the most prominent of these artists was a former punk rocker named Gary Panter, whose style and approach built on the underground comics aesthetic that Robert Williams was involved in earlier in the decade.

Of course, the punk-rock trend—that is, the musical style, the attendant fashions, and the associated bare-bones and provocative art—would fade, as such things do. But that didn't mean the aesthetic didn't remain highly relevant and lastingly influential. For instance, another L.A.-based punk rock label, SST, commissioned album covers from a young artist and former punk musician and high school math teacher who went by the name of Raymond Pettibon. Pettibon's bare-bones line-drawing style and his violent and antiauthoritarian imagery would be hugely influential not only to the punk scene but to inter-national art—as his work would eventually connect his punk roots

to Conceptual Art's "anti-stylistic emphasis on subject matter" and made him the "apotheosis of so-called 'bad' drawing."[61] According to another photographer of the time, Glen Friedman, the two fields of skateboarding and punk intersected in creating a sort of authentic California-based cultural experience. "Hardcore music (punk or rap) and skateboarding," Friedman said years after the scene had morphed into something less savory, more commercial, "have been instigators for an incredible number of radical ideas and channels for unbelievable creativity the likes of which I could barely expect older generations to understand. These interests are shared by millions . . . ."[62]

Interestingly and perhaps inevitably, over time the various street sensibilities began to merge and see interesting crossover. As a result of this commingling, many of the cultural enterprises created a style that reflected the various aspects of California's street culture. In 1981, an Argentinian-born entrepreneur named Fausto Vitello would co-found, with partners Eric Swenson and Kevin Thatcher,[63] a new style of skateboard magazine. *Thrasher* was a mixture of edgy photography, interviews with youthful skateboarders, articles about the latest skateboarding tricks, fashions, and gear, and, importantly, reviews of the music favored by skateboarders, which meant mostly punk rock. The magazine was a near instant success, and as Vitello's business empire grew, so did the number of projects he undertook. He founded additional skateboard companies, helping build what was once thought of as a fad into a billion-dollar industry, and he also started the publication company High Speed Productions. It was this company that would publish several more successful magazines, including one—an art magazine of all things—that would bring him around, some years later, to the doyen of local cultural and aesthetic trendsetting in California, none other than Robert Williams.

AS WILLIAMS LATER RECOUNTED, IN THE 1970S IN LOS Angeles the various countercultural artistic elements seemed to be pulling the culture toward a revolt against the mainstream art market. It

had, Williams suggested, all begun with the culture of his youth. "You look back at the '50s as Mr. and Mrs. Idyllic America: the housewife in the apron, the man in the business suit," wrote Williams. "There were all these standards set up to revolt against, all these ideologies to knock down one by one." The tools of rebellion began, of course, with cars. "Hot rods were a mechanical–spiritual thing," Williams continued. "There was a romance to messing with the spirit of the car. There was also a machismo." From car culture, a clear form of art developed—from pinstriping, scallop paint jobs, metallic and metal flakes and pearlescent paints to overall car design, fabrication, metal-crafting, welding, chrome-plating, and so on. The revolution in car culture begat the underground comics movement, which in turn helped foster the rock 'n' roll–fueled psychedelic movement and evolved into the punk movement. "A lot of people who were doing punk were also going to art school," Williams continued, "so a whole shock wave of art came along with the music. It was like the '50s when Abstract Expressionism accompanied free jazz. Punk art was sloppy with a lot of Day-Glo colors. I was pulled into the energy of that . . . —rough, crude, and fast."[64]

The punk art movement, which had come along in the middle of Williams's career, inspired the artist to begin a series of paintings in the late 1970s called the *Zombie Mystery Paintings*. These works, which were even stylistically and thematically coarser and more raw than any he'd done before,[65] in turn influenced the look and feel of the reemerging cultures of surfing and skateboarding. To Williams, this all made sense—as it was all part of one driving impulse. He wrote in a chapter from his book from 1979 called *Lowbrow & Oddball Art*:

*"There is a thing called the Bohemian syndrome that pops up throughout history every fifteen or twenty years. It is the movement that makes a romantic virtue out of being contrary to the status quo, and its members have included revolutionaries, anarchists, malcontents, and parasites. This attitude, shared*

*by many artists, must go back to the beginnings of civiliza-
tion, but the name Bohemian was coined by the young French
Romantics of the early 19th century. The list includes famous
mavericks like Delacroix, Gauguin, Van Gogh, Cezanne,
and many other notables . . . . Whether they're Romantics,
Impressionists, Expressionists, Dadaists, Cubists, members of
the Lost Generation, Existentialists, Beatniks, poets, Hippies,
Flower Children, outlaw motorcycle packs, or artistically
inclined dope fiends, it's the same. It's the Bohemian spirit. It's
the desire to exceed social barriers and come up with some-
thing new, strong, and all-consuming, and to devastate former
cherished ideals."*

By the end of the decade and into the early 1980s, without anyone
really noticing how it happened, the streets and corner alleys and teen-
age basement bedrooms and nooks all over Southern California had
absorbed Williams's new bohemian spirit of the Southern California
streets. Everywhere could be found the trappings of an alternative,
broad-based, dynamic artistic sensibility and aesthetic that challenged
all notions—at least those notions received from the elite centers of
the art world—of what art was and how it functioned in the world.
And with all the creative production that was swirling around L.A.'s
streets at the time, Williams continued doing his damnedest to make
his art, and the art of others like him, impossible to ignore. Calling his
art practice a "blind obsession," Williams said he "put in about seven,
eight, nine hours a day, seven days a week" at it. And he promoted it
almost as tirelessly. "I have to get out and explain this artwork and
make it a functioning form of art," he added. "It's not about me as
a celebrity. I hate it, but I have to aggressively take this art out to the
youthful students, catch 'em while they're young."[66]

Perhaps not surprisingly, well after the close of the 1970s Williams
would prove successful in his quest—and wildly so. That he would
do so by sticking to his rebellious guns and also co-opting the very

system and structures he so often railed against says a lot about the sort of person that Williams was, as well as about the spirit of the various alternative cultures that percolated up like primordial tar from the streets of Los Angeles in the troubled decade. "On the one hand," said the curator Paul Schimmel, Williams always kept his back turned to the art world in terms of subject matter, iconography, and his embrace of popular culture. "So he kind of says, 'Screw you. But it'd be nice to be part of the group.' Well, you know, he is who he is."[67]

# The Horizontal City

*Public Art in the Landscape of L.A.*

A MONG THE COMMUNITIES OF THE GREATER Los Angeles metro area, none possessed streets that were more raw and colorful than Compton. Later notorious as the epicenter of gang violence and related urban blight, 1970s Compton, a community of around 100,000 residents almost eleven miles due south of Los Angeles, was just beginning to come to grips with a phenomenon later known as "Black Flight." African Americans had first flocked to Compton in the great postwar migrations of the 1950s and '60s. By the early 1970s, Compton had gained renown as a major center for African American culture. Boasting a population that was more than 90 percent black, the city elected its first African American mayor, Douglas Dollarhide,[1] in 1969. It was at this moment, however, that the churning, roiling, ever-restless streets of Los Angeles had a brutal effect on Compton, as many of the more mobile, middle-class African Americans who had helped build Compton into a vibrant urban center of black culture began to move away to more attractive areas that were quieter and boasted of better schools. And while the gap left behind by this second wave of migration would be filled by increasing numbers of (often lower-income) Latino and Hispanic residents, the new residents could not help solve the city's declining commercial and property tax base. In 1977, an audit revealed that Compton was two million dollars in debt. As a result, then, the streets of Compton in the 1970s became

an intense, microcosmic reflection of the forces that played on the psyches of residents of Southern California. The streets of Compton, in other words, were a place of struggle and unease, as well as a source of inspiration for a person open to it.

One person who would find inspiration there in the early 1970s was the local African American artist Elliot Pinkney. Having settled in Southern California after serving in the Air Force in World War II, Pinkney earned an art degree through the G.I. Bill at a local college and moved to the then-appealing city of Compton to set up shop as a sculptor, poet, and painter. By the early 1970s, he worked with an arts school called the Compton Communicative Arts Academy, which offered community-centered art education programs for local African American and Latino youth. At the Academy, Pinkney would befriend the African American painter, sculptor, and arts administrator John Outterbridge, who later became the first director of the Watts Tower Art Center. Between 1970 and 1976, Pinkney spearheaded a number of mural projects that involved the students of the academy. One from the early 1970s, for instance, was called "Ignorance and Poverty."[2] The mural depicted a two-headed snake (each head of the snake is labeled with the titular vices of the mural) wrapped around the torso of a large, bald, African American man in a twisting, S-shaped composition. This central figure held a giant eyeball in his outstretched right hand and a lit torch in his left. Two smaller figures battled against the snake at the foot of the painting, while in the top corners were two indigenous designs—one a sun with a face, the other a moon-like mask. Perhaps created as a way of coping with the realities of his changing community, Pinkney's painting was heavily didactic, but the artist compensated for this didacticism by employing the vibrant color, boldly emblematic shapes, and the dynamically flowing, twisting composition that local Chicano muralists had developed a few years earlier.

In 1976, Pinkney left his job at the Arts Academy and, thanks to a grant from the California Arts Council, focused his attention completely

on decorating the walls and public spaces in and near Compton. That year, Pinkney painted a small (three-by-six-foot) mural on a back door of one of the buildings at the Watts Towers Arts Center. Called "Peace and Love," its central image is the head of an African American man wearing a headband from which an ominous metal lock dangles. Down in the corner of the image, next to two smiling children, is an open book, out of which flows a rainbow that spans over the man's head and culminates in a key, presumably meant to unlock the band over the man's forehead. Again, the work makes an obvious statement that reveals the interior struggle of the artist, but Pinkney's verve and expressive energy overshadows the mural's obviousness and make a poignant statement about the troubles of the time and place.

In 1977 and 1978, the artist painted eight major murals whose thematic thrust was to celebrate the culture of African Americans both locally and beyond and to promote cross-cultural understanding. One massive work, called "New Worlds" (1977), depicted the sculptor Charles Dickson and was painted on the outside of his Rosecrans Avenue studio. It was a cheerful pastiche, painted in a typically lively style with a primary color palette and snaking pattern of composition. The mural included a sharp lineup of imagery: an African mask, a tribal woman with her child, a full-sized astronaut floating on a space walk flowing into a head-and-shoulder portrait of a saintlike African American matriarch, a man playing a jazz trumpet, and a large harlequin-like head of an African American youth.

Mural works like "New Worlds," in a sense, forced anyone coming within its vicinity to take notice. At ten feet in height and fifty-seven feet in length, the mural was designed to stand out even amid the blur of shapes and colors of the Southern California streets. It was meant to force you to contemplate what it celebrated—in this case, the history and culture of the African American community that lived along busy and heavily trafficked streets like Rosecrans Avenue. Later, Pinkney painted murals in more surprising places, where the ubiquitous commuters of Los Angeles would least expect to find sophisticated and

visually dynamic works of art. Starting in 1979, for instance, Pinkney took on the challenge of painting the freeway pylons located in the cast-off space underneath the elevated 91 Freeway at the corner of Santa Fe Avenue and Artesia Boulevard in South Central Los Angeles. This complex mural project, called "5 Pillars of Progress," was ultimately comprised of five pylons painted floor to ceiling with a pastiche of images not unlike the work found in Chicano Park. In sum, the work was meant to portray the progress of the black civilization; it included African tribal figures alongside African elephants, depictions of the slave trade and of the American era of slavery, the Civil War and eventual emancipation, and the twentieth-century struggle for Civil Rights. More mature and nuanced in its painting style, the murals must have been a neat surprise for any driver who noticed them in the dark and useless freeway-overpass space.

MUCH AS WITH THE CHICANO ART MOVEMENT'S USE of murals as an alternative, highly public, and community-oriented form of art, Los Angeles had been home to a long—though less celebrated—tradition of mural art by African American artists. Earlier in the century, for example, the thriving black-owned Golden State Mutual Life Insurance Company took an interest in fostering African American art, both by collecting it and by commissioning murals. In 1948, the company asked the African American architect Paul Williams to include two murals in the lobby of the company's new headquarters on Western Avenue. Painted on canvas by Charles Alston and Hale A. Woodruff, their two-panel mural, called "The Negro in California History," depicts little-known black figures and important community events from the previous several centuries in California. This includes images of the original pueblo settlers, "more than half of whom were of African descent,"[3] as well as depictions of African Americans who participated in the Pony Express, the building of the Boulder Dam, and the construction of the Golden Gate Bridge. " 'The Negro in California History' stands in stark contrast to L.A.'s other pre-1950 murals,"

wrote Robin Dunitz, an author and independent researcher on murals. "In the 1920s, banks, hotels, theaters, and major insurance companies hired successful artists to decorate their marble lobbies and offices with classical landscapes and glorifications of capitalist progress, and the local legacy of the federally sponsored New Deal murals (1933–43) is largely one of idealism—scenes of happy European-American suburbanites at leisure and sanitized versions of early California history."[4] But Alston and Woodruff's work presented another view of a community struggling to attain some semblance of the promised good life in America.

In the 1960s and '70s, as activists and organizers led the massive social push to eliminate discrimination and injustice against people of color, artists were motivated to follow the example of "The Negro in California History" and tell the true story of the local African American experience. In 1967, two brothers, Dale and Alonzo Davis, began gaining a reputation for their exhibitions of local African American artists like David Hammons and John Outterbridge, and starting in 1968 the Black Art Council began pushing the L.A. County Museum of Art to present African American–focused programming. Meanwhile, as occurred with the Chicano Art Movement, local black artists who were desperate for venues to show their work found whatever space they could in local community centers, church halls, libraries, and, of course, on the public walls and other structures of the city. "In 1976 I was a junior at UCLA," remembers muralist Richard Wyatt. "At that time I was bothered by the fact that there weren't enough works of art in the inner cities. I really wanted to start putting works of art where people lived. That was it for me, the niche—public works of art that are just as finely crafted as any gallery or museum piece."[5]

As was clear in the work of muralists like Elliott Pinkney, artists in Compton and its environs were clearly beginning to understand the unique qualities of the landscape. A number of African American and other artists took to decorating the many empty walls on the outside of buildings, on the edges of playgrounds and parking lots, and on

other roadside structures, with large and explosively colored murals. The empty walls and other spaces made premiere canvases for their works, perfectly suited to catch the attention of the constantly moving and churning streets of the city. Further, the walls were a perfect soapbox; that is, the "impetus for artists to use murals" was driven by a desire to secure an openly public forum to voice their political beliefs.[6] According to Robin Dunitz, more than one hundred murals were painted around Los Angeles in the 1970s and '80s by more than a dozen African American artists like Elliot Pinkney, Charles Freeman, Richard Wyatt, Roderick Sykes, and Alonzo Davis. Concentrated in places like Compton, South Central L.A., and Watts, the murals' themes, subjects, and styles varied widely. The most popular types are celebratory, boldly depicting black heroes, key historical events, and various aspects of African American culture. Others provide obvious didactic messages promoting education or warning of the dangers of drugs and gangs. "African-American muralists often see themselves as motivators," wrote Dunitz. "Instead of either reflecting or ignoring the despair and deterioration around them, they frequently choose to offer images of inspiration, beauty, and hope—a way forward."[7]

ASIDE FROM THE READY AVAILABILITY OF THE WALLS in Los Angeles, artists painted murals locally for another practical reason. These spaces existed within view of the streets, the very locales where Angelenos spend an inordinate amount of their time stuck inside their automobiles. If the automobile had been, for several decades now, the dominant influence on the culture of L.A.—a source of inspiration and consternation, of celebration and bemusement—then it makes sense to realize that a life spent inside a car traversing the sprawling array of local streets and highways had a marked effect on how locals saw the world. The role of the freeway in the development of the spacial sensibilities, aesthetics, even worldview of Southern Californians cannot be overstated. To understand Los Angeles, in other words, you need to know and understand its byways and highways. "The

freeway system supplies Los Angeles with one of its principal meta-phors," wrote author David Brodsly in the early 1980s. "Employed to represent the totality of metropolitan Los Angeles, it is the city's great synecdoche, one of the few parts capable of standing for the whole."[8] Or, as Joan Didion famously put it, "the freeway experience . . . is the only secular communion Los Angeles has . . . . Actual participation [in the freeway experience] requires a total surrender, a concentration so intense as to seem a kind of narcosis, a rapture-of-the-freeway. The mind goes clean. The rhythm takes over. A distortion of time occurs, the same distortion that characterizes the instant before an accident."[9] According to another commenter, the filmmaker Reyner Banham, driv-ing on L.A.'s freeways is a "special way of being alive . . . bring[ing] on a state of heightened awareness that some locals find mystical."[10] "The L.A. freeway is the cathedral of its time and place," David Brodsly added. "It is a monumental structure designed to serve the needs of our daily lives, at the same time presenting what we stand for in the world. It is surely the structure the archeologists of some future age will study in seeking to understand who we are . . . . The Los Angeles freeway is a silent monument not only to the history of the region's spatial orga-nization, but to the history of its values as well."[11]

By the 1960s, the local freeway system had grown so vast and omnipresent that it affected the ways people saw and thought about the urban landscape. By the '60s, the freeways were L.A.'s calling card. "Los Angeles' appeal lay," wrote David Brodsly, "in its being the first major city that was not quite a city, that is, not a crowded indus-trial metropolis. It was a garden city of backyards and quiet streets, a sprawling small town magnified a thousandfold and set among palms and orange trees and under a sunny sky . . . . The L.A. Freeway makes manifest in concrete the city's determination to keep its dream alive."[12] The system, after all, was so predominant it was the first physical aspect of the landscape that new immigrants to the region—including those coming up from Mexico, or African Americans coming West in search of a better life—experienced of the region.

In earlier times, when less resource-intensive but less self-determined modes of travel held sway, city transportation fostered a "multicentered way of life,"[13] in which smaller communities connected with each other through various and diverse patterns of movement. After the construction of the urban freeway system, the suburbs of greater Los Angeles suddenly were connected by a fluid system of constant exchange facilitated by the freeways. The way Angelenos tended to see their city in the 1970s (and now)—from behind the windshield of a fast-moving, freeway-bound car—was therefore an impressionistic and blurred mishmash of images. The visual aspect of Los Angeles was, and is today, in a word, *horizontal*—unvaried, devoid of visual highs and lows, riddled with white noise. L.A.'s shapes, structures, colors, neighborhood sights, landmarks—all the visual markings of the region—are, to the constant commuters that call the city home, flattened. To Angelenos on the go in the 1970s, nothing in the landscape, except perhaps only the most jarring breaks in the visual pattern, stood out.

The Angelenos' way of viewing the landscape led to several clear consequences. For one, advertisers and developers began creating bold and oversized signage, billboards, electronic displays, and technology-driven architectural ornaments that would attract attention. "The truth is," social critic Tom Wolfe wryly wrote in a 1968 essay, "how drab Los Angeles . . . would be without the electrographic car fantasy mobile architecture that America's avant-garde commercial artists have given them."[14] In addition, the Angeleno sense of space that emerged in the 1960s and 1970s created a particular condition. In a region that was too vast and flattened to be comprehended or held onto at once, Angelenos battled a constant sense of spatial anxiety and sought compensation of any sort. In this, the local freeway system became a clear coping mechanism, and by the early 1970s it was the freeway that locals turned to in order to integrate the region's disparate parts and provide a sense of connection. Considering the central position of the freeways amidst the vast visual noise of an ever-expanding city, it

made sense that they would eventually come to loom large in the cultural outlook of L.A.'s creative artists.

By the mid-1970s artists had realized that the best locales for their murals were the retaining walls, berms, and other freeway containing structures of the city. In 1973, for instance, Los Angeles established, with the help of a federal grant, the Inner City Mural Program, the first such mural program in the city. Funded specifically by both the Los Angeles County Department of Parks and Recreation with a matching grant from the National Endowment for the Arts, the project commissioned twenty murals during the twelve months following June 1, 1973. One of the best known results of this granting program is Kent Twitchell's "Old Lady of the Freeway" (also known as the "Freeway Lady" and "Old Woman of the Hollywood Freeway"), which, though it would be painted over by the owner of the building it appeared on in 1986,[15] was later identified as one of the earliest Los Angeles murals to be designed with freeway travelers in mind.

Twitchell's story is in line with that of other L.A. muralists of his time who came to the region on the Eisenhower Freeway Systems during the country's automotive heyday. Born in Michigan, Twitchell joined the Air Force out of high school and headed west after his discharge in 1966. Twitchell studied art at several local schools, including Otis College, and took up mural painting in 1971, honing his own particular sharp and stunning photo-realist style. Even before the "Old Lady" mural, Twitchell had tended to paint many of his projects on the large sides of buildings near or facing freeways, relishing the idea that drivers would be startled by the images' almost cinematic qualities as they zipped by and caught only a furtive glance at them. Twitchell painted "Old Lady of the Freeway" on a wall in Echo Park that looked down on the passing Hollywood Freeway traffic; the mural depicted an elderly woman wrapped in an old-fashioned, rainbow-colored, knitted afghan. The look on the woman's face was uncompromising, confronting the passing travelers with a knowing and, some said, comfortingly sad look. The hand that grasped the afghan was gently aged

and somehow just as comforting as the woman's face; her white hair, elegantly and dramatically pulled back on her head, gave her an additional aura of dignity and wisdom. In the dark space over the woman's right shoulder, meanwhile, was a blue-marble-like image of the moon. Over the moon, the afghan curled and flowed as if being buffeted by a somewhat strong wind. Apparently, in the relatively brief time that the "Old Lady of the Freeway" existed, local commuters came to love the mural. So many locals were shocked when it was suddenly whitewashed over that this led to the founding, in 1987, of an organization dedicated to the protection and conservation of L.A.'s many murals—the Mural Conservancy of Los Angeles (or MCLA).[16]

The Inner City Mural Program was ultimately a pioneer in the placement of murals on and around the city's freeway retaining walls, on-ramps, overpasses, and other such structures. Another of these freeway murals during that first year was Judith Von Euer's "Flow Inversion Project: Inverted Freeway."[17] Von Euer, who was appointed professor of art at Los Angeles Valley College in 1963 and had a strong interest in the overlap between fine art, dance, and music, had applied to the Inner City Mural Program after reading about it in a local newspaper. As Von Euer described it, she was interested in designing a mural that would create a background setting for jazz and other musical performances. Luckman Glasgow, the director of the Inner City Mural Program, informed Von Euer that two freeway walls were available, and the artist chose a spot in downtown because it reminded her of Pershing Square, where she and her sisters performed tap dance routines during World War II bond drives, and of the Mayfair Hotel, where she performed jazz. To complete her mural, Von Euer enlisted the help of several L.A. Valley College students and though the image is massive—spanning 36 feet in height and 135 feet in length—the team completed the mural in only four days. Using just six colors of Dunn and Edwards paint—ranging from white and pinkish ochre to slate gray and black—"Flow Inversion Project" depicts an energetic abstract pattern of slanting background bands over which are painted

four scallop shapes each containing their own abstract pattern. In sum, the image looks something like a quick atmospheric glimpse of storm clouds, or perhaps a fleeting video of smoke pouring from a blazing fire. Von Euer's own description of the image suggests she saw it as something much less literal: "a link between northbound Los Angeles traffic and Fremont St. pedestrian traffic, . . . a diagram of a system of interactions, a backdrop for city events, street gangs, L.A. Fire Dept. Sunday morning maneuvers, Dorothy Chandler Pavillion (sic) viewing parties, and secret inner-city happenings."[18]

After the Inner City Mural Program ended, the impulse for artists to paint freeway spaces slowed but did not disappear. In 1975, underneath the Hayvenhurst Avenue overpass on the Ventura (101) Freeway, Sandy Bleifer painted a mural tinged with edgy and humorous social commentary called "Can of Cardines." Executed in a loosely photo-realist and slightly Surrealistic style and sponsored by the Citywide Mural Project, Bleifer's mural depicts several stacks of multicolored, 1960s-era discarded car carcasses stuffed inside a giant sardine tin. The top of the can has been rolled back with a key to reveal the cars inside, hinting at the artists' feelings toward the increasingly disposable and out-of-control nature of the local culture. Bleifer was a Southern California native who studied art and classical music at UCLA and worked as an artist-in-residence at area schools. Her other, non-mural art was often about conservation, making use of recycled materials, handmade papers, and other elements of the natural world. As for the viewer's (i.e., typical freeway driver's) experience of the work, while the mural is sizeable—measuring ten feet in height and twenty feet in length—fully comprehending it must have been challenging and reliant on repeated viewings. Still, the color and spirited nature of the work was popular enough to Angelenos that it was chosen, out of the nearly 1,500 murals that were eventually painted in Los Angeles, to be one of the first projects restored and protected by the Mural Conservation Program of L.A.'s Department of Cultural Affairs.

BY 1975, THE GROWING LOCAL ART MURAL MOVEMENT
began to show signs that it was defining and refining itself. While the
basis of the mural movement had been established by works of intrigu-
ing cultural and historical value, each successive mural project subtly
pushed artists to make work of deeper local significance. Though most
murals in Los Angeles in the mid-1970s still tended to be somewhat
one-dimensional—either populist in nature (realist portraits, Pop-Art
influenced, or simplistic abstractions) or blunt in addressing political
or social issues (racial strife, community empowerment, and other
bootstrap exhortations)—around 1975 a new generation of young,
ambitious artists began to explore what was truly possible to create on
local walls. As a result, during the second half of the decade in the open
streets and on the public walls of L.A. artists created a broad range of
expressive, experimental, and conceptually daring works of art.

One of the earliest and best examples of a more meaningful mural
was created by the artist group known as Asco. Beginning in 1972 and
lasting through the decade, Asco, whose name comes from Spanish
slang for "nausea,"[19] began as a tight-knit core of artists from East Los
Angeles—including Harry Gamboa, Jr., Gronk (aka Glugio Nicandro),
Willie Herrón, and Patssi Valdez—who sought to connect the burgeon-
ing local Chicano Art Movement to the current national and interna-
tional discourse in avant-garde art. This fact made the group fairly
unique at the time and forced them into something of a cultural and
aesthetic no-man's land. "Geographically and culturally segregated
from the still-nascent Los Angeles contemporary art scene," wrote the
authors C. Ondine Chavoya and Rita Gonzalez in a survey of the work
of Asco some years later, "and aesthetically at odds with the emerging
Chicano art movement, Asco interacted with but were never fully inte-
grated into either scene or framework."[20] Asco's approach was par-
ticular and risky, but because of what art historian Shifra M. Goldman
described as their unique ability to "extrapolate successfully from the
U.S. avant-garde . . . and make social statements,"[21] the group's work
also was explosively idiosyncratic and confrontational.

Asco's highly sophisticated work paid close attention to the specific conditions and the economic, social, and ideological boundaries that existed in their Los Angeles home and that acted upon, in particular, young urban Chicanos. At the same time, the very sophistication and the forward-thinking ideas and work practices of the group thrust these artists into the middle of the international art dialogue of the time—and into the ongoing development of such new movements as Correspondence Art, Fluxus, and other Performance and Conceptual Art networks of "like-minded, marginal(ized) practitioners around the globe."[22] The results were not insignificant. "What Asco achieved that is so important and powerful," continued Chavoya and Gonzalez, "is to combine the Conceptual with political specificity and a sense of responsibility . . . . Asco's involvement in the new tendencies of body art, Conceptual practices, dematerialization, and Happenings were inherited or in dialogue with broader social and aesthetic contexts, taking shape in a highly political and volatile moment in history . . . . This condition was further amplified by their interest in hit-and-run tactics, ephemeral or dematerialized practices, and the ways in which their work frustrates the archives and collecting practices of art institutions and the art market."[23] Asco's work was designed to be transgressive and difficult to define—subverting, exploiting, and challenging the conventions of existing cultural detritus like murals and gang graffiti by addressing them with guerrilla-like interventions. In the end, these Asco interventions transformed local cultural trappings into highly charged and socially provocative art infused with movement, action, and performance.

Asco's first public work, for example, was a performance called "Stations of the Cross" (1971). Conceived as a one-mile procession that would move along busy Whittier Boulevard in East Los Angeles during the holiday season, the work subverted the Spanish and Mexican Catholic tradition of *Las Posadas*, a mock procession that symbolized the pregnant Mary's travels to Bethlehem. In the work, Gamboa, Gronk, and Herrón donned costumes and painted their faces as Day

of the Dead–style skeletons and dragged a fifteen-foot cardboard cross, decorated with spray paint and glitter, along the sidewalk of the busy boulevard. At the end of the procession, the three costumed artists stopped in front of a Marine Corps recruiting center, observed a ritual moment of silence, then dropped the cross at the center's door and fled the scene. The intention of this first public work of performance by Asco was to commemorate and protest the deaths of young Latino soldiers in Vietnam, but the most remarkable thing about the work, perhaps, is the fact that it was barely distinguishable from the real cultural background noise of the streets of L.A.—at least not in view of the wider mainstream. As a case in point, a photographer named Seymour Rosen just happened to be on Whittier Boulevard that day looking to photograph something "traditionally Chicano"[24] as a holiday image. It wasn't until later that Rosen realized his photos documented the first public appearance of an energetic new art group.

After "Stations of the Cross," Asco developed a range of projects. In early 1972, members made a "ceremonial journey" to the Mara Villa projects in East Los Angeles to inspect "hidden murals" at the construction site. The three artists wore costumes similar to the ones they wore in "Stations," and their approach was again theatrically ceremonial. They scaled the location's mounds of dirt, made grainy 8-mm movies of their activities, and later used the footage to build theatrical performances. Even this early in the group's existence, several key components to their artistic approach were evident. For one, their social critiques focused primarily on "contested urban spaces"[25]—that is, Asco operated in the congested barrio streets, around crowded public housing developments, and in other places associated with public strife and frustration. Still, they asked questions of these spaces that other artists were not asking.

In 1973, Asco artists Gronk, Gamboa, and Herrón established a shadowy project called Midnight Art Productions that began marking up the abandoned wall spaces of outdoor Los Angeles in a series of high-concept projects called the "Instructional Destruction Projects."

These works were dualistic in nature, at once "comparable to the lin-
guistic forms of dissent that appeared on walls internationally, ema-
nating more from post-1968 protest rhetoric," but also adopting the
style and feel of "Cholo graffiti that centered on the *placa* (insignia) as
a symbolic marker of territory or affiliation."[26] All along Santa Monica
Boulevard for nearly three years Midnight Art Productions spray-
painted provocative phrases in the typical manner of other *placas* that
even people in the know could scarcely distinguish from the regular
graffiti noise on the city's walls at the time. Among the phrases the
group used, though, were sophisticated and sharp political messages
that reflected the concerns of the expressway generation, including:
"Pinchi Placa Come Caca" ("Fucking Cops Eat Shit"), "Gringo Laws
= Dead Chicano," "Comida Para Todos" ("Food for all"), "Yanqui
Go Home," and "Viet/Barrio." "Unlike the revolutionary aspirations
of the Brown Berets or the C.L.F," wrote Chavoya and Gonzalez,
"Midnight Art Productions expressed the ultimate irony: the graffiti
conveyed a point of view encountered by its public but, as Gamboa
recalled, 'it's an expression of how powerless we ultimately are since
we left the buildings standing.' "[27]

In 1973, two members of Asco—Willie Herrón and Gronk—
made a splash by painting a mural on the wall of a housing project on
Olympic Boulevard in the Boyle Heights neighborhood of Los Angeles.
This fact alone was not unusual—by one count, eighty-two mural
projects were commissioned in the area between 1972 and 1978[28]—
but this mural, called "Moratorium: The Black and White Mural,"
had a few unusual features. First, it was monochromatic, completed
using just black and white paint. Second, its various motifs—which
invoked the institutionalized injustice of certain historical events[29]—
were arranged in a sharp grid-like pattern and painted with a gritty
and grainy lack of focus that resembled television news images and/
or the films of the European New Wave, such as Gillo Pontecorvo's
*The Battle of Algiers* (1966). For once, this was not folkloric uplift and
exhortation; instead, "Moratorium: The Black and White Mural" was

a highly sophisticated, deeply charged, art world–insidery bit of image-making that would not have been out of place in the halls of CalArts.

The walls of L.A. over time became a key component of Asco's highly experimental artistic investigations and performances. Prior to the founding of Asco, Willie Herrón had been widely known around East Los Angeles for his boldly expressive murals, particularly "The Wall That Cracked Open" (1972), which is considered by many to be a local high point of the Chicano mural movement. The work, which was the artist's tribute to his brother, a victim of gang violence, employed *trompe l'oeil* effects in depicting an anguished face and several other figures emerging from a crack in the wall's surface. Many of the works that Herrón and Gronk would create as part of Asco would be more subversive and unsettling than was normal in local murals, particularly in how they called attention to the contentious nature of public spaces. A number of Asco's "mural" projects were also framed as a response to the Vietnam War and its effect on the community. "A lot of our friends were coming back in body bags," said Gronk some years later, "and we were seeing a whole generation come back that weren't alive anymore."[30]

In approaching such issues, Asco sometimes played fast and loose in defining what exactly comprised the mural form. As with the artists who rejected the premise of the "Art and Technology" show in 1971, the young artists of Asco sought to oppose the power structure by mobilizing the public through alternative modes of expression. The Asco "mural" often more resembled the Happenings of Allan Kaprow or the "be-ins" of radical political organizers. As he readily admitted, Gamboa had become radicalized in the late 1960s. "I was very active in the affairs of my community," Gamboa wrote in an autobiographical statement around that time. "I was deeply bothered and disgusted with the condition of my community and of the Mexican-American people. I learned to distrust and dislike everything that was pro-establishment."[31] Adding to the sense of alienation and frustration of these young Chicano artists were the shifting conditions of East Los Angeles. In the late 1960s, as

happened in San Diego and many other cities, the Los Angeles Transit Commission constructed a series of freeway interchanges and retention walls with no regard to neighborhood continuity, and East Los Angeles was divided from itself. The action created so much awareness of how public policies and urban planning could create conditions of economic and geographic disparity and stratification that the scholar Raul Homero Villa called this the "expressway generation."[32]

Asco's emphasis on street-based protest, and on Performance, Action, and Conceptual events, reflected the group's own particular response to the times. The work of Asco, suggested Villa, "identifies a conjunction of social effects that, like a social cordon around the barrio, set the limits of mobility for many of its residents."[33] By design, then, Asco's aesthetic focus rejected the Chicano Art Movement's focus on historical imagery, pseudo-surreal expressiveness, and semi-socialist-realist portraiture and exhortations to la raza. In the process, Asco created an entirely new category of hybridized art: Conceptual graffiti. And the group's interest in walls and wall murals would explode after 1972. That year, according to an oft-told story, Harry Gamboa, Jr., visited the Los Angeles County Museum and, noting the absence of Chicano and Mexican artists in the galleries, later sought out a museum curator to discuss the lack. The curator's dismissive response, that Chicanos did not make fine art but made "folk art" or were "in gangs,"[34] raised Gamboa's hackles. One evening shortly thereafter, Gamboa and two of his Asco collaborators, Gronk and Herron, scrawled their names in graffiti-like lettering at the entrance of the museum, as though they were claiming the institution as their own turf. The next morning, Gamboa returned to photograph a fourth Asco member, Patssi Valdez, standing near the work, which he now called "Spray Paint LACMA" (1972). That the work was quickly painted over didn't matter; this only added to the subversive value of the performance, making it another "hidden mural" like the ones they found at the Mara Villa projects or that existed under the industrial paint applied by the mainstream culture. In time, a photo of "Spray

Paint LACMA" circulated far and wide as a kind of calling card, and call to arms, for the group.

After this watershed moment, the group continued working "to enliven and rethink muralism in an attempt to make mobile and elastic a form of art that by the early 1970s—for some artists—had become institutionalized and all too often restated nationalistic or domestic themes and iconography."[35] Among the tactics Asco used to do this was ephemerality. By treating the mural as a temporary thing, they were able to bypass the "rigidity of muralism's status as the proscribed and generative vehicle for artistic training, expression, and experience within the Chicano movement."[36] In a subtle and subversive way, Asco raised questions about the value—in an era of continued discrimination, increasing economic strife, and the injustices of the Vietnam War—of the standard style, themes, and format of murals. And the group raised questions of what expressive tools, exactly, could be employed—temporary graffiti, expressive marks, performance, theater, etc.—to make a work that, while still remaining far outside tradition, could still be called a "mural." In 1972, for example, the group created an amusing work called "Walking Mural." In his work, which was a mural in name only, the group set up a performance in which they were cast as classic characters from the Mexican culture. Herrón, located in the center of the composition, held three paper heads similar to Mexican masks, while Valdez was a creepy Virgen de Guadalupe in a see-through costume, and Gronk was a blue-ornamented Christmas tree. After some time, the characters became so bored with themselves and their staid surroundings that they separated themselves from the wall and took off down the street. The obvious message of this work was to comment on the staleness of the ubiquitous Chicano mural and its inert, almost cliché imagery and ineffective sociopolitical messages. "Walking Mural" also continued, in a subtle way, Asco's efforts to reclaim public space for work that was more biting in its political messaging.

According to Gronk, "Walking Mural" was a small turning point for the group, setting them off on a path of sudden and spontaneous,

in-your-face performance art events. "I was interested in the temporal nature of things," he said of that era. "And I think one of the important things about our activities was the idea that we didn't ask for permission to do any of the work."[37] A few years after "Walking Mural," the group conceived of an iconic reconsideration of the mural. Called "Instant Mural" (1974), in this work Gronk acted as a ringmaster-like figure, positioning two Asco collaborators, Patssi Valdez and Humberto Sandoval, against a blank wall on Whittier Boulevard and, as traffic rumbled by, theatrically affixing them to the wall using roles of fat white paper tape. Gronk wrapped Valdez in so much tape that she appeared enshrouded and stuck on the surface of the mural. A moment later, Valdez burst from the tape, as though she were freed at last from the constraints of the staid mural form. This would be the ultimate statement by a group bent on bringing an ossified art form up to contemporary times.

OTHER SOCIALLY AND AESTHETICALLY INNOVATIVE and forward-thinking mural-type works complemented Asco's rethinking of the mural form, and these proliferated around the streets of Los Angeles throughout the 1970s. For instance, the African American artist David Hammons, finding local avenues for his work slowed by speed bumps similar to those faced by Chicano and women artists, formed his own collective, called Studio Z, that met in his space on Slauson Avenue to explore a range of alternative media and formats of expression. Hammons had come to Los Angeles from Springfield, Illinois as a young man in 1963, studying first at Los Angeles City College before transferring to the Otis Art Institute and the Chouinard Art Institute, from which he graduated in 1968. Starting by making body prints similar to those of Yves Klein, in the 1970s Hammons's production became more and more experimental, drawing influence from Dada, Art Povera, and the home-grown assemblage of artists like Ed Kienholz. In time, he developed a style that incorporated such eccentric elements as barbecue grease, chicken bones, rocks, empty

wine bottles, and other found materials that connected him with his physical surroundings and were charged with racial identity.

Meanwhile, in collaboration with his shifting cast of cohorts at Studio Z—including Franklin Parker, Houston Conwill, Ulysses Jenkins, Maren Hassinger, and Senga Nengundi—Hammons also made work that was performance-based, highly political, and connected with the streets, walls, and public spaces of Los Angeles. "I think I spend 85 percent of my time on the streets as opposed to the studio," he explained some years later. "So when I go to the studio I expect to regurgitate these experiences of the street. All of the things that I see socially—the social conditions of racism—come out like a sweat."[38] One important collaborative relationship that developed out of Studio Z was Hammons's with Senga Nengundi. Born Sue Irons in Chicago, Nengundi came to Los Angeles with her mother when she was seven. While majoring in art and dance at Cal State Los Angeles in the late 1960s, she volunteered at the Watts Tower Art Center and learned about community-based art practices and the use of experimental art materials. Pantyhose, for instance, appeared in her work. Often transformed, filled, knotted, torn, and stretched to the limit, this unique material seemed, in Nengundi's hands, to suggest certain feminist ideas—constriction, pain and violence, pregnancy, and the bodily presence of a woman. "Nengundi steals the prize for delight with her inventive series of installations of pantyhose," wrote one critic of her work in the 1970s. "By stretching, filling parts with sand, and artfully tucking and pulling, she has created images which are at once tender, poignant, and funny reminders of the frailty of human form."[39]

In March of 1978, these artists' interests and the group energy of Studio Z culminated in a collaborative artwork called "Ceremony for Freeway Fets." Conceived of and instigated by Nengundi in concert with Hammons, Hassinger, and others, this performance work took place underneath the massive freeway underpass of Pico Boulevard near the Convention Center and marked the occasion of Nengundi's sculpture "Freeway Fets" being installed at the spot. That the project

was supported by Caltrans, the governmental department that oversaw the freeways and roads of the state, was a sure indication of the rising stature of murals, Performance Art, and the intersection between the two. "They had initiated this art program," Nengundi told a filmmaker at the time, "where they were trying to get sculpture and paintings, murals on freeways or surface streets. We started talking about it and started looking for areas that might be suitable. In my mind, I wanted it to be around the freeways where the columns were. So I started look- ing at those areas." The site Nengundi chose was appealing because the spot was vaguely reminiscent of Africa. "There were little tiny palm trees," she said, "shrub grass, and a lot of dirt. It was just the kind of feeling that I wanted. I kinda wanted to make it like fetishes, and I called it 'Freeway Fets.' Fet was short for 'fetishes.' " Nengundi draped the columns in different ways with varying sorts of cloth, bulging and tangles masses of pantyhose, and so on to make a play back and forth between different types of energy. "Some of the columns were to repre- sent female energy, and the others represented male energy."[40]

The opening ceremony for "Freeway Fets" also explored the play between male and female energy. For the performance, Nengundi dressed up in loose, white drapery and wore female-like headdresses, while Hammons dressed up with a strangely amorphic headgear and darkly male clothing. "I was kind of bringing these two forces together to unite," Nengundi said. "I put that mask on and it was a whole 'nother person dancing around in there. It was one of the most unique experi- ences I ever had. I really just felt as though I was someone else. I really felt at a point that I was practically possessed, some kind of energy was just moving me around there. At one point, I didn't ever know what I was doing. It was just in this rapture, and I just kept going."[41]

BY DESIGN, THE WORK OF THE MORE AVANT-GARDE, Conceptual-minded mural artists in the later 1970s diverged from its source of inspiration—the more populist and social revolution– minded muralists of the Chicano Art and other social-minded group

movements—and pushed the form closer to current art-world dis-course. The push by these artists to bring local mural art up to date in terms of art-world currency, however, did not halt the continued development of more populist and sociopolitical mural work in Los Angeles. Indeed, in 1976, even as Asco delved further into its ongo-ing investigation of the urban fabric with a series of absurdist, experi-mental "No-movies,"[42] a lone artist had conceived of a project that would be the *ne plus ultra* of local populist mural works. The project's organizer was an energetic young artist named Judith Baca, and her conceived project would, in time, become the largest, most elaborate mural project in California (and, some suggest, in all of the world).

Baca, a Southern California native of Mexican heritage who grew up in Watts, earned an art degree at California State University, Northridge (then called San Fernando Valley State College), and began work as a high school teacher. She was fired, along with several of her fellow Latino teachers, after participating in the 1970 Chicano Moratorium to protest the Vietnam War. At a loss for what to do next, she took a job teaching art for a summer program with the Los Angeles Parks and Recreation Department located in Boyle Heights, a neighborhood known for its high number of gangs. While in this posi-tion, Baca noticed that many of the walls of the neighborhood were heavily marked with graffiti. Realizing the importance of the walls, she decided to enlist members of four different gangs to join a group called "Las Vistas Nuevas" ("New Views") that would create murals as meaningful and attractive outlets for the neighborhood to express and explore its own culture. "I want to use public space," she would later explain of her approach, "to create a public voice for, and a pub-lic consciousness about, people who are, in fact, the majority of the population but who are not represented in any visual way. By telling their stories, we are giving voice to the voiceless and visualizing the whole of the American story."[43]

Of utmost importance to any mural project, Baca realized early on, were the specific realities of the site and its surrounding culture.

These details were often necessary to secure buy-in from local mural participants and, ultimately, to bridge differences that existed in the surrounding community. "It doesn't matter whether it's East Los Angeles or whether it's Skid Row or whether it's a migrant farm workers' town," Baca later insisted. "In each case you begin with an analysis of that site. And you begin to find out what are the social as well as the physical elements of a particular place."[44] The first "New Views" mural that Baca spearheaded was situated in Hollenbeck Park. Called "Mi Abuelita" ("My Grandmother"), the work depicted a typical elderly Mexican American woman with her arms outstretched as if to offer a hug. The project was not easy to complete—gang members not involved in the group, for instance, tried to interfere, and the site was frequently vandalized. The police and city officials also flatly refused to sanction the project, considering it a dangerous experiment. But Baca was determined to carry on, setting up lookouts to warn her of approaching gang members and police. And she somehow got the job done, in the process winning over the skeptical city officials. "The city was amazed," said Baca, "making murals with kids who scared directors out of neighborhood centers."[45] The neighborhood, too, was more than pleased with the work. "Everybody related to it," Baca said. "People brought candles to that site. For twelve years people put flowers at the base of the grandmother image."[46]

Spurred by the attention and positive feedback, *Las Vistas Nuevas* would complete a total of three murals that summer. Because of her success, in the fall of 1970 Baca was offered a position as the director of the new Citywide Mural Project. Again she was thrust into a maelstrom of city politics—this time over the proper way to depict life in Los Angeles. On one side, artists and community members sought to depict life as it really was. On the other, however, city officials were sensitive to any depictions of controversial subjects. After one fight over a mural that depicted people struggling with the police, Baca decided to step down from her job with the Parks and Recreation Department and start her own mural organization. In 1976, she formed, along with the

painter Christina Schlesinger and filmmaker Donna Deitch, a nonprofit organization called the Social and Public Art Resource Center (SPARC).

SPARC's mission was to foster the creation of murals and other forms of public art around Los Angeles (and beyond) that address social issues, foster cross-cultural understanding, and promote public discourse about a range of issues. The center also sought to preserve and educate the public about the wide diversity and rich cultural heritage represented by the public art works situated in and around Los Angeles. In more explicit terms, SPARC was intended particularly to produce and promote murals and other public projects that reflected the lives and struggles of the community's ethnically and economically diverse populations. This included, in the view of Baca and her colleagues: women, the working poor, youths, the elderly, and new immigrant communities. "Our ultimate purpose," suggests the vision statement of SPARC today, which still exists even more than thirty-five years later, "is to examine what we choose to memorialize through public art, and to innovate means which not only produce excellent art works but also provide a vehicle for the betterment of community through a citizen's participatory process. SPARC's works are . . . a collaboration between artists and community members, resulting in art which rises from the community rather than being imposed upon it."[47]

With SPARC, Baca drew upon the precedent of the Chicano mural artists to create murals that highlighted the ethnic identity and cultural history of the community. She had no idea of how wide the scope of the organization's biggest and greatest achievement would be: A mural whose focus encompassed the rich ethnic and cultural diversity of the entire region. Back in 1974, when Baca was still working for the city, she had been contacted by the local U.S. Army Corps of Engineers about creating a mural on the walls of the Tujunga Wash flood control channel. The section of the wash that the Army Corps had targeted for beautification was located at Coldwater Channel Avenue between Burbank Boulevard and Oxnard Street in Van Nuys. The structure, which served the purpose of channeling any potential flash flooding

that occurred in the ancient, mostly dry riverbeds of the San Fernando Valley and sending it quickly into the nearby ocean, was generally considered to be an urban blight and an eyesore—a wide and dull squarish expanse of concrete over which were built a number of large roadways and freeway overpasses that crisscrossed the landscape. By the 1970s, as well, the Tujunga Wash and the entire flood control system were deemed a disaster, depleting local aquifers and causing widespread pollution in the Los Angeles bays.

In 1976, with the backing of her new organization and the financial assistance of a number of government agencies such as the Summer Youth Employment Program, community organizations, local businesses and corporations, charitable foundations, and individuals, as well as cosponsorship of the Citywide Mural Project and Project Heavy–San Fernando Valley, Baca began the effort to paint a massive mural on the walls of the Tujunga Wash. For much of the year leading up to the commencement of the project, Baca worked hard to research subjects and potential images for the mural, organized a team of professional artists to muster the efforts of the youths who were to execute the work, and then recruited the several dozen youths of various ethnic and cultural backgrounds between the ages of fourteen and twenty-one, whom she called the Mural Makers. At the start of the first stretch of the "Great Wall of Los Angeles," as the project came to be known (though its official name was "The History of California"), there were fifteen supervising artists representing the diverse communities of the region.[48] Still, the real keys to the project were the fifty-nine youths who signed up to work in the Mural Maker crews. Many of these youths were from low-income family backgrounds and were paid through the city's Youth Employment Program. SPARC provided these young artists instruction in painting techniques and art and cultural history (of the subjects to be depicted in the mural), and also provided improvisational theater and team-building exercises that were intended to provide the Mural Makers the ability to work within a group of people with diverse cultural backgrounds.

After Judith Baca completed her design sketches for the mural in collaboration with her team of supervising artists and youths, she blew up the sketches to large pieces of paper that would serve to transfer the image to the painting surface using the "pounce" technique.[49] The plan was to paint a length of the wall that would stretch to 1,000 feet, divided into ten segments of 100 feet each. Each segment, while meant to be somewhat integrated into the whole of the image, was designed by a different artist and had its own subject, themes, and, , ultimately, its own independent look and feel. Before transferring the drawings to each wall segment, crews first sandblasted the working surface of the wall to remove dirt and smooth it down. They followed by water blasting the wall and covering the surface with an acrylic sealant that would protect the painting on top from any moisture seepage. Gridlines were painted on the segments to match the lines that had been made on each drawing, giving each painting crew a series of smaller, clearly discernible sections of the image to paint. Crews then applied, as a ground for the image, a transparent magenta paint, which would help harmonize the mural colors even as it reduced the glare of the midday L.A. sun that would shine back into the artists' eyes as they painted.

The project faced several logistical problems from the start. There was no easy way to get the dozens of Mural Makers and artists to the bottom of the wash where the mural was slated to appear, so they all had to be driven to (and back from) the site from an entry point located two and a half miles away. This tedious process was further complicated by the fact that everything the crews needed—water, food, portable toilets—had to be carried with them, adding to the general exhaustion felt after toiling long hours under the Los Angeles sun. Furthermore, the entire mural area had to be sandbagged so that any residual water from the elusive Los Angeles River could be kept away from the work crew, where it might cause a hazardously slippery ground on which to place ladders and scaffolding and other devices and structures necessary to the work.

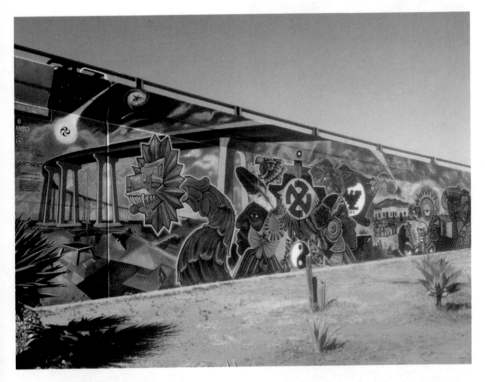

**"The Return of Quetzalcoatl" (1973)**
*Artists: Mario Torero and El Congreso de Artistas Chicanos en Aztlán (CACA)*

The first mural painted at Chicano Park in San Diego, "The Return of Quetzalcoatl" was the work of muralist Mario Torero and his group El Congreso de Artistas Chicanos en Aztlán (CACA).

PHOTOGRAPH BY MARIO TORERO AND USED COURTESY OF THE ARTIST AND EL CONGRESO DE ARTISTAS EN AZTLÁN (CACA)

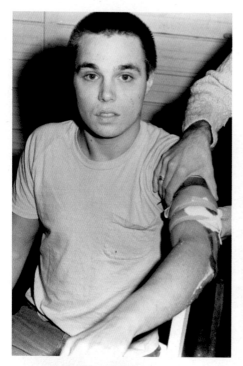

**"Shoot" (1971)**
*Artist: Chris Burden*

Burden's own description for his seminal Performance piece "Shoot," which took place at the F Space in Santa Ana, California, on November 19, 1971, read simply: "At 7:45 p.m. I was shot in the left arm by a friend. The bullet was a copper jacket .22 long rifle. My friend was standing about fifteen feet from me."

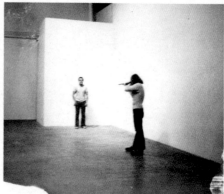

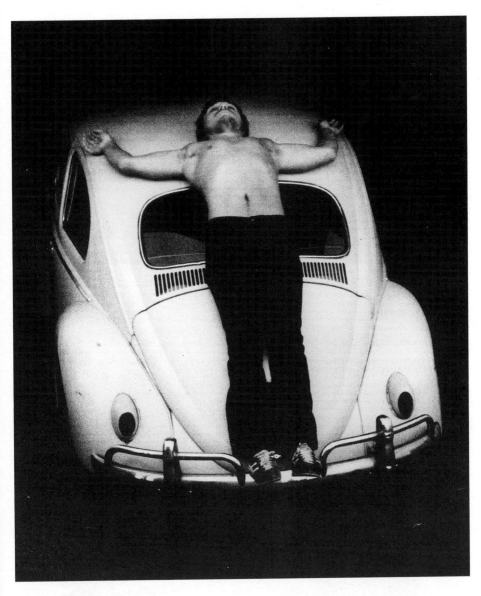

**"Trans-fixed" (1974)**
*Artist: Chris Burden*

Burden's description for his shocking 1974 performance "Trans-Fixed" read: "Inside a small garage on Speedway Avenue, I stood on the rear bumper of a Volkswagen. I lay on my back over the rear section of the car, stretching my arms onto the roof. Nails were driven through my palms into the roof of the car. The garage door was opened and the car was pushed half-way out into Speedway. Screaming for me, the engine was run at full speed for two minutes. After two minutes, the engine was turned off and the car pushed back into the garage. The door was closed."

**"In Search of the Miraculous (One night in Los Angeles)" (1973)**
*Artist: Bas Jan Ader*

This 1973 photo by Bas Jan Ader, given the handwritten caption "yeh, I've been searchin'," was the first in a series of eighteen silver gelatin prints made as part of a larger Performance Art work by the artist called "In Search of the Miraculous (One night in Los Angeles)."

**"Ablutions" (1972)**
*Artists: Aviva Rahmani, Sandra Orgel, Suzanne Lacy, and Judy Chicago*

On June 6, 1972, four artists—Aviva Rahmani, Sandra Orgel, Suzanne Lacy, and Judy Chicago—presented, at the studio of Guy Dill, a stirring Performance Art work called "Ablutions" that was intended to decry the violence of rape, incest, sexist conditioning, and social oppression.

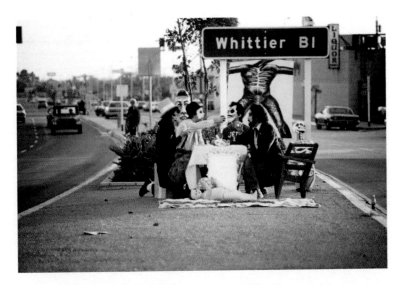

**"First Supper (After A Major Riot)" (1974)**
*Artists: Asco—depicted: Patssi Valdez, Humberto Sandoval, Willie Herrón, and Gronk (Glugio Nicandro)*

In a photo taken by Harry Gamboa Jr., the group Asco performs a celebratory dinner to commemorate a momentous 1971 clash between the police and local Latino community demonstrators.

©1974, HARRY GAMBOA JR.

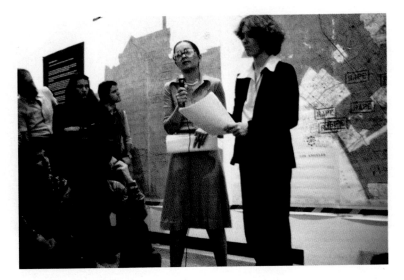

**"Three Weeks in May" (1977)**
*Artist: Suzanne Lacy*

Caption: In this performance, Suzanne Lacy marked rape cases that occurred over three weeks in May, 1977, on a map of the Los Angeles area.

INSTALLATION FROM THE BOLOGNA ARTS FAIR, 1977; PHOTO COURTESY OF THE ARTIST.

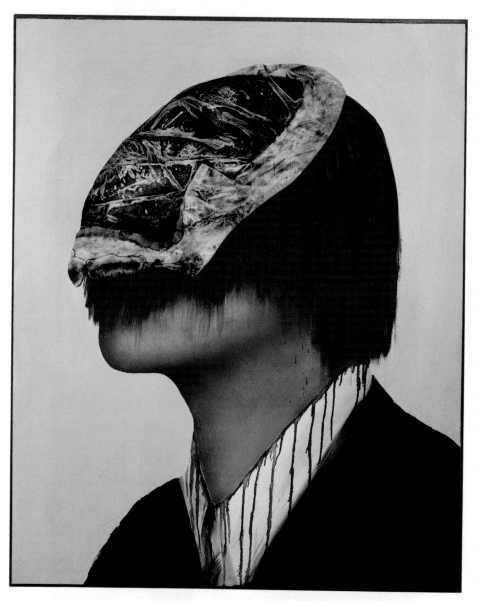

**"Who's on Third?" (1971–73)**
*Artist: Llyn Foulkes*

An apparent self-portrait, Llyn Foulkes's "Who's on Third?" from 1971–73 was described by critic Marilu Knode as "an image in which the real is won and lost at in the same instant."

PHOTO COURTESY OF LLYN FOULKES AND KENT FINE ART

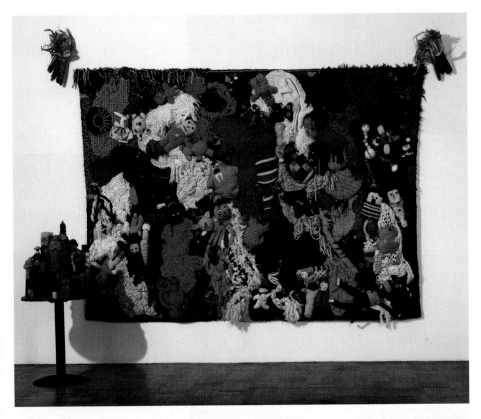

"More Love Hours Than Can Ever Be Repaid" (1987), mixed media 96 x 127 x 5 inches, and "The Wages of Sin" (1987), mixed media 52 x 23 x 23 inches. Installation view at Rosamund Felson Gallery in Los Angeles.
*Artist: Mike Kelley*

Kelley's full "arrival" as an artist was, in part, cemented by a 1987 work in which he first used a material that would come to define his art career—stuffed animals (and, in particular, stuffed sock monkeys), often worn and tattered, that he had found at secondhand stores and flea markets.

**"Cremation Project" (1970) Detail**
*Artist: John Baldessari*

In a seminal Performance Art piece, on July 24, 1970, the artist John Baldessari gathered up more than 120 of his paintings, broke them up into pieces, and had them burned to ashes at a local crematorium.

IMAGES COURTESY THE ARTIST

Maria K. Lloyd.
S/9. 10. 11 (37406)        President

## AFFIDAVIT
### (GENERAL)

State of California,
County of San Diego
ss.
Being First Duly Sworn, deposes and says:
Notice is hereby given that all works of art done by the undersigned between May 1953 and March 1966 in his possession as of July 24, 1970 were cremated on July 24, 1970 in San Diego, California.
JOHN BALDESSARI,
National City, California.
Subscribed and sworn to before me this 7th day of August, 1970.
MARGARET HAMMERSLEY.
Notary Public
8/10 (37531)        in and for said State.

## NOTICE OF PUBLIC HEARING

To make the images, the supervising artists directed the young Mural Makers to apply colors first as flat fields, then they followed by filling in highlights and shades. When that was complete, the artists would supervise any refinement and touch-up of the image as a whole, before applying a clear acrylic sealer over the finished sections to protect them from the elements. The overall conceit of the project, and the resulting mural, was to depict the history and cultural legacy of the state of California from prehistoric times up to about 1910. The first panel, as read from left to right, was designed by supervising artist Kristi Lucas and attempted to depict what life might have been like in prehistoric times beginning around 20,000 BC. Using as its primary resource the local fossil record from the nearby La Brea Tar Pits, the mural starts with a depiction of the flora and fauna that would have been common at that time—giant sloths, saber-tooth tigers, condors, and woolly mammoths—and moves to a depiction of the arrival of humans to the region about 10,000 BC. From here, the next few panels depict: California in 1,000 AD (Early California); the Spanish Arrival in 1522; the era of Mexican Rule around 1822; and the Gold Rush Era of 1848. This panel, the fifth in the series of ten, is a highlight of the first segment. Full of bold, violent colors to match its sharp social political message, the panel, designed by the supervising artist Ulysses Jenkins, depicts the African American experience in the early days of California's history. On the far left of the image, a dark and somber segment shows a lone covered wagon carrying African American passengers pressed in by a looming Confederate flag and a large block of letters that spell out "WHITE ONLY." It was in these years, after the 1848 discovery of gold in Sutter's Mill in Northern California that commenced the first widespread migration of African Americans (along with Mexicans, Indians, and Anglos) to California. The segment also includes a sepia-toned portrait of Mifflin W. Gibbs, the publisher of the first Black newspaper in the state, and portraits of Mary Ellen Pleasant, a Civil Rights activist who helped defend escaped slaves charged under the fugitive slave laws; Biddy Mason, an ex-slave who successfully fought her extradition and

later became a wealthy benefactor who helped found the First African Methodist Church in Los Angeles; and Joaquin Murrieta, a Robin Hood–like horse-riding figure of Mexican legend who fought for the rights and welfare of the oppressed. Rounding out the image are lurid, boldly colored images of a lynching and other implied violence, and a startlingly abstracted image of the "Iron Horse," or the railway that connected California with the rest of the country around that time, but also that pushed aside the existing tribal cultures in the quest to grab ever more lands for development.

The final panels of the first stretch of "The Great Wall of Los Angeles" depict the Sojourners of 1868 (immigrants brought by the "Iron Horse" to California from China and other places); Frontier California in 1880; "From the Mountains to the Shore" ca. 1890, depicting the spread of development around that time across the L.A. basin; Immigrant California ca. 1900; and California during World War I. Buoyed by the successful creation of the first segment of the "History of California," as well as by the positive response to the work, Judith Baca followed up by organizing, without much assistance of any government entities this time, the design and execution of another four panels (an additional 350 feet of mural) in 1978.

THE "GREAT WALL OF L.A." WOULD, AT DECADE'S END, be the ultimate vision of what mural art expresses in a churning, constantly moving city. Visible from several nearby busy roadways of the city—Coldwater Canyon Avenue and Burbank Boulevard—the sprawling work of art was an unavoidable mass of bold color, expressive design, and evocative figures and shapes. The "Great Wall" was also a force of symbolic connection almost without precedent. "In the case of the Great Wall," said Baca, "the metaphor really is the bridge. It's about the interrelationship between ethnic and racial groups, the development of interracial harmony. The product—there are really two products—the mural and another product which is invisible, [is] the interracial harmony between the people who have been involved."[50]

That Baca, at the turn of the decade, was planning for the creation of several additional panels that would depict even more of the city's rich heritage and history, was, on one hand, remarkable, but on the other hand somewhat bittersweet. By the end of the 1970s, the decade-long quest by local artists to expand their art far and wide across the landscape of the horizontal city was—notwithstanding the efforts to add to the "Great Wall of L.A."—beginning to peter out. Whether they were daunted by the idea of even approaching the level of relevancy and sheer scope of Baca's project, or they simply had grown bored with the novel canvas of the city's walls, buildings, and freeway structures, at the dawn of the 1980s the mural movement in L.A. was no longer quite the vibrant, self-driving cultural practice it had been earlier in the decade. The "Great Wall of L.A.," it seemed, was the ultimate realization of the mural form in Los Angeles, and it would likely never be topped.

CHAPTER VIII.

# The Mongols in the West

*A Trio of Outsiders Quietly Subvert the L.A. Art World*

D URING THE RESOURCE-STARVED 1970S, AS A generation of young, newly emerging artists struggled to establish their careers in a confused and disjointed art market, it makes sense that the art of Los Angeles has long seemed, in retrospect, so unfocused, confused, and uncentered. "The decade of the 1970s saw an explosion of art across America," wrote the critic Peter Frank some years later. "Nowhere did this explosion have more resonance than in Los Angeles; during the decade the city flooded with artists, newly graduated from Southern California's many art schools and departments or attracted by the city's growing cultural sophistication and complexity. And nowhere more than Los Angeles did the anomalies of 1970s artistic discourse make themselves powerfully felt."[1]

One characteristic of the art of Los Angeles in the 1970s that is crucial to understanding the artistic output of the era is that it was an era of transition. The unified narrative that had ruled art during the Modernist era was being replaced by a more divergent, multipolar set of narratives. As we can see in the Feminist, Chicano, and Black Art Movements, in the rise of L.A. brands of Conceptual, Performance, and other experimental art, and in the slow development of an entirely home-grown "lowbrow" art sensibility, the reasons for this transition are various and often contradictory. Still, however one chooses to explain the cultural shift from Modernist monolithism to

Postmodernist eclecticism is almost beside the point. What is clear is that the artists of the era continued creating art whose meaning, intention, and future direction is impossible to parse with anything approaching a single, simple, coherent narrative. In Los Angeles in the 1970s, then, there were any number of artistic storylines that took time to digest and appreciate.

Amid the varied output of the renegade, revolutionary, subversive, and underground groups, there still remained some very compelling art that was impossible to classify, its own particular life-form created by nearly uncategorizable artists who chose to remain outside the new, evolving mainstream of art. One of these artists was Vija Celmins. Celmins had first come to Los Angeles in 1962, drawn west by the graduate painting program at the University of California in Los Angeles, where she earned her MFA in 1965, and where she quickly garnered a reputation in the local art world as something of an unfriendly and dismissive snob.[2] Long before she came to the state, however, before she was even ten years of age, in fact, Celmins had already had her share of travel-based alienation. Born in Riga, Latvia, in 1938, she escaped with her family—her parents and older sister—from the advancing Soviet army in 1940. Unfortunately, the family chose to flee to Germany, where they survived the war and the Nazi regime by staying in a United Nations refugee camp for Latvians located in Baden-Wurttemburg. After the War, Celmins's family was relocated to the U.S. through the Church World Service. They settled in Indianapolis, Indiana, where her father found work as a carpenter and her mother as a hospital laundress.

In America, in the strange and foreign reaches of Indiana, Vija Celmins was an obvious outsider. Just ten years of age and already having experienced a lifetime of uncertainty, she was now surrounded by people whose language she did not speak. In her loneliness and alienation, Celmins began to draw, and she exhibited enough early talent that her teachers encouraged her. In 1955, at age sixteen, Celmins enrolled at the John Herron School of Art in Indianapolis, which was

attached at the time to the Indianapolis Museum of Art and later became part of the Indiana University system. It was here that, for the first time in her life, Vija Celmins did not feel like an outsider. "In art school, we were all on the same wavelength," she later said. "And I found my home, maybe, with a group of people . . . . I was always drawing. I mean, I was, like, the artist in high school that did everything."[3] Art was also, it turns out, Celmins's way of coping with a home life made unhappy by its disappointments and stresses. Whatever the impetus, Celmins was so accomplished by her college years that she won in 1961 a fellowship award to attend summer school at Yale. And there, as fate would have it, she met lifelong friends Chuck Close and Brice Marden, and she fell under the spell of the works of Italian still-life painter Giorgio Morandi. A year later, Celmins completed a BFA at the Herron School and moved to Southern California to begin graduate school at UCLA.

In L.A., far from the firm influence of her embittered, old-world parents and given access to the near-limitless possibility of Southern California, Celmins ate up the sudden freedom. "I wanted to get away," Celmins said of these years, "and then when I got away, I had to really come to terms with my art, with my whole life, with building a sort of self. You know, like everybody does . . . . At UCLA, you were totally on your own, so I had a lot of freedom, you know? But it was the first time I had really been away from my parents."[4] As a result of her newfound freedom, Celmins experimented artistically, switching her focus from the late-Modernist influences she had soaked up at the Herron School and at Yale to explore the Pop Art influences that were seeping all around the art market at the time—especially in L.A. Significantly, the year that Celmins arrived in Los Angeles was the same year that Andy Warhol had his first solo show—of his Campbell's Soup cans— at the Ferus Gallery. "When I dropped this sort of semi-abstract painting that I had been doing," Celmins said, "[I] started doing these very severe objects. They were like interrogation things. I was straight on. I was trying to throw away all the things that I thought I had learned,

not from my own doing, but that were from magazines, from other people's ideas. And I was trying to get back to some kind of a basic thing where I just look, and paint, and sort of an old-fashioned kind of way of starting out."[5]

The primary figures that moved Celmins at the time, according to later interviews, were the consummate American materialist Pop Artist Jasper Johns and the English-born sensationalizing photo-realist painter Malcolm Morley.[6] Under these influences, Celmins developed a deadpan representational style in a series of monochromatic paintings of mundane consumer objects like TVs, lamps, pencils, erasers, and hot plates. A main reason for her interest in the work of Jasper Johns was the manner in which the artist—in his completely faithful sculptural recreations of Ballantine Ale cans and the like—was blurring the lines between object and representation, between art and life itself. "This type of back and forth with the idea of representation itself," wrote the curator Michelle White of Celmins's early influences, "exemplified by Johns's intentionally confusing semantic dance between the sign and the signified, was changing the meaning of painting and, by extension, art."[7] Celmins's first paintings were then an intellectual exercise. They simply followed the Pop Art stratagem of making icons of the trappings of American consumer culture—consumer products, packages, and mass-media trappings—without investing emotional energy in the depicted object or the work of art itself.

Celmins came of age when artists across Los Angeles, including many of the Ferus artists and the "Cool School," were translating the language and interests of Pop Art to form a localized version of the genre. The critic Philip Leider defined L.A.'s particular Pop sensibilities in a 1964 essay in *Artforum* magazine. He described the work of such local artists as Joe Goode, Larry Bell, and Ed Ruscha as having a "cooler," more subtle response to mass media's growing dominance of visual culture (than New York–based, or international, Pop artists). California Pop was based, according to Leider, on "a hatred of the superfluous, a drive toward compression, a precision of

execution," much less prone to the histrionically bold graphic treatment of Andy Warhol's Campbell's Soup cans or Brillo boxes. And this local approach played a distinct role in Celmins's own developing aesthetic and interests, as her first paintings at UCLA displayed a marked sense of reserve. The common objects that Celmins painted, such as the space heater in "Heater" (1964), were exactingly but ultimately understatedly rendered. The heater in this painting, for example, is dead set in the center of the painting, a brown-gray industrial relic of the age in the middle of a dull gray-brown background. While a cord stretches out of the scene, presumably to a power source, the object barely seems to make a dent in the coldly expansive brown, concrete-like field on which it rests. Even the glowing coils of the device burn with such a gentle and soft orange light that they could hardly be giving off any significant warmth. The reductive depiction, composition, and ambiguously gray and cold setting of this image points to the artist's interest in playing up the bleaker qualities of the material culture of the time, perhaps even stretching back to her own experiences in a bleak postwar world. The atmosphere is as grim as any winter battlefield, and the heater looks as solitary and alone as any soldier would be in the Ardennes forest—though this may be too great an interpretation. Suffice to say that the first published review of Celmins's work, by Rosalind Wholden in *Arts Magazine*, cautioned that "Celmins's paintings keep the viewer at arm's length."[8]

"Seen within the context of that fertile geography and intellectual moment," wrote Michele White, "the type of questions her early paintings bring forth about the complex relationship of form and content—the how and what of painting—reveals her conceptual strength as an artist and, within a wider historical lens, the precarious place of representation in the painting of the 1960s."[9] Celmins's very strategic approach to painting, which she developed in L.A., was to remove completely from the surface of her work any of the emotive content that appeared in the Abstract-Expressionist art of the previous generation. "I decided," she said some years later of this work, "to go back

to looking at something outside of myself. I was going back to what I thought was this basic, stupid painting. You know: there's the surface, there's me, there's my hand. There's my eye. I paint. I don't embellish anymore. I don't compose, and I don't jazz up the color."[10] Her sense of restraint in painting and her removing of personality and emotion from the act of painting not only foreshadowed much of L.A.'s most cutting-edge Performance Art projects a few years later, but it also was disingenuously reductive. After all, making the conscious decision to bring no personal touch or point of view to an art work ironically imbues that art work with a strong sense of touch and point of view in the absence of such. That is, by being willing to remove oneself from being reflected in one's object of creation, the artist makes viewers more aware of the presence of the artist in the work. Celmins's seeming personal disregard for the art work, and her cool remove from taking any stance on what she depicts, in the end became a marked aspect of her very distinctive, somewhat bafflingly solitary style of painting.

CELMINS'S UNIQUE SPIN ON THE POP ART SENSIBILITIES of the time, under the influence of a peer critique group at UCLA with whom she had developed a very competitive dynamic, began to come under increasing scrutiny by the artist. "We'd look at each other's work and size each other up," Celmins said of the group, which included Tony Berlant and several others, "see who had a little talent and who didn't, and who was going to go somewhere and who didn't . . . . [In the studio] I was thinking, 'I'm going to throw away a lot of the ideas I had about making The Great Painting, and I'm going to see what's left.' . . . I had a lot of weird things that came out there. I tried to paint them without a lot of theatrics, without a lot of artificial color, all those things that I had been doing without, really, without composing, you know? Just deadpan. Just the facts, man."[11] When Celmins realized, thanks to her crit cohorts, that she was being limited by sticking to painting things that she knew—the consumer objects and other detritus around her studio—she began to look farther afield, collecting

images that intrigued her in various sources—magazines and old books, old snapshots, and so on. Soon, she found herself making paintings out of the most evocative of her found pictures. One of the earliest of these was "Hand Holding a Firing Gun" (1964). In this typically simple image, Celmins has painted a single, androgynous arm that extends from the painting's right edge to the center of the image. The hand holds a gun, which has, from the telltale pattern of smoke and tracer path, just discharged a bullet. There is very little other information; the rendering is muted. In keeping with her Minimalist aesthetic, the background is empty and dun-colored. Still, various intellectual implications—violence, particularly of the military sort, speed, power, and the human impulse toward all four of these—are implied simply by the subject matter. This is true even though the image has been stripped of almost all sense of drama or danger; there is no apparent victim, and it's completely unclear where, if anywhere, this event took place. This is about as mundane a shooting incident as one will ever see depicted, and yet the quiet impact of the painting is still somewhat jarring. The play between her dry, emotionless, and deceptively simple rendering and the disturbing object and subject she is depicting creates a pressing confusion as to what the painting means and how a viewer should feel about it. In effect, Celmins had finally arrived at just the sort of push-pull—between her dry mastery of painting and the mystery of what she depicts, between the intellectual practice of art and the confusing array of emotions in the subject matter—she had wanted all along.

After 1964, Celmins continued this deeper investigation into seedier, somewhat more disturbing, photo-based subjects in a series of intricate and exacting paintings that seem made almost as if by compulsion. In "T.V." (1964), she painted a realistic image of a television in a typically blank and shadowy setting, on which is depicted an air battle scene, most likely from a recent war. The image here is very similar to the gun image from earlier in the year—the scene is softly frozen, the clouds of smoke from an exploding fuselage are hazy and lovingly rendered. There is menace and tragedy in this image, but it is

extremely muted, treated almost as something elegant and beautiful like any flower still life or Madonna portrait. The muted emotional content of the painting is enhanced by the practical choices Celmins makes. Her treatment of light and shadow in the painting—in particular how she matches the ethereal background tones in the room behind the TV to the background tones behind the exploding plane—serves to flatten and soften the impact of what is essentially a fairly dire subject matter. All of which, of course, obscures the intentions of the artist and enhances the sense of mystery about the image.

A frozen sense of menace, played off against a meticulous and muted rendering, appeared also in her painting "Time Magazine Cover," which depicts, for the most part, the real magazine cover as it appeared on August 20, 1965.[12] In the painting three photos, each layered one atop another, depict scenes from the riots that took place in Watts that summer. In the top photo, a blur of smoke billows from some of the buildings of the city district affected by the uprising. In the middle photo, as a contrast, an upturned and burned-out car makes a Cubist spectacle—all angles and edges in different shades of gray and near-black. The bottom photo, a famous image, depicts several young men running through the streets with looted TVs and other consumer goods tucked under their arms. While "Time Magazine Cover" was a more raucous painting than the still-life images she'd made up to this point, her approach to the rendering, composition, and other painterly elements is the same as always: The beauty of her painting pushes up against the horror and tragedy she is depicting. What is clearly different now, in 1965, is how Celmins's visual interests have begun to show more and more urgency and timeliness. That is, in this image, for the first time, she has begun to take note of how the mass media representations and images that are proliferating around her on television, in magazines, and so on, related to what's happening around her.

At the time she painted "Time Magazine Cover," the riots had only just recently taken place a few miles from Celmins's studio. By diving into a depiction of this disturbing event, she was moving into

territory that a few Pop artists had been mining for some time. In 1962, Andy Warhol made "129 Die in Jet" using a photo from the front page of the *New York Mirror*. Though he had long made images from mass-produced media sources, this image would be the first of his to reference death; but it wouldn't be the last. Also in 1962, after the suicide death of Marilyn Monroe in August, Warhol began a series of "Suicide" paintings, in which he used a number of obscure tabloid images of self-inflicted death. In 1963, Warhol began work on his "Death and Disasters" series, which were silkscreen images of grisly mass media–proliferated events such as car crashes, suicides, race riots, and executions. What makes Celmins's efforts stand out, however, is the sheer amount of careful consideration she takes in rendering them. Whereas Pop artists often used disturbing mass-media images in their work, it was always done as a sort of metonymy—a kind of stand-in for the idea of a modern world gone haywire. That is, Pop artists used easy mechanical reproduction techniques—for example, Warhol used photo-reproduction methods to make his silkscreens—which somewhat drains the original images of some of their impact. As a result, the images are more about the media, and the images that surround us, than about the horrible subjects being depicted. Unlike the Pop artists, Celmins took great care in rendering these images, thereby digging deeper into the potential impact of the subjects both as personally and socially resonant images and as historical relics. In Celmins's hands, the images suggest that the artist does not take these subjects lightly, and that neither should we.

No matter her intentions, one result of Celmins's adoption of mass-media imagery as a source was that she was freed to explore even more personally meaningful and resonant imagery. That is, something about the tragic images of exploding planes and riotous streets—as well as a realization at the time that she was alone and far away from family in the big and dangerous city of Los Angeles—seems to have unlocked an autobiographical impulse in her work for the rest of the decade. And in fact, around the time that she painted "Time Magazine Cover,"

Celmins was growing increasingly outraged about the United States' involvement in the war in Vietnam, and she had begun participating in public protests about the war. Her outrage and her involvement in the protests seem to have brought to the surface her own complex feelings of a war-torn childhood. As a result, Celmins began making paintings of warplanes—imagery that hearkened back early childhood memories shuffling from Latvia to Germany to, eventually, the United States.

To create her warplane paintings, Celmins used as source material some small scale models she'd collected as well as a series of war photographs that she found in (and clandestinely ripped from) library books. In many of these images, the bombers and fighter planes hover in the air, frozen in a kind of stasis en route to whatever fate may be in store for them. In other images, the planes explode, tumble from the sky, or vanish into a burst of fire and smoke. "Suspended Plane" (1966) is one of the latter types of images. It depicts an American warplane floating somewhat placidly in a grainy and atmospheric space, high in the sky above the cloud line. As with her earlier images of guns, televisions, and magazine covers, it is clear that the source of this image is some sort of photo representation. Yet, as always, Celmins's choices—of composition, tone, and paint application—make this placid, atmospheric image something more mysterious, edgy, and anxious than it otherwise would be. Celmins infuses just the right amount of emotional content into her representation. "I painted this in the middle of the Vietnam War," Celmins said years later to a documentary filmmaker. "I was remembering the planes when I was in Europe myself in 1944, just a small child, I remember the airplanes. I'd never seen one, of course, but I heard them."[13] To create these images, she acknowledged that she had to make a number of intuitive leaps. Not to have done so would have yielded, the artist believed, something clinical rather than evocative and strangely compelling, full of import and meaning that seems just out of reach. "This is an invented thing," she said. "It's not a copy of nature, or a copy of a photograph. It's an invented thing that you have in front of you."[14] In the airplane images, we can see that Celmins,

through the conscious artistic choices she was making in order to dig at
the emotional content of the image, has increasingly begun to master
her style. "It all unfolded intuitively," Celmins concurred, "with a kind
of urgency that only someone in love with those machines and these
grays could muster. They were not in any way calculated."[15]

After delving into her childhood through her airplane paintings,
Celmins continued her photographic-based investigations for the rest
of the 1960s and into the 1970s. In addition to making numerous air-
plane paintings, she also worked on a series of softly nostalgic paint-
ings and sculptural representations of toys, childhood games, big Pink
Pearl erasers, pencils, and other trappings of youth. Then, starting in
1969, perhaps influenced by the changing times, Celmins made a series
of exacting graphite-on-paper images based on images of the moon's
surface. Through her level of visual investigation of the fields of dirt,
her digging into every particular detail in a sea of details, and evok-
ing with every pencil stroke the light and texture and infinite disar-
ray of the image, again Celmins lifted these images above the level
of mere photo-realism. And from this time on, until the current day,
Celmins continued using certain photographs that provided her with
a complicated field of imagery—a stretch of the ocean, fields of dirt
and rocks (either on the moon or from a local desert), vast stretches
of snow, a wide expanse of the sky—as a source for creating mul-
tiple reproductions of the same imagery in a wide range of mediums.
All of the images would be created from the same cool, somewhat
fascinated, somewhat bemused remove, and all of the images would
seem, in the words of the critic Alain Robbe-Grillet, "constantly out of
reach."[16] In fact, several commenters have compared Celmins's work
from the late 1960s to the late 1970s with slightly earlier practices by
the Minimalist artists of the era—particularly since the artist is mas-
terful in working the minute, almost endless details of an image into
a single, compelling whole. Still, unlike with Minimalism, the images
that Celmins made well into the 1970s remained reliant on their pho-
tographic sources and were also embedded with an ineffable sense of

desire, longing, mystery, or some other emotion that comes through simply by the artist's particular touch.

Celmins's paintings over time have grown increasingly uncanny in this way, exhibiting two traits in virtual opposition—a highly mechanical and proficient image-making process and a deep and abiding push toward something deeper. "It could be argued," wrote the critic Lane Relyea, "that what Celmins's drawings and paintings depict, what they refer to, is . . . split and displaced. On the one hand there is a specific reality, a precise moment in time and location in space, the hyper-detailed character of which has long dissolved back into flux by the time the photograph has captured indexically and turned over its remains to Celmins's art. And on the other hand there is the image's iconic side, its pared-down conceptual identity, the single noun that comes to mind ('sea,' 'desert,' 'sky'), which, in opposition to the indexical, is entirely status and general, without specific time or place . . . . And yet never do the two [realities] coincide and possess each other; like a gunshot and its echo, they are always slightly out of synch, no matter how much they seem to come from the same place, no matter how hard they try to reach back towards that sense of shared origin."[17] This contradictory nature made Celmins's work somewhat unique in American art. And Celmins was a wholly eccentric artistic voice. Her art, born from the inner recesses of an active mind, is without parallel, and completely outside art trends in Los Angeles and across the nation.

"To be sure," wrote Michele White, "Celmins's work does not categorically conform to the tenets of any movement, and she does not believe her work adheres to any stylistic school. While she considered many Los Angeles artists of her time, including Robert Irwin, James Turrell, and Douglas Wheeler, to be colleagues and friends"—her studio in Venice had connected her with an array of the most dynamic artists in Los Angeles at the time—"she has said that her work lacked the 'L.A. Look' and that her approach to painting isolated her from her peers."[18] Stylistically speaking, when compared to the Conceptual,

Performance, and process-based art practices that were on the rise in 1970s Los Angeles, Celmins's work seemed an anachronism, though as critic Lane Relyea has pointed out, the disjunctions and complications of Celmins's work actually fit in quite well with the work of the time. The overwhelming sense of displacement in her work, Relyea suggested, "was a pervasive condition of the art world into which Celmins emerged, and her art is as exemplary in its response to that historical condition as anybody's . . . . By rendering endless stretches of deserts and oceans, and eventually the open blankness of the night-time sky . . . Celmins most firmly establishes homelessness as a dominant motif. The point of view that her art now assumes, either looking down at the ground or up at the sky, suggests a traveller brought to a standstill, shaken loose from a sense of direction or destination."[19]

As enigmatic and confounding as her paintings were, Celmins's unique voice would emerge as an influence on new art movements that coalesced in the late 1970s and exploded nationally in the 1980s. It seems almost obvious in retrospect that without Celmins's updating of Pop sensibilities for a more cerebral and conceptual age, it is likely that a later movement with strong roots in L.A., called the "Pictures Generation," would never have occurred. In the end, Celmins's deceptively simple, confusingly elusive approach to painting is probably best not overanalyzed and simply enjoyed for its own qualities. "She makes an image," Lane Relyea continued, "that has too much presence, too much impact and physicality just to be a representation; and yet it also feels too belated, too poignantly residual to stand as an autonomous entity . . . . Each piece by Celmins is just an image, and yet so much more than an image. And each is like an autonomous object, and yet humbly, touchingly less and other than that as well."[20]

WHEREAS CELMINS FORGED HER OWN ECCENTRIC expressive path—one that was informed by a wartime refugee's alienation from the culture that surrounded her—another artist with a similar outsider outlook, Charles Garabedian, also emerged in the L.A. art

world around the same time. His physical approach to art, however, couldn't have been more different.

Born in Detroit in 1923 to Armenian immigrant parents who had escaped the World War I–era massacre of Armenian civilians by the Ottoman army, Garabedian had been placed in an orphanage at age two after his mother's death. Garabedian's father, a Ford Motor Company worker who had been crippled by an automobile accident, was unable to care for his three children. "I was in the orphanage until I was nine," Garabedian said many years later. "My sisters were in the same orphanage, but the boys were separate from the girls . . . . I don't remember it as being unpleasant or pleasant. The only thing I recall about the food was that I learned to hate tapioca pudding."[21] At age nine, Garabedian was abruptly removed from the orphanage when his father came into some insurance money. "He gathered us up along with my uncle, who was my mother's brother," Garabedian continued, "and we drove out to California in a 1933 Buick. This was in 1933. My father and uncle went in as partners and bought a chicken ranch in San Gabriel . . . . The chicken ranch failed and we were very poor and lived on welfare until my sisters, Irene and Liz, and I got out of high school, and Irene and Liz could go to work."[22]

After coming west, Garabedian lived in East Los Angeles among an ethnic thicket of Russians, Armenians, various Slavic peoples, and Latinos. Most people in the area, though not all, were like Garabedian's family—struggling to get by on scant income. After attending Garfield High School, Garabedian joined the Army Air Forces just as America was entering World War II. "I traveled all over the country for my training," Garabedian said, "Colorado, Nebraska, Florida, Texas, and finally I went overseas by way of South America, Brazil, and British Guiana, then to Africa, and finally to England, where I was a gunner on a B-24. I saw a lot of the world, but I think I was still a very young nineteen-year-old. I wasn't too aware at that time, other than that I was out in the world and doing a lot of drinking and carrying on and getting through flying my missions."[23] After the war, Garabedian

returned home uncertain, like many young war veterans, what to do with his life. Garabedian also was uncertain about his relationship with his family. "When we moved from Detroit it was like four strangers were suddenly thrown together," Garabedian said. "My father could not speak English and we could not speak Armenian. We didn't know one another that well, so you can see what that must have been like with these four people together. I think we liked one another and we got along fairly well, but there was still a strangeness that was there."[24]

Fortunately, the GI Bill came along, and Garabedian began taking classes at the University of California in Santa Barbara. "I thought, hell, I might as well go," Garabedian said. "I still wasn't awake. After two years at Santa Barbara, I transferred to USC and went back to living at home, and still nothing was there. I studied very lightly and I wasn't really interested in learning; I was just interested in not having to work."[25] After two years at USC, Garabedian got a job and moved out of the house. According to his own account, he did not particularly enjoy any of the work he did, and he bounced from job to job, filling the gap by drinking, going to the racetrack, playing golf, and fishing in Ensenada. Then, fatefully, Garabedian met a new friend who would change the direction of his life. His name was Warren Reiss. "He was like nobody I had ever known before," said Garabedian. "He was a very bright and an extremely talented guy. It was like talking to a total stranger when I was talking to him because he was so different. He and I and another friend of his got an apartment over on the Westside of town up in the Crenshaw area, and through him I met Ed Moses."[26] Meeting Ed Moses was the final catalyst that Garabedian needed. Moses, who had served as a medical assistant in the navy, had failed to get into medical school after the war, and on a lark he took an art class at Long Beach City College from an eccentric instructor named Pedro Miller. At first, Moses had not taken the class seriously, cracking jokes and goofing off, even going so far as to complete a class assignment by finger-painting it. To Moses's surprise, however, when the instructor saw this painting he immediately crowed: "Now here's a

real artist." Moses, who had been as directionless as Garabedian, had found a new calling.

Having failed to get accepted to the graduate school in art at UCLA, Moses was working on improving his drawing at the time by studying with a locally known artist named Howard Warshaw, who ran the Finch-Warshaw School of Art. "Ed would go there one night a week and draw under Howard's thing," said Garabedian. "So I saw him one night while he was on his way. I asked him where he was going. He said he was going to Howard's to draw and said, 'Why don't you come along?' "[27] At the school, Warshaw gave Garabedian a piece of paper and a pen and ink and pointed at a cow skull. "Start making lines," he said. "Don't try to draw the skull, just start making lines in relationship to it." After three hours, Warshaw look a look at Garabedian's drawing and said, "Not bad. Why don't you come back?"[28] Garabedian studied at the Finch-Warshaw School of Art for the next several months, learning the importance of employing art techniques to illustrate an idea. When Warshaw was suddenly offered a job to teach in Santa Barbara and decided to close his school, he told Garabedian he should continue his development as an artist. "Go to UCLA," Warshaw said, "and study with Bill Brice."[29]

At UCLA in the late 1950s, art instruction was fairly traditional and staid, focusing mostly on the figurative and not pushing the limits of art practice much. Fortunately for Garabedian, he quickly found a mentor in Bill Brice, the son of the actress Fannie Brice (aka "Funny Girl"), who was known for large abstract canvases that he painted in a style called "classical Modernism" by local critics. The greatest impact of Brice, however, came from his mentor-like approach to teaching. "Bill was a very responsible person," Gardabeidan said, "and he felt he had to teach responsibly. Maybe that responsibility was his sense of bringing people along as he felt they wanted to be brought along. So we just fell under his spell. He would have let us do anything we wanted to if we had enough brains to do it. He was a great teacher."[30] Garabedian also quickly met a like-minded community of artists at

the school. Louie Lunetta, a fellow art student who would go on to have a career as a painter in Los Angeles before his death in 1996, was Garabedian's first close friend at the school. "Louie was just totally out there," Garabedian said. "My second summer at UCLA, Louie and I, we got in an old Pontiac and we went down and toured Mexico for a couple of months. Louie wanted to make a movie and he had this 16mm camera, and we bought a ton of black-and-white film . . . I was the star of the movie. I had to wear this black suit and he photographed me riding horses, tap dancing, being sick on trains, and climbing the ruins all the way from Mexico City to Palenque. Louie was a factor in my life and I guess he probably still is."[31]

By the time Garabedian's time at UCLA ended, his list of compatriots included Luneta, Ed Carrillo, Bob Chavez, Les Biller, Lance Richbourg, Max Hendler, and Arlene Hendler. All of these figures were associated in some way with the school, and all painted and worked in a similar, reductively expressive mode. Being associated with this group ultimately had a profound affect on Garabedian's development and, eventually, his career. "It was a good group of people and very interesting and talented," said Garabedian. "I can't say we were naive because we weren't . . . . We did talk about a lot of German Expressionism and Mexican artists, primarily, Orozco . . . . I think it's obvious that this early group affected what I did as a painter. The work was always figurative and always, I guess, you'd say a very readable narrative art."[32]

On graduating with an MA in art in 1961 at the fairly advanced age of thirty-eight, Garabedian found piecemeal work as a lecturer at UCLA. He also promptly had his first local exhibition in 1962 with three other painters—called "Four Painters"—at a new gallery called Ceeje. Founded during the heyday of the Ferus Gallery, Ceeje was thought of as the quirky alternative to its more muscular rival. The gallery showed the work of a number of the UCLA graduates of the time, including "the fantastical narratives of Louis Lunetta, surreal landscapes of Ed Carrillo, intense Expressionist portraits of Roberto

Chavez, obsessive realism of Maxwell Hendler, and Wild West allegories of Lance Richbourg."[33] The Ceeje Gallery artists, who remained dedicated to painting in an Expressionist mode and considered themselves independent of any school or "-ism" of the time, all fed Garabedian's "restless experimental impulses." In a catalogue from a 1964 show that Garabedian participated in, called "Six Painters of the Rear Guard," an artist named Fidel Danieli summed up the funky gallery's position in the local art market. "If Ferus Gallery was the cutting edge of L.A. Modernism," he quipped, "Ceeje was the ragged edge, and several of the artists could parody their own situation and bill themselves as the rear guard."[34]

Under the influence of other Ceeje artists, Garabedian began to ask important artistic questions. Whereas he had been driven by a fascination with art history while in school, and his developing style had been shaped by the artists who taught at the school—particularly Bill Brice, Sam Amato, and Elliot Elgart—Garabedian quickly recognized the local art market demanded something different. "I realized," he said, "that I had to throw out the rules I'd so dutifully learned if I wanted to get anywhere."[35] To some degree, this meant starting over. "I didn't even realize I was supposed to have a voice," he said. "I thought I was supposed to paint like Holman Hunt or something like that. That was my goal, I don't know why, maybe because I thought that's the correct way to paint. And yet, I didn't really learn to maybe appreciate art while I was in school, or to see just how wonderful some of the things were that these people were doing. I just liked the idea maybe of being an artist and I thought I knew that being an artist simply meant to draw and paint pictures."[36]

Between 1962 and 1965, then, Garabedian worked intently on developing his style and approach. One work, "Family Portrait" (1964), gives a sense of the direction his work was taking at the time. This image is a casual composition depicting part of his family—father, mother, and daughter—framed by the bones of a house his father is constructing. The simplified, boldly expressive, almost naive rendering

style is still present, but it plays off the sophisticated way that the artist composes the image. The house and floor, for instance, employ one-point perspective that is reminiscent of the pavilion image in Piero della Francesca's "Flagellation" (ca. 1454). Further, the poses and gestures of the mother and sister are reminiscent of those traditionally found in Italian Renaissance images of Mary, Joseph, and the Christ child. Interestingly, despite hints at the artist's understanding of art history in this and other paintings, Garabedian has claimed to be unaware of any direct connections between what he painted and specific imagery. "I don't know who picked up on it as a Holy Family," he said, "but at the time I thought that was crazy."[37] In his effort to redefine his artistic style even as he worked through his own emotional inner life, Garabedian was pulling personally and historically resonant imagery from his deep understanding of art tradition almost as if by rote.

After 1965, Garabedian's art increasingly came into its own. Having begun experimenting with some alternative forms, including large-scale paper sculpture and a looser and more impromptu painting style that tapped directly into his subconscious mind, his paintings began opening up to reveal deeper and more evocative truths. Interestingly and somewhat ironically, Garabedian has suggested he had little to no control over the subject matter in works from this era, and no control over how viewers responded to it. "The audience is never considered," he said. "By nature, I'm suspicious of myself and curious about myself. You question and question and tease yourself and try to confuse yourself . . . . I think it's important that it be a one-to-one dialogue with myself. Once you start thinking of other people, you start thinking 'let me make this a little clearer.' If you do that with your paintings, it makes the paintings dull."[38] As a result, Garabedian's work began to thrive by revealing its own struggles and inner contradictions and dead ends. The jumbled subject matter—body fragments, abstracted forms, jumbled cityscapes, symbolic objects—played off against a purposefully clumsy and often slapdash painting style and an immediate and make-do sense of composition and rendering. The

work's push-pull tension between an awkward and immediate style of painting, and an obvious sophistication of intent and knowledge, was increasingly thrilling to some viewers, or as a 1965 *Artforum* review by the painter Irving Petlin put it: "There is, in a few instances, a concession to the idea of the painting as object [in Garabedian's work], as some of the frames become an extension of the image, extending the delicate awkwardness outward. The elaborate game of first canceling and then revealing insight, information, and sensibility about paintings and periods is part of the Garabedian love-hate relationships to tradition itself. This is never resolved and is a continuous 'edge' that tenses almost all the works shown."[39]

Through the late 1960s and early 1970s, Garabedian continued to push his work, push his creativity. In the boldly experimental atmosphere that ruled Los Angeles at the time, the artist took a different tack—dipping further back into the imagery and styles of the past. Here and there, in bits and pieces, Garabedian made passing reference to such diverse source materials as religious icons, classical Greek art, classical Chinese painting, and the high-Modernist painting styles of artists like Jackson Pollock, Philip Guston, and Mark Rothko. While Garabedian was resolutely non-Conceptual in his approach, his sampling of the throwback styles of the past was as experimental as anything in the local art avant-garde. "Creativity is a strange thing," he said of his work in the 1970s, "very elusive. The important thing is that everybody has to do something and everybody should find out who they are. That's important. Not even to find out who you are but to investigate who you are . . . . I wonder who I am, what I'm capable of, what I can do—and so I figure, 'What the hell. Find out.' Boy, I can do some bizarre things. I'm really a shy person. I can't proceed in a flamboyant way in public, so I make my work and I wonder where it comes from. It comes from who I am, obviously, but that still doesn't answer the question."[40] Garabedian's work had at least one other aspect in common with the local avant-garde. As the 1970s progressed, the response to Garabedian's unique approach

to art-making grew increasingly agitated. "Garabedian approaches painting as a kind of battlefield of the psyche," suggested the curator Julie Joyce, "manned by cultural tropes and personal memories. An instinctual Freudian, he offers mythic retellings of war, friendship, death, and sexual experience, mining both individual and collective consciousness for sparks of unconscious truth. This untamed process is evident throughout his works, manifested in dreamlike landscapes and seascapes littered with lumbering forms, sketchy marks, crumbling architecture, and skewed body parts. These are visual representations of the artist's thought, designed to entice viewers to follow the associational processes of an artist on a voyage of self-discovery that just might result in shipwreck."[41]

The year 1975 proved to be Garabedian's watershed moment. That year, several of his works, including a faux-naive evocation of cartoony violence called "Bullet for Cliff" (1974), was included in the Whitney's biennial exhibition. Marcia Tucker, director of the New Museum, wrote of Garabedian's work:

"When it was first seen in New York in 1975 it was extremely difficult to come to terms with, existing as it did in a stylistic limbo between abstraction and figuration, painting and sculpture. Garabedian's work is wonderfully perverse, since he is completely uninterested in abiding by the rules of good taste, draughtsmanship, appropriate subject matter, formal composition, or stylistic consistency . . . . No matter what his subject matter, however, Garabedian tackles it at the extreme; images of violence, passion, helplessness, greed, lust, absurdity, and outrage constitute the framework of his investigation. There is no attempt at representational rendering in his work, except—unexpectedly—when a fragment of a painting might contain an exquisitely sensitive and naturalistic image, indicating that Garabedian has discarded a learned tradition rather than avoided one he couldn't master . . . . Garabedian does

*not concern himself with naturalism, mimetic color, or stylistic*
*consistency because he feels that those issues have already been*
*resolved by artists in the past, and resolved in a way upon which*
*he does not feel he can improve. The directness and 'primi-*
*tive' quality of the work are a result of the sources Garabedian*
*uses as visual catalysts, sources from popular culture, folk-*
*lore, mythology, kitsch objects, and exotica which readily lend*
*themselves to appropriation in unorthodox ways."*[42]

Interestingly, the overall reaction to the Whitney Biennial was, as it often is to this major showcase of American and international art, overwhelmingly negative. Dubbed "The Virgins' Show" by the critic Amy Goldin, the 1975 exhibition seemed to dissatisfy the New York art establishment because of its overwhelming focus on artists who had not shown in New York before. Of the 147 artists included in the show, a large number came from outside of New York and were widely unfamiliar to critics. As such, the critics did not hold back, using a wide range of insults to describe the work in it: "indulgent," "well-meaning," "muddle-headed," "frustrating," "uninspired," "dis-appointing," and "dull." One critic in particular, Emily Genauer, was unabashed in her criticism: "Boring, Childish, Awful," read the headline of her review in *Newsday*.[43] Whatever the response to the Biennial, however, after his appearance in the show Garabedian was offered a lectureship at CalArts, and his reputation as an artist began to expand. In 1977, he was awarded an individual artist fellowship from the National Endowment for the Arts, and in 1979 he received a prestigious Guggenheim Fellowship. Still, through it all he remained dedicated to his personal artistic mission. "I make art to find out who I am," Garabedian said a few years later, on the occasion of a twenty-year retrospective exhibition at the Rose Art Museum, "and so far I've been rather disappointed in what I've discovered. I'd hoped to find Giotto or Omar Khayyam in there somewhere. I can key it to three words. I want my work to be primal, archetypal, and monumental.

Those qualities are at odds with my nature, which is lighthearted, yet you can't help pining for things."[44]

TO MANY CASUAL OBSERVERS OF THE LOCAL AND national art scenes in the 1970s, it would have been easy to assume that the fine art of painting was a dying relic of the past—fast going the way of the old telephone interchange system, leaded gas, lead paint, and DDT. And to be sure, all across America and in Europe, painting had indeed become stifled by confusion about what the artistic practice could be in a Postmodernist art world. Yet, it is a grave mistake to say that painting was dying during the troubled decade. "In the wake of Minimalism, Conceptual Art, and the proliferation of 'Media Arts' (video, performance, artists' books, etc.)," wrote Peter Frank some years later, "many proclaimed the death of painting. But painting flourished—and, in response to the moment's heady sense of experiment, the discipline mutated, fused with other practices, and generally metamorphosed as if emerging from a chrysalis."[45] Vija Celmins and Charles Garabedian are good examples of Frank's claims. Both painters, who began toiling at their highly individualistic, somewhat eccentric painterly visions in the early 1960s, matured in the 1970s after some years toiling at their craft. And the arc of their careers, it turns out, was not unusual—it was a course similar to that followed by a spate of local painters who worked, throughout the troubled, confusing decade in the most eccentric, groundbreaking, and unpainterly sorts of ways. "In L.A., in fact, painting seemed to emerge from a mad scientist's laboratory," Frank continued, "a de-domesticated creature able to adopt many guises and absorb many substances. Many pictures were all but invisible. Many 'paintings' lacked paint. Things hung on the wall as if on a coat rack or shelf—or they didn't hang at all. Paintings, paint-things, non-paintings, and un-paintings could be produced as readily in a tool shed or car repair shop as in a studio."[46]

As is evident in the contrast between the work of Celmins and Garabedian, it is tricky to characterize local painting in any coherent

way. "Once the stylistic floodgates opened," wrote Peter Frank, "every-
one seemed to try everything—including personal expression."[47] Some
artists continued working in the Modernist traditions and modes,
though somehow informed now by the anything-goes spirit of the cur-
rent age. Other artists forged new paths that were purposely contrary to
the directions, traditions, and modes of the previous decade. Abstract
Classicism, for instance, was a Los Angeles art movement of the 1970s
associated with four veteran local artists who remained dedicated to
the Modernist styles of the previous generation—John McLaughlin,
Lorser Feitelson, Frederick Hammersley, and Karl Benjamin, as well
as the semi-figurative Hard-Edge painter Helen Lundeberg. In their
wake, younger Geometric painters included: Ron Davis, who made
Geometric *trompe l'oeil* paintings; Norman Zammitt, who was known
for gradated "sunrise" abstractions; and a host of painters who
explored the ultimate Minimalism of monochrome paintings, including
James Hayward, Roy Thurston, Edith Baumann, Alan Wayne, David
Trowbridge, Sam Erenberg, and Patsy Krebs. Self-consciously deco-
rative pattern painters included Merion Estes and Kim MacConnel,
each of whom employed eccentric, nontraditional materials as sup-
ports for their pattern painting. A number of other artists, including
Jerrold Burchman, Charles Arnoldi, Charles Christopher Hill (known
for his decayed collages of rags and newsprint), and Patrick Hogan
(who embedded shapes described with rope in thick, almost volcanic
surfaces), delved even further into paint-based processes of making art.
Several artists continued working with Hard-Edge abstraction of the
sort that had been evident in the Finish Fetish and Light and Space
art movements of the previous decade. Doug Edge and John Miller,
for example, used grids as both a structural armature and as a way
of "disappearing" compositional incident. Photo-realism and other
forms of hyper-representation thrived in the examples not only of Vija
Celmins, but also in the stylized palm trees of Laurence Dreiband and
the snapshot-like figure groupings of D.J. Hall. And finally, the know-
ing Neo-Primitivism of Charles Garabedian[48] and Eduardo Carrillo

and several other colleagues who showed at the Ceeje Gallery would be taken up by a number of younger Latino painters including Gronk, Patssi Valdez, Frank Romero, and Gilbert "Magu" Lujan. Peter Frank summed up all of these painting trends succinctly: "Painters working in and near Los Angeles in the 1970s spanned sociological as well as aesthetic distinctions, personal backgrounds as well as artistic approaches, yielding a dizzying array of visual experience ranging from the narrative to the perceptual, sensual experience to Conceptual experience."[49]

That L.A. experienced a veritable free-for-all in painting may have everything to do with the times, as the 1970s were an era of exploding numbers of artists, art venues, and overall awareness of the position and role of artists in society. At the same time, a particular set of circumstances also marked L.A. as a place rife for artistic foment. The city's status as a center for artistic practice in the twentieth century had arrived relatively recently, in the late 1950s, and this meant there was no lengthy tradition of painting that artists in the 1970s needed to answer to. "Artists, painters in particular, are not hothouse plants," wrote Peter Frank. "They may grow in hothouses, but they flourish in the wild. Southern California in the '70s was a wilderness in that regard, poor in areas of exposure even while rich in areas of spontaneous growth and cultivation. As a result, painting exploded in and around Los Angeles, its various manifestations madly mutating and crossbreeding. Sometimes it didn't look or act like painting at all. Sometimes it did. Sometimes it did and didn't, even when it stuck to the 'rules' of painting. It was still painting, but it had become something else as well, something that could be painting and something besides painting at the same time. In the 1970s, whatever it did elsewhere, painting re-invented itself in—and arguably because of—Southern California."[50] Also, because of the region's "growing surfeit of art schools and art departments," many of which were new and hungry, Los Angeles at the time became a place where "one could tinker with painting, expanding its techniques and tweaking its definitions without concern for the disapproval of an entrenched establishment."[51] And

finally, as we'll see in the example presented by some of L.A.'s most lastingly innovative artists of the era, painting in the city was affected by the large and growing shadow cast over the local culture by several dominant cultural institutions—namely, the Hollywood film studios, television studios, and, in particular, the Disney Company, with its complex of studios, amusement parks, and ubiquitous cultural icons.

THE MOST APPROPRIATE WAY TO DESCRIBE PAINTING in L.A. in the 1970s was to call it eclectic. And when it came to eclecticism, no one perhaps embodied the ideal of the era more than artist Llyn Foulkes, whose work was once noted for its "genre instability."[52] Among other things, Foulkes explored the forgotten realms of landscape painting, portraiture, and narrative tableaux even while delving into truly contemporary, and very Californian, subjects and themes.

Born in Yakima, Washington, Foulkes grew up during the Depression and World War II. As a young boy in a fatherless household, he drew, for solace, pictures of Mickey Mouse and Donald Duck on whatever scraps of paper he could find. At age eleven, Foulkes, inspired by his favorite musical comic Spike Jones, formed his own one-man, vaudeville-style band. He called himself "Spike" and traveled around the Pacific Northwest to play what he called "cartoon music."[53] In high school, Foulkes discovered Salvador Dali, whose dreamy images and outlandish character he found appealing. After high school in 1954, Foulkes was drafted into the army and served in Germany, where he saw and painted watercolors of the bombed-out ruins of the great cities of Europe. His shock at the remnants of the wanton violence and destruction in Europe found an outlet in the art he would make after the war. In 1957, Foulkes was released from the army, and he made his way to Los Angeles to attend the Chouinard Art Institute, where Abstract Expressionism still held complete sway. Foulkes absorbed the lessons of his expressionist teachers, particularly Richards Ruben, mastering the visual language of abstract painting while investigating the conflicting and spiraling emotions he still

grappled with from his years in the army. As was common in L.A. at the time—particularly in the work of such Beat-era masters as George Herms, Bruce Conner, and Ed Kienholz—Foulkes added collage and assemblage elements to his increasingly dense and textured abstract art, and in 1959 he left Chouinard and set to work establishing himself as an artist.

Much of the work by Foulkes in the early years after he left Chouinard employed imagery and concepts from the War. His construction/painting "Medic Medic" (1960), for example, gives a good indication of the artist's focus at the time. Made from a reclaimed window frame, the imagery includes a cross shape in the bottom half of the image—painted in black on a gold ground—that evokes the symbols that various armies employed during the war. In the top half of the image, a collaged photographic image of a soldier has been altered by the artist with splotches of paint to appear dead and bloodied. It seems clear, from this one painting, that Foulkes was fairly intent on working through his conflicted feelings about his experiences as a soldier. Other self-searching images that Foulkes created include: "Dachau" (1961), which evokes the tragedy of the titular concentration camp through angry swipes of muddy paint, and "Flanders" (1961–62), a diptych in which a plastic tarp has been attached to the image surface and melted into a shape, jutting out into the viewers' space, that resembles a dying angel falling into a dark and very foreboding landscape.[54]

These works gained quick attention for Foulkes. In 1961, he mounted his first one-person exhibition at the Ferus Gallery, a series of broodingly dark paintings that was somewhat at odds with the gallery's growing focus on the lighter side of Pop Art. While Ed Moses would claim that Robert Irwin and Billy Al Bengston were the leaders of a boycott of Foulkes at the gallery,[55] for whatever reason Foulkes never showed again at Ferus. For the time being, however, his career marched onward. The next year, in 1962, Foulkes showed more than seventy of his works in a solo exhibition at the Pasadena Museum of California Art. In 1963, Foulkes would pointedly take up with the Rolf

Nelson Gallery, directly across the street from the Ferus Gallery, and in 1964 he mounted a solo exhibition at the Oakland Art Museum. In 1967, Foulkes was awarded the Prize for Painting at the Paris Biennale, which meant his work was featured at the Musée d'Art Moderne de la Ville de Paris, and, later in that same year, he was selected by curator Charles Proof Demetrion to represent the United States in the Saõ Paulo Art Biennial in Brazil.

Despite these successes, true financial stability was hard to come by for Foulkes, as the heavy quality of his earlier works somewhat discouraged collectors from snapping them up. Foulkes would actually later claim that running up against the rising popularity of the slick Pop-inspired, Finish Fetish style of artists like Bengston and Irwin, would nearly "kill" his painting, as these movements' emphasis on flatness and on the removal of the hand from the image was at odds with his natural approach. Given such circumstances, it's understandable that Foulkes, beginning in 1969, abandoned the heavy assemblage constructions of the first part of his career in favor of simpler images that were large, dramatic, and straightforward in style and sentiment. More specifically, Foulkes began painting multilayered scenic landscapes that made use of imagery from picture postcards, vintage landscape photography, and Route-66 signage. The intent of these works was to explore the artist's ideas about the social and environmental climate of Southern California at the time, as the region was first beginning to be aware of the irrevocable degradation of its environment. While these works of the early 1970s brought Foulkes, for the first time, some amount of commercial and critical attention, these successes also raised a host of questions in his mind about the value of art, why certain works sold while others did not, and his role in the art world. As a result of his confusion and frustrations, Foulkes eschewed painting for a brief time and returned to his first love—music.

Foulkes began his exploration of music by playing in a friend's rock band, before forming, in 1973, his own group, The Rubber Band, which toured widely and once even appeared on *The Tonight Show*

*Starring Johnny Carson.* After The Rubber Band folded in 1977, Foulkes returned to his childhood fascination with Vaudeville-style one-man bands, eventually creating the "Machine," a contraption comprised of horns, a xylophone, empty water bottles, and other ordinary items employed as percussive objects. Some commenters at the time suggested that, with the Machine, Foulkes had finally given in to the local draw of Performance Art—a charge that he denied. Whatever the case, throughout the 1970s, Foulkes wrote and performed songs that critiqued the popular obsessions of America, and it was this lyrical material that would lead Foulkes to a new phase of his career as an artist. Around 1971, Foulkes returned to painting after a hiatus with a series of shocking "portraits"—images of bloody heads, similar to the one that had first appeared in "Medic Medic," that allowed the artist to again explore his tormented inner life. The portraits typically were made with found photos, which Foulkes would overpaint with gruesome imagery. Occasionally, in perhaps a nod to the times, pop cultural figures like Charlie Chaplin and Mickey Mouse would make an appearance. Other times, the pain was clear even if the faces weren't. "Some of the faces seem to be eaten by venal misery from within," wrote the curator Marilu Knode about these works, "while others appear to be smashed by foreign objects, obliterated by geometric forms, or stained by unsaintly attributes."[56] A good example of this work is an ostensible self-portrait, "Who's On Third?" (1971–3). In this painting, a clean-shaven head-and-shoulder image of a man dressed in a collared shirt and jacket is marred by a dark and ominous mask-like object that covers most of his face and the front part of his head. Out from under the mask flow feathery blood-red brushstrokes of color that cover most of the figure's head, hair, and face, save for his chin and neck. Adding to the gruesome quality of the image are a series of oozing, blood-like drips of color that cover the collar of his shirt. It's clear in "Who's On Third?" and similar works from the early 1970s that Foulkes was grappling with feelings of disconnection from the world and, perhaps, the times. It's difficult to look at any one of

Foulkes's head-portraits and not wonder what pain and frustration the artist was feeling. And perhaps this was as Foulkes wanted it. "This is the primary work of the artist," Marilu Knode said of Foulkes's "Who's on Third?" "to interpret the contemporary world as experienced in terms of his own inner life. Ultimately, Foulkes's self-portrait is an image of the way in which the real is won and lost in the same instant."[57]

Interestingly, despite Foulkes's move toward a more incisively disturbing sort of imagery, his art-world success resumed. In 1977, he was awarded a Guggenheim Fellowship, and, a year later, the Museum of Contemporary Art in Chicago mounted his first retrospective survey exhibition. Foulkes's work also would become, in the second half of the 1970s, a significant source of inspiration for a cohort of hungry young artists who would grapple with similar feelings of alienation, pain, and disconnection. "Foulkes explores the underside of the American dream," wrote one curator. "His edgy paintings express the moral desolation and violence he perceived in late-twentieth-century society. Yet he holds fast to his romantic ideals. He believes in art's power to change society."[58] The fact that many of these artists would pick up on this element of Foulkes's output—his mixed feelings about the American dream in a disturbing and disappointing era—would make Foulkes a harbinger of an important local moment, if not exactly a movement. It was a moment in which local artists would, without realizing it, create the future.

CHAPTER IX.

# Future Shock

*The Birth of L.A.'s Young Romantics*

THE L.A. AVANT-GARDE OF THE 1970S—THOSE artists who followed their own expressive paths of personal unease, social and political radicalism, general nihilism, and even oblivion—did not exist in a vacuum. By the second half of the 1970s, it was becoming increasingly clear to commenters and pundits in Los Angeles and elsewhere that the country was passing through a very strange and unsettled time. It's difficult, even today, to explain exactly why. Certainly the prolonged economic malaise of the decade was distressing; but taken alone, the downturn doesn't fully explain the deep-rooted societal unease, especially compared to the Depression experienced forty years earlier. The demographic changeover from the Depression and wartime generations to the vast Baby Boom no doubt played a role in the era's mood, but the country had seen such generational changeovers many times before without the same level of confusion and uncertainty. Whatever the reason, the years between 1975 and 1979 were noted for a sense of national hopelessness so entrenched that a newly elected president, Jimmy Carter, seemed overcome by it in his own inauguration speech. "We have learned," Carter said in the January, 1977, speech, "that more is not necessarily better, that even our great nation has its recognized limits, and that we can neither answer all questions nor solve all problems."[1]

One possible explanation for these problems may actually have been evident in two seminal events—one local to Los Angeles and one that originated in the U.S. but quickly grew into an international phenomenon. In 1970 and 1971, as has already been described, the Los Angeles County Museum of Art began rolling out its multifaceted exhibitions called "Art and Technology." It was a project that wholly failed to achieve the lofty goals set at its conception in 1968. Chief among the reasons for this failure was a significant miscalculation. Curator Maurice Tuchman had had no way of knowing that over the two years that the "Art and Technology" program was in its planning phase the prevailing spirit of the country changed— from an optimistic, confident, and forward-thinking consumerist and technology-loving culture to something approaching its opposite. Sometime after 1970, America became a nervous, brooding, pessimistic place whose citizens seemed put off and overburdened by the times. The era of malaise, it seemed, had begun without anyone ever having an inkling why.

As it happens, there was at least one person—the social theorist and author Alvin Toffler—who was pretty certain he knew what was going awry at the time. And Toffler wrote it down for all to see in his best-selling and groundbreaking book *Future Shock*. "Future shock is the dizzying disorientation brought on the premature arrival of the future," Toffler wrote. "It may well be the most important disease of tomorrow. Future shock will not be found in *Index Medicus* or in any listing of psychological abnormalities. Yet, unless intelligent steps are taken to combat it, millions of human beings will find themselves increasingly disoriented, progressively incompetent to deal rationally with their environments. The malaise, mass neurosis, irrationality, and free-floating violence already apparent in contemporary life are merely a foretaste of what may lie ahead unless we come to understand and treat this disease. Future shock is a time phenomenon, a product of the greatly accelerated rate of change in society . . . . It is culture shock in one's own society."[2]

The disharmony and disruption of the 1970s, in Toffler's view, were the result of the wide-ranging and accelerating pattern of cultural change. The root source of future shock was that Western society was speeding up. Technology was making culture happen faster, life was becoming more and more harried, and societal institutions and traditions were growing ever more fleeting. "We have in our time released a new social force," the author continued. "A stream of change so accelerated that it influences our sense of time, revolutionizes the tempo of daily life, and affects the very way we 'feel' the world around us. We no longer 'feel' life as men did in the past. And this is the ultimate difference, the distinction that separates the truly contemporary man from all others. For this acceleration lies behind the impermanence—the transience—that penetrates and tinctures our consciousness, radically affecting the way we relate to other people, to things, to the entire universe of ideas, art, and values."[3]

Explained in a more complete way, future shock involved almost all facets of culture and society: Human patterns of living and urban development; throwaway consumerism and the cult of convenience; dehumanizing medical practices; changing patterns of political organization; nontraditional lifestyles and the "Me" generation's raging individualism; and the rapid expansion of technology, information, and knowledge, which led to the increasing push toward the information age and gave rise to the modern phenomenon of "information overload" (a term that Toffler popularized). And in point of fact, the first part of the new decade saw the emergence of a host of new technologies that would, in time, revolutionize modern life—particularly in the area of communications—in ways that would eventually be as sweepingly dramatic as the Industrial Revolution. The decade saw the continued spread of television—particularly the development of satellite imagery and the beginning of a move toward cable television—alongside the development of a number of powerful new personal communications devices and tools. In 1971, software developers in Massachusetts sent the first email. At the same time, the first computer floppy disk was

hitting the market, eventually making possible the proliferation of the first inexpensive personal computer.[4] The first car phone appeared in Finland in 1971, while the first commercially viable home video format (VCR) had been developed by Philips in the Netherlands in 1970. The first voicemail system appeared, courtesy of the Thomas J. Watson Research Center in Massachusetts in 1973, as did the first cell phone (courtesy of Motorola), and the first magnetic resonance imaging machine (at SUNY Stony Brook). For the first time in human history, it became possible to share information nearly simultaneous to actual events. The expansion of fleeting electronic media images, and the effect of this expansion on the society, was not just noticed by Toffler. Stephen Barber, author of a 1975 book called *America in Retreat,* was prominent in suggesting that the growing preoccupation with modern media was the reason there was so "little strength or direction in the mass of American society" at the time and why the dominant mood of the age was one of "retreat and isolationism."[5] Our ever-advancing technologies for capturing, sharing, and spreading visual, written, and spoken information were speeding up the world and, for the first time, overwhelming our collective psyches.

Understanding Toffler's notions about the origins of America's feelings of disconnection and psychic displacement may shed some light on inspiration for Llyn Foulkes's troubled paintings in the early part of the decade, or perhaps even for the anguished and disturbing nature of Bas Jan Ader's final art performance in 1975. It also may explain why the country's many efforts to shock itself out of its disorientation and confusion were abject failures. Almost as soon as President Carter finished his inauguration speech, he set about on a campaign to free the country from its malaise. These efforts, on the whole, were ineffective. So much so that, toward the end of his presidency, with the country now mired in its hopelessness, Carter delivered an extraordinary speech on television to the American public. On July 15, 1979, a bit more than four years after Bas Jan Ader had last been seen alive (and just a month after he had been declared "lost at sea"), and exactly

three years after Carter accepted the presidential nomination from the Democratic Party, Jimmy Carter's "Crisis of Confidence" speech was a presidential call to arms. "It's clear that the true problems of our nation," Carter said, "are much deeper—deeper than gasoline lines or energy shortages, deeper even than inflation or recession. And I realize more than ever that as president I need your help . . . . So, I want to speak to you first tonight about a subject even more serious than energy or inflation. I want to talk to you right now about a fundamental threat to American democracy. I do not mean our political and civil liberties. They will endure. And I do not refer to the outward strength of America, a nation that is at peace tonight everywhere in the world, with unmatched economic power and military might. The threat is nearly invisible in ordinary ways. It is a crisis of confidence. It is a crisis that strikes at the very heart and soul and spirit of our national will. We can see this crisis in the growing doubt about the meaning of our own lives and in the loss of a unity of purpose for our nation. The erosion of our confidence in the future is threatening to destroy the social and the political fabric of America."[6]

The "Crisis of Confidence" speech did, according to spot polls, raise the spirits of many Americans, but only for a fleeting few days. Two days after the speech, Carter ruined any positive after-effects to his speech by asking for the resignation of every one of his cabinet members—an act that gave the impression that the "crisis of confidence" was actually located within his administration. Over the next few days, as political opponents speculated about the president's mental health and rumors spread around the world regarding the imminent collapse of the U.S. Government, the dollar dropped sharply. The accelerated spread of information, made possible through the rising media and communications technologies of the 1970s, only made the situation worse—particularly since the government seemed out of synch with its messaging and unprepared with its damage control. As a result, the country's mood turned darker than ever before, damaging not only the economy but also the social fabric. Carter, for his part,

kept trying to contain the damage and bring a sense of sanity to his country, but it was akin to shooting a water pistol at a raging conflagration. In March of the next year, during the election season, Carter again spoke on TV. "As Jimmy Carter stepped before the television cameras in the East Room of the White House last Friday," wrote a *Time* magazine reporter, "his task was not just to proclaim another new anti-inflation program but to calm a national alarm that had begun to border on panic. Inflation and interest rates, both topping 18 percent, are so far beyond anything that Americans have experienced in peacetime—and so far beyond anything that U.S. financial markets are set up to handle—as to inspire a contagion of fear."[7]

THE 1970S, OF COURSE, WERE NOT THE FIRST ERA IN human history that struggled with social disharmony, disequilibrium, and duress brought on by a transition in the social and cultural fabric. In the late eighteenth and early nineteenth centuries, during the vast social changes that were brought on primarily by the effects of the Industrial Revolution in Europe, people across the world were unmoored. As various life-altering inventions were rolled out with increasing speed during those years—including the development of large-scale factory production methods, the mechanization of farming, the advancement of medicine and science, greater and greater economic specialization, increasing speed and efficiency of transportation methods, the explosion of urban populations, and so on[8]—dramatic changes took place in the social and economic structure of countries that had not vastly changed in centuries. "Many people felt that the changes taking place, naturally, spontaneously, and in ways no government could possibly prevent," wrote historian Paul Johnson, "were as much as society could conveniently digest . . . . Changes were constant. All over the advanced world, men knew that life was changing irrevocably and at increasing speed. Writers and artists were particularly aware of it."[9]

While the Industrial Revolution ultimately increased overall well-being and life expectancy, raised living standards, encouraged the

development of a professional class, fostered a population explosion, and promoted the expansion of democracy, its refashioning of the social fabric ruptured the long-standing and traditional social structures of the time. As a result, the early 1800s were marked by social unrest and small riots, such as the "Luddite" riot of 1811 in Britain. Rural communities in particular suffered the effects of industrialization, small farms and traditional craft professions perishing at the hands of mass industry and farm consolidations. Poets like William Wordsworth described these tragic circumstances in revealing detail. "A happy land was stricken to the heart," he wrote in his 1797 poem "The Ruined Cottage." "'Twas a sad time of sorrow and distress, . . . I with my pack of winter raiment saw/The hardships of that season." The painter Benjamin Robert Haydon, meanwhile, lodged his own complaints about the rapidly changing shape of the landscape. "Since I was on this road last," he wrote in his journals, "streets, in fact towns, have risen and beautiful fields were disfigured by cartwheels, stinking of bricks and whitened by lime!—these wounds on solitude, purity, and nature are horrid." Many artists of the era were so affected, they took part in a widespread cultural movement, called Romanticism, that spanned the fields of literature, poetry, fine art, crafts, and music. The movement focused, in a nutshell, on preserving the dignity of the individual in the face of increasing change and disorientation.

Americans struggling with the disharmony, confusion, and duress of the "future-shocked" 1970s followed a similar path as people affected by the Industrial Revolution. During the 1960s, frustrated Americans—particularly young ones—had mounted protests against the times. This ranged from the focused protests of the Civil Rights Movement to the broader protests of the Student Free Speech Movement, the Student Nonviolent Coordinating Committee (SNCC), the Students for a Democratic Society (SDS), and the Youth International Party (Yippies). As the 1970s approached, the protests grew ever more strident, leading to the shocking events of the 1968 Democratic Convention, in which ten thousand demonstrators were

met by twenty-three thousand police, and at Kent State University on
May 4, 1970, in which an Ohio Army National Guard unit shot and
killed four students and wounded nine others. During the 1970s, the
attitudes and views of some of the youthful protesters hardened, lead-
ing to the proliferation of a range of militant underground revolution-
ary cells such as the Weather Underground, the Symbionese Liberation
Army, the Black Panthers, and so on.

As happened during the Industrial Revolution, artists also
responded to the mood of the times. Many artists of course partici-
pated in the revolutionary movements of the era—such as the Feminist
Movement, the Chicano Movement, and the Black Power Movement.
But others grappled more directly with the expansion of technology
and mass media, its "ideological power and seductive materialism,"
and its "unrealism, artifice, immateriality, and replication"[10] through
their art. "In the 1970s," wrote curator and author Lisa Phillips, "as a
new generation of artists came of age . . . the media literate were aware
of and addicted to the media's agenda of celebrity-making, violence-
mongering, and sensationalism."[11] It makes sense that a number of L.A.
artists would take the lead in visually grappling with the disruptions
of the times. As has already been explained, by the early part of the
decade California was not only the country's chief source for much of
the entertainment media and new technology that preoccupied its peo-
ple, but the state's increasing traffic, chronically bad air quality, disap-
pearing open space, advancing sense of alienation, and other signs of
retreat increasingly belied the nature of the American Dream of just a
few years before. Not only were Bas Jan Ader and his reductive and
nihilistic cohorts raising avant-garde queries about the nature of art-
making, but they were positing a larger existential question: *How do
we fit into this world?*

The artists and poets of the "Romantic" era of the early 1800s
had many of the same concerns, and of course L.A.'s new generation
of bemused and embattled artists were well aware of this. One of the
most famous paintings of the Romantic era, Caspar David Friedrich's

"Der Mönch am Meer" ("Monk by the Sea," 1808–10), was one that Bas Jan Ader admired. This painting portrayed a tiny, solitary figure facing a turbulent and vast void of sky and ocean. The sky, which fills perhaps three-quarters of the painting, is the true subject of the painting; while the titular monk, who is insignificant next to the sea and sky, rendered nearly-but-not-quite invisible, raises the same questions asked by L.A.'s experimental artists of the 1970s: *How do we fit in?* Amid all the noise and confusion of a rapidly changing world, then, the artists of both the Romantic era and the 1970s were made to ask the same hard questions about their place in the world. When Jack Goldstein buried himself for a performance piece at CalArts, or when Bas Jan Ader set sail alone in a twelve-foot sailboat with only three months' worth of food, or whenever Chris Burden put his own body at risk—they were all grappling with the same seemingly meaningless void as Friedrich's monk.

AFTER 1976, WHEN IT BECAME CLEAR THAT BAS JAN ADER *had* truly disappeared from the world, that Chris Burden had abandoned the dangerous line of artistic inquiry that had brought him to "Doomed," and that Jack Goldstein and his various early CalArts peers—David Salle, Matt Mullican, Tony Brauntuch, James Welling, and several others—had embarked to New York, a host of new young artists in Los Angeles picked up the strains of the investigation of the confusion, disharmony, and malaise of the progressing decade. Mostly situated in and around the art studio ghetto of Venice Beach, this new strain of pseudo-Romantic investigation included such artists as: Paul McCarthy, Mike Kelley, Terry Allen, Alexis Smith, Carole Caroompas, Michael Balog, Betye Saar, Jim Ganzer, and Tony Oursler. These diverse young artists, whose artistic output was in no way stylistically or thematically cohesive, did have in common two traits. All were unique voices intently focused on establishing their art careers in Los Angeles, and all were sensitive and insightful artists desperately grappling with the troubled nature of the times.

Many of these artists found inspiration from several local sources to feed their two artistic impulses. The first, and most obvious, were the strains of slightly nihilistic Conceptual and Performance Art as exemplified in the innovations of John Baldessari, Chris Burden, Allen Kaprow, and the art programs at the California Institute of Arts, the Claremont Graduate School, and UC Irvine. John Baldessari, arguably, had the most profound effect on these artists, and on the development of the art discourse going forward over the next several years. After all, as was clear in the careers of the first batch of CalArts graduates—Jack Goldstein, et al—the post-studio approach was at once a driver of artistic freedom, even as it focused these young artists' output toward a drily humorous, concept-laden, and very pictorial aesthetic that was in perfect tune with the times.

The second influence on this new generation of artists was the city itself. Los Angeles was dominated on one hand by stunning physical features such as its massive automotive infrastructure, its sprawling and diverse population, and its landscape of mountains, mountain valleys, beaches, and sun. But on the other hand, Los Angeles was haunted by the unique cultural institutions of Hollywood, the movie and TV (and music) industries, and the strange institutions and iconography of Walt Disney. "L.A. had never been much of a painting town," wrote Peter Frank of the years leading up to the mid-1970s. "Its major creative industry,"—i.e., Hollywood—"favored image over object and tended to regard the act of painting as a backlot-workplace job rather than a sacred ritual. The end product was the goal, and if the end product bespoke the process of its making, that process was one of material fabrication rather than personal expression."[12] Many of the new young generation of artists—L.A.'s "Young Romantics," we'll call them—were profoundly influenced by the psychic pull of Hollywood and its constant stream of pop-cultural artifacts and detritus, as well as by the overweening psychic effect that the explosion of popular media was having on the culture at large. And they mined the Hollywood dream machine incessantly for visual, thematic, and psychic material for use in their art.

And the final influence, which was hidden far beyond the large shadows cast by the Ferus Gallery, as well as by the growing reputation of John Baldessari and CalArts and the cultural influence of the city itself, was that of an eccentric solitary artistic voice who had been producing his work outside of the accepted local -*isms* and L.A. art trends since the early 1960s—Llyn Foulkes. The "Young Romantic" artists were inspired by the eccentric and variegated approach of Foulkes, as well as by his Romantic-esque use of a kind of "inner dialogue" in his work, or an alternate narrative that broke down the assumptions and presumptions of society and attempted to explain the era's confusion and despair. Foremost among the progeny of Foulkes was the Kansas-born, Texas-raised artist Terry Allen. Having come to L.A. to attend the Chouinard Art Institute a few years after Foulkes, Allen from the get-go worked in multiple media simultaneously—including painting, installation art, Performance Art, and even music (Allen would record several albums of folksy country-western songs he wrote and performed himself). While it would have been easy for Allen to get swallowed up in the prevailing aesthetic of the second- and third-generation Abstract Expressionists who dominated Chouinard at the time—and remnants of the aesthetic did find their way into Allen's highly expressive work—like Foulkes Allen veered toward the influence of the more absurdist movements, Dada and Surrealism.[13] As a result, Allen's earliest work at Chouinard included the first works of a vast, multimedia series that would alternatively employ painting, illustration, text, collage, constructions, assemblage, artist books, poems, watercolors, prints, photographs, songs, a screenplay, a live radio show, and several musical theater pieces in a sustained (40+ years) investigation of the feel, look, and spirit of the Mexican border town of Juárez.

Taken as a whole, the varied early works in Allen's "Juárez Series" are dense with hidden meaning, as if giving a glimpse into someone's secret dialogue with the world. They overflow with imagery, objects, words, and visual and verbal clues that, when examined in depth, more often than not lead into spiraling circles of obscurity and

shrouded symbolism. Terry Allen's "Juárez Series" started with works like "The Cortez Sail" (1970), a crisply Surrealistic illustration of a sail on which is depicted a colorful array of rocky desert mountains, random floating human eyes of various colors, and a sky filled with churning clouds. An image of a Mexican Catholic sacred heart makes an appearance, as does a fish skeleton trying to swallow a chicken carcass; the entire illustration resting atop collaged snippets of a road map that reveals the cities Montezuma and Cortez, Los Angeles, San Diego, Tijuana, El Paso, and Ciudad Juárez. Other works from the series, such as "Writing on the Rocks Across the U.S.A." (1972), both refer back to and build upon the visuals, locations, and references in previous images. For example, the "Cortez Sail" fish reappears in "Writing on the Rocks Across the U.S.A.," now more fully fleshed out, and other elements—a chalkboard with various words and word snippets, place names, and scribbles, snapshots of rugged mountain terrain, and drawings of fishing lures—are added.

Often compared to surrealism and Dada, Allen's artistic approach served to, according to one curator, stimulate "a complex emotional and intellectual involvement on the part of the viewer."[14] Another notable critic, Dave Hickey, described Allen's work as having an "uncanny aura of nature and culture, nature and nurture, jammed and blended into one strange object." Hickey would continue, suggesting that Allen made his own brand of opera, "full of intelligent creation: music, song, dance, couture, drama, and spectacle."[15] Indeed, Allen's first musical album, a collection of story songs called "Juárez," is all opera and spectacle as filtered through a Romantic, world-weary country troubadour's voice. Sung in a gravelly twang with a simple piano-and-guitar accompaniment, the songs in the album are a mixture of folkloric stories and sharp personal observations by Allen that subtly rail upon the spirit and values of the times.[16]

As with Foulkes, Allen made no secret of the inspiration for his agitated artistic output. "My ideas come from impressions and incidents that have actually happened," he told an art critic a few years later.

"As soon as I isolate them, they expand to have other meanings and possibilities . . . . I don't believe art comes from art. It comes from what you perceive is going on within yourself and other people."[17] Allen's artistic grappling—with the hidden meanings and cultural confusion of the border places that he was fascinated by—were his attempt to employ his internal imaginings in order to balance, in much the same way as the Romantics did, and as Foulkes was doing as well, his experience of the confounding external world. And Allen would be only the first among many local artists whose artistic drive came from this same "Romantic" impulse.

Like Terry Allen, Allen Ruppersberg first came to Los Angeles from another place—Cleveland, in this case—to study art at the Chouinard Art Institute in the early 1960s. After graduating with a BFA in 1967, Ruppersberg began working as an artist in Los Angeles, while keeping an apartment in New York and connections in Ohio. Ruppersberg's works were, like Allen's, an unusual array of Conceptual and Performance Art events, paintings, prints, photographs, videos, sculptures, installations, and artist books. His inspiration was just as varied, including such trappings of his adopted home as the local (L.A.) architecture, popular movies and pulp fiction novels, current magazines, poster art, television advertisements, and so on—all of which he collected as raw grist for his art. "One can identify varied artistic influences in Ruppersberg's work," wrote one curator, "Surrealism, Beat assemblage, Pop Art. Like Pop artists, Ruppersberg appropriates imagery from popular culture, eschewing the Modernist distinction between 'high' and 'low' art. But his technique, that of creating new meanings through juxtaposition, relates both to Dadaism . . . and also to the French Surrealist poets' practice of decoupage, or the cutting up and rearrangement of text. Beat assemblagists similarly combined their humble materials in unexpected and evocative ways."[18]

From the beginning of his career, Ruppersberg parodied the mass media that inundated and surrounded him and everyone else within the general ethos of early Conceptualism, particularly that of Southern

California, where his closest associates were the Dutch artists Bas Jan Ader and Ger Van Elk, as well as William Leavitt, Allan McCollum, and William Wegman. Over the years, however, Ruppersberg developed his "own type of Conceptual practice based in the belief that the ordinary culture of America can speak volumes about the fundamental issues of human experience."[19] Ordinary culture, in this case, meant his environment of Hollywood or Los Angeles. "The degree of intimacy that he maintains with the sub-cultures around him," suggested the curator Helene Winer as long ago as 1972, "allows him to convincingly isolate and manipulate the superficial elements for his own complex purposes. Like the fictional detective Philip Marlowe, he is in touch with most of what is going on in the city and seems to have personal relationship to an astonishing number of unlikely aspects . . . . The evidence of Ruppersberg's encounters is clear in his art. We see fragments of contemporary places, conversations, cliches, styles, fads, and attitudes selected and combined to arrive at a reality beyond the sum of the parts."[20]

From the start—whether he was creating mock versions of movie and carnival posters, hand-writing mock versions of sensationalized newspaper articles, or by carefully copying the text of popular novels—Ruppersberg was a kind of shaman, attempting to tame or bring under control the overwhelming visual information of the age. "Reality," Ruppersberg once told the curator Howard Singerman, "only needs a slight adjustment to make it art."[21] This penchant for bending reality through art is apparent in the first works of Ruppersberg's that gained some public notice in Los Angeles. His performative installation "Al's Cafe" (1969), for instance, played with notions of what comprised the restaurant experience—questioning whether it was the act of serving food to hungry customers or more of a social interaction. A simulacrum of a restaurant, "Al's Cafe" superficially resembled in its interior any typical greasy-spoon diner. It had plenty of neat tables and chairs, a counter with stools, a large coffee urn, signs advertising sandwiches, menus, and so on. But in reality Ruppersberg's experiment

was quickly revealed as a warped and subversive twist on the entire notion of a neat and tidy American cafe. Menu items, for instance, were unnatural versions of typical dinner foodstuff. "The meals were actually small assemblages of bits of nature and cultural artifacts," remarked a curator some year later. "Evocatively titled—'John Muir Salad (Botany Special),' 'Grass Patch with Five Rock Varieties Served With Seed Packets on the Side,' 'Patti Melt' (a photo of Patti Page covered with toasted marshmallows), 'Al's Burger: Sky Land and Water,' et al—they sold for the price of an ordinary meal. Ruppersberg was referring to Earth Art . . . but also to such California assemblagists as George Herms and Bruce Conner, and to their elevation of the everyday, especially the cast-aside clutter of our lives. Like other artists of the time or even somewhat earlier who operated temporary shops— for example, Claes Oldenburg with 'The Store' (1961)—Ruppersberg removed art from the rarefied atmosphere of a museum or gallery and inserted it into an ordinary, commercial context."[22] Whatever the artist's full intentions, the idea of feeding and sustaining customers was removed from the equation of the cafe, and much of what went on in the cafe was ritualized and pointedly weird, as if questioning the nature of this simplest of human interactions.

While "Al's Cafe" was open, it was a something of a hangout— for fellow artists,[23] for art appreciators, and for people who stumbled upon the strange experiment. Ruppersberg had been uncertain when he started how long he would keep the cafe open, and its sudden end seemed almost perfectly in keeping with the experiment. After three months of closely watching the space, and seeing such confusing shenanigans as the passing around of odd plates of twigs and leaves by long-haired kids, local police raided the space and arrested the artist for serving alcohol without a license. While Ruppersberg later recalled the case being matter-of-factly dismissed by the judge, the sudden arrest and closure, in a weird way, validated the work's subversively questioning intent. "I thought," said Ruppersberg, "okay, that's perfect, that's the end. I can't do any better than this."[24] Or, as one critic

later suggested, the sudden end to the project "provide[d] a lesson in seeing and believing—and also what can happen when things escape being looked at as art."[25]

THE QUESTIONING AND GRAPPLING OF THE ARTISTS of L.A. during the age of future shock almost immediately gained the attention of the international art world. On the strength of his early Conceptual installation work, Ruppersberg was included in curator Harald Szeemann's "Live In Your Head/When Attitudes Become Form," exhibition in 1969. This exhibition, of course, eschewed the idea that art should be precious, and the works included in the exhibition were marked by their ephemeral, non-consumerist, impermanent, and questioning qualities. Ruppersberg's contribution to "When Attitudes Become Form" was called "Untitled Travel Piece, Part 1" (1969). It was a flatfooted tableau that included a card table, a folding chair, and four American daily newspapers. The work, quiet and poignant as it was, got swallowed up by the churning and chaotic nature of the exhibition, where works were positioned nearly on top of each other and movements were presented in a jumble (as opposed to segregated like with like). But despite the challenges of the show, or perhaps because of them, the exhibition and the exposure it offered to the young artist were a huge boost. In 1971, Ruppersberg continued to question the nature of certain aspects of the culture of Los Angeles in a work called "Al's Grand Hotel." For this performative event, which ran from May 7 to June 12, Ruppersberg took over an old two-story Craftsman home located at 7175 Sunset Boulevard and converted it into a fully functioning hotel. Before its opening, Ruppersberg sent out a message on authentic-looking letterhead and a seemingly real brochure advertising the hotel's rooms, including the oddly named Jesus Room, Ultra Violet Room, and the Al Room. The brochure also listed various items that could be bought from the hotel, including "seven framed wedding photos" for $35, a "Wanda" pillowcase for $50, and the "Entire Hotel" for $3,500. A much more mild and less subversive

sort of event than his earlier "Cafe," it was no less an investigation of the confusion of the times—exploring the nature of modern market- ing, advertising, and the like. The trick to all of this, of course, was the simulacrum-like nature of both projects, or, as Ruppersberg himself said of his cafe and hotel projects: "As much as I could make them, they were real. That was the point: they had to be real to escape being looked at like art."[26]

The activities at "Al's Grand Hotel" during its run even included Saturday-evening concerts by Terry Allen, who was a close friend. Both young artists continued for the next several years investigating and finding ways to cope with the current age of discord. Terry Allen continued the multifaceted assault on the issues that fascinated him: the mestizo-mixture of bordertown cultures that crossed and recrossed from Mexico into his two homes, Texas and California; the wild, Western drug trade and local shamanistic mysticism; and the vast open desert with its particular landscape features, creatures, myths, and abiding spirit. He continued his Juárez series all through the 1970s and beyond, creating ever more elaborate and evocative tableaus and installations, adding drama and melodrama, music and poetry, sharp words and dark imagery. A visual work called "Melodyland" from 1974 contains a pinup-board tableau of objects including a Mexican flag, a pop-up map of the Southwestern United States, a large image of a señorita in a party dress, various picture postcards of Southwestern one-horse towns, a terrarium with colored rocks and cacti, and a raw- wooden bench-like object—all tacked onto a slate-gray chalkboard- like backdrop. Allen's investigation of Juárez, in sum, would amount to the expansive product of an artistic mind constantly evaluating and reevaluating, of someone trying to place oneself in a world of one's own making through various approaches, mediums, and forms.

As the 1970s progressed, Allen Ruppersberg too found him- self asking questions similar to his friends'—though often less fre- netically, and more literally and directly. A good example of this is Ruppersberg's project "Where's Al?" from 1972. As the title suggests,

the work is, in part, the artist's existential questioning of himself. At the same time, however, the work also somewhat obscures the relationship between artist/author and work of art. Ruppersberg himself described it as a "short story," and, in essence, the work is a sprawling mass of clues insufficient for providing an answer to the question posed by the title. It was comprised of a mishmash of items—150 snapshots of unknown or obscured people, 121 typed index cards of strange snippets of dialogue, statement, and questions—that are then tacked to the wall in seemingly random order. In the cards are depicted young, artsy-looking sorts of the 1970s—long-haired young men and women having fun at the beach, at parties, in cafes.

In its way, in how it attempts to show how visual and verbal remnants approximate—but never fully are equal to—the identity of an absent author, "Where's Al?" is a vast questioning of the position of the person in the muddle of the times. While the material provides some sort of clue to the nature of the missing "Al"—what he likes, where he travels, what he reads—it never actually amounts to much of a sense of the subject. It never answers the question, either in a literal or figurative way. And over time, the information presented begins to contradict itself, so that afterward there is only an essential mystery to this work. One even suspects a deep existential disquiet is at play here: What is Al trying to avoid, after all? What isn't he telling us about himself, the world, his place in it? One card even suggests that Al's story may actually be tragic:

> "He: Isn't Al here?
> She: No. Not yet.
> He: He could be in an accident somewhere.
> She: I guess."

In the end, the ambiguity of "Where's Al?" is a core quality of the artist's intent. To Ruppersberg, the surface of his works—the imagery and language used therein, the structure and feel of them—are just the tip of a much deeper investigation into the nature of things of the

world. His work is clearly a mechanism for coping with the times. "I try to set up a network of ideas and emotions," he once said to an art critic in explanation of this work in particular, "with only the top showing. The major portion of the piece continues to whirl and ferment underneath, just as things do in the world at large."[27]

AS THE AGE OF FUTURE SHOCK PROGRESSED, MORE and more artists were inspired to take on the changing times in their work. A number of young artists in Los Angeles, seeing the examples set by Terry Allen, Llyn Foulkes, and Allen Ruppersberg, began making art that balanced a confused and conflicted internal perspective with a sharply observant representation of the frenetic visual and psychic landscape of the times. No single visual style dominated these artists' take on the times. The varied artists deployed messy collage/assemblage, flat-footed illustration, photo-based realism, cartoony expressionism, appropriation, and other styles and approaches to get their points across. This stylistic diversity made some sense. That is, in the mixed-up, sped-up, and muddled times, wrought as they were with a growing sense of unease, the art world was naturally a morass of confusing stylistic disjointedness. In many ways, the visual confusion was the only honest way to portray the decade.

Because of the growing role media played in the confusion of the age, and because this was Los Angeles—the headquarters for much of the era's media—many local artists of the late 1970s used media imagery, pop culture iconography, and the idea of Hollywood in their work. The apotheosis of the Hollywood-bedazzled "school" of artists were two young figures who confronted the broad profusion of media-based and consumerist images and themes each in his own way. Both were new to town, both were based in Venice, and both were friends. Mike Kelley had been born in Detroit to a Catholic family in the mid-1950s. While still a young man, not yet a graduate of the University of Michigan, Kelley had been involved in the Detroit music scene as a member in the underground noise band Destroy All Monsters.

In school, he had been influenced by his discovery of Joseph Beuys, Vienna Actionism, and other edgy "action art" movements. In 1976, after graduation, Kelley left Michigan (and Destroy All Monsters) to move to Los Angeles. Drawn by CalArts' reputation as an interdisciplinary Mecca, Kelley intended to continue his pursuit of artsy music by studying with CalArts' electronic music composer Morton Subotnick. On arrival, however, he was disappointed to learn that art students were not actually allowed to take music classes. And while Kelley did continue to dabble at music with some fellow students—namely Tony Oursler and Don Krieger (in bands called Polka Dots and the Spots and the Poetics),[28] at CalArts Kelley struggled to reconcile his looser all-inclusive, anything-goes artistic roots in noise music and action art with the cool approach preferred at CalArts.

"When I arrived at CalArts," Kelley recalled some years later, "I was suddenly faced with a group of artists and a set of art terminologies that were completely foreign to me. The faculty was composed primarily of Conceptual artists, and photography, accompanied by text, was clearly a dominant methodology."[29] Though Kelley does acknowledge the influence of a number of CalArts professors—such as Baldessari, Laurie Anderson, Douglas Huebler, Robert Cummings, and David Askevold[30]—he was frustrated by the dry theoretical approach at the school, and so spent much of his time exploring the wider art scene and landscape of his newly adopted city. Kelley visited swap meets to scour for art materials, music clubs to sample the diverse scene, and the region's many other art schools to find out what new styles and movements were percolating up. At the Otis College of Art and Design, Kelley met the brothers Bruce and Norman Yonemoto, who made jumbled images that drew from low, high, and popular sources—Marxist theory, comics, gay porn, identity politics, and so on. Kelley also dove headfirst into literature between 1976 and 1978, reading a wide array of books[31] and getting involved in the literary circle that grew up around Beyond Baroque, an independent literary art center in Venice that local artistic figures like Dennis

Cooper, Bob Flanagan, Benjamin Weissman, Amy Gerstler, and Tim Martin frequented.

To synthesize what he was learning outside of the school, Kelley also began to write. In time his writing became a tool for absorbing the ideas he was being exposed to and for refining his thinking about his growing artistic interests—appropriation, collage and montage composition techniques, humor and irreverence, parody, political radicalism, system construction, and the overall the aesthetics of dissembling. Much of the writing later made an appearance in the performance art he dabbled in after graduation. "It's actually not cut-up," Kelley would later explain of his frenetic emerging aesthetic, "it's very much organized . . . like improvisational music."[32] For this work, Kelley would employ such cultural detritus of the time as mop poles, squeeze toys, whoopee cushions, Indian toy drums, cast udders, monster figures, and a series of props that his occasional collaborator, Tony Oursler, described as "marvelously inventive, equal parts Bauhaus and county-fair science project, . . . which would later morph into his sculptures and drawings."[33] In the early performances "My Space I" (1978), "The Monitor and the Merrimac" (1979), and "Parasite Lilly" (1980), Kelley registered above all else his take on the confusion of the times. "We were both interested in a kind of kaleidoscopic art form," Oursler added, "wondering at all kinds of combinations of text, music, performative actions, images, and sculpture that came almost out of nothing: Some plastic garbage bags, string, blocks of wood, a dime-store plant can, a cassette player, and a cardboard tube became an intricate system of oration performed by the sublime and dark Mike Kelley. A natural writer, . . . his poetic use of language was stunning when combined with his unique droning voice. He had a gift for understanding and transforming low or 'base' materials, as he called them . . . . He yelled through long tubes, banged big drums while doing dances; he would quiet down and place a small paper flower on his chest, mesmerizing the audience as the flower pulsed to the beat of his heart."[34]

Through all of these experiments, Kelley sought to defend himself against, and to co-opt for his own purposes, the cultural timbre of the times. "The idea that art could pass into the realm of pop culture had great appeal to Mike and me," said Oursler. "Somehow, a side effect of studying Conceptual Art was that we came to believe that there could be new ways of making movies and TV shows as well as theater."[35] In his work in the 1970s, suggested Cary Levine recently, Kelley "consistently pursued a strategy of entrapment, placing viewers in paradoxical situations that confounded some of society's most entrenched values and norms. He was essentially an assemblage artist, archiving and rearranging objects, techniques, materials, and languages in ways that force theory and practice into direct confrontation with each other. His medium of choice was, above all, social meaning itself." In sum, Kelley's intention was to provoke and goad viewers into reexamining what they thought about a wide range of ideas, assumptions, and cultural categories—particularly distinctions between "normality and abnormality, good and bad, high and low, liberal and conservative, the natural and the unnatural. Cornered by his art, viewers must reevaluate some of their most deep-seated assumptions and beliefs."[36] Kelley would later allow, however, that his aesthetic at the time ultimately failed as a "strategy of resistance" because it simply emulated the "sped up and ecstatic effects of the media,"[37] rather than, perhaps, finding a way to cope with them.

As Kelley struggled to find his own voice amid the incoherence of the times, another artist—Paul McCarthy—was grappling with the culture with a similarly warped and edgy aesthetic that first emerged out of the Los Angeles performance art scene. McCarthy was even quicker than Kelley to push social boundaries, ask pointed questions about the repression and restriction in society, and challenge rules of propriety. In his work, he deployed the tools of obscenity, absurdity, disgust, and self-abuse to unsettle an already unsettled audience. "Like Kelley," wrote a critic, "McCarthy exploits the social values embedded in everyday substances, and he has similarly described his approach as

a 'form of research.' But whereas Kelley's gestures are generally dispassionate and cerebral, McCarthy's are riotous and antic. He stages orgiastic hyper indulgences in materials—most notably food products—misusing them in ways that pervert conventional classifications. Resituating ordinarily wholesome substances and behaviors within 'indecent' scenarios—sexual, violent, scatological—the artist explores the ways in which ideals and standards are conditions in the home, thought institutions, and via mass media."[38]

Born in the last year of World War II to a Mormon family in Salt Lake City, Utah, McCarthy's somewhat constricted upbringing was overshadowed by the unusual situation of his family home. "A California contractor had the idea," McCarthy once explained, "to build a giant suburb where veterans could buy houses capitalizing on the GI loans." The developer, unfortunately, managed to complete only three homes before going bankrupt. "At my parents' house, when you went out the back door, there were no other houses for miles, it was vacant landscape. When you went out the front door you were staring at a street in the suburbs, it was like a film set, built only for the cameras."[39] McCarthy's acute awareness of his family's isolation, coupled with the sense of being on display—as though in the middle of a movie—gave him a dual sense of both security and foreboding, of exceptionalism and miserable loneliness. "McCarthy remembers sensing at a young age," writes biographer Cary Levine, "that there was something askew about his idyllic milieu and its institutions . . . . He felt that he was living in 'Shangri-La,' he recalls, 'with some sort of underbelly that I couldn't put my finger on.' "[40]

Likely adding to McCarthy's understanding of the complex, off-kilter nature of the world were his somewhat troubled school years. Suffering from dyslexia, McCarthy was not a good or happy student. Art became his only refuge, and before graduating from high school McCarthy was exposed to artists like Picasso, Edvard Munch, the Ashcan School, Käthe Kollwitz, and John Cage. After high school, McCarthy studied art at Weber State in Ogden, Utah, where he used

an old projector to incorporate mass-media imagery like dragsters and pinup girls in his work. McCarthy made several triptych paintings in these years that included pornographic images on the side panels and gas mask–wearing figures in the center. The paintings were then scorched by the artist to an unrecognizable state. In 1966, McCarthy transferred to the University of Utah, where he studied at the school's new experimental film program and became interested in the Fluxus movement, particularly Yoko Ono's work. In the early 1960s, Ono had created a series of works she called "Instructures," in which she enacted a performance/painting based on a few simple instructions.[41] Around this time, McCarthy also discovered the works of Allan Kaprow through the catalogue *Assemblage, Environments & Happenings*, and was slowly realizing the potential for art that was based on action and change. McCarthy combined the approaches of Kaprow and Ono with his own personal penchant for destruction and havoc in performances like "Saw" (1967). For this work, McCarthy arranged some furniture on a stage at the University of Utah into a faux domestic tableau. Then, with the help of a friend, some hammers, and a chainsaw, he demolished everything to the accompaniment of a rock band. He planned that same year to follow up "Saw" with a performance in which he would, for an audience, bulldoze an abandoned house, but city officials blocked the work from being completed. Instead, in his last works in Utah, McCarthy added elements of personal danger and destruction. His "Too Steep, Too Fast" (1968), for example, came with these instructions: "Run Down a Hill. The angle of the hill should increase so that one has the sensation of falling." When McCarthy performed the work, he ran downhill until he lost physical control and tumbled head over tail. In his work "Mountain Bowling" (1969), meanwhile, McCarthy tossed bowling balls down a hill, transforming them into dangerous projectiles.

In 1969, McCarthy left Utah and spent a year at the San Francisco Art Institute, where he studied with Irby Walton, whose "low" aesthetic and embrace of corniness and playfulness further inspired McCarthy's

developing aesthetic. After his year at the art institute in San Francisco, McCarthy returned to Utah to deal with his draft status.[42] While there, he took graduate art classes at the University of Utah, formed an artist collective, performed noise music, and experimented with sound and recording. His object, he said of these years, was to be "fucked up . . . . There was nothing normal about any of it."[43] In an early video work from this time called "Spinning," McCarthy simply spun in circles for sixty minutes while brushing his hand against a wall. By now, the key elements of McCarthy's aesthetic had begun to congeal: Raw actions, buffoonish and pathologically compulsive behavior, a trafficking in banal or low-culture materials, and a general questioning of what comprised reality. In 1970, McCarthy moved to Los Angeles intending to become a filmmaker. He entered the interdisciplinary art and film program at the University of Southern California, but his teachers and classmates exhibited little interest in his efforts to overturn and subvert Hollywood conventions and little support for his interest in the new medium of video. He did, however, gain one thing while in the program: An abiding fascination for the city of Los Angeles and its "mix of glamour, counterculture, and percolating violence."[44]

At this time, the artist also connected with Kaprow, and he began spending time at CalArts. In fact, the work McCarthy made to complete his degree at USC in 1973 was more closely tied to that of the early-'70s CalArts scene than to his graduate program.[45] "Crucial to his development," suggested an art critic, "was the confluence of Conceptualism and Performance at CalArts, particularly the idea of Performance as a method of analysis and communication—or, as McCarthy put it, 'education and reeducation.' "[46] By the mid-1970s, Paul McCarthy was focusing primarily on Performance and performance-based video work. A series of simple "instruction" works—similar to Yoko Ono's "Instructures" as well as works by artists like Bruce Conner, Vito Acconci, Lawrence Weiner, and Sol LeWitt—reveal his own artistic obsessions: basic routines pushed to absurdist limits, an examination of the limits of the human body, a

dark and humorous irreverence regarding the trappings of low and mainstream culture, and a push toward social impropriety. Here are a few examples of his instructions (which also doubled as the titles of the works): "Hold an apple in your armpit" (1970); "Invite friends over. Cook them a pot of Vaseline petroleum jelly." (1971); "Comic books displayed on the floor in a single line" (1971); "Give your magazines a shower" (1971); "Use a shovel to throw dirt in the air" (1972); and "Plaster your head and one arm into a wall" (1973).

Paul McCarthy's emerging Conceptual and Performance-based aesthetic was, as with the work of some other artists grappling with the rising confusions and uncertainties of the mid-1970s, pointedly absurdist, parodic, even ridiculous. A 1971 video called "Ma Bell" was a good early hint at his artistic intentions. In this work McCarthy sat in his studio overlooking the city of Los Angeles and, while cackling with maniacal energy, he opened a phone book, poured motor oil, cotton, and flour onto a page, and then turned to a new page where he repeated the action, pounding on each turned page with increasing ferocity. While this video is akin to his other simple instruction works of the time, it is distinguished by the focus on corporate-based, life-organizing systems and consumer products—the phone book, cotton, oil—as well as by the artist's rising emotional tone as the performance progressed. This latter development was key to the artist as well, as McCarthy later explained, "Ma Bell" was "the first piece I did as a sort of persona, as a sort of character. I imagined myself as a kind of hysterical person."[47] His development of an increasingly frenetic, id-addled character, in fact, would distinguish McCarthy from the other Conceptual–Performance artists of the time, and particularly from prominent L.A. figures such as Baldessari and Chris Burden. McCarthy was not making Performance Art as a "concrete reality, where you don't *represent* getting shot, you actually *get* shot"; rather, he explained, he was moving his work toward artifice, toward "mimicry, appropriation, fiction, representation, and questioning meaning."[48]

McCarthy's aesthetic complemented Mike Kelley's own experiments in the later 1970s. Kelley's art, wrote critic Cary Levine, was just as fascinated with artifice, his work involving "entanglements of words and things, the high and the low, the quotidian and the esoteric, the sacred and the profane."[49] Taken as a whole, the body of work of each artist was titillatingly inappropriate and intriguing in the manner of a village idiot's public babbling. In 1979, for instance, shortly after graduating from CalArts Kelley mounted a collaborative work with his mentor David Askevold for a student–teacher show at the Foundation for Art Resources in Los Angeles. Called "The Poltergeist: A Work between David Askevold and Mike Kelley," the multimedia project explored the two artists' mutual fascination with occult practices and nineteenth-century spiritualist photography. Though the two artists' contributions of cartoonish drawings, cheaply and blatantly manipulated photos, and mystifyingly purple prose were hardly convincing regarding the existence of the supernatural, the work did succeed in humorously meshing the imagery and ideas of the so-called lowbrow, vernacular world of pulp fiction, B-movies, and other campy pop-cultural trappings with the dry and uptight language and presentation of Conceptual Art of the time, creating in the process something cleverly connected to the spirit of the times.

AMID THE INEXPLICABLE AND EXPANSIVE MULTIFORM and multimedia approach of Terry Allen and Allen Ruppersberg and the subversive grinding and meshing Performance and Conceptual work of Paul McCarthy and Mike Kelley, the Los Angeles art world of the 1970s had struck upon a relevant new approach to art-making. The media-focused, genre-bending, stylistically fluid, and visually fragmented aesthetic of these Young Romantics inspired several pockets of activity—mostly notably coming out of CalArts and centered in the studio districts of Venice—that would thrive and influence a new generation of artists in the coming new decade. Among the L.A.-based artists who picked up on this aesthetic and worked to make it their own

were two very different women artists who each had studios in Venice, among other like-minded artists grappling with the confused times.

One of the most Romantic of these Young Romantics was the locally raised collage artist Alexis Smith. Born Patricia Anne Smith, she had grown up in nearby Norwalk, California, on the grounds of a mental hospital where her father was assistant superintendent. It had been an oddly sheltered, yet strangely charged, atmosphere. "It had very small, manageable versions of all the things you find in a real city," Smith said. "I think that probably made my life different . . . . I wasn't the kind of person who always knew I was going to be an artist, but I always did what I do now in some form—making things, collecting things. I used to chop words out of magazines and put them together or try to coerce the neighborhood kids into putting on plays that I wrote . . . . I had a lot of time to fill."[50] In 1970, Smith completed a bachelor's degree in art at UC Irvine, studying with Robert Irwin and Vija Celmins during the early years of that school's art program, and afterward made the conscious decision to eschew graduate school in favor of focusing on making work. After establishing a small storefront studio in Venice, Smith got a part-time job as an assistant to the L.A. architect Frank Gehry and connected with other artists working in the area at the time—including Chris Burden, with whom she became romantically linked. She also participated in a women's group for several years along with Celmins, the art historian Barbara Haskell, and others. Her earliest works were informed by all of these associations.

In the early 1970s, Smith gained notice for her small, simple, almost Minimalist collage works and a series of artist books. One of the earliest of her collages gives a good sense of the nature of Smith's interests. Called "Ma-chees-ma" (1971), this collage is comprised of two standard-sized white envelopes and a Hollywood glamour shot of a starlet that has been cut from a magazine and slipped, neatly and elegantly, into the envelopes. On one of the envelopes, Smith has penciled the title of the work. "A phonetic, feminine form of the Spanish noun *machismo*," explained the curator Richard Armstrong, "the title

simultaneously alludes to the wiles—here eroticized—of female movie stars and to Smith's declaration of independence in converting herself from Patricia Anne to Alexis."[51] Smith had taken the name "Alexis" when she went to college at age seventeen. "I guess I had the desire to be somebody different, to reinvent myself. I first picked the name Alex arbitrarily from a person in a movie as a sort of nice, androgynous nickname. Then it turned out there was an Alexis Smith," (who herself had been born "Gladys Smith"), "who was a movie star. So I lengthened the nickname, and Alexis became my pseudonym."[52] The work, then, was self-referential—perhaps a bit of *macho* flag-planting for her own career. It also hints at Smith's own feminist-infused fascination with the culture of Hollywood. It was a subject that was, of course, increasingly on the minds of L.A.'s Venice-based, future shocked, avant-garde artists at the time. And Alexis Smith would explore it in the extreme in her art.

"Hollywood is a fantasy place that has a real locale—here, L.A., where I live," said Smith. "It's also a place of the imagination; for decades people have been talking about going to Hollywood. It's the fantasy that one day you're working in a gas station or as a waitress, and the next day you're under contract to MGM. It's the quintessential American transformation myth—a nobody one day, and a somebody the next. Initially, it was a fertile territory for my work."[53] After 1972, Hollywood and the visual flotsam and jetsam produced by Hollywood would occupy Smith's artistic imagination for much of the next decade and provide a mechanism for her to explore various narrative themes. Smith's ransacking of Hollywood often created an evocative "objective correlative" relationship that exposed hidden, alternative narratives behind the confusion of the times. For instance, a series of multi-panel collages from 1974 used imagery from the Charlie Chan movies to explore themes of otherness, madness, and genius—themes that perhaps went back to her childhood spent on the grounds of a mental hospital. Other collage projects drew from such Hollywood fodder as *The Red Shoes* (1975), *Orpheus* (1974), *Beauty and the Beast* (1977),

and so on. In 1978, Smith began a series of simple, single-panel collage works that she called "Chandlerisms," which presented emblematic bits of collaged and assemblaged materials along with typed snippets of dialogue from Raymond Chandler's hardboiled detective novels. The gritty, street-smart metaphors and turns of phrase in Chandler's writing turned out to be the perfect foil to the Romantic-esque interests of Smith. In "Chandlerism #35," for example, the line "The color of her hair was dusky red, like a fire under control but still dangerous" appears below a single matchbook, on which is a printed advertisement for the Venus Di Milo Production Agency. In "Chandlerism #31," meanwhile, the lines—"I just sat there and looked at her and waited. Our eyes met across great gulfs of nothing."—appear below a kitschy colored postcard of an empty, 1950s-era greasy spoon diner.

In all of her images from the 1970s, Smith's imaginary visual landscapes mined meaning out of the manufactured images and emotions of Hollywood. While the Minimalist aesthetic lingered in her work—many of her individual collages were single images with single words—they slowly gained graphic sophistication once she began using a linear, left-to-right, multi-panel composition in them. To keep these works from falling apart visually, Smith developed a number of compositional tricks: different-colored papers as the successive grounds to each collage image; interrelated compositions between multiple panels in her works; assemblaged found objects; sophisticated typography; illustration; even, on a number of occasions, installation and performance. Even with this visual refinement in place, Smith's work grappled with the confusing real world and with the confusions and contradictions of the consumer and media culture, bringing the confused viewers right along with it.

AS THE DECADE MOVED TOWARD A CLOSE, THE YOUNG Romantic aesthetic seemed to grow increasingly codified in Los Angeles, leading to the emergence of a number of similarly agitated artists in the later 1970s. Carole Caroompas, for instance, switched

in 1974 from a strict Conceptual approach to painting to a kind of fractured-collage approach that was influenced by "literature, autobiography, romance, gender, and high and low culture."[54] The conflicting nature of Caroompas's work on the whole, and the disjointedness in content and form—particularly the elegant touches of painting and design played off against some raw and explicit subject matter, and the fluid visual imagery and fragmented collage juxtaposed against snippets of text that reference a host of cultural and popular sources—were at the core of her intentions. "Carole Caroompas . . . has remained consistent to her own vision outside the faddish modes of contemporary art," wrote a curator in 1984. "Each image is a puzzle piece that doesn't necessarily solve the mystery or complete the thematic quest. Viewers are often left in the situation of being lead in parallel circles."[55]

Caroompas, for her part, admitted that unresolved accretion was a core interest for her in art. "I really like those things together," she said in an interview some years later. "They create a clash and also create a fissure that opens up other information when those things are collapsed together . . . . When I pick text as a source, I usually will pick text that most people have a reference to . . . . A lot of the things that I pick have also been referenced in film. And that's also very important, in terms of how I work with the fragmented narrative, the cinematic quality is definitely there. But it's being cut and edited all the time, on the surface of the painting."[56]

By 1978 Caroompas, who had originally come to Los Angeles from Oregon to study art at the University of Southern California, expanded her artistic output to include, like Terry Allen, performance, storytelling, and music. "The performances are three-dimensional collage of visual images, text, and music set in 'real' time," Caroompas explained, "a layered narrative using the means of visual props, text, and song as cross reference to explore romance and myth in ancient and contemporary culture through the metaphors of science, history, games, and alchemy." Through these various and multimedia approaches, somehow Caroompas worked to guide the viewer through

the confusing tangle of meanings she explored. "I have always been interested in the act of translation," said Caroompas. "How the viewer approaches a work to collect visual and verbal clues out of context and recombines them to form conclusions. How the mind gathers, how the memory collects, how the transmutation become complete . . . . I think what I ask of the viewer [is] to bring to the work more than one vision. To really be able to SEE."[57]

Other artists also made art that was just as fractured and befuddling. Betye Saar made assemblage works inspired by such diverse sources as Joseph Cornell, the Watts Towers, racist advertising, and folk images of figures like Aunt Jemima, Uncle Tom, Little Black Sambo, and the like, and ritual and tribal objects from Africa. Her boxed assemblages of the 1970s raised such banal-yet-loaded items by treating them as almost magical and mystical objects that helped explain the culture of the times as well as the long history of injustice and prejudice face by African Americans. The L.A.-born artist Michael Balog had a similar transformation as Caroompas's. While the Minimalist drawings he made in the very early 1970s had brought him attention in the New York art world, after growing disillusioned with that city and returning to his native Venice Beach in 1974 his artistic focus evolved. Starting that year, Balog made strange, fragmented, semi-representational images that depicted aspects of the local culture—such as the local club scene in "You Girls Look So Nice" (1974); local fashions in "It's What I've Always Dreamed Of" (1974); and modern romance in "A Moment Alone" (1974). Mike Kelley's collaborator and friend Tony Oursler would pursue a similar type of work in his career, most notably in a series of fractured-narrative video films such as "The Loner" (1980). The mishmash of layered soundtracks, hand-designed and sculptural sets, stop-motion animation, and odd visual effects by the artist that used such unusual tools as mirrors, glass, water, and the like, revealed the artist's interest in the disjointed and disorienting effects of art. Finally, the locally born sculptor/surfer Jim Ganzer made, from the Venice studio he shared

with Ron Cooper and Larry Bell, a series of Joseph Cornell–like assemblage tableaus that assembled the imagery of his experience—surf and auto logos, palm fronds, snapshots of cars and waves, and so on. In the 1980s, Ganzer would pursue his visual interest in the iconography of California's surf scene to launch a clothing company called Jimmy'z, whose cult-like success would transform the artist's life and creative output for the rest of his career.

The varied approaches of the various young (Romantic) artists affected and disturbed by the age amount to a summation of the emotions, fears, and confusions experienced by the country in the 1970s. The sense of concern for the future of a world that had seemed to have sped up beyond control—this phenomenon called "future shock"—was of course a natural source of inspiration for these sensitive and observant artists. Taken as a whole, the new aesthetic advanced by this loose cohort of Los Angeles artists was profoundly influential for much of the next decade and beyond.

CHAPTER X.

# A Last Look at the "L.A. Look"

T HE END OF THE FERUS GALLERY IN THE LATE 1960s did not end the growth and development of art in Southern California—despite the indignant art critics like Mark Davis, Peter Plagens, and Christopher Knight would have us believe. As this book has argued, the end of the "L.A. Look/Cool School/Finish Fetish" moment was just the start of Los Angeles' growing influence on the art world. What eventually replaced the high-Modernist high-water mark of the 1960s was a broadened and enriched visual art scene that predicted what art would become at the end of the twentieth and early twenty-first centuries.

If the sense of calamity that prevailed amid the local art world around 1970 is refuted by one simple fact, it is that the Cool School artists themselves did not stop making art after the Ferus moment had passed. The varied artists who, for a short but significant time in the 1960s came together under banner of the Ferus gallery, each continued their careers. For some, the fade from the local and national spotlight of the '60s was tragic; for others, the fade was not so tragic—almost a willing and deliberate escape from the ongoing grinding rat race of the local art market. And for still others, the fade was slow and agonizing—the result of a reluctance or inability to adapt to the new realities of the art market and times. Only a few of the Cool School artists would continue to grow their reputations, primarily by adapting to the complicated new times.

THE DEATH OF JOHN ALTOON, WHO WAS WIDELY acknowledged as a key driver of the Ferus group's muscular machismo, at the age of forty-four after several years of heavy substance abuse and extended bouts with depression and schizophrenia, was a sharp shock. Irving Blum, who had championed Altoon when he became part owner of the gallery, was among those most affected by his death. "If the [Ferus] gallery was closest in spirit to a single person," said Blum, "that person was John Altoon—dearly loved, defiant, romantic, highly ambitious—and slightly mad."[1] The death of Altoon, in many ways, was the moment that signaled these artists' time in the sun was at an end. It was a difficult realization. After all, for the better part of a decade, the Cool School had ruled the local art world roost—even as the cultural, social, and economic prestige of their home state of California was reaching its apex.

Still, in some ways Altoon's death was almost symbolically inevitable. Altoon's ultra-macho, occasionally belligerent, sometimes paranoid and destructive personality was something of a funhouse mirror reflection of the group itself. The Ferus artists were, to a person, contrarian, divisive, and combative, and somewhat rude and abusive to anyone who did not fit their mold regarding what artists were meant to look and feel like. So it was almost inevitable that the Ferus group's currency would run short. Keep in mind, after all, that their treatment of the young wannabe-artist Judy Chicago helped play a role in inspiring her to launch the Feminist Art rebellion. And even before Altoon's death there were ominous signs of a shift in cultural forces and values. The vaunted Ferus Gallery itself, where many of the cohorts first established their reputations, had already closed down. In 1967 one of the gallery's founders, the visionary Walter Hopps, had lost a prime position as director of the Pasadena Museum of California Art and left town to set up shop in Washington, D.C., at the Corcoran Gallery. In 1970, Irving Blum gave up trying to sustain a local art gallery and escaped for the more economically stable art market of New York City. *Artforum* magazine had picked up and left L.A. a few years before for

much the same reason. As more and more figures in the local art world were realizing at the end of the decade—while it was one thing for Los Angeles to have become a noted far-Western cultural outpost in the 1960s, it was quite another thing to maintain the infrastructure and economic exchange mechanisms for a stable art market.

Once it was clear that Los Angeles' burgeoning art scene was fizzling, what took place next was all but inevitable. By the early 1970s, many of the Ferus Gallery artists began spending more time outside of L.A. than in. In this, the artists anticipated a growing disillusionment with the L.A. way of living. Of the several Cool School departures from the city, Ed Kienholz's was the most portentous. The first to be accorded the status of a local art giant, Kienholz was early to grow disillusioned with the city and the place and function of art within it. Chief among the frustrations for the noted curmudgeon was the response to his work in his LACMA show, and particularly to his "Back Seat Dodge '38" installation. Though the controversy had the ultimate effect of bringing vastly greater numbers of viewers out to see his work, Kienholz was far from pleased at the crowds. "Ed would come home," said his wife of the time, Lyn Kienholz, "and he'd say, 'Everybody always talks about controversy, but nobody talks about art.' "[2] Whatever the fallout to Kienholz, his career, and local art, shortly after the brouhaha died down in 1966 the artist began spending summers at a place he had purchased in Hope, Idaho, a small community located in the northern "panhandle" of the state near the shores of Lake Pend Oreille. Kienholz kept his connection to the L.A. art community for several years, but then, as fate would have it, another series of events further separated Kienholz from the local goings on. In 1972, while at a party in L.A., the forty-four-year-old Ed Kienholz, still married to his fourth wife Lyn, met a twenty-eight-year-old, self-taught artist named Nancy Reddin, whose father had been the city's chief of police a few years earlier. Within a few months, he and Reddin were working closely together.[3] They were also, more or less secretly, carrying on an affair that would dismantle Kienholz's marriage. In 1973,

Kienholz got divorced for the fourth time and married Nancy. In the fall of the same year, Kienholz, who had been offered a grant by Karl Ruhrberg of the Deustscher Akademischer Austausch Dienst, left with Nancy for Berlin, where he would work for a year as a guest artist at the German Academic Exchange Service. Because of his experience in Germany, which the artist considered extremely fruitful and much more palatable than his recent experiences in L.A., Kienholz sold his Los Angeles home in 1973, essentially leaving the city behind for good. For the next several decades, the Kienholzes split their time between Hope and Berlin, never slowing in their production—collaborating to complete numerous assemblage pieces and installation works.[4]

In 1977, the Kienholzes' giant and wide-ranging installation, "The Art Show," would be featured at the Centre National d'Art et de Culture Georges Pompidou in Paris. This installation was a crystalliza-tion of Kienholz's approach to art, comprised of figures cast in plaster from real life people and distorted in some surprising or vulgar way by the addition of assemblaged found objects and consumer goods like radios, cameras, and so on. The work in the exhibition and the Centre Pompidou was rough-hewn, loosely composed to create a free-flowing gestalt, drippy and sloppy with oozing materials to bind and tie objects together. The overall effect then was a heightened and somewhat sub-limely beautiful sense of the vulgarity and pain and slipperiness and despair of life in Western consumerist society at the end of the twenti-eth century. "When I saw the ['Art Show']," wrote the curator Henry Hopkins, "I was struck by the fact that it indeed recaptured the era— the Sixties reborn in the seventies . . . ."[5] Buoyed by the attention over-seas, the Kienholzes opened, in 1977, "The Faith and Charity in Hope Gallery" at their Idaho studio, where they showed their own work and also brought in international art figures like Peter Voulkos and Alberto Giacometti. In Los Angeles, however, Kienholz's contributions to the local arts slowly faded from memory. Kienholz would not mount a show in Los Angeles until 1980. In fact, after 1973 and until the artist's death in 1994, the Kienholzes were much more prone to exhibit their

work in Europe rather than stateside, and the artist's reputation suffered in his home country. Even the artist's groundbreaking work from the heyday of the 1960s was all but discarded, his gritty assemblage style seemingly deemed passe and of little interest to the Conceptual and experimental-minded artists of the troubled decade. What works of Kienholz's from the '60s that had been purchased by major collections were mothballed and left out of permanent displays for years. Even "Back Seat Dodge '38" was kept in storage by Lyn Kienholz until she could convince the L.A. County Museum to purchase it in 1981. Kienholz was all but forgotten by the new generation of artists.

KIENHOLZ DIED SUDDENLY IN IDAHO IN JUNE OF 1994. The artist was out hiking in the mountains near his home when he suffered a heart attack. His final gesture, undertaken after his death, in some ways sums up what he was about as an artist. In his will, Kienholz made a specific request regarding his manner of burial. The prominent art critic Robert Hughes, who was at the funeral, described it in a *Time* magazine article he wrote called "All-American Barbaric Yawp." Kienholz's "corpulent, embalmed body was wedged," wrote Hughes, "into the front seat of a brown 1940 Packard coupe . . . . A bottle of 1931 Chianti beside him and the ashes of his dog Smash in the back. He was set for the afterlife. To the whine of bagpipes, the Packard, steered by his widow Nancy Reddin Kienholz, rolled like a funeral barge into the big hole."[6] The symbolic gesture, melodramatic and funky as it was, was perfectly Kienholzian (and perfectly Southern Californian).

Ed Kienholz wasn't the only Cool School giant to fade slowly away once the 1970s got underway. Craig Kauffman and Larry Bell both spent significant time away from L.A., and both saw their local presence and, in the case especially of Kauffman, reputations diminish before the end of the decade. Craig Kauffman was perhaps the most seminal early figure in the emergence of the Ferus Gallery, credited by several of the other artists of the group with steering the early direction

of the group's collective efforts and providing some key vision to his fellow artists as they struggled to emerge in the local art market. "It was Kauffman who showed us the way," said Billy Al Bengston.[7] "Craig was the smartest guy," said painter Ed Moses, a colleague and long-time friend. "He had traveled. He knew all about the New York School and what was going on in Europe. He had a very sharp eye. We all learned from him."[8] But the traits that others admired in Kauffman—his restlessness, his active mind, his irrepressible will to travel physically and psychically, his drive to evolve and keep changing—would also eventually be the cause of his diminished standing in the art world.

Kauffman went to school at both of the major (and rival) institutions of higher learning in L.A.—USC and UCLA (where he earned a master's degree in art in 1956)—and seemed destined for big things. After his graduation, Kauffman's work was included in the inaugural show at the Ferus Galley in 1958, "Paintings and Drawings." It caused a minor sensation. "The 'clean' Abstract Expressionist work by Craig Kauffman," wrote Peter Plagens in a review, "could be the point at which Los Angeles art decided to live on its own life-terms, instead of those handed down from Paris, New York, or even San Francisco."[9] Kauffman would follow with four solo exhibitions over the gallery's ten years of existence and two more solo exhibitions at the Irving Blum Gallery. The qualities of light and space that revealed themselves in Kauffman's work came, according to the artist, out of his experience of the local landscape and its light-filled atmosphere. The vastness and flatness of Los Angeles, contrasted with the rich vibrancy and buoyancy of its light, are among the city's, and region's, most noticeably unique characteristics. "Everything is spread out and diffused," Kauffman once remarked of the environment in L.A., "and you can't get a hold of it really."[10] Observers often noted the light-based qualities present in Kauffman's work. Spatial elusiveness, a characteristic of the artist's physical environment, became a chief and influential feature of his work and helped give other artists an idea of what could be unique about Angeleno art-making.

Still, what kept the other Ferus artists, and the Ferus Gallery itself, dedicated to Kauffman was the way he worked, particularly as he moved through the heady decade of the 1960s. As an artist Kauffman was a sponge, well-versed in art history and quick to pick up on any new artistic development, new technique, or novel line of thinking. "Kauffman [was]," wrote Robert McDonald, "an investigator, advancing intellectually and experientially. Despite ostensible differences among bodies of his works, there are underlying harmonies in his aesthetic approaches, in his vocabularies of images and forms, and in his palettes of colors . . . . The perceptual continuities are light and space as integral, not merely accidental, components of his works; a fusion of organic image and color; a controlled color expressiveness that is sometimes flamboyant, sometimes aggressive, sometimes even sublime, but always personal and seductive; and craftsmanship in execution."[11] With his penchant for experimentation and strong artistic sense of self, Kauffman helped push the Ferus group to create evolving bodies of work that had a distinctive coherence. That coherence involved light, often in combination with plastic, an important industrial material that was in wide use in the area. Kauffman's example encouraged his fellows to be independent and take professional pride in their efforts. Or as Bengston put it, "Kauffman was the first Southern California artist *ever* to paint an original painting. His paintings of '57 and '58 proved we had to wash our hands, throw away our dirty pants, and become artists. Prior to these works every Southern California artist was suffering from a bad case of Northern California sensibility."[12]

Despite the early successes, Kauffman would eventually struggle. Larry Bell, another Ferus compatriot, recalled Kauffman as "a sophisticated, very scholarly guy who knew a lot about painters and painting." Eccentric and reclusive, "he had a disciplined way of working," Bell said. "He demanded a certain kind of perfection of things, whether paintings or plastics, that were unequivocally what they were. He was always on the case."[13] Unfortunately, Kauffman's questioning mind seemed rarely to be satisfied for long. In 1958, shortly after his

first solo show at Ferus, he found fault in his work, saying "he could not cope with what he had already achieved."[14] His frustration was so intense that Kauffman moved to San Francisco, got married to his first wife (of many), and then took off with her to Europe for a two-year stay.

Kauffman would repeat this pattern of growing so impatient with his experiments that he retreated from the city, then returning and scrambling to catch up and surpass his peers, several times. In the late 1960s, he experimented with the industrial process of plastic vacuum-forming to make molded shapes, an idea that was inspired by the plastic signs common in the commercial businesses of L.A.[15] The resulting Minimalist, shaped-plastic, low-relief paintings—work Kauffman would continue making into the early 1970s—were created with high-key transparent Murano acrylic pigments, and sometimes were also spray-painted from the back. The overall appearance of many of these was, according to the critic Jane Livingstone, "of viscous material melting together," though another local critic also somewhat belittled the slick and easily digestible work by calling them "Jell-O paintings."[16]

Kauffman's molded plastic forms heavily influenced his peers (especially Bengston and Robert Irwin) and put Kauffman back at the forefront of innovating L.A.'s art. Yet Kauffman remained discontented with the idea of staying with one style or mode of working—one type of "product," if you will—for very long. He moved from the initial "Jell-O paintings," to a series of more low-relief "washboard paintings," then from there to a series of bubble-shaped works he called "awning paintings" and on to ovoid shapes. In 1968, Kauffman again left L.A. to teach a summer session at Berkeley, and he made significant tweaks to his work by abandoning the bright hues of acrylic paint he had been using in favor of more pearlescent grays and pastel colors. The poet and art critic Peter Schjeldahl described the resulting atmospheric and pulsating work in a review as "at once blatant and ephemeral, immaculate and a trifle obscene, like something you might dream of finding on the ocean floor."

Kauffman's frenetic experimentation and constant stylistic shifts continued. This was part and parcel of what he was as an artist, and likely could not have been helped. From the ovoid works, he moved onto his "Loops," a series in which he took sheets of tinted Plexiglas and looped the top edge of the work. In 1970 and 1971, Kauffman made his "strips," which reduced the image to vertical bands of clear plastic that cast unusual shadows on the walls behind. Also in 1971, he appeared in a show at UCLA, which involved fellow Light and Space artists Larry Bell, Peter Alexander, and Robert Irwin, called "Transparency, Reflection, Light, Space: Four Artists." For his work in this show, Kauffman created—using spotlights, electric fans, mirrors, and three plastic troughs filled with water—patterns of shadows that undulated in several directions on one of the gallery's bare, twenty-foot walls. With this work, and this show, Kauffman found himself again at the forefront of L.A.'s home-bred brand of light-infused Minimalism, and he could have continued evolving this work and line of inquiry for some years. But the ever-restless artist, for some reason, turned away from these investigations almost immediately, "deliberately and consciously during a period of reflection and introspection, one of the most difficult turning points in his life."[17]

As Kauffman himself put it, he always "let the work take me where it wants to go after I've made certain decisions."[18] And though artistic evolution was not unusual for artists, especially among his peers in Southern California, the urge for Kauffman to evolve his work was rather extreme. "When I was working with plastic," he explained, "I was kind of letting it take me where it wanted to go, and when it took me to the water reflections, I said, 'I don't want to go that way.' . . . Then I started rethinking about what painting was for me, what it could be and what were the good things about it from a philosophical point of view, and how I wanted to deal with things from a practical point of view in my own way."[19] Unfortunately, Kauffman's decision to head in still another artistic direction at the turn of 1972 couldn't have been, ultimately, more

unhappy. By turning away from a major artistic development—the creation of light/space environments—he missed the chance to work in a fashion that would "lead to increased renown for practitioners like Robert Irwin and James Turrell."[20] Kauffman's new work after 1972, meanwhile, was generally dismissed by critics, curators, and collectors. And the marketplace failure of Kauffman's new work took its toll on the artist.

In 1976, perhaps disillusioned, perhaps simply needing to find a new vista where he could clear his head, Kauffman left California altogether, returning to Paris, where he had spent several years in the late 1960s. While in Paris, Kauffman somewhat came to regret the directions that his art experimentation had taken him, even going so far as to blame the L.A. art scene for steering his career off track. "It was strange," he said, "being there for a total of seven months, a lot of things, ideas I think I had about things that I really wasn't all that conscious of, started coming to the surface in a way, and then they would sort of drift off . . . . I think when you're living just here [in Los Angeles] you tend to have a more immediate view of what's going on. You tend to think that everything that's happened in art that's really important is going on in the last few years."[21] Kauffman admitted he had all but surrendered to the realities of his creative output—that it just wasn't on the leading edge anymore. "A lot of concerns and maybe prejudices about contemporary art that I had," Kauffman said, "I just don't think I have anymore. Not that I went to any effort to have any other kind of an attitude, it's just that the urgency of it just doesn't seem all that interesting to me."[22]

Whatever the reasons for the state of Kauffman's career in 1976, in the years that followed Kauffman's work increasingly faded from public view. Though his wide-ranging artistic output would be featured in a retrospective at the La Jolla Museum of Art in 1981, Kauffman's exhibition record grew sparer and sparer going into the 1990s, the year he decided to completely retreat from Los Angeles, and from public view, by moving to the Philippines. It was here, in his home in

Manila, that the artist would die in 2010 from complications due to pneumonia at age seventy-eight.

LARRY BELL'S CAREER SUFFERED A SIMILAR FATE AS Kauffman's, though in much less dramatic a fashion as his ever-evolving friend. As the 1970s progressed, Bell was one of the most widely admired and heavily exhibited artists to hail from California—the subject of a major solo exhibition, organized by Barbara Haskell, at the Pasadena Museum of California Art in 1972 and a participant in major American sculpture surveys at the Smithsonian Institution in 1975, the Whitney Museum of Art in 1976, and the San Francisco Museum of Modern Art in 1977. The source of much of his art world reputation was work he began making in the late 1960s—a long series of luminescent three-dimensional "boxes" formed from adroitly joined sides of mirrored and translucent and/or subtly reflected glass. Like other Ferus artists, Bell shaped his output around an interest in and celebration of the phenomenon of light, as well as through an embrace of technology, new methods and materials, and an urge to change and experiment that was endemic to the Los Angeles artistic outlook. In particular, Bell embraced the technique of vacuum-coating glass in order to manipulate the reflective and refractive qualities of it. This helped him create varied effects of translucence and color without adversely affecting the surface of the glass.

Beyond the technical aspects, however, there was also always something ineffable about Bell's sculptures during their heyday. "Bell has said about his works," wrote curator Barbara Haskell in 1972, "that they 'are about "nothing" and illustrate in the most literal sense "emptiness and lack of content" ' . . . . The superb craftsmanship in Bell's work goes beyond the Minimalist concern for machine-like finishes. It is not motivated by a desire to eliminate any traces of the artist's hand, but by a desire to make full use of the potentialities of the surface."[23] Certainly, one of the aspects that people noticed about Bell's work was the elegance and beauty of the materials and craftsmanship.

(As an example of Minimalist, Formalist art, Haskell maintained, their rich sensuousness is akin to "Mediterranean hedonism.") The resulting sense of infinite space that characterized the best of Bell's work around 1970 was thought to be inspired by Los Angeles itself, a city that extended in all directions by virtue of its vistas of the Los Angeles plain that stretched out to the Pacific Ocean, as well as the sprawling, horizontal character of the buildings.

Larry Bell got his artistic training from the Chouinard Art Institute where he enrolled after high school in 1957. His transition to the school did not come easy at first. "It was not a good year for him," wrote a classmate from those years, Dean Cushman. "He had yet to find his *raison d'être* for being at Chouinard. He had to wait for a specific incident to trigger that awareness and bring it to the forefront."[24] That incident, according to Cushman, occurred when Bell made a flip remark in critiquing the work of a fellow student who was a Korean War veteran. Afterward, Bell had a dawning realization: He, like the war vet, was getting older, and he only had one chance to make something of his life. "The message hit home," wrote Cushman. "From that moment on Larry began to think seriously about his own future, about who he was and what he wanted—aspects of his life he'd never considered with much depth until then."[25]

Bell took a break from classes for a short time, finding a job at a framing shop in the San Fernando Valley, where he gathered up scraps of glass and other materials to take back to his studio. In time, Bell took note of how glass reflected light, but also transmitted it, and he experimented setting glass panels into some boxes backed with colored paper. In these works Bell would become obsessed with a single shape—the square. These works would, in time, replace the fairly run-of-the-mill Minimalist abstract paintings he had been doing, a fact that would change the direction of the artist's career. Bell returned to Chouinard in 1959 and left a short time later, his degree uncompleted, for unusual reasons. An instructor of his at the school, Herb Jepson, had grown concerned with Bell's visual fixation on square forms, to

the point that Jepson sent Bell to what the instructor termed an "aesthetic advisor," who was, according to Bell, supposedly seeing "students who had a different point of view."[26] Bell went to this person, whose name was Steinberg, four or five times to talk with him about his developing work. At first Bell felt great about these meetings and credited some of his artistic development that year to Steinberg. But then he learned that Steinberg was a psychiatrist. The truth of Bell's visits to Steinberg greatly upset him. "My whole world just collapsed," he said years later, still obviously feeling the pain. "I had thought that for once I was making decisions about my work and where I was going and this guy [Jepson] had just set me up because he thought I was some kind of nut. I went to the school, took out all my stuff, and I never went back."[27]

Pocketing what was left of his tuition money, Bell found a bar job in Hollywood and set up a studio in a garage behind his apartment. In the cramped space, he returned to his fixation on the square, pushing his work to become simpler and more hard-edged. In time, realizing he was painting illustrations of cubes in his work, he decided to construct the shapes themselves out of glass, moving for the first time into the realm of sculpture. Though the sculptures were expensive and tedious to make—such that he could only produce no more than eight per year—the work created a local buzz about the young artist. In time, he began hanging around the seminal L.A. art haunt, Barney's Beanery, and spending time with his former Chouinard teacher Robert Irwin, as well as young and hot local artists Ken Price and Billy Al Bengston. All through this period, Bell struggled to make ends meet and to find time to create work, but he was driven by lingering feelings of indignation about the episode at Chouinard.

Shortly after creating his earliest glass cube sculptures, Bell learned the industrial glass-coating processes that transformed his work. "I was after a certain surface treatment on a single piece of glass," said Bell, "that would reflect on both sides rather than taking two pieces of mirror . . . . I wanted it all on one piece of glass."[28] As a result of Bell's

technical investigations, he was freed to let his imagination roam. Bell's boxes, according to critic Douglas Kent Hall, would "radiate the beauty with which Bell had infused it, . . . [and each had] a life of its own in its particular space."[29] Three years after leaving Chouinard, with this new work, Bell landed his first solo show at the Ferus Gallery. It would be the first of a series of eight solo shows Bell would have in L.A., at the Ferus, Mizuno, Helman, and Ace Galleries, over the next ten years.

Like Kauffman, Bell eventually grew restless with his own art innovations, and he too began to grapple with what new directions to take his art in the new decade. In his 1972 solo show at the Pasadena Museum of California Art, he presented a series of glass "walls." Though he touted the work for severing his "link with traditional sculpture," since they were boundariless objects with "an ambiguous spatial existence,"[30] the work brought Bell to a kind of abrupt dead end. "Without abandoning materials—even transparent materials," wrote the local critic Henry Seldis in a mostly praising review of the Pasadena show, "it is hard to see where Bell will go from here in his researches into the phenomenology of perception."[31] Tellingly, after the Pasadena exhibition Bell grew restless in his living situation, and in 1973 he decided to leave his native Los Angeles once and for all for Taos, New Mexico.

IF ONE DATE COULD BE PINPOINTED AS THE DAY THE fantasy regarding L.A.'s Golden Age of art finally and completely melted away, it was February 18, 1976—the day of Wallace Berman's tragic and untimely death. Though less remembered today than he should be, Wallace Berman was a semi-legendary figure in Los Angeles art. Having cut his teeth with the Beat Generation of the 1950s and on the West Coast assemblage aesthetic, he was in a very real way the doyen of the Ferus group. He had come to California in the 1930s when his family moved from Staten Island to Boyle Heights. After being expelled from high school because of his lifelong penchant for gambling, Berman wrote poetry and then got involved in the West

Coast jazz scene, collaborating on a rhythm-and-blues-infused song for the vocalist Jimmy Witherspoon.[32] After attending classes at the Jepson and Chouinard Art Institutes for a few years in the 1940s, Berman starting working in a furniture factory. In his spare time, he used some of the wood scraps he gathered at the factory to make funky abstract sculptures. This led to his becoming a full-time artist. In the later 1950s, Berman began publishing *Semina*—a prototypical "zine"-like mishmash of found imagery, collaged textures, hand-scrawled notes, pen drawings, and the poetry of Beat-era writers Michael McClure, Philip Lamantia, David Meltzer, Charles Bukowski, William S. Burroughs, Allen Ginsberg, and Berman himself (under the pseudonym Pantale Xantos).[33]

With his link to the Beats and his wide-ranging circle of artistic friends, as well as his uniquely dense and poetic brand of assemblage/collage art, Berman was a natural choice to be featured in one of the first exhibitions at the Ferus Gallery in 1957. Unfortunately, his work in the show resulted in Berman being charged and convicted with violating local obscenity ordinances, a fact that caused Berman to withdraw from the local art scene and refuse to show his work in any gallery. "The mysterious nature of Berman's art was reflected in his life," wrote the curator and author Michael Duncan, "which included radical shifts and surprising inconsistencies . . . . Berman tended to cloak himself in mystery—especially when dealing with strangers or the press."[34] In 1961, Berman moved his studio to Topanga Canyon. Despite fostering an outward appearance of hermeticism, Berman was a fulcrum around which a wide-ranging artistic community revolved. Numerous artists over the years in fact praised Berman for his artistic and spiritual support. One artist, Charles Brittin, described visiting Berman's home in Topanga Canyon as a deeply moving experience. "He wouldn't put on a show or entertain you," said Brittin. "What happened is that you'd listen to some music and you'd smoke some pot and talk and look at things. What I enjoyed was not the conversation but the things we looked at. We did a lot of that. There were books,

pictures, art books, clippings from newspapers. There were evenings where there was not much talk. People would change records, walk over, and say, 'Look at this. Wow!' "[35]

The circle that spiraled around Berman in those years was a cutting-edge cohort of cultural outsiders that would come to be known as the "*Semina* culture." Fascinated by anything outside the conformist mainstream of Middle America, the group embraced French literature, the work of lesser-known Surrealist poets like Jules Supervielle, the ideas of the Kabbalah and other exotic and esoteric systems, and consciousness-shifting drugs like peyote. Berman's mystique continued to grow even after the Ferus Gallery imploded and the Cool School began to fracture in the late 1960s. In 1967, Berman's likeness appeared on the cover of the Beatles album *Sgt. Pepper's Lonely Hearts Club Band*. In 1968, Berman's work was featured in exhibitions at the Los Angeles County Museum of Art and the Jewish Museum in New York, and in 1969 the artist was given a small role in *Easy Rider* by the film's director, Dennis Hopper, who was a collector of his work. Berman continued producing work into the 1970s, though his regular circle grew increasingly fragile because of its growing chemical demons. Among the friends and followers of Berman who died in those years due to drug-related issues were the artists Ben Talbert and Arthur Richer, actor Bobby Driscoll, and poet/artist John Reed. Still, Berman somehow maintained his social status despite the tragedies and disruption. "As casualties among the artists and poets began to grow," wrote Holland Cotter of the 1970s art underground, "no high in the world could have hidden the truth that time is very short, and that love is only as trustworthy as its object. People trusted Mr. Berman; that was the bottom line. They found him steady and there."[36]

Drugs, unfortunately, eventually contributed to Berman's death. One day in mid-February, 1976, Berman was driving on a winding highway of Topanga Canyon when his car was struck by an intoxicated driver named Ronald "Spike" Miller, a well-known local drug dealer. Miller, dazed and perhaps concerned what might be found in

his car, attempted to flee the scene of the accident, only to be caught, ironically enough, by Randolph Mantooth, a local actor who was at the time known for playing a paramedic on the popular television series *Emergency!* Unfortunately, Mantooth the actor couldn't save the artist's life. Berman died a few days later on his fiftieth birthday, February 18, 1976.

Sorrow spread far and wide afterward among Berman's wide circle friends and acquaintances in the Los Angeles art community. "I don't believe in gurus," wrote Cotter years later, "and especially not in art gurus, even those like Wallace Berman who didn't want to be one. But I can understand why, when he died after being hit by a drunken driver on the eve of his fiftieth birthday, there was much grief."[37] Still, even if John Altoon had not died in 1969 and Berman in 1976, and even if Kienholz, Kauffman, and Bell had not left the city, the Golden Age of the Cool School still most likely would have faded during the troubled decade of the 1970s. In light of the larger forces that people were grappling with in L.A. and across much of the country, all that the Cool School represented and stood for—the deeply Modernist art and patently macho and heroic postures—would have likely given way to the confusing morass of varied individual and group artistic approaches, styles, and ideologies that better fit the times. In fact, as was clear in the struggles of Kauffman and, to a lesser degree, Bell, determining how much to evolve one's work in the face of the changing times was a critical dilemma facing the Cool School artists in the 1970s. Others in the group had lesser or greater success in adapting to the times.

Billy Al Bengston had long been the *enfant terrible* of the group.[38] While several other artists who exhibited at one time or another at the Ferus Gallery—Sonia Gechtoff, Alan Lynch, Les Kerr—faded to relative obscurity, none of the Ferus group was as much a disappointment, considering his seeming early promise, than Bengston. Swaggering and haughty, outspoken and dismissive, Bengston's early reputation was as much a product of his innovation with the Finish

Fetish as it was his demon drive to promote himself. He encouraged L.A.'s art collectors in the early 1960s to associate his art with the motorcycle subculture by cultivating a persona as the quintessential scenester, known for his swagger, burly facial hair, slicked-back hair, slick sunglasses, and leather jackets. Bengston's posturing mostly worked, and he had five solo shows at Ferus from 1958 to 1963, as well as a major exhibition at the Los Angeles County Museum of Art in 1968. He also received grants from the National Endowment for the Arts in 1967, from the Tamarind Lithography Workshop in 1968, and the Guggenheim Foundation in 1975. After the mid-1970s, however, Bengston's reputation crashed. Of Bengston's work, for instance, the critic Grace Glueck wrote, dismissively, that it was "slightly over the hill" and his paintings struggled to hang on "to their virility."[39] And though Bengston continued making work into the 21st century, he mostly faded from the view of the art world in L.A. and beyond after the end of the 1970s.

Only a very few Cool School artists continued to live up to their early promise. The Abstract-Expressionist painter Ed Moses, who had exhibited his work at Ferus very early on in 1958, fought hard during the 1970s to push the development of his abstract work. From the start, Moses's work was thought to be somewhat innovative, even though its trajectory strictly followed that taken by the second generation of abstract painters—particularly John McLaughlin, Richard Diebenkorn, and Sam Francis—who had, by the 1960s, all but exhausted what could be done in abstract painting. Still, argued the critic John Yau, "whereas McLaughlin, Diebenkorn, and Francis developed a mature signature style and/or compositional approach by which they and their work became canonized, Moses developed along a different path, one with a far more radical outcome." Moses, in a nutshell, invented highly involved mechanical processes around which to build his work. "In contrast to the photorealists, who resorted to the use of a slide projector," explained Yau, "and to Warhol, who incorporated silkscreen processes in his work, Moses never utilized the

technology of reproduction to aid him in his drawing and painting. Image, mark, structure, gesture, and spatiality are all the result of the particular manual processes he used in making his work. His attention to process is both highly defined and open-ended, and his ability to shift the focus of this attention has enabled him to resist developing a signature style. In this regard, Moses is a postmodern artist who has more in common with Jasper Johns, Sigmar Polke, and Gerhard Richter than with his Modernist forebears."[40]

Throughout the 1960s and into the 1970s, Moses continually attempted to reorient his painting methods and reconsider the proper materials for expressing his ideas. He exhibited his shifting abstract output at the Ferus Gallery in 1963 and 1964, the Everett Ellen Gallery in L.A. and Alan Gallery in New York in 1965, and the Riko Mizuno Gallery in 1969, building a solid reputation as an innovator in a somewhat dying mode of art. Throughout the 1970s, Moses would exhibit his work around the country and in galleries in Europe. Through the years, he pushed the limits of his abstraction, incorporating materials like resin, and visual elements from Navajo blanket designs, crisscrossing colored grids, and Cubism and Suprematism. "Moses wanted to discover if he could make a painting which eliminated all referents and thus ascended into . . . a final 'zero of form,' " wrote Yau. "The uninflected, hard, bright surfaces are chilly and standoffish. This is about as pure as 'pure art' gets . . . . He reached a dead end and simultaneously cleared a path for himself."[41] A dead end, of course, is not a optimal place for an artist to end up, but the "cleared path" brought on by his constant innovation is likely what kept Moses's outmoded approach to art fresh in a new era of art. In 1980, Moses received a Guggenheim Fellowship. That same year, he began exhibiting at the L.A. Louver gallery, a relationship he would maintain for fifteen years. And in 1996 his work was the subject of a major retrospective exhibition at the Museum of Contemporary Art in Los Angeles. He continues to produce art even today, and his work is included in the collections of many of the leading art institutions around the world.

Beyond Moses, two more Cool School artists evolved out of the 1960s to build lasting careers. Both Ed Ruscha and Robert Irwin had in common the fact that they were driven by two urges: The urge to constantly reinvent and recalibrate their work through deeper artistic investigation and experimentation, and the urge to remain intellectually engaged with the changing times. Ed Ruscha, wrote one art critic fairly recently, is "one of the most consistently inventive and influential artists of recent times" but also is "difficult to categorize . . . . In looking over forty years of Ruscha's artistic output, what emerges is the portrait of an artist who made decisions based not on the fashions of the day but on his commitment to engage with the problems of making art in the contemporary world."[42] Among the counterintuitive and unconventional artistic decisions made by Ruscha during his long career was his early insistence, in the 1960s, that his work not be labeled as "Pop Art"—even despite how in demand Pop Art was at the time. Then, at the moment in the 1960s when his brash and monumental monosyllabic word paintings were most popular and in demand, Ruscha deliberately stopped painting them and shifted instead to artist's books. Of course, Ruscha's books were highly influential—particularly to the output of 1970s innovators like Baldessari and Burden—yet, by the time of the rise of Conceptual and objectless art, Ruscha stopped making them. In fact, Ruscha's shifting output and styles through the years constantly flew in the face of all the public, and art market, expectations. Between 1969 and 1971, Ruscha was experimental-minded and his work expanded to include varied media such as photography, short films, and drawings with alternative materials like blood, rose petals, and blueberry extract.

Throughout the troubled decade, then, Ruscha's artistic production remained a constantly moving target, and this may have been his biggest strength. "If curators and writers thought they had him neatly tied up in a bow as an idiosyncratic, laid-back L.A. proto-Conceptualist," wrote Kerry Brougher, "they were once again caught off guard in the late 1970s when he reintroduced painting with a vengeance, producing

a long-running series of widescreen and then silhouetted images that are startlingly cinematic and imbued with strong doses of narrative, memory, and even nostalgia."[43] Through all the changes, Ruscha was blessed with an abiding sense of what made compelling art. In fact, Ruscha's work would continue to remain extremely popular and internationally admired (and honored)[44] throughout his career, which continues even to today.[45] The artist was even recently named, in 2013, to *Time* magazine's annual list of the 100 most influential people in the world. The magazine went so far as to suggest that, since 1956 when he "drove from Oklahoma City to Los Angeles to help gestate the West Coast division of Pop Art," Ruscha has been the "faux-naïf funnyman of American art, posing smart riddles about what we think we know."[46]

Over much the same time period, Robert Irwin's approach was as restless and searching as Ruscha's. The key to Irwin's enduring success, especially compared to other Cool School artists, is that he, like Ruscha, never seemed concerned about whether or not his work would have broad populist appeal. Both artists preferred instead to focus on the quality of the work. As critics have argued, Irwin's cerebral, ever-evolving work has inspired more young artists than most of his contemporaries in the L.A. art world. "[Irwin] has convinced more young people to become artists," suggested the curator Michael Govan in 2007, "than the Velvet Underground has created rockers."[47] The range of Irwin's investigations in the 1960s was legendary, spanning various materials, modes of working, and conceptual bases. This included, for instance: his Minimalist abstract paintings of the early 1960s, his Finish Fetish–inspired painted aluminum discs of 1966–67, his Light and Space–inspired illuminated clear acrylic discs of 1968–69, his clear acrylic columns of 1970, his investigations with perception and the use of scrim material at major exhibitions at the Museum of Modern Art in New York in 1970 and the Walker Art Center in Minneapolis in 1971, and his investigations of "sightlines" and "places" across the Southwest in 1972.

Throughout the 1970s Irwin was driven by investigations on the nature of perception that he had begun (but were scuttled) for the "Art and Technology" exhibit. Over time, Irwin's work became more and more ethereal, based as it was on simpler and simpler manipulations and interventions of existing spaces. Irwin's investigations, ironically enough, considering similar actions taken by John Baldessari, even led him to sell off the contents of his Venice studio. "I cut the knot," Irwin said. "I got rid of the studio, sold all the things I owned, all the equipment, all my stuff; and without knowing what I was going to do with myself or how I was going to spend my time, I simply stopped being an artist in those senses. I just quit."[48] Irwin gave up painting, but continued to work as an artist, and dedicated himself to making art that ever was more and more immaterial and fleeting. This meant mostly installations that used light and transparent materials such as acrylic, wire, and theater scrim. In 1975, Irwin shifted the focus of his investigations yet again, taking what he knew about how viewers perceive line, color, and light in built environments to the field of land-scape design. And since then, Irwin has been commissioned to create fifty-five different experimental site projects around college campuses, museums, art institutions, and other public spaces. In 1984, as a sign of his prominent role as an art-world thinker, Irwin became the first artist to receive a MacArthur Fellowship. He was also elected to the American Academy of Arts and Letters in 2007 and continues to accumulate honorary degrees for his accomplishments.

THE FACT THAT ONLY A FEW COOL SCHOOL ARTISTS managed to maintain their vaunted reputations past 1970 is not surprising. The group, after all, had been reliant on the city's growing reputation in the 1960s, and on their image as a cohort of young men who reflected the spirit and ambition of Southern California's hey-day. When the region's reputation began to fade in the early 1970s, so too did the Cool School's. And while the final failure of the Cool School/Ferus gang/L.A. Look was tragic in some ways, it was also, in

retrospect, wholly necessary in order to open up the local landscape to the irrepressible surge of the looming Postmodern moment in art. The Cool School, that is, had to fade away and disperse to make necessary room for women artists, artists of color, and for those of alternative artistic visions—street artists, makers of so-called lowbrow art forms, and other independent-minded mavericks—to pursue their own particular visions of art-making.

As the art made in L.A. during the 1970s would reveal, the "L.A. Look" was but a fleeting chimera. Los Angeles, in fact, was an incubator of independent creative voices, a home for diverse experimental and innovative visions in art, and the locus of an artistic legacy that has stood the test of time. Los Angeles in the 1970s was where artists created the future of art.

# The Lingering Afterimage of L.A.'s Art of the 1970s

THE ARTISTIC GENERATION THAT CAME OF AGE IN Los Angeles during its "lost" decade went to great lengths to free themselves of the strictures of the dominant culture of the 1960s, from the burden of making pictures and objects in favor of concepts, and from the distractions of commodification and the machinations of the art market in favor of non-object and Performance Art. This group of artists, in effect, created the future of art in which the former era of dominant group-driven art narratives—i.e., the era of art "movements"—was replaced by a fragmented "society of the spectacle" wherein consumerist and media images now "dominate individual subjective experience"[1] and guide artistic and cultural production.

The stylistic pluralism that characterized art in the 1970s carried on into the 1980s, with the new re-embrace of "picture-making" and "representation" by the loose cohort of hot young artists known as the "Pictures Generation," as well as the reemergence of a number of throwback "neo-" movements—Neo-Pop, Neo-Geo, Neo-Expressionism, the New Image artists, the German equivalent *Neue Wilde*, and so on. Much of what the "Pictures Generation" believed about artistic practice, and the concepts they employed to make their pictures, had originated out of the theories and concepts that drove the L.A. art scene for the several years that preceded them. "The importance of art

schools in supporting new art forms that eventually made their way to
New York," wrote Paul Schimmel:

> *"can be seen in the influence of the post-studio classes of John
> Baldessari and Michael Asher at CalArts on artistic practice
> during the mid- to late 1970s. Along with questioning the very
> premise of being an 'artist,' CalArts regarded its students as
> 'already' artists, resisting the hierarchical models that informed
> other schools . . . . Many artists who came to be associated
> with the Pictures Generation—including Jack Goldstein, Matt
> Mullican, David Salle, and James Welling—passed through
> CalArts during the mid-1970s . . . . A direct line can be traced
> from California pluralism to New York Postmodernism, as the
> revolutionary effect of pluralism on the studio practices of art-
> ists came to define what we now know as the hallmarks of
> Postmodernism in art, including the deconstruction of visual
> tropes, media critique, identity politics, and artist activism. To
> this day, California remains closer to the ideals represented by
> the pluralistic and inclusionary tendencies of Postmodernism."*[2]

Baldessari might seem an odd figure to pin the Postmodern return
of pictures to the art world, but the California Conceptualist never
completely discounted the idea that pictures had no place in art. While
Baldessari's post-studio classes rejected "the progressive mastery of
established technique and skills" and "the formal elaboration of the
individual image" as the focus of art education, it instead focused on
the value of originality and of "expression that relies neither on exam-
ple of others nor on tropes and cliches."[3] If originality came in the
shape of representation, then so be it.

As a result of the school's particular approach to educating them,
the first group of graduates from the new CalArts viewed art and art-
making through a very au courant prism. "The primary question in
the minds of the younger, post-Conceptual generation of artists was,"
wrote Douglas Eklund, "in effect, what constitutes an artist."[4] Around

1975, a generation of CalArts graduates—and Baldessari acolytes—
like Jack Goldstein, Tony Brauntuch, Matt Mullican, James Welling,
Barbara Bloom, and David Salle,[5] found themselves faced with a
dilemma: How to reconcile their copious ambition and refined sense of
their own worth as artists with the hard practical realities of life after
art school. The answer, which was suggested first by Baldessari, was
obvious: Go and take your best shot in the country's art capital, New
York. "I thought L.A. was out of touch with the rest of the world,"
Baldessari said. "I wanted the students to have a space where they
could do something other than painting or making objects . . . . I could
see pretty clearly that a lot was going on in the world that wasn't hap-
pening in Los Angeles. It was very provincial. Good teaching is giving
students a vision. I wanted to ignite a fire in their eyes. That was it.
Then they were gone."[6] It didn't take much to convince the students to
go where the opportunities were. "At the time," Jack Goldstein con-
tinued, "it seemed that the L.A. art world had room for one of every-
body—one Conceptual artist, one sculptor, one painter, but only one
star in each category . . . . Anyone who was ambitious had to get away,
had to go to New York."[7]

The name for the Pictures Generation came from an influential
1977 exhibition at Artists Space called "Pictures," curated by Douglas
Crimp and Craig Owens, which included the artists Tony Brauntuch,
Jack Golstein, Sherrie Levine, Robert Longo, and Philip Smith. As with
the Young Romantic artists in L.A. around the same time, the artists of
the Pictures Generation grappled with the nature of the "picture" in an
era of media-driven cultural confusion and fragmentation. The differ-
ence being that the Pictures Generation was more commercially savvy
and dedicated to creating consumable artifacts out of their investiga-
tions than their peers back in L.A. "They [the Pictures Generation],"
wrote Eklund, "were part of the first generation to be born into the
swarm of images spawned by the rapidly expanding postwar consumer
culture—movies, magazines, and music . . . . It was precisely this trans-
formation of the American economy from one based on need to one of

desire, dependent on the continual promoting of consumption at the deepest level of subjectivity, that shaped their outlook on the world."[8] In addition to the Young Romantic artists of Venice in the 1970s, some members of the group were also clearly influenced by the Pop-infused realism of Vija Celmins. In many ways, the so-called Pictures Generation sought to advance the painterly investigations of Celmins, though with less technical proficiency and more expression. Celmins's influence is perhaps most clear in Robert Longo's obscure photo-based portraits of oddly posed, well-dressed figures, the fractured and media-infused collage/assemblages of David Salle, the strange and obscure photo-based compositions of Eric Fischl, and the hypercharged photo-realist paintings of Jack Goldstein.

After 1975 or so, Baldessari's students merged on the nation's art capital en masse, their strong ambition so apparent to the local establishment that they were quickly dubbed the "CalArts mafia" by the arts press in New York. "The East Coasters would come to see them as a kind of Frankenstein's monster," wrote Richard Hertz, "let loose on the more genteel members of the earlier generation."[9] Despite the group's precocious bluster, its members took care to hedge their bets once they'd settled in New York. Goldstein, for instance, kept his studio in the Pacific Building in Santa Monica, returning regularly to L.A. for weeks at a time to decompress in the somewhat less harried local atmosphere (and shooting languid Conceptual films more cheaply than he could in New York). "It seemed like a long shot at the time," said Jack Goldstein, in some respects the most prominent and uniquely talented (though ultimately not the most successful) of the group. "Few people had made it big [in New York] from the West Coast. Maybe Diebenkorn, but he had already been round so long . . . . Ed Ruscha has also made it big . . . . But the others had to settle for teaching jobs elsewhere; they gave up making it big on the East Coast."[10] Others of the group also tried to remain connected to the polite nurturing of their mentor, John Baldessari. "After we graduated," said Jack Goldstein, "John received the announcements about

us, about our shows, and would laugh about them . . . . It seemed to us that he didn't take us seriously."[11]

This ambivalence may have had something to do with the fact that Baldessari's own art career had, for much of the 1970s, gone nowhere. "John wasn't making a lot of money then," Goldstein continued. "By the late seventies, we were making money . . . . His work was too sophisticated and witty."[12] It probably didn't help that the Pictures Generation did, with its reembrace of painting and focus on making commodified art objects, reject some key principles of Baldessari's. Though, in other ways, much of what these artists did simply built on what they had learned at CalArts. Photography was the key. "The California playacting and paste-up aesthetic," wrote Thomas Crow of the particular aesthetic that Baldessari had imparted to his students, "found adherents among other recent arrivals: Cindy Sherman— just down from Buffalo, New York—remembers first conceiving the idea for her Untitled Film Stills (1977–80) while shuffling through a Baldessarian miscellany of photographic prints strewn around Salle's apartment."[13]

Among the "CalArts Mafia," David Salle was perhaps the most attuned to Baldessari's outlook and also the most willing to reject it in service to his own art. Baldessari often acknowledged his connection with former student David Salle. "[He was] one of the students I talked with and felt very close to," said Baldessari. "He came to CalArts as a painter and then he went into video and photographic pieces, and so on. And I think his paintings show a lot of that kind of thinking, media images, disjunctive images, and that thinking . . . ."[14] With his enigmatic montages that drew from a wide array of sources, Salle became a particular critical darling among the Pictures Generation. Working in a pastichy manner similar to earlier Angeleno painters like Terry Allen, Llyn Foulkes, and Carole Caroompas, Salle filled large canvases with a "continuous membrane of paint with a miscellany of pieced-together and overlapping imagery" that embodied the "CalArts-engendered idea of the 'artist as porous membrane through which everything

passes.' "[15] Fractured and fragmented in imagery, completely in synch with the timbre of the times, these paintings made Salle an art-world force going into the new decade. Critics have rightly pointed out that there were already artists "active in Los Angeles during the early 1970s who were translating into monumental painting a similar amalgam of bluntly rendered images from sources old and new, cultivated and vernacular." But it was Salle, more commercially savvy and better adept at playing the art game in New York, who became the biggest star of the movement.[16]

Salle's work was so influential, in fact, it helped spawn a new art-world term. " 'Appropriation' became the catch phrase," said Jack Goldstein of the term that came into vogue after the buzz generated by the "Pictures" show of 1977. "Some did it well . . . . Baudrillard became an art guru for five minutes with his idea of simulation, where what is pictured becomes more important than what you are supposedly representing—it takes on a life of its own apart from any apparent signifiers. We learned that we weren't representing anything, or at least nothing stable and fixed. It was just like the television screen. We were playing with the signs and images of the commercial world, which had formed all of us as we grew up watching television. We were the first generation of 'raised on TV' artists, so the art changed from being something weighty and formal and self-important to art that was more playful and decorative, fast, ironic, even cartoon-like."[17] For a brief time, Jack Goldstein was also a bright light in the Pictures Generation. His initial output was varied and dynamic, spanning the genres of painting, photography, performance, film, even musical recordings. "More than most post-Conceptual artists who came to mind," wrote David Salle of his friend and cohort in a 1978 exhibition catalogue, "Jack Goldstein's work seems directly related to fears and anxieties about living in the world, and yet, significantly, the look of the work is almost antiseptically divorced from any cliché notion of the language of Angst . . . . There is in Goldstein's work almost a sense of allegiance to the conventions of commercial presentation, which

becomes ironic because of his intention to locate a source of control over his imagistic environment."[18]

The soaring ascent of Goldstein to the heights of art-world success, coupled with his precipitous fall a few years later, was indicative of a new art-world reality. Once the United States began a sustained period of economic growth in the 1980s, the market for art around the world began a nearly unprecedented boom as well. Between 1984 and 1990, overall prices for all segments of the art market rose by about 500 percent. For the top quarter of the market, prices rose by more than 750 percent. Hand in hand with a bubble-based infusion of cash came an explosion of hype and PR, and an insatiable appetite for easily consumable (but often flash-in-the-pan) art trends and hotshot young artists. Jack Goldstein was among the first to enjoy the fruits of a new star-making function—as well as its secondary "star-breaking" function—of the contemporary art market.

IN LIGHT OF HIS ROLE IN FOSTERING THE PICTURES Generation movement of the early 1980s, Baldessari emerged a few years later as a new art guru. For several years stories had circulated of the small, seemingly insignificant actions of Baldessari in his post-studio classroom, and in time the art market grew curious about his work. In regards to this guru status, Baldessari was circumspect. On one hand he was pleased for his students' successes. "I was happy I could contribute," Baldessari said years later. "I was happy I could help. I was happy I could speed things up for some of my students. I think the first generation of successful students was the result of an amazing stroke of fate."[19] On the other hand, he was fully aware of the brash new trend he had loosed on the art world. After all, Lawrence Weiner famously and jokingly blamed Baldessari for the Pictures Generation. "It's your fault, John," Weiner said, "you called them artists."[20]

To his credit, Baldessari did not surrender his idealistic ideas about art, nor did he ever stop making the best art that he knew how to make. Though overshadowed by his students in the national limelight,

between 1970 and 1980 Baldessari showed regularly in solo shows in New York and Europe.[21] In fact, it was Baldessari's elusive search for the truth, and his penchant for avoiding a quick and easy style in favor of multiple modes of working to get at deeper truths, that kept his work fresh to viewers and critics even through the passage of time. "Critical and institutional acclaim grew [for Baldessari]," wrote Leslie Jones, "and as writers and curators tried to make sense of the era's deluge of conceptually based photographic works, Baldessari's art was named and renamed according to the critical trend of the moment."[22] Baldessari's work, at one time or another, was tellingly associated with myriad "movements" and mini-trends: The "Earthworks" movement in the early 1970s, Performance Art, telephone art, body art, narrative art, word art, Poststructuralist Art," and so on. "While this bespeaks the richness and breadth of Baldessari's creative enterprise," Jones continued, "it also reflects a generation coming to terms with pluralism and a critical restructuring that soon would place such work under the tidy rubric of Postmodernism."[23]

Baldessari's first career survey exhibition was held in 1981 at the New Museum of Contemporary Art in New York, featuring more than eighty works organized by Marcia Tucker. Critical reception to the show was mixed. For Kim Levin, writing in the *Village Voice,* it was interesting to see in Baldessari's show at the New Museum his "unencumbered images, . . . now that amnesia about the '70s is rapidly setting in and we're getting weighed down once more with big heavy canvases and expressive thick paint."[24] Despite the response to his first national showcase, Baldessari refused to sit still. In 1984, around the time that he mounted his first solo show in Los Angeles in eight years at the Margo Leavin Gallery, he began focusing on photographic stills, mostly from Hollywood movies. Baldessari had become interested in psychotherapy and the deeper workings of the human mind, and how the archetypal images of Hollywood expressed such things. As a result, the Leavin show was replete with "images of desire and intrigue, murder and death" that were very different from his goofy deadpan images

and videos from just a few years earlier. Baldessari's friend Lawrence Weiner, on seeing the show, reacted to it much as he had to the Pictures Generation. "John . . . understands," Weiner said, "that art is based on the relationship between human beings and that we, as Americans, understand our relationship to the world through various media. We think of any unknown situation in terms of something we've seen at the movies. That is the basis of our normal mass consciousness and how we see the world. John is dealing with the archetypal consciousness of what media represent, using the material that affects daily life."[25]

The work of Baldessari would continue to evolve, often keeping one step ahead of expectations for it. This evolution was assisted when, in 1986, the artist received a Guggenheim Fellowship and was able to leave his position at CalArts and devote himself solely to art-making. His career, in time, also grew to an art-market stature that gave him additional self-sufficiency and freedom to maneuver. "Over the course of the 1980s," wrote Leslie Jones, "Baldessari's work entered many public, private, and corporate collections. For some, his montages of mass media imagery seemed 'dangerously close to many current advertising strategies.' For others, the increased scale and slick finishes indicated a tailoring of his Conceptualism to meet the stylistic demands of corporate culture . . . . Artists who work with the visual language of media culture must walk a fine line, but for Baldessari, it's a matter of understanding how images work. 'I am interested in what gets us to stop and look as opposed to simply consuming images passively. If there is anything political in my work then it is to be found in the ability of my images to question the nature of imagery itself,' he said. 'The more we are able to read images and understand how they work within our culture then the more empowered we will be as individuals.' "[26]

Baldessari's ultimate success, when it came, was less a flash flood than a constant stream of admiration and praise. In 1990, Baldessari somewhat belatedly was the subject of a retrospective in his hometown at the Museum of Contemporary Art in Los Angeles. Along

with garnering numerous prizes and awards, his work has been exhib-
ited internationally in one-person shows at the Stedelijk Museum
in Amsterdam, the Sonnabend Gallery in New York, the Museum
Folkwang in Essen, Germany, the Contemporary Arts Museum in
Houston, the Santa Barbara Museum of Art in California, and the
Museo Nacional Centro de Arte Reina Sofía in Madrid. His work
has also been featured in international group showcases such as
Documentas 4, 5, and 6 in Kassel, Germany, the Venice Biennale,
the Palais des Beaux Arts in Brussels, the Museum of Modern Art in
New York, the Kolnischer Kunstverein in Cologne, and the Whitney
Biennial in New York. In 2004, he was elected to the American
Academy of Arts and Sciences, and in 2009, his retrospective exhi-
bition *John Baldessari: Pure Beauty* opened at the Tate Modern in
London.[27] In all, some forty long years after he chose to incinerate all
of his paintings and start his art career over, Baldessari managed to
keep his art-world currency well into the twenty-first century.

THAT JAMES TURRELL'S CAREER FOLLOWED A TRAJECTORY
similar to Baldessari's is partially attributable to the power of the ideas
that percolated up from the L.A. art underground in those days, as
well as to the individual genius of each artist. Turrell, however, was
the first to hit significant artistic pay dirt. Having been awarded, based
on his work with the Italian Count Panza di Biumo, a Guggenheim
Fellowship in 1974, and also having lost his studio space around the
same time, Turrell took a chance on the freedom that was offered to
him and headed out toward the horizon, both literally and figuratively.
A trained pilot, he flew off in his small plane into the dry stretches
of desert landscape that spread out eastward of Southern California,
where he had been born and raised. He scanned the countryside from
the foothills of the Rocky Mountains to the Pacific coast, and from Lake
Louise in Canada all the way down to Chihuahua near the Mexican
border. Turrell wasn't just looking for a sense of release, however; he
had something much more specific in mind. "I had this thought to just

bring the cosmos closer, down to the space where we occupy," Turrell said some years later. "That was how I found Roden Crater."[28]

The Roden Crater is an extinct volcanic cinder cone that had been formed about 400,000 years ago and was located near Arizona's Painted Desert. Turrell first saw the crater from his plane in the late afternoon, and he was struck by how the site was lit by the low, raking light of the desert sun. Situated at an elevation of 5,400 feet above sea level and raised about 600 feet above the surrounding plain—the site fit Turrell's conditions. More importantly, Turrell was inspired by the site. "It was nice that it was away from other ones [volcanic craters in the San Francisco Volcanic Field in Arizona]," Turrell said. "But I think the important thing is just this kinda sense of power that each place has. So the place felt right."[29] Turrell's plan, in essence, was to move the work he had been doing at the Mendota Block "out into the environment in order to take advantage of the visual qualities available in the sky."[30] At the Roden Crater, then, Turrell envisioned building a naked-eye observatory that would tap into the visual phenomena that humans had observed and recorded going back to ancient times more than 10,000 years ago. Turrell had studied the essential features of other such observatories, such as one built in Jaipur, India, in the eighteenth century, and wanted to use the "fine qualities" of light and allow visitors to observe the celestial movements of planets, stars, and distant galaxies. Turrell ultimately wanted to gather "starlight that was from outside the planetary system," he said, "which would be older than our solar system. You can gather that light and physically have that in place, so that it's physically present to feel this old light."[31]

In 1977, with help from the Dia Foundation, Turrel was able to purchase the Roden Crater from a rancher and retired railroad magnate named Robert Chambers, who had originally scoffed at Turrell's idea.[32] It had taken several years of negotiating, but in 1979, once the purchase had been finalized, Turrell moved his studio to the nearby Flagstaff area and began construction on the crater. Turrell "sculpted the dimensions of the crater bowl" and cut a series of chambers,

tunnels, and apertures into it. Over the next decades, as the construc-
tion advanced and Turrell's career evolved, the artist's vision for
the project changed as well, and completion has been long delayed.
Through the years, even as Turrell has gained accolades, garnered sig-
nificant commissions and awards, and been featured in international
solo exhibitions,[33] Turrell added or altered spaces and features at the
Roden Crater as he gained better awareness and skill in working with
the light at the site. Still, most of Turrell's original idea remains intact:
Creating an observatory at the site that will, when finished, contain
twenty separate spaces into which light will stream from a variety of
vantage points.

In the end, when all the dust has settled and construction has
ended, Turrell's project at the crater will amount to his career's crown-
ing achievement, and a perfect distillation of what this revolutionary
artist from L.A. is all about. "Roden Crater has knowledge in it and it
does something with that knowledge," he said. "Environmental events
occur; a space lights up. Something happens in there, for a moment, or
for a time. It is an eye, something that is itself perceiving. It is a piece
that does not end. It is changed by the action of the sun, the moon, the
cloud cover, by the day and the season that you're there, it has visions,
qualities, and a universe of possibilities."[34]

THOUGH CHRIS BURDEN'S ART CAREER DID NOT RISE,
despite his early renown and notoriety, quite to the eventual level of
Baldessari's and Turrell's, he never stopped making work. There are
likely several reasons why Burden's career seemed to cool as the cha-
otic decade of the 1970s wound down. For one, in 1975, after the
personal ordeal he had endured during his nearly two-day perfor-
mance of "Doomed," Burden decided to phase out his self-imperiling
performance art works in favor of other expressive forms. "I think
the first time, after graduate school, that I didn't do a performance
was the 'B-Car,' " said Burden of his 1976 sculptural prototype of a
lightweight motor vehicle that he claimed could reach speeds of one

hundred miles per hour and could travel one hundred miles on one gallon of gas. "That was a change in my career because I was supposed to go to Europe and do two performances, but then came up with this idea of building a car that I could build myself, that would be revolutionary . . . . It was sort of a gradual process where I sort of shifted over and gradually started making objects and doing installations too."[35]

In 1976, after all, Burden had turned thirty and likely realized his body would not take the punishment of his performances much longer. The resulting diffusion in the artist's creative output across genres like installation, mail art, printmaking, kinetic sculpture, and Conceptual fabrication somewhat served to confuse his image in the art world. These works were difficult to connect with the daring and breathtaking actions of the younger artist, though they were often marked with an eccentric sense of humor and play. For instance, in 1978 Burden made "In Venice Money Grows on Trees," which he described in his usual deadpan way: "Just before sunrise two friends and myself glued one hundred brand-new one dollar bills to the leaves of two very low palm trees on the Venice boardwalk. The bills were folded lengthwise several times so that they fit into the creases on each palm leaf. Although in plain sight and within arm's reach, some of the money remained untouched for two days."[36] Among other works he made in the later 1970s were an installation work called "Natural Habitat (with Alexis Smith)" (1976), which was a scale-model reconstruction of the living space of his Venice studio (which he shared with Smith); a "mail art" project called "Merry Christmas from Chris Burden" (1976), in which he sent envelopes containing $10 bills to one hundred of his art-world acquaintances; an installation called "C.B.T.V. (Chris Burden Television)" (1977), in which he recreated and demonstrated a mechanical apparatus invented by John L. Baird that many consider to be the first television; a performance called "C.B.T.V. to Einstein" (1977), in which he launched a stick-and-tissue model airplane he had constructed from the back of the cabin of a Concorde

jet while in flight; and a print project called "DIECIMILA" (1977), in which Burden created a double-sided facsimile of an Italian 10,000-Lira note.

In 1978, Burden became a full-time professor in the art department at the University of California in Los Angeles, a position that he retained until 2005.[37] As a result, his artistic output slowed somewhat—at least from the remarkably fecund period of creation he had enjoyed between 1972 and 1978—and so he fell further, though not completely, from public consciousness. This is unfortunate, because there was much that Burden still had to offer as an artist. For instance, in 1979, Burden capped off the decade with a masterful kinetic sculpture called "The Big Wheel." For this work, Burden constructed, out of cast iron, an eight-foot-wide, three-ton flywheel that he attached to an axel aperture. When a motorcycle was moved into place and revved loudly, the smoothly lubricated iron wheel would rotate up to 200 rpms, continuing to do so, thanks to the force of momentum, for two and a half hours after the motorcycle was removed. An L.A. critic, upon seeing the work, enthused about the work's "fearsome power, inert absurdity, hypnotic beauty, and raw intelligence," then added: "For all its strange unwieldiness, [it] is emphatically traditional as art."[38]

Career highlights slowed somewhat during his years at UCLA, though he had significant works included in the Whitney Biennial in 1992 and at the Tate Gallery in London in 1995. After he stepped down from his position at the school, Burden's international reputation enjoyed something of a resurgence—with the positive reception to works like his 2008 public installation work "Urban Light," which installed dozens of vintage street lamps at LACMA, and his massive kinetic sculpture of toy car tracks and toy cars from 2011, "Metropolis II." The enthusiasm expressed by critics and the general public over these works was reminiscent of the response to his evocative and unsettling early work, reminding the art world of the Californian's unique talent for creating memorable works of art.

WHEN BURDEN STEPPED AWAY FROM PERFORMANCE Art in the second half of the 1970s, it carried on even without one of its guiding lights. In fact, by 1978 or 1979, a second generation of Performance artists had begun to emerge from the shadows. Rejecting the austerity of Performance Art up till then, as well as its general antipathy to popular culture, this new generation of artists, who had been fully weened on TV and the exploding media forms of the era, changed the direction of Performance Art for better or worse. For one, they took their art outside the safe confines of the art galleries, moving into theaters and clubs, and recording their work on videotape and on film. Often combined with striking visual elements, the new Performance Art often seemed stylistically conflated with other artistic genres such as avant-garde dance, drama, stand-up comedy, and musical performance. "This [1978–1983] was a period of rupture," wrote the artist Suzanne Lacy and the art historian Jennifer Flores Sternad. "The desire for . . . critical distance from the market that had existed throughout the 1970s receded as the decade ended. More was expected of what now was a critical mass of artists who considered Performance Art their primary medium."[39]

The tendency of Performance Art in L.A. to bridge genres and operate in tandem with more popular art forms is clear in the work of a number of crossover artists who emerged starting in the late 1970s and 1980s. This list of artists includes musicians Laurie Anderson and Phranc, actor Ann Magnuson, and vaudevillian clown Bill Irwin. The Kipper Kids—Martin Von Haselberg and Brian Routh—had moved to Los Angeles in the mid-1970s to find success in the city's Performance Art scene, and by the later 1970s their brand of performance—which featured nudity and odd costumes, slapstick humor, music, food fights, and other unexpected elements—made them notorious and popular among fans of L.A.'s burgeoning punk scene. "In the beginning," said Routh of that era, "it was less entertainment, much darker, more focused . . . . But by the time we'd been in L.A. a bit, the shows became raucous and loud, . . . much more entertainment-oriented."[40] Another

Performance Art duo, Bob & Bob, focused on creating multimedia "events" that employed performance, film, music, humor, and audience interaction that would attract large crowds. "We were more concerned about our popular audience than our art audience," said the duo. "We got massive amounts of people out because Bob & Bob were . . . making an appeal to a bigger culture out in L.A.—punk people, designers, filmmakers."[41]

The mutating, multimedia, often humorous nature of later Performance Art in L.A. likely owed a debt to a looming figure from the previous generation of local experimental artists, Allen Ruppersberg. Ruppersberg had long displayed characteristics that hearkened to the loosey-goosey style of late-1970s Performance Art, and as the decade passed he grew more eccentric and diverse, developing a "unique voice within Conceptual art" that drew visual inspiration from a "vast collection of images and texts" he had amassed. "As an ardent collector—[and a] vernacular anthropologist," wrote the curator Elsa Longhauser, "Ruppersberg has spent years amassing an immense trove of everyday things: postcards, educational films, magazines, posters, comic books, obituaries, newspaper clippings, and other artifacts of public communication . . . the ephemera of daily life, especially that of mid–twentieth-century middle America, when and where he happens to have been born and raised."[42] In 1978, Ruppersberg commenced an offbeat performative work called "A Novel that Writes Itself." As a means of involving the audience in his creative process, Ruppersberg sold "roles" in the novel at various price points. A leading role, for example, was priced at $300, while bit parts were just $50. Among the people who paid to appear in the book were the critic Dave Hickey, his old artist friend Terry Allen, and the gallery owner Rosamund Felsen. Over the next two decades, Ruppersberg wrote the "text" to the novel on poster boards, finally completing the work for his 1997 retrospective at Le Magasin in Grenoble, France. The final work was a sprawling and unconventional collection of eight hundred posters that juxtaposed poetic language with the conventions of mass advertising.

Not all of the great innovators of L.A.'s first generation of Performance artists appreciated the changing style of the form. Nancy Buchanan was particularly disenchanted by the new focus on entertainment and media. "So much of what was called performance," said Buchanan, "had become stand-up comedy, confessional, or just generally theatrical-cathartic, that I felt the expectations were antithetical to my interest in making a live image with largely unpredictable outcomes. It seemed to me it was becoming a sideshow."[43] When Buchanan realized that the audience for Performance Art didn't seem to agree with her, she stepped away from her practice of it. Paul McCarthy also chose to leave the form behind when he saw how it was evolving. "By 1979, 1980," said McCarthy, "the alternative art world had changed . . . . I wasn't interested in the performance space being a black space with lights, like a cabaret, or performance in front of a crowd. It felt like it was over."[44]

Despite the changing focus of Performance artists, and the growing mainstream acceptance of the structures, techniques, and quirks of Performance Art, Los Angeles continued to produce a number of socially engaged, politically edgy Performance artists well into the 1980s. This included, for example, the work of a gay Latino Performance artist name Cyclona—aka Robert Legorreta—who regularly put on women's clothing and thick makeup and paraded along Whittier Boulevard in East L.A., often to predictably troubling results. The loose conglomeration of experimental musicians known as the L.A. Free Music Society, meanwhile, used Performance Art techniques and daring sonic sensibilities to push the limits of what could be considered musical performance, and the Los Angeles Poverty Department (LAPD), founded a bit later, created "performances and multidisciplinary artworks that connect the experience of people living in poverty to the social forces that shape their lives and communities."[45] The veteran Performance artist Rachel Rosenthal taught classes at Womanspace in the late 1970s, even as she performed an array of stunningly emotive performances—with titles such as "The Death Show"

(1978) and "The Arousing (Shock, Thunder)" (1979)—throughout the era. And established L.A.-based artists like Suzanne Lacy, Faith Wilding, Allan Kaprow, and others continued making their brand of socially and politically engaged Performance Art well into the 1980s.

That Performance Art may have reached its high point in Los Angeles in the late 1970s is suggested by the establishment of the quarterly magazine *High Performance,* which covered, at least initially, the latest goings on in the field.[46] Shortly after *High Performance* commenced publishing, the political temperature of the country changed dramatically upon the election of Ronald Reagan in 1980. "The whole country was getting more conservative with Reagan," said Performance artist John Malpede, who had founded the Los Angeles Poverty Department in 1985, "[and] people were trying to figure out what to do with their Performance Art careers . . . . A lot of people were hitting their head on the roof of the bargain basement of Performance Art, and thinking about what to do next."[47] The singular event that, in essence, quashed the full-fledged Performance Art movement of the 1970s and early '80s, tellingly, involved two Angelinos. The so-called "NEA Four trials," in which four artists were censored after receiving grants from the National Endowment for the Arts and filed a lawsuit because of this, involved two artists, Tim Miller and John Fleck, from Los Angeles. (A third of the four, Karen Finley, also had strong ties to California and created a great deal of her work there). While the four artists were vindicated when the Supreme Court ruled in their favor in 1993, afterward the NEA shelved its funding programs for individual artists. Performance Art for the most part eventually faded from public favor in L.A. and elsewhere.

PERHAPS AS A RESULT OF THE CHANGING TIMES, BOTH of L.A.'s most wide-ranging and dynamic political art movements of the 1970s followed a trajectory into the 1980s that was superficially similar to that of Chris Burden's. While much of the early output of the Feminist Art Movement was designed, like Burden's early work,

to shock the audience or remain fixed afterward in a viewer's mind, by the middle of the decade the practices of L.A.'s Feminist artists had become diffused and kaleidoscopic. For example, in addition to the numerous Performance artists who had been nurtured by the Feminist Art Programs in Fresno and at CalArts, as well as the Feminist Studio Workshop at the Woman's Building, by the second half of the 1970s the local Feminist Art Movement counted among its number an array of artist types, including: installation artists like Barbara Munger and Dori Atlantis; sculptors like Bruria Finkel; fiber artists like Cynthia Friedman; painters like Sherry Brody and Ann Isolde; graphic designers like Helen Alm; video artists like Vanalyne Green and Cheri Gaulke; and artist/writers like Terry Wolverton and Bia Lowe.

With their varied production and growing success, Feminist artists increasingly seemed not to need the programs that had once helped them gain a foothold in Los Angeles and elsewhere. Miriam Schapiro, who had continued the Feminist Art Program at CalArts with the help of Sherry Brody after the departure of Judy Chicago, left the school (as did Brody) in 1975. This departure in particular effectively "signaled," according to Faith Wilding, "the end of organized Feminist Art activity" at the school.[48] The Woman's Building, meanwhile, would see a similar exodus of talent a few years later, in 1981, primarily as a result of the shifting "cultural and economic climates of the Unites States" in the era, and the drive of the organization's founders "to pursue other projects."[49] As a result of the changing times, and this changing of the guard at the Woman's Building, the Feminist Studio Workshop closed down and the Building's educational focus shifted to programs for working women, rather than for young artists aspiring to infiltrate the fine art world. The Woman's Building itself would carry on its work for another ten years, closing its doors for good in 1991.

Though these closures and program discontinuations signaled the end of an important era in local art, they also were clear signs of the positive effects of the Feminist Art Movement. Already by the middle part of the decade, "the first blush of feminism" in L.A., "where discovering

and naming sexism and discrimination" was a priority, had passed, and groups of feminists were moving on to bigger goals. Some were focused on "establishing women-centered institutions where they could enact Feminist principles and lifestyles."[50] The artist Leslie Labowitz-Starus for example, who had come to California from her native Germany in the early 1970s, in 1977 founded along with Suzanne Lacy a new-model Feminist Art organization: Ariadne: A Social Art Network. The network was a coalition of artists, activists, media reporters, and politicians that mainly functioned as a support system for Feminist artists by providing media outreach, sources of funding, and other professional resources. By the late 1970s, Feminist artists were beginning to focus more and more on their own careers, and many of the first generation of Feminist artists in L.A. were now spreading out and finding their way into various corners of the art world. In a real way, the scuttling of Los Angeles' shining moment as a beacon of Feminist Art scholarship was a sign of the success of the whole enterprise.

In this evolutionary moment, once again, Judy Chicago was a leader. As early as 1974, just a year after she helped found the Feminist Studio Workshop, Chicago wanted to escape. Ever since starting the Feminist Art Programs in Fresno and at CalArts, Chicago's art practice had taken a back seat to her career as a leader of the Feminist Movement. "She had been on a national lecture tour," wrote the feminist author Jane Gerhard, "visiting art schools, women's studies programs, and cultural centers. She had finalized a manuscript of her memoir and had been in discussion with publishers to get it in print, all this while teaching classes . . . ."[51] In December of 1974, nearly five years after starting up the Feminist Art revolution in Los Angeles, she just wanted to be an artist again. And this desire motivated her to pull back from a community she both identified with and took pride in. "Critics saw in that move a deep-seated desire to be recognized by the very art world she criticized, to be the token woman in a world where men still controlled the rules and the resources. Supporters understood her decision as her desire to make art."[52]

What happened next was both unexpected and, considering the personality of Judy Chicago, somewhat predictable. Chicago would, over the next five years make a monumental work that embodied and depicted the history of women. Taking all the knowledge she'd gained during her years leading L.A.'s Feminist Art Movement, as well as all the pent-up creative energy she'd had to stifle during that time, she began an extended single art project called "The Dinner Party." Chicago had for years researched the unsung historical and cultural contributions of women, and, some time in the previous year, she had hit upon the idea of creating an imagined dinner party in which a number of notable yet overlooked female historical figures would be symbolically seated. To realize her imagined project, Chicago connected with several scholars who were experts in women's history. She also redesigned her studio to more easily realize her plans—splitting it into distinct areas where people could come and contribute to the ambitious project without disturbing her own space. She then brought in the young acolytes. As with the design of the Feminist Art Programs at Fresno, CalArts, and the Woman's Building, prospective young female artists "who came to work at the studio would learn the value of work and discipline and . . . have the chance to work on a major piece of Feminist Art in a feminist environment."[53]

The results speak for themselves—in the end, "The Dinner Party" (1979) was arguably the monumental achievement of the 1970s Feminist Art Movement. Taking over six years, hundreds of thousands of dollars, and countless work-hours by more than four hundred volunteers, the final installation piece was an impressive, impossible-to-dismiss experience. Comprised of an expansive,[54] triangle-shaped table on which were placed thirty-nine unique decorative place settings—representing thirty-nine historical women ranging from Sappho and Eleanor of Aquitaine to Emily Dickinson and Georgia O'Keeffe[55]—the work evoked a very mixed response when first exhibited at the San Francisco Museum of Modern Art in March of 1979. Some critics praised the work's attempt to forge a new visual language for Feminist

Art while others dismissed it as "tacky" or "vulgar." After the end of its premiere exhibition, however, "The Dinner Party" went on a nine-year tour of various national and international exhibition venues during which an estimated fifteen million people viewed the work. Since 2007, "The Dinner Party" has been on display at the Brooklyn Museum in New York where it still elicits mixed reactions from visitors to this day, but there is no discounting the fact that the work is a crowning accomplishment.

Like the Feminist Art Movement in L.A., during the later 1970s and 1980s the Chicano Art Movement also grew diffused and unfocused, though in its own particular way. Because they were focused on the long-term battle to change society and the position of Chicanos within it, many Chicano artists were less strident about achieving the mainstream art-world success that feminist artists eyed. This meant many Chicano artists were less interested in cutting-edge production and more in creating a consistent message. For example, many Chicano artist collectives that had formed in the early 1970s—such as the Mexican American Liberation Front (MALAF), the Royal Chicano Air Force (RCAF), Los Four, and others—continued making the same style of politically charged murals and posters well into the 1980s and even 1990s. In addition, many of the community art centers and workshops that were founded in the early 1970s to serve Chicano artists—such as Self Help Graphics, Galeria de la Raza, the Centro Cultural de la Raza, the La Raza Silkscreen Center, and the Social and Public Art Resource Center (SPARC)—continued pursuing their particular social missions throughout the 1970s and beyond.

That's not to suggest that there weren't aesthetic or political disagreements among these groups and community centers; there was actually a fair amount of splintering and conflict among Chicano art groups, though the centers still tended to hold together in a way that the Feminist Art institutions could not. And it's not to suggest that Chicano artists didn't want more mainstream success. By decade's end, in fact, there also were quite a few Chicano artists, working in

a wide array of styles, genres, and media, pushing to have their work considered as part of the national art dialogue. While experimental-minded Chicano artists, such as the members of Asco, had from the beginning skirted a line between Chicano art and the mainstream art world, after mid-decade a growing number of galleries around the country—including the L.A. County Museum of Art, the Los Angeles Municipal Gallery, the Heard Museum in Phoenix, the Contemporary Art Museum in Houston, the University Art Museum in Berkeley, the Tucson Museum of Art, and so on—featured exhibitions of Chicano artists whose work addressed more national concerns. And toward the end of the 1970s, a number of the individual artists emerged out of the Chicano Art Movement in Los Angeles to establish themselves as independent artistic voices in a medium or style not typically associated with Chicano art. Oscar Castillo, for instance, was a photographer of gritty pictures that documented the Chicano communities in Los Angeles—including the political events and turmoil of the barrio and the cultural practices of local Latinos—all while eschewing easy stereotypes and revealing the beautiful human side of his subjects. Carlos Almaraz was a painter who, though he had risen up through the ranks of the politically focused Chicano movement, became known for more prosaically themed, but poignantly expressionistic images— particularly his "Echo Park" series of paintings that showed the sights of the area of Los Angeles where he lived. And Dora De Larios was a sculptor who worked to merge the imagery and forms of Chicano art with Japanese aesthetics and forms. De Larios had grown up among Japanese and Mexican immigrants until the local Japanese people had been taken away during the War. "I think that through art she is trying to bring the community back together," wrote one critic of her work, "and it's fascinating to see."[56]

At the end of the 1970s, then, unlike with the Feminist Art Movement, the elements of the original Chicano Art Movement remained intact—its various institutions still operating and poised to continue the struggle. Yet, at the same time, just as with women

artists, the artistic focus of Latino artists across Los Angeles (and else-
where) had diversified and grown to include all manner of working
style and method.

THE EXPANSION OF THE CHICANO ART MOVEMENT
into new genres and locales had the ironic effect of steering the com-
munity's interest slowly away from the art of mural painting. One
clear example of this was seen at Chicano Park in San Diego. "By
1980," suggested an online history of the Chicano Park, "large-scale,
organized painting appeared to have lost its momentum. Individual
artists would return to the park to repair murals vandalized by graffiti
or paint bombs, or damaged by environmental elements. The murals
appeared to have been forgotten by the barrio, and they were relatively
unacknowledged by the citizens of San Diego."[57]

In fact, as the 1970s came to a close, the energy across Southern
California mostly seemed to have drained from the local mural move-
ment—both in Latino neighborhoods and across the wider city.
Though accurate data on L.A.'s murals is difficult to come by, one
guidebook on street art—just to cite one example—lists nearly ninety
separate murals that were painted in East Los Angeles, the home of the
Chicano mural movement, between 1970 and 1979—an average of
about nine murals per year. The book lists only twelve mural projects
that were painted between 1980 and 1983, or only three per year.[58]
Accelerating the decline, perhaps, is the fact that around 1980 drug-
related gang activity intensified in Los Angeles, and this brought about
a vast expansion of gang graffiti, much of which damaged existing
murals and discouraged other artists from taking on new projects. The
sense of an era's passing was so palpable at the time that, in 1981, the
French social commentator and filmmaker Agnes Varda felt compelled
to document L.A.'s murals in an experimental documentary film called
*Mur Murs*.

The city's unique tradition of mural art did not vanish com-
pletely. The murals were, after all, permanently affixed to the

city—semipermanent art works whose function was to transform and enliven the concrete jungle that was Los Angeles. By the 1980s, then, there were still plenty of art lovers who paid attention to the murals of Los Angeles. One of these was the community organizer and artist Alonzo Davis. In 1983, Davis teamed with prominent L.A. muralist Kent Twitchell to propose a project to the arts commission appointed by the upcoming Los Angeles Olympic Games. In the proposal, ten of L.A.'s best muralists—including Judith Baca, Frank Romero, Glenna Avila, Richard Wyatt, Roderick Sykes, Davis, Twitchell, and others— would be commissioned to paint a series of murals on the containing structures along the freeways leading to the L.A. Memorial Coliseum, which would serve as the location for the opening and closing ceremonies to the Games. "Our objective," Davis told a *Los Angeles Times* reporter at the time, "was to get artists who represented the energy of various communities within L.A. We wanted a diversified aesthetic statement."[59] The Olympic Organizing Committee backed the mural project, and the eleven murals created by the ten artists were widely celebrated by the press, city leaders, and visitors to the city during the Olympics.

As a result, after the Olympics the city saw a strong uptick in mural projects through the decade. Still, there is no denying that the function and treatment of the murals of Los Angeles had, by the 1980s, markedly changed from the 1970s. A good example of this change is evident in one noteworthy project created in the aftermath of the Olympics mural project. This was a work commissioned by Bill Burke, a prominent local businessman who had been a commissioner during the Games in 1984. In 1986, Burke founded the Los Angeles Marathon. To create a highly visible visual symbol of his fledgling race, Burke hired Kent Twitchell to paint a mural. Called "L.A. Marathon Runners" and situated on a containing wall for Interstate 405 near Inglewood, Twitchell's mural was more than three hundred feet in length and featured twenty-six large-scale figures. It quickly became one of the most recognized and reproduced visual images in the city. Still, despite its

popularity, Twitchell's "L.A. Marathon Runners" endured a constant cycle of defacement and damage—from graffiti, smog, and weather— and cleaning. And of course the marathon mural was not an isolated case. Countless of L.A.'s treasured murals suffered damage throughout the 1980s.

The problem was so widespread that in 1987 Kent Twitchell founded, along with the fellow artist Bill Larasov, the Mural Conservancy of Los Angeles (MCLA)—a coalition of artists, public art advocates, city and state officials, and restoration specialists with the mission to restore, preserve, document, and advocate for the murals of the city. The organization has directly worked to fund the restoration of dozens of murals through the years, has run education programs about the city's unique artistic legacy in its murals, and has managed an online archive to steer public attention to the murals that remain in place. Despite this group's effort through the years, however, the struggle to protect and maintain the artistic legacy of L.A.'s murals has remained an uphill climb. Murals have continued to be damaged by graffiti, rain, smog, and natural forces, while some others have been deliberately destroyed altogether or painted over. "It has endured a drawn-out and indignant death," said Kent Twitchell of the local mural tradition. "It could still be revived, I suppose, but I don't see the resolve necessary to do it."[60] Twitchell's own marathon mural, for example, was nearly destroyed by the repeated cleanings necessary to remove graffiti that eventually threatened the paint that lay beneath a protective coating. In 2005, officials from Caltrans and the city's Cultural Affairs department moved the mural, hoping to protect it, to a new site near Dodger Stadium. And when the mural continued to be marred, a few years later Twitchell agreed to have the mural "hiber- nated." This is a process developed by Caltrans in which murals are coated with an environmentally friendly organic material and covered with a special gray paint that can later be removed without affecting the original painting. "If we ever get a more civilized generation that wants to restore it, then they'll be able to," Twitchell said. "You sort

of toughen up when you're doing exterior pieces . . . . We always thought we were working in Florence, that people would appreciate what we were doing because we were putting our all into it. And for a while they did. Then at some point in the mid-'80s it started to deteriorate out there so much that there was no respect for anything."[61]

WHILE L.A.'S MURALS WERE UNDER ASSAULT DURING the 1980s and beyond, the city's other street-based artistic movements faced their own sort of reckoning. At the end of the 1970s, L.A.'s various street artforms—its graffiti art, hot rod stylings, underground comic art, punk art, skater and surfer designs, and the like—slowly had coalesced into something approximating a counterculture-based art movement. In 1979, Robert Williams published a book with Last Gasp Publishing in San Francisco called *The Lowbrow Art of Robert Williams*. Part biography, part retrospective look at his oeuvre to that point, and part manifesto, the book is best known today for a neologism, "lowbrow art," which Williams coined to capture and encapsulate all the swirling cultural production that was going on around him in California. While the "highbrow" art world at the time—wrapped up as it was in increasingly polemical, academic, and dry forms of Conceptual Art—had scarcely taken notice of L.A.'s monumental commingling of various street sensibilities and popular aesthetics, Williams had a clear vision not only from whence this lowbrow movement had come, but where it could go. That is, Williams wanted to take this art straight to the people who needed it most: the vast bulk of the public that he was sure would respond to art that was both visually challenging and conceptually accessible.

By the early 1990s, after more than a decade of banging on art-world doors, Robert Williams had become fed up with the fine art world's willful ignorance of an entire microcosm of artistic production. "Let me stress that I am for all these ideas of Minimalism and Abstract Expressionism," said Williams, "but they're not leaving any leeway for anything else. All I want is space in a goddamn museum."[62]

Some time early in the decade, then, Williams had struck upon an idea. "With his experience in underground publishing and looking at the work of so many talented unknown artists," wrote Meg Linton, "Williams came up with the idea of *Juxtapoz* . . . a magazine dedicated to the art and culture of those not recognized by the art establishment on high."[63] After a false start with a New York publisher, Williams connected with a West Coast–based publishing company—High Speed Productions—that was owned by former skateboarder, publisher, and entrepreneur Fausto Vitello, who saw the value in Williams's vision. The intention for *Juxtapoz,* as Williams wrote in his editorial for the first edition of the magazine, was to envision:

> *"a publication in this romantic and bohemian style [of French art magazines of the early twentieth century], [even though] unfortunately, the revolutions are over, the battles won, and everybody is now a rebel. We are free to do as we please, place a crucifix in a jar of piss or can of feces or whatever, and our work will enjoy the title of fine art. I have no criticism with this, I think the freedom is good, and if it makes everyone an artist, so what? But there are still other factors, what about the virtuosity of imagination, forethought, and craftsmanship? What about all the capable people who can draw and paint and sculpt and shape? . . . A lot of people want to see art that reflects a compulsion to stimulate thought with shape and color, be it abstract or representational, be it done crudely or be it done with chronic precision . . . . With this magazine this wrong will be righted. We intend to create a publication that will stimulate investigation, activate imagination and (dare I use this term?) entertain the animal hunger in all of us."[64]*

As it happened, all that Williams hoped for came to pass. "The bimonthly publication," Linton wrote, "generated a new and viable branch of the art market. Its success has had a positive impact on museum curators, gallery dealers, and collectors, while launching

dozens of artistic careers."[65] *Juxtapoz* became a launching pad for numerous artists who might never have become known. At the same time, the publication became one of the most widely circulated—if not the most widely circulated—art magazines in the country. Williams's so-called lowbrow art movement, born of the various street cultures of L.A. in the 1970s and herded through the decades by a wholly maverick and admitted obsessively driven artistic voice, had remarkably resilient legs. It even later became a mainstay of many mainstream art-world institutions. Many New York art dealers, such as Jeffrey Deitch and Earl McGrath, today deal lowbrow artists to a growing public, while the great halls that Robert Williams long stood outside of now readily accept lowbrow artists in their exhibitions. Peter Schimmel, the long-time chief curator at L.A.'s Museum of Contemporary Art, famously included Robert Williams in his 1990 survey of contemporary art, "Helter Skelter" (alongside other L.A. mavericks like Mike Kelley, Llyn Foulkes, and Paul McCarthy). And many other institutions—such as the Museum of Modern Art (MoMA), the Whitney Museum of American Art, the Foundation Cartier in Paris, and several other "highbrow institutions"[66]—eventually organized shows featuring lowbrow art.

Through it all, Williams has continued to make art. Collectors include such notable people as Nicolas Cage, Debbie Harry, Artie Shaw, Ed Ruscha, and Leonardo DiCaprio. In 2010, at one of the largest and most respected art fairs in the world, Miami Art Basel, no other booth generated as much Internet attention as the Shafrazi Gallery's exhibit, which featured wallpaper designed by Williams himself along with eight-foot-tall Williams sculptures. "Looking at Williams's work is a dynamically charged experience," wrote Meg Linton. Today, Williams is acknowledged as a uniquely prescient artist, a maverick of the California ilk who stuck to his guns even when it seemed foolish and futile to do so. Because of Williams and his particular artistic genius and abiding spirit, the so-called lowbrow art that rose as a byproduct of the street sensibilities and alternative cultures of Los Angeles is a vastly popular, almost ubiquitous phenomenon that even

some of the fine art world guiding lights acknowledge as meaningful and valuable as anything else produced over the decades since the end of the 1970s.

IT'S A PARTICULAR CHARACTERISTIC OF THE ART OF L.A. in the 1970s that even the most uniquely maverick and self-directed artists, such as Robert Williams and others, would rise to fairly exalted status in the art world. Among the L.A.-based artists whose unusual artistic careers gained increasing attention and accolades in coming years, and whose influence helped steer the future direction of American and international art, were Vija Celmins, Charles Garabedian, Llyn Foulkes, and Mike Kelley.

Perhaps no single artist of her era has been so devoted to the craft of painting as Vija Celmins, and her brand of genre-busting and eerily meticulous photo-realist works simultaneously helped make "pictures" a viable artistic pursuit and put her in a unique position in American art. In 1980, Celmins was awarded a Guggenheim Fellowship for her work and also mounted her first retrospective survey exhibition, at the Newport Harbor Art Museum. In 1981, after receiving an invitation to teach at the Skowhegan School of Painting and Sculpture in Maine, Celmins moved permanently to New York, where she established a studio on Crosby Street in Soho. During the 1980s, she taught at Cooper Union and the Yale School of Art, found gallery representation at the David McKee Gallery in New York, and appeared in major survey shows at museums and other venues such as the Pennsylvania Academy of Art, the Brooklyn Museum, the Contemporary Arts Museum of Houston, the Museum of Contemporary Art in Los Angeles, the Cincinnati Art Museum, and the National Gallery of Art. Her reputation ever growing, Celmins's exhibition pattern continued in the 1990s and 2000s, and she appeared in several major retrospectives and in a number of national and international art survey exhibitions.

Celmins remains a somewhat elusive, even standoffish figure in the art world, but she continues to garner awards. In 1996, Celmins

received the American Academy of Arts and Letters Award in Art, and in 1997 she was given a John D. and Catherine T. MacArthur Fellowship. In 2006, Celmins received the RISD Athena Award for Excellence in Painting; in 2008 she was awarded the Carnegie Prize; and on and on. Her status among informed art-world denizens is no less preeminent. "If I were stranded on a desert island and could have only one contemporary art work," wrote the national art critic Peter Schjeldahl, "it would be a picture of a starry sky, a spiderweb, or a choppy ocean by Vija Celmins—a smallish painting, drawing, or print that is sombre, tingling with intelligence, and very pure. I imagine that the work's charge of obdurate consciousness would give my sanity a fighting chance against the island's lonely nights, insect industry, and engirdling, unquiet waters."[67]

Though less widely celebrated than Vija Celmins, the singular and eccentric art of Charles Garabedian has continued to flourish in the decades since the end of the 1970s. Having come to be represented by the L.A. Louver Gallery in Venice in the late 1970s, for the next forty years Garabedian continued mounting solo exhibitions there, and at galleries in cities such as San Francisco, La Jolla, Chicago, and New York. In 1982 and 2012, the Santa Barbara Museum mounted full retrospective exhibitions of his work. He also has appeared in dozens of major group exhibitions over the past three-plus decades, most often that celebrate the expressive qualities of his work.

Long considered a "painter's painter,"[68] Garabedian's name was, in the 1980s, regularly mentioned as helping bring about a resurgence in figurative and expressive art—as practiced in the era and beyond by such artists as Eric Fischl, Francesco Clemente, Julian Schnabel, Lari Pittman, Laura Owens, and Dana Schutz. Though his art remains generally underrecognized at the larger institutional level, Garabedian has his champions. As a result of his particular approach to art, in 2000 he received the American Academy of Arts and Letters Award in Art. And curator Julie Joyce remained convinced that the artist's due will ultimately come. "While it is important to analyze Garabedian's

pioneering and continued individuality," suggested Joyce in 2011, "it is equally essential to place his work within a historical context . . . . The current pluralism of contemporary art is due in no small part to the developments in art that were being made on the West Coast from the 1960s through the 1980s. Garabedian is one of its significant progenitors."[69]

For many years, meanwhile, as Celmins and Garabedian garnered accolades despite, or perhaps because of, their idiosyncratic approaches to art, Llyn Foulkes struggled in relative anonymity. Much of this, he readily admits, is his own fault—the result of his "consistently inconsistent" output, that "confound[s] critics and galleries" by undergoing "dramatic changes of direction whenever it seemed he was about to be overtaken by popular acclaim."[70] After the bloody heads of the late 1970s, for example, Foulkes switched gears in the 1980s and started making more socially edgy art. "My heart has been very political," Foulkes once said, "which has been one of my downfalls in the past. You just don't do political art and get into museums. It's as simple as that."[71] The 1980s were a particularly difficult time for Foulkes; his art was not widely in demand and his exhibition record was fairly limited. While he was able to support himself by teaching at UCLA for a number of years, he never received the security of tenure. In retrospect, Foulkes suggested that this may have been the "best thing that happened to me, because I started losing my soul [as a teacher]."[72] Things picked up somewhat exhibition-wise for Foulkes in the 1990s and 2000s. His first retrospective exhibition was held in 1995 at the Laguna Art Museum, and his work was featured in the seminal "Helter Skelter: L.A. Art in the 1990s" exhibition at the Museum of Contemporary Art in Los Angeles in 1992. Still, his frustrations continued. "When I was in the Helter Skelter Show, I had this big thing," said Foulkes in 2006, "[but] after that I was like cut off."[73]

It is one of the ironies of art that its pursuit can seem sometimes so capricious and uncertain. Foulkes, who was a major, if mostly background, force in the developing L.A. scene of 1970s and early

1980s—particularly with his influence on a generation of young, genre-busting, socially engaged "Romantic" artists in and around Venice—was so generally frustrated with his career that he almost gave it up before he finally realized his greatest moment of success. In 2008, Foulkes was awarded the American Academy of Arts and Letters Award, and in 2009 he received the Artists' Legacy Foundation Award. Both awards foreshadowed the artist's culminating career triumphs in the years between 2011–2013. In 2011, he was featured in seven "Pacific Standard Time" exhibitions, which surveyed the art of Southern California at numerous institutions around the region. In 2012 his paintings were included in Documenta 13 in Kassell, Germany. And in 2013, the Hammer Museum in Los Angeles mounted a long-overdue career retrospective exhibition that then traveled to the New Museum in New York. It would be the first major exhibition at a New York museum for Foulkes, at last giving the artist, at age seventy-nine, some semblance of recognition for his work.

AS ART GREW EVER MORE DISPARATE IN STYLE, TONE, genre, and approach after the 1970s, it became clear that there was no returning to the singular and heroic art narratives of the past. "In hindsight," suggested the L.A. curator Paul Schimmel in 2011, "pluralism can be seen as one of the most important developments to affect postwar art . . . . during this post-Watergate, post-Vietnam era."[74] In this, the post-1970s artists were influenced by a host of cultural and social forces—the continuing effects of future shock, or whatever term you applied to the particular confusions of the times; the political disjointedness of the Reagan era; the advance of the so-called Culture Wars, which seemed to unfairly target artists for a host of imagined offenses. All of these factors had a hand in shaping the future of American art, but so too did the particular influence of the varied and maverick artists from L.A. in the 1970s—ranging from Lyn Foulkes to Judy Chicago, from John Baldessari to Chris Burden, from Vija Celmins to James Turrell—leave a marked imprint on the art of the 1980s and beyond.

When "disillusionment had eclipsed 'California Dreamin' ' and hippie optimism," the individualized, idiosyncratic, politicized, and occasionally angry art practices that flourished in Los Angeles became the signpost to the future of art practice. "What cohered as Postmodernism during the 1980s," Schimmel continued, "effectively codified ideas and concepts evolving from . . . the exceptionally fertile and diverse production from all across California during this tumultuous transitional period in United States history."[75]

It is both a remarkable culmination and an enduring tragedy that the last lingering afterimage of 1970s art in L.A. is a troubled view of one the most unique artists to emerge out of the end years of the decade. In the early years of the 1980s, Mike Kelley's work exploded in popularity, making him one of the most visible and sought-after artists of his time. In 1982, only four years after his graduation from CalArts, Kelley signed on to be represented by two of the country's top galleries—Metro Pictures in New York and Rosamund Felsen in L.A. Three years later, Kelley's work appeared in the Whitney Biennial exhibition, an important showcase of contemporary art.[76] In 1987, Kelley's full "arrival" as an artist was cemented by two events. First, he became an instructor at the influential Art Center College of Design in Pasadena. And second, he began working with a material that would come to define his career and, ultimately, influence the culture—stuffed animals (and, in particular, stuffed sock monkeys), often worn and tattered, that he had found at secondhand stores and flea markets.

For a show at the Felsen Gallery called "More Love Hours Than Can Ever Be Repaid," Kelley arrayed old blankets and clumps of tattered stuffed animals around the gallery's floor and hung a mass of multicolored animals on the wall. While the show didn't sell well at the time, later on the Whitney Museum bought the work for a then-personal high price for the artist of $9,000. Kelley continued making the stuffed animal works, raising essential questions of nostalgia, childhood safety, family issues, and memory and myth—as well as widespread speculation about what personal meaning the objects

might have had to the artist—well into the 1990s, even comprising the bulk of the work shown at a retrospective exhibition at the Hirschhorn in 1991. By 1996, however, Kelley had to give up the practice. "I had to abandon working with stuffed animals," he wrote in an essay for *Architecture New York* in 1996. "There was simply nothing I could do to counter the pervasive psycho-autobiographic interpretation of these materials." Around this time as well, Kelley began suffering more acutely from various mental ailments, including agoraphobia, anxiety, and, portentously, depression. Still, Kelley's artistic production never flagged, and his reputation continued to grow, as did the variety of his output, which encompassed not only installation, assemblage, and sculpture, but also performance, video, textiles, and drawings.

In 2004, Kelley switched to the Gagosian Gallery, which allowed him to mount more elaborate productions and create massive environments in the large Gagosian spaces. In "Day is Done" (2004), Kelley produced a wildly successful and popular spectacle that involved dozens of performers who acted out skewed versions of the rituals of middle America—high school football games, 4-H Club events, and the prom. Still, despite all the success, Kelley's career would end tragically, with his death at his own hand in early 2012. The warning signs in retrospect seem clear. A few years before, Kelley had been hit hard when his older brother Gary, a retired policeman, had died suddenly of natural causes. Shortly afterward, both his older sister and mother passed away. As a result, Kelley started drinking heavily, which exacerbated a heart condition and other physical and mental ailments that the fifty-seven-year-old artist suffered from. Just a few months before his death, Kelley received a scathing review of a show of Superman-themed work at Gagosian's London gallery. "Kelley has been thinking about this stuff for more than twenty years," wrote the critic Adrian Searle in the *Guardian* newspaper. "What does it all add up to? You almost expect to see a dead horse up there on screen, getting a good flogging. Kelley overdoes it, time and again. Ah, you might say, but that's the point. It's what he does, to the sound of all that cinematic thrashing."[77] After this,

Kelley's mental state worsened. When his live-in girlfriend of the time broke up with him, friends of Kelley's began a "Mike watch" to keep an eye on him. Kelley attempted to go through rehab for his alcohol addiction, but he gave up after just eight days. With a number of major exhibitions looming, in early 2012 Kelley seemed more and more distraught and distracted, but there was little anyone could do to help.

After his suicide at the end of January 2012, supporters and admirers bemoaned his loss. "Mike Kelley was one of the most admired artists of his generation," said major L.A. art collector Eli Broad, whose foundation owns fifteen major works by the artist. "In his lifetime, through his own work as well as his support for young artists, he both shaped and witnessed the transformation of Los Angeles into a leading capital for contemporary art. We are honored to include him in our collection, and we are shocked and saddened by this profound loss."[78] It's perhaps most revealing that one of the last works of Mike Kelley's formidably diverse and extensive career was a symbolic return to his place of origins. In his public installation/sculpture "Mobile Homestead" (2005–2013), the artist recreated the architectural style of his boyhood home in a two-part structure. The first structure, the "front" of the house, was carried on a flatbed trailer truck in 2010 on a route situated between the Museum of Contemporary Art in Detroit and his former home's neighborhood in Westland, Michigan, located twenty miles to the west. "He had a conflicted relationship with his hometown, as many people do," says James Lingwood, the codirector of Artangel, an art organization that collaborated on the project. "He became really interested in producing a displaced version of the house he grew up in. And then in the idea of it being displaced to the city itself."[79] The second structure, or rear of the house, was to be located on a site next to the museum and used for special exhibitions or events, but it was never completed. Several videos of the performance part of the public art project were shown at the 2012 Whitney Biennial and dedicated to his memory. "The sculpture and the video provide," wrote John Welchman, "a commentary not only on the history of Detroit . . .

but on the city's postindustrial fate, as various communities continue to redefine their role, 'place,' and physical and social environments."[80] Kelley himself thought that the "performance" was a failure, but, as one critic put it, "he was obsessed with abjection and failure."[81]

The tragic death of Mike Kelley, arguably the leading figure to emerge from the struggling L.A. art world of the failing decade of the 1970s, put a capstone on a surprisingly and lastingly influential era in art. Kelley, whose "chaotic low-fi installations, paintings, and sculptures, all animated by a punk's sneer at popular culture and social hierarchies, had become increasingly meaningful to younger artists, who appreciated his defiance and refusal to settle into easy repetition."[82] Kelley is an abject hero who emerged from an aesthetically frazzled, almost baroque era of artistic production. That the prevailing sensibility of our era, according to the Italian semiotic professor Omar Calabrese, is "neo-baroque," and our cultural relics and art are marked by a fractured and frantic quality and tendency toward "instability, polydimensionality, and change,"[83] owes something to Kelley and his L.A. peers. That the artists of Los Angeles in the 1970s were among the first to navigate the troubled nature of the times and make art that pointed to the "neo-baroque" era of today meant they, essentially, created the future of art many years before it arrived. The fact that they did so with scant financial and other resources, and despite the sense of confusion, disjunction, and soul-searching that pervaded the wider community, only highlights their accomplishments. In a real sense, these artists struggled against the historical tides and desperately sought any possible niche for themselves when, for all intents and purposes, the local art market had been all but shuttered and boarded up for the duration. Summed up, the art of the 1970s in Los Angeles, created in an era of futility and retrenchment, was a cultural triumph that still resonates today.

# END NOTES

## INTRODUCTION

1. The growth of California—or at least of its Southern region—during the first three-quarters of the twentieth century was fostered by a host of propagandists. In 1923, a local invest-ment firm that was heavily invested in real estate published an illustrated brochure titled, "Why Los Angeles Will Become the World's Greatest City." The publication included descriptions and images of the appealing natural beauty of the region—verdant foothills, lush flora, wide-open skies, and sun-drenched valleys—as well as an ambitious new vision of the city that included wide parkways, a series of stunning monuments and public buildings, and ornate arches and other landmarks leading from the ocean to the city's center interior. "Los Angeles," wrote Sherley Hunter, the brochure's author, "has touched the imagination of America. She has become an idea . . . . A longing in men's breasts. She is the symbol of a new civilization, a new hope, another try . . . . It is the place where dreams come true, the veritable Land of Heart's Desire . . . . Can there be any doubt but what Los Angeles is to be the world's greatest city . . . greatest in all the annals of history? Can there be any doubt but what MAN wants her to so become . . . or doubt that she has touched the imagination of general public opinion as no other city in history has touched the millions?"

2. The two partners who founded Ferus along with Kienholz were the curator Walter Hopps and the poet Bob Alexander. Kienholz would sell his share of the Ferus Gallery to Irving Blum in 1958.

3. Bell's first solo show ran at the Ferus Gallery in 1962, and Ruscha's followed close behind in 1963.

4. The business side of the gallery was the responsibility of the astute salesman Irving Blum, who, among other things, honed Ferus's image by limiting the number of its affiliated artists and built its reputation by cultivating collectors who appreciated the gallery's chauvinism.

5. The success of this exhibition would lead directly to Hopps's appointment to the Pasadena Museum of California Art's directorship in 1963.

6. The Watts riots began after the August 11, 1965, arrest by Los Angeles Police officers of a young black man who was driving erratically. Behind this singular event, however, was a litany of demeaning incidents and general malaise among the area's mostly black resi-dents. The construction of freeways in the 1950s and early 1960s blocked Watts residents' access to other parts of the city, causing widespread economic hardship. For four days that August, the streets of Watts were overrun with disenfranchised youths who set fires, looted local shops, scuffled with police, beat white motorists, and blocked the fire department from reaching spots to help. Nearly 1,000 buildings in Watts were damaged or completely destroyed.

7. The Sunset Strip was a stretch of Sunset Boulevard that ran through West Hollywood and was home to a collection of boutiques, restaurants, music clubs, and nightclubs. By the

1960s, the Strip had become a center for the countercultural elements of Los Angeles. When police attempted, starting in 1966, to enforce the area's youth curfew, clashes occurred. And while these clashes were relatively minor, the cultural symbolism was so strong that the riots became immortalized in film—including the 1966 "teen exploitation" flick *Riot on Sunset Strip*—and songs by numerous rock and pop groups, including the Monkees, Frank Zappa and the Mothers of Invention, the Standells, and Buffalo Springfield.

8.  According to then-city-council-member (and eventual replacement for Sam Yorty) Tom Bradley, Yorty "was no more than a part-time mayor. Most of the time [he] wouldn't arrive until mid-morning, and then he was gone by mid-afternoon." Yorty, by 1968, was so ridiculed locally for his poor work ethic and his penchant for using his office as an excuse to visit places like Europe, the Far East, and Mexico, he was known by the nickname "Travelin' Sam."

9.  The reasons for the assassination remain somewhat unclear. After Kennedy's win in the California state presidential primary election on June 5, the candidate was shot three times as he passed the kitchen of the downtown Ambassador Hotel to attend an impromptu news conference. The assailant was a twenty-four-year-old man named Sirhan Sirhan, a Palestinian Arab Christian with Jordanian citizenship who had settled in Southern California with his family around age twelve or thirteen. His motives for the killing appear to have born of obsession with anti-Zionist beliefs and with Robert Kennedy himself. A diary found during a search of Sirhan's home stated, "My determination to eliminate RFK is becoming more and more of an unshakable obsession. RFK must die. RFK must be killed . . . . Robert F. Kennedy must be assassinated before 5 June 68."

10. "Many people I know in Los Angeles believe that the Sixties ended abruptly on August 9, 1969," was author Joan Didion's famous assessment of the death of the pregnant actress Sharon Tate and several others at the hands of the Manson family. She explained further how this moment felt to many Angelenos. "This mystical flirtation with the idea of 'sin'—this sense that it was possible to go 'too far,' and that many people were doing it—was very much with us in Los Angeles in 1968 and 1969 . . . . The jitters were setting in. I recall a time when the dogs barked every night and the moon was always full . . . . I remembered all of the day's misinformation very clearly, and I also remember this, and wish I did not: I remember that no one was surprised."

11. Aka California's Family Law Act of 1969.

12. At the time, increasing numbers of observers noted Southern California's increasing systemic problems, many of which were attributed to the region's growing urban sprawl. According to a 1960 study—located at http://www.autolife.umd.umich.edu/ Environment/E_Casestudy/E_casestudy.htm—nearly two-thirds of the land in metropolitan L.A. at the time had been dedicated to car-related needs: highways, roads, driveways, freeways, parking lots, service stations, and car lots. Average people across the region were affected by the resulting traffic congestion, diminishing air standards, and economic problems.

13. The sentiments would be echoed around the same time by another Brit, Albert Hammond, who, in his composition "It Never Rains In Southern California," sang: "Ooh, that talk of opportunities/TV breaks and movies/Rang true/Sure rang true . . . . Out of work, I'm out of my head/Out of self respect, I'm out of bread/I'm underloved, I'm underfed, I wanna go home/It never rains in California/But girl don't they warn ya/It pours, man it pours."

14. Hopps was later said to be at the museum only two or three days a month. In addition, after Hopps's departure, the Museum faced such dire financial difficulties—no doubt as a result

of a string of ambitious and sprawling (and expensive) exhibitions mounted by Hopps during his tenure—that it was forced to file for bankruptcy.

15.  Plagens, Peter. *Sunshine Muse: Art on the West Coast*, 1945–1970. Berkeley, CA: University of California Press, 1974.

16.  Ibid.

17.  Davis, Mike. City of Quartz: *Excavating the Future in Los Angeles*. NY: Verso, 1990.

## CHAPTER I.

1.  McLuhan, Marshall. *Understanding Media: The Extensions of Man*. New York: McGraw Hill, 1964.

2.  Author interview with Gechtoff, Summer, 2004.

3.  Goodyear, Anne Collins. "From Technophilia to Technophobia: The Impact of the Vietnam War on the Reception of 'Art and Technology.' " *Leonardo*—Volume 41, Number 2, April 2008.

4.  Wilson, William. "Maurice Tuchman: Still the Enfant Terrible," *Los Angeles Times*. October 22, 1989.

5.  Seldis, Henry J. "Unforgettable Art Experience at Expo '70," *Los Angeles Times*. March 22, 1970.

6.  Wilson, William. "Blending of Art, Technology," *Los Angeles Times*. May 7, 1971.

7.  Plagens, Peter. *Sunshine Muse*. Berkeley, CA: University of California Press, 1974.

8.  Unattributed. "Art: Man and Machine," *Time* Magazine. June 28, 1971.

9.  Davis, Mike. *City of Quartz: Excavating the Future in Los Angeles*. NY: Verso, 1990.

10. Quoted in *The Cool School*, a documentary film on 1960s art in California directed by Morgan Neville.

11. Ibid. Don Factor is the son of Max Factor, the founder of the famous cosmetics company.

12. Kramer, Hilton. " 'Art and Technology' to Open on Coast," *New York Times*, May 12, 1971.

13. Ibid.

14. Ibid.

15. Anonymous (manifesto billed a "L.A. Council of Women Artists Report"). "Is Woman a Work of Art?" *L. A. Free Press*, June 15, 1971.

16. Tuchman, Maurice. "Introduction," A Report on the Art and Technology Program of the Los Angeles County Museum of Art, 1967–1971. Los Angeles County Museum of Art, 1971.

17. A Report on the Art and Technology Program of the Los Angeles County Museum of Art, 1967–1971. Los Angeles County Museum of Art, 1971.

18. Sypher, Wylie. *Literature and Technology: The Alien Vision*. New York: Random House, 1968.

19.  Goodyear, Anne Collins. "From Technophilia to Technophobia: The Impact of the Vietnam War on the Reception of 'Art and Technology.' " *Leonardo*—Volume 41, Number 2, April 2008.

20.  Ibid.

21.  Richard Serra was born in San Francisco and studied for a time very close to L.A., at the University of California, Santa Barbara.

22.  Scott, Gail R. A Report on the Art and Technology Program of the Los Angeles County Museum of Art, 1967–1971. Los Angeles County Museum of Art, 1971.

23.  Goodyear, Anne Collins. "From Technophilia to Technophobia: The Impact of the Vietnam War on the Reception of 'Art and Technology.' " *Leonardo*—Volume 41, Number 2, April 2008.

24.  Ibid.

25.  Californian universities in 1969, for example, comprised three-quarters of the locus—at Stanford, UCLA, and UC Santa Barbara—of the infrastructure that would eventually become the Internet, and California also saw the first computer mouse developed at the Xerox research center in Palo Alto in 1970. In 1971, in Mountain View, California, a manufacturer called Nutting Company developed the first commercial computer arcade game—Computer Space. The first computer microprocessor was developed in the same year by a nearby company called Intel. The first natural processing language—i.e., a computer framework for understanding human speech—was developed by Terry Winograd at Stanford University in 1973. And so on.

26.  Plagens, Peter. *Sunshine Muse*. Berkeley, CA: University of California Press, 1974.

27.  Davis, Mike. *City of Quartz: Excavating the Future in Los Angeles*. NY: Verso, 1990.

28.  Widely quoted.

29.  Saltz, Jerry. "The New York Canon: Art," *New York* Magazine. April 7, 2008.

## CHAPTER II.

1.  Chicago, Judy. *Through the Flower*. New York: Authors Choice Press, 1975.

2.  Ibid.

3.  Ibid.

4.  Levin, Gail. *Becoming Judy Chicago*. New York: Crown, 2007.

5.  Ibid.

6.  Chicago, Judy. *Through the Flower*. New York: Authors Choice Press, 1975.

7.  In a lecture she delivered at California State College in Los Angeles in early 1969, Chicago tipped off the audience to her full intentions when she declared she was herself "preparing to go to war against the culture." Source: Levin, Gail. *Becoming Judy Chicago*. New York: Crown, 2007.

8.  Chicago also ran ads that included the text in the October and December, 1970, editions of *Artforum* magazine. The December ad became notorious for featuring a photo of the

artist wearing boxing gloves and standing in the corner of a boxing ring. "I thought it was amusing," Chicago said of the ad years later, "but it freaked out the art world."

9.  Chicago, Judy. *Through the Flower*. New York: Authors Choice Press, 1975.

10. "Otis presents Pioneers of the Feminist Art Movement: Joyce Kozloff," http://www.youtube.com/watch?v=W9hCObXWwyA&feature=relmfu.

11. "Otis presents Pioneers of the Feminist Art Movement: Bruria Finkel," http://www.youtube.com/watch?v=_fM-8QCGgKc.

12. "Otis presents Pioneers of the Feminist Art Movement: Joyce Kozloff," http://www.youtube.com/watch?v=W9hCObXWwyA&feature=relmfu.

13. That single woman, Channa Davis Horwitz, was a member of the group; her invited proposal to the exhibition was turned down after she submitted it.

14. The LOS ANGELES COUNCIL OF WOMEN ARTISTS REPORT, published June 15, 1971, revealed the following: "At the Los Angeles County Museum of Art, between 1961 and 1971, only 4 percent of the works shown in group shows have been done by women. (Of 713 artists shown, only 29 have been women.) Of the 53 one-artist shows at the museum in this time, only 1 was devoted to a woman artist. On June 1, 1971, a count of works on display in the Ahmanson wing of the museum revealed 520 by men, 285 anonymous, and exactly five (less than 1 percent) by women. On that same day, the rental gallery displayed 32 works by men, 3 by a woman. Of the 29 works displayed in the sculpture court and on the grounds, all 29 were by men. The 24 Young Los Angeles Artists show included 21 works by men, 3 by women . . . . These statistics clearly indicate the discrimination practiced against women artists, not just at the Los Angeles County Museum, but all over the country."

15. "Otis presents Pioneers of the Feminist Art Movement: Joyce Kozloff," http://www.youtube.com/watch?v=W9hCObXWwyA&feature=relmfu.

16. The full text of the report made by the Los Angeles Council of Woman Artists can be found here: http://blogs.getty.edu/pacificstandardtime/explore-the-era/archives/i143/.

17. Ibid.

18. LACWA's twelve-point program read thusly:

1.  That henceforward half of all contemporary work shown by the L.A. County Museum of Art be the work of women artists.

2.  That henceforward half of all one-artist shows mounted by the L.A. County Museum of Art be devoted to women artists.

3.  That henceforward half of those contemporary works purchased by the museum for its permanent collection be the works of women artists.

4.  That a concerted effort be made to seek out works by early women artists to add to the older works in the permanent collection.

5.  That half of the Board of Trustees be women, and that one of these women be a working artist.

6. That, starting from the bottom up, all jobs at the L.A. County Museum be granted, at EACH LEVEL OF QUALIFICATION AND SALARY, half to women and half to men. This applies equally to senior curators and to secretaries.

7. That the job of docent be a paid position, thus creating job opportunities for men and women seeking professional careers in the arts and eliminating a situation whereby certain women are, in effect, penalized because of the success of their husbands.

8. That fund-raising functions be eliminated from the curator's job and that curators not be permitted to advise private collectors. A curator with no obligations is freer to choose an unknown artist's work either for purchase or for exhibition.

9. That there be no interlocking directorships; that in cases where conflict of interest necessitates the resignation of a trustee, he or she be replaced by a trustee more representative of a cross-section of the Los Angeles community, so that eventually the museum really belongs to its constituency, which includes Blacks, Chicanos, Asians, and women.

10. That resale of purchased or donated work be publicly announced, since it is in the public domain.

11. That museum directors, curators, etc., support the Seth Siegelaub contract which protects artists by entitling them to a royalty on each resale of work.

12. That an EDUCATIONAL PROGRAM be initiated in the following manner:

    A. That a fund be established to cover the salaries of one or more women art historians to research the history of women in art, with an aim both to purchase works by women for the permanent collection and to establish a slide bank of works which be available for educational purposes both to schools and to the general public.

    B. That half of the prizes awarded annually by the New Talent Committee to young Los Angeles artists be granted to women.

    C. That a fund be established to provide scholarships for women who wish to train as art historians and art critics, with special efforts made to attract women from minority groups.

    D. That the museum provide funds to develop a program for teaching secondary and primary level children about the contributions of women artists, and about opportunities and training programs for future women artists.

    E. That a Museum Council for Women in Art be set up to supervise the implementation for these proposals, and to provide continuing educational programs for adults and children about women in the arts.

19. The show would be called "Women Artists: 1550-1950" and would run at LACMA in 1977.

20. "Otis presents Pioneers of the Feminist Art Movement: Bruria Finkel," http://www.youtube.com/watch?v=_fM-8QCGgKc.

21. "Otis presents Pioneers of the Feminist Art Movement: Joyce Kozloff," http://www.youtube.com/watch?v=W9hCObXWwyA&feature=relmfu.

22. Chicago, Judy. Through the Flower. New York: Authors Choice Press, 1975.

23. Ibid.

24. Ibid.

25. Ibid.

26. Ibid.

27. Ibid.

28. The full list of the fifteen students who made up Chicago's first class of women artists in Fresno included: Susan Boud, Dori Atlantis, Gail Escola, Vanalyne Green, Suzanne Lacy, Cay Lang, Karen LeCocq, Jan Lester, Chris Rush, Judy Schaefer, Henrietta Sparkman, Faith Wilding, Shawnee Wollenman, Nancy Youdelman, and Cheryl Zurilgen.

29. Suzanne Lacy to Moira Roth, Archives of American Art, March 16, 1990.

30. Chicago, Judy. *Through the Flower*. New York: Authors Choice Press, 1975.

31. Ibid.

32. Ibid.

33. Levin, Gail. *Becoming Judy Chicago*. New York: Crown, 2007.

34. Ibid.

35. Although Chicago left Fresno for CalArts after only a year, the Feminist Art Program she left behind continued on for a number of years. From 1971 to 1973 the program was taught by Rita Yokoi, and from 1973 to 1992 it was taught by Joyce Aiken.

36. After learning lithography at Lynton Kistler's facility Wayne exhibited her prints and paintings widely. In 1960, she had established the Tamarind Lithography Workshop (later the Tamarind Institute) to help preserve the then-fading craft of lithography. She worked with such luminaries as Richard Diebenkorn, Sam Francis, Rufino Tamayo, and Louise Nevelson. (Source: tamarind.unm.edu/aboutus.html.)

37. Wilding, Faith. *By Our Own Hands: The Woman Artist's Movement*, Southern California, 1970–1976. Santa Monica, CA: Double X, 1977.

38. Levin, Gail. *Becoming Judy Chicago*. New York: Crown, 2007.

39. Previously, CalArts was housed in an interim campus at Villa Cabrini in Burbank. Planning for the school's new home had been ongoing for much of the past decade.

40. Gertler, T. "The Pee-wee perplex." *Rolling Stone*. February 1, 1987.

41. Taylor, Scott. "Metamorphokit: You Can Make It Anything You Want." News from California Institute of Arts. February 14, 2011. Source: http://blog.calarts.edu/2011/02/14/metamorphokit-you-can-make-it-anything-you-want/.

42. Loeffler, Carl E. and Darlene Tong. *Performance Anthology: Source Book of California Performance Art*. San Francisco: Last Gasp Publishing, 1990.

43. Levin, Gail. *Becoming Judy Chicago*. New York: Crown, 2007.

44. Ibid.

45. Ibid.

46.    Quoted from *Womanhouse*, a film by Johanna Demetrakas. 1974, 47 minutes. Color.

47.    Coincidental to the opening of "Womanhouse" was the opening of the West Coast Women Artists' Conference at CalArts, which attracted participants from states all over the country. Conference attendees toured "Womanhouse," watched performances by students from CalArts, listened to various women give talks and show slides of their art, and discussed the exclusion of women from major museum exhibits and gallery spaces. (Source: Guide to the California Institute of the Arts Feminist Art Materials Collection 1971–2007 [bulk 1972–1977], California Institute of the Arts Archive, California Institute of the Arts.)

48.    Chicago took great pleasure in the fact that the man she called a "sexist from way back" — i.e., Tuchman — sat placidly through her "Cock and Cunt Play."

49.    Stories on "Womanhouse" appeared in the *L.A. Times*, *Ramparts* magazine, *Life*, *New Woman*, and on CBS and NBS news.

50.    "Womanhouse Opens," *Los Angeles Free Press*. February 4, 1972.

51.    Levin, Gail. *Becoming Judy Chicago*. New York: Crown, 2007.

## CHAPTER III.

1.    Deverell, William. *Whitewashed Adobe*. Berkeley, CA: University of California Press, 2004.

2.    Carr, Harry. *Los Angeles, City of Dreams*. Los Angeles: D. Appleton-Century, 1935.

3.    Jackson, Carlos Francisco. *Chicana and Chicano Art*. Tucson, AZ: The University of Arizona Press, 2009.

4.    Ibid.

5.    The origins of the term "Chicano" is uncertain, though most often it is thought to be a shortened form of Mexicano.

6.    Jackson, Carlos Francisco. *Chicana and Chicano Art*. Tucson, AZ: The University of Arizona Press, 2009.

7.    Diaz, David R. *Barrio Urbanism: Chicanos, Planning and American Cities*. New York: Routledge, 2005.

8.    Villa, Raul Homero. *Barrio-Logos: Space and Place in Urban Chicano Literature and Culture*. Austin: Univ. of Texas Press, 2000.

9.    Tom Wolfe, in his long *Esquire* magazine essay from 1963 on the California hot rod phenomenon, "There Goes (Varoom! Varoom!) That Kandy-Kolored (Thphhhhhh!) Tangerine-Flake Streamline Baby (Rahghhh!) Around the Bend (Brummmmmmmmmmmmmmmm) . . . ," called the main design feature of the hot rod — stripping the car down by removing convertible tops, hoods, bumpers, windshields, fenders, and the like to give the car more speed — the "streamline."

10.    Griffith, Beatrice. *American Me*. Boston: Houghton Mifflin Company, 1948.

11.    Ibid.

12.    Ibid.

13. Because of a policy agreement struck between the U.S. and Mexico in 1942, the so-called Bracero Program (*bracero* is a Spanish word meaning "one who works using his arms") encouraged more than four million unskilled farm workers to come to the U.S. from Mexico over a period of about twenty years. Even after the program ended, in the early '60s, undocumented immigrants continued to come to the U.S. to find work. As a result, by 1990 the number of native Mexican Americans and immigrant Mexicans in Los Angeles County exceeded three million, making it the Latino "capital" of the United States, "housing more people of Mexican descent than most cities in Mexico." Source; Howell, James C. and John P. Moore. "History of Street Gangs in the United States." National Gang Center Bulletin, No. 4. Office of Juvenile Justice and Deliquency Prevention. May, 2010.

14. Graffiti derives from the Italian word *sgraffiare*, or "to scratch."

15. Beatrice Griffith describes this infamous event in *American Me*: "Everyone close to the picture knew that trouble had been brewing, but with a kind of hypnotic indifference those agencies and authorities responsible for coping with such disturbances ignored the threats and 'incidents.' For over a year the police had been conducting unwarranted mass arrests of local Mexican-American boys and girls . . . . As a result of the sensational publicity of these mass arrests and bad behavior of a few Pachucos, some public places of amusement refused to admit zootsuiters . . . . The maladjusted grew more anti-social and aggressive . . . . As the tension grew in the Mexican colony, war workers, service men, and law-abiding citizens felt that they were being engulfed by a 'Mexican crime wave' . . . . There have been many reasons suggested for the newspaper blowup of the 'Mexican' juvenile gang activities. Some say news was scarce, and these kids were good copy. Others believe that there was a well-planned conspiracy afoot to incite race riots and put the Mexicans in their place. Whatever the cause, the results were patent; the jitterbugging Mexican-American youth, who looked upon the zootsuit as his mark of style distinction and group security, had become the chief adversary of servicemen and a threat to local civilians . . . . Primed by inflammatory newspaper stories, . . . the riot fever and community madness had caught on . . . [leading to] the 'ugliest brand of mob action since the coolie race riots of the eighteen-seventies,' according to *Time* magazine . . . . During the weekend riots, Mexican-American boys (and some Negro) were dragged from theaters, stripped of their clothing, beaten and left naked on the streets. Later they were taken to jail by the police, 'who cleaned up the Pachuco debris in the wake of the sailors.' Youngsters were dragged out of restaurants and off streetcars, mauled and beaten by the yelling mob. The police officers stood by doing little or nothing to thwart the rioting servicemen . . . . Groups of Mexicans gathered in their neighborhoods. In all the Mexican barrios the sailors, marines, and soldiers hunted their quarry. The women were crying. Everybody was excited and angry. Wild rumors, confusion, threats, and prayers ran throughout the Mexican communities." Source: Griffith, Beatrice. *American Me*. Boston: Houghton Mifflin Company, 1948.

16. Cummings, Scott (editor). *Gangs: The Origins and Impact of Contemporary Youth Gangs in the United States*. Albany, NY: State University of New York Press, 1993.

17. Romotsky, Jerry and Sally R. Romotsky. *L.A. Chicano Graffiti*. Venice, CA: Environmental Communications, 1974.

18. Phillips, Susan A. *Wallbangin': Graffiti and Gangs in L.A.* Chicago: The University of Chicago Press, 1999.

19. Canclini, Nestor Garcia. *Hybrid Cultures: Strategies for Entering and Leaving Modernity*. Minneapolis, MN: University of Minnesota Press, 1995.

20.  Interestingly, by the 1970s, despite local mainstream abhorrence of graffiti, some mem-
     bers of the L.A. art world began to recognize it as a true aesthetic practice. In 1970, a local
     curator, Hal Glicksman, who ran the art gallery at Pomona College, decided to mount what
     likely was the first exhibition of Chicano graffiti "art." The idea came to Glicksman, ironi-
     cally enough, while he was working on LACMA's "Art and Technology" show. "I had an old
     Volkswagen," Glickman said. "I didn't like to go on the freeway, so every day I'd explore
     different ways to go from my house in Pasadena to LACMA and back. And I started notic-
     ing all of the graffiti. I fell in love with some of it. At the time, graffiti was definitely a local
     phenomenon . . . . So I started documenting it. I ran into Robert Allikas who had also made
     a bunch of photographs of graffiti. We decided to do a show. People hated the idea of glo-
     rifying graffiti . . . . [But] that turned out to be a really interesting show." Source: McGrew,
     Rebecca. "Hal Glicksman Interviewed by Rebecca McGrew." It Happened at Pomona: Art at
     the Edge of Los Angeles 1969–1973. Pomona College Museum of Art, 2011.

21.  Manson, Bill. "Original Artists Work to Restore Chicano Park Murals," San Diego Reader.
     July 4, 2012.

22.  Solis is said to have commandeered a bulldozer to flatten more of the land for planting, but
     the story sounds somewhat apocryphal. Source: Manson, Bill. "Original Artists Work to
     Restore Chicano Park Murals," San Diego Reader. July 4, 2012.

23.  Officials attending the April 23, 1970, meeting included Jacob Dekema, district man-
     ager for the Division of Highways, D. T. Donaldson, supervising inspector of the highway
     patrol, Captain Vincent J. Herr and Lt. Larry Watching of the highway patrol, Pauline Des
     Granges, city director of parks and recreation, and Clinton McKinnon of the San Diego
     Urban Coalition.

24.  "History of Chicano Park." The Chicano Park Historical Documentation Project. http://
     www.chicanoparksandiego.com/index.html.

25.  The project generally credited with being the first modern mural was the "Wall of Respect,"
     painted in Chicago's South Side in 1967 by artist members of the Organization of Black
     American Culture. Black artists, in fact, would work alongside Chicano artists to push the
     limits of modern mural art in Southern California in the 1970s. For a more complete study
     of the Black Arts Movement, which was active in Southern California at least through the
     mid-1970s, check out the essays in the catalogue to the exhibition "Now Dig This! Art and
     Black Los Angeles 1960–1980." (Prestel Publishing, 2011.)

26.  And so on—the number of Chicano art groups spread across California was so great that
     a larger support and advocacy organization, called Concilio de Art Popular, was formed in
     1976, which served more than twenty individual art groups by writing grants, sharing infor-
     mation, and eventually publishing a magazine called Chismearte.

27.  Montoya would later move to Sacramento as a fellowship recipient in the Mexican
     American Education Project. There, Montoya connected with the artist Esteban Villa and
     some other students and, as a way of supporting Cesar Chavez's United Farm Workers
     activities in the heavily agricultural region around Sacramento, founded the artist-activist
     group called the Rebel Chicano Art Force (RCAF), which, after often mistakenly being
     called the "Royal Chicano Air Force" later adopted the misnomer and employed air force
     motifs in their art and activities.

28.  Brookman, Philip. "El Centro Cultural de la Raza Fifteen Years." Made in Aztlán. San Diego,
     CA: Tolteca Publications, 1986.

29.   Cockcroft, John Weber and James Cockcroft. *Toward a People's Art: Contemporary Mural Movement.* New York: Dutton, 1977.

30.   Guzmán, Kristen. *Self Help Graphics & Art: Art in the Heart of East Los Angeles* (Chicano Archives Series Vol. 1) Los Angeles: UCLA Chicano Studies Research Center, 2005. Good analogues to the Chicano art centers were, of course, the spaces that L.A.'s feminist artists created in the 1970s out of the need to establish their own support structure outside the mainstream. Some African American artists in L.A. also followed the same impulse, as is evident in David Hammons's Studio Z collective and so on.

31.   Guzmán, Kristen. *Self Help Graphics & Art: Art in the Heart of East Los Angeles* (Chicano Archives Series Vol. 1) Los Angeles: UCLA Chicano Studies Research Center, 2005.

32.   Ibid.

33.   Jackson, Carlos Francisco. *Chicana and Chicano art: ProtestArte.* Tucson, AZ: University of Arizona Press, 2009.

34.   "Mexican American Liberation Art." A statement for the exhibition "New Symbols for La Raza Nueva" (ca. 1968–9). Documents of twentieth-century Latin American and Latino Art. Museum of Fine Arts, Houston.

35.   Brookman, Philip. "El Centro Cultural de la Raza Fifteen Years." *Made in Aztlán.* San Diego, CA: Tolteca Publications, 1986.

36.   Ibid.

37.   Ibid.

38.   Alurista asked Torres, who was enrolled in the Master of Fine Arts program at the college, to illustrate a book of his poetry. Torres became subsequently involved in Alurista's MAYA student group, eventually calling for the group to develop a "cultural and artistic arm." "The artists are the spearheads of all this," Torres said at a meeting of the association, "and we should identify each other, know who we are and go forth." Source: Brookman, Philip. "El Centro Cultural de la Raza Fifteen Years." *Made in Aztlán.* San Diego, CA: Tolteca Publications, 1986.

39.   Aranda had known Torres from both artists' involvement in a San Diego-based artist group called Los Artistas de los Barrios, which had organized Chicano art exhibitions in various spaces, commercial and public, around San Diego and particularly in Logan Heights. "There was already a move to organize 'Mexican-American' artists," said Aranda of those times. Source: Brookman, Philip. "El Centro Cultural de la Raza Fifteen Years." *Made in Aztlán.* San Diego, CA: Tolteca Publications, 1986.

40.   Proposed uses for the Ford Building in the years before its occupation by Torres and other Chicano artists included an Indian and Fisheries Building (1936), an exhibit hall and restaurant (1936), a roller skating rink (1937), a public library (1937), an armory (1938), a rifle range (1948), an aquatic coliseum (1950), a trade show building (1957), a home for the Museum of Man (1957), a convention center (1958), a civic auditorium (1959), a fallout shelter (1960), a science center (1963), and a Spanish pavilion (1968).

41.   "Chapter 11: The Chicana and the Arts," San Diego Mexican and Chicano History website. San Diego State University, 2000-2012.

42.   It was at this meeting that Alurista recited a poem called "El Plan Espiritual de Aztlán." The poem then was the basis of a new manifesto that advocated Chicano nationalism, called

upon Mexican Americans to take up grassroots political and social causes, and argued that
Chicano art and culture was the moral backbone of the Movement. "Our culture invites
and educates the family of La Raza towards liberation with one heart and one mind. We
must ensure that our writers, poets, musicians and artists produce literature and art that is
appealing to our people and relates to our revolutionary culture." Source: Brookman, Philip.
"El Centro Cultural de la Raza Fifteen Years." *Made in Aztlán*. San Diego, CA: Tolteca
Publications, 1986.

43.    "A Cultural Center for La Raza," *La Verdad*. San Diego. April, 1970.

44.    Guzmán, Kristen. *Self Help Graphics & Art: Art in the Heart of East Los Angeles* (Chicano
       Archives Series Vol. 1) Los Angeles: UCLA Chicano Studies Research Center, 2005.

45.    Ibid.

46.    Ibid.

47.    Tobar, Hector. "Sister Karen Boccalero, Latino Art Advocate, Dies," *Los Angeles Times*.
       June 26, 1997.

48.    Brookman, Philip. "El Centro Cultural de la Raza Fifteen Years." *Made in Aztlán*. San Diego,
       CA: Tolteca Publications, 1986.

49.    "Water Tank Leased as Art Center," Evening *Tribune*, San Diego. January 29, 1971.

50.    "The Tolteca Inauguration," *La Verdad*. San Diego, July–August, 1971.

51.    Ibid.

52.    Mulford, Marilyn, director. Mario Barrera and Marilyn Mulford, producers. *Chicano Park*.
       Video. San Diego, CA: Redbird Films, 1988.

53.    Latorre, Guisela. *Walls of Empowerment: Chicana/o Indigenist Murals of California*. Austin,
       Texas: University of Texas Press, 2008.

54.    Ibid.

55.    Dear, Michael. *Postborder City: Cultural Spaces of Bajalta California*. New York:
       Routledge, 2003.

56.    Including Galeria Ocaso, Goez Gallery, Mechanico Art Center, Plaza de la Raza, and the
       Social and Public Art Resource Center (SPARC).

57.    Asco, the Chicano Art Student Organization, El Concilio de Arts Popular, Council of
       Latino Photographers/USA, Los Four, and East Los Streetscapers.

## CHAPTER IV.

1.     Kapuściński, Ryszard. "Revolution I—Shah of Shahs," *New Yorker*. March 4, 1985. And
       "Revolution II—The Dead Flame," *New Yorker*. March 11, 1985.

2.     Ibid.

3.     Dean, Robert and Patrick Pardo. "The Making of John Baldessari's Cremation Project,"
       Yale Press online. July 24, 2012.

4.     Ibid.

5.    Small, Michael. "John Baldessari Rises From His Artistic Ashes and Finds That He's Hot,"
      *People*. December 10, 1990.

6.    Davies, Hugh M. *John Baldessari: National City*. San Diego, CA: San Diego Museum of
      Contemporary Art, 1996.

7.    Mundy, Jennifer. "The Death of Painting," Lost Art, a project of the Tate Galleries.
      (Formerly online at http://galleryoflostart.com/#/17,0/essay; to be released in book form in
      May of 2014.)

8.    Ibid.

9.    Ibid.

10.   Small, Michael. "John Baldessari Rises from His Artistic Ashes and Finds That He's Hot,"
      *People*. December 10, 1990.

11.   Ibid.

12.   Humanist philosopher/author Marshall Berman put it thusly at the tail end of the Modernist
      era: "In the twentieth century, the social processes that bring this maelstrom into being,
      and keep it in a state of perpetual becoming, have come to be called 'modernization.' These
      world-historical processes have nourished an amazing variety of visions and ideas that aim
      to make men and women the subjects as well as the objects of modernization, to give them
      the power to change the world that is changing them, to make their way through the mael-
      strom and make it their own. Over the past century, these visions and values have come to
      be loosely grouped together under the name of 'Modernism.' " Source: Berman, Marshall,
      *All That Is Solid Melts Into Air: The Experience of Modernity*. London: Penguin, 1988.

13.   Landi, Ann. "Auto-Destructive Tendencies," *Artnews*. December 24, 2012.

14.   Baldessari, John. Letter to Marcia Tucker, 1970. Marcia Tucker Papers, Getty Research
      Institute. Los Angeles.

15.   According to the Encyclopedia of Superstition, Folklore, and the Occult Sciences of the
      World (by Cora Linn Daniels and C. M. Stevan), a superstition from the Northumbrian
      region of Northern England and Southeast Scotland suggests: "After death has taken place
      in a family, the straw or chaff from the bed of the departed is taken into an open place and
      burned. Among its ashes the survivors look for a footprint, and that member of the family
      whose foot fits the impression, will be the next to die."

16.   The full text of the Sentences on Conceptual Art by Sol LeWitt can be found here: http://
      www.ubu.com/papers/lewitt_sentences.html.

17.   Kimmelman, Michael. "Sol LeWitt, Master of Conceptualism, Dies at 78," *New York Times*.
      April 9, 2007.

18.   Ibid.

19.   Stemmrich, Gregor, Gerti Fietzek, Cindy Sherman, and Lawrence Weiner. *Having Been
      Said: Book Writing and Interviews of Lawrence Weiner, 1968–2003*. Ostfildern, Germany:
      Hatje Cantz Publishers, 2004.

20.   Morgan, Jessica, and Leslie Jones. *John Baldessari: Pure Beauty*. Los Angeles: Los Angeles
      County Museum of Art and Prestel Press, 2010.

21.   Exhibition bio. "James Turrell: Into the Light." Mattress Factory website. 2003.

22.  Adcock, Craig. *James Turrell: The Art of Light and Space*. Berkeley, CA: The University of California Press, 1990.

23.  Ibid.

24.  Ibid.

25.  Ibid.

26.  Ibid.

27.  Today, the spaces once occupied by Turrell's studios are a neat and clean Starbucks and a small antique shop, above which are small walkup living spaces. The thrift store that had once existed across the street from the Mendota Block is now a boutique electronics and audio shop, and the space kitty-corner from the building is now an Irish pub.

28.  A noted figure from the Bay Area art scene, Diebenkorn had been hired that year to teach at UCLA. He set up a studio a few blocks away from Turrell's Mendota Block and began to paint flat, fractured-grid abstractions influenced by the local light and landscape that collectively became known as the Ocean Park series.

29.  Finkel, Jori. "Richard Diebenkorn and Ocean Park: A Special Light," *Los Angeles Times*. February 26, 2012.

30.  Adcock, Craig. *James Turrell: The Art of Light and Space*. Berkeley, CA: The University of California Press, 1990.

31.  These works he called his Cross-Corner Projections.

32.  Single-Wall Projections.

33.  Adcock, Craig. *James Turrell: The Art of Light and Space*. Berkeley, CA: The University of California Press, 1990.

34.  Ibid.

35.  Coplans, John. Jim Turrell. Exhibition catalogue. Pasadena Museum of California Art, 1967; Coplans, John. "James Turrell: Projected Light Images," *Artforum*. October 1967.

36.  Adcock, Craig. *James Turrell: The Art of Light and Space*. Berkeley, CA: The University of California Press, 1990.

37.  Turrell's first New York show wouldn't take place until October, 1980. Source: Tomkins, Calvin. "Light," Talk of the Town, *The New Yorker*. December 15, 1980.

38.  According to Craig Adcock, Turrell claimed he eventually reimbursed the gallery "with the help of Larry Bell," who put the debt on his own account with the gallery and then accepted payments from Turrell over the next several years "through various barter arrangements." Adcock also reports, however, that Glimcher does not recall ever being paid back by Turrell. Source: Adcock, Craig. *James Turrell: The Art of Light and Space*. Berkeley, CA: The University of California Press, 1990.

39.  Adcock, Craig. *James Turrell: The Art of Light and Space*. Berkeley, CA: The University of California Press, 1990.

40.  Davis, Douglas. "The View from Hill and Main," *Newsweek*. October 27, 1969.

41.  Sharp, Willoughby. "New Directions in Southern California Sculpture," *Arts* Magazine 44. Summer 1970.

42.  Baker, Elizabeth. "Los Angeles 1971," *Artnews* 70. September 1971.

43.  Livingston, John. "Art and Technology" catalogue. Los Angeles County Museum of Art, 1970.

44.  Irwin was said to be baffled and hurt, particularly since it appears that Turrell never explained to the elder artist his reasons for dropping out; while Turrell seems never to have looked back, discussing the incident only obliquely. "[I had to get away from] all ideas of ambitions and PR and constructing yourself in the second derivative," said Turrell, "feeding back things, so you're watching yourself in this very peculiar mirror . . . very good for the head. Trying to maintain any sense of vanity, and looking at that, was hard . . . I decided all that didn't seem necessary." Source: Livingston, John. "Art and Technology" catalogue. Los Angeles: Los Angeles County Museum of Art, 1970.

45.  Tompkins, Calvin. "Flying into the Light," *The New Yorker*. January 13, 2003.

46.  James, Nicolas Philip and James Turrell. *James Turrell: Inside Outside*. CV/Visual Arts Research Volume 57. CV Publications, 1996.

47.  Tomkins, Calvin. "Light," Talk of the Town, The New Yorker. December 15, 1980.

48.  "James Turrell on Burning Bridges," Pace Gallery online. January 18, 2012. http://www.pacegallery.com/news/304/ james-turrell-on-burning-bridges-part-of-january-s-pst-festival.

49.  Ibid.

50.  Panza had turned his focus on American Minimalist and Conceptual artists in 1966 and was among the first collectors to acquire works by Brice Marden, Robert Morris, Bruce Nauman, Robert Ryman, Richard Serra, Lawrence Weiner, Joseph Kosuth, and Turrell. Source: Tomkins, Calvin. "Flying into the Light," *The New Yorker*. January 13, 2003.

51.  James, Nicolas Philip and James Turrell. *James Turrell: Inside Outside*. CV/Visual Arts Research Volume 57. CV Publications, 1996.

52.  Adcock, Craig. *James Turrell: The Art of Light and Space*. Berkeley, CA: The University of California Press, 1990.

53.  James, Nicolas Philip and James Turrell. *James Turrell: Inside Outside*. CV/Visual Arts Research Volume 57. CV Publications, 1996.

54.  Phillips, Glenn. "Interview with Chris Burden." Pomona College Museum of Art online. May 18, 2010. http://www.pomona.edu/museum/artists/chris-burden.html.

55.  Ibid.

56.  Ibid.

57.  West, Kevin. "Public Offering," *W* magazine. May, 2008.

58.  Stiles, Kristine and Peter Howard Selz. *Theories and Documents of Contemporary Art: A Sourcebook of Artists' Writings*. Berkeley, CA: The University of California Press, 1996.

59.  Horvitz, Robert. "Chris Burden," *Artforum* magazine. May, 1976.

60.  Ibid.

61.  Hoffman, Abbie. *Steal This Book*. New York: Pirate Editions/Grove Press, 1971.

62.  Quoted in Stiles, Kristine and Fred Hoffman. *Burden of Light*. London: Thames & Hudson, 2007.

63.  Press release for "Chris Burden (February 16–March 9, 1974)," Ronald Feldman Fine Arts in New York online. Recovered October 1, 2013. http://www.feldmangallery.com/pages/exhsolo/exhbur74.html.

64.  West, Kevin. "Public Offering," *W* magazine. May, 2008.

65.  Daniel, Noel. *Broken Screen: 26 Conversation with Doug Aitken Expanding the Images, Breaking the Narrative*. New York: Distributed Art Publishers, Inc., 2005.

66.  Stiles, Kristine and Fred Hoffman. *Burden of Light*. London: Thames & Hudson, 2007.

67.  The notion became so widespread that Burden's work, no matter what it was, would be for years misleadingly labeled as "Body Art."

68.  Burden was arrested and booked for causing a false emergency with "Deadman"; the charges were later dropped when the jury failed to reach a decision. Source: Burden, Chris. "Chris Burden: Dead Man and a Hot Dog Stand," *L.A. Weekly*. September 22, 2011.

69.  Johnson, Ken. *Are You Experienced? How Psychedelic Consciousness Transformed Modern Art*. New York: Prestel, 2011.

70.  Campagnola, Sonia and Valentina Sansone. "Chris Burden: Face the Dragon Head On," *Flash Art*. October, 2013.

71.  Horvitz, Robert. "Chris Burden," *Artforum* magazine. May, 1976.

72.  "I used to use myself as a target," Anderson sang. "I used myself as a goal. I was digging myself so much, I was digging me so much, I dug myself right into a hole."

## CHAPTER V.

1.  Sinclair, John. "White Panther Party Statement." 1969. The turmoil and unrest of 1969 would carry over somewhat into the early 1970s. News reports were filled with the actions, often very violent, of small nationalist, separatist, and revolutionary movements. In Quebec, for instance, in October of 1970, the Front de liberation du Quebec kidnapped and assassinated Labor Minister Pierre Laporte. A month earlier, on September 6, 1970, Palestinian terrorists conceived of a new and modern strategy in asymmetric warfare by hijacking four airliners holding more than two hundred people. Later, during the 1972 Summer Olympics in Munich, Germany, Palestinian Arab terrorists from the Black September group kidnapped and killed eleven Israeli athletes. Groups like the Marxist paramilitary Red Brigades in Italy and the Red Army Faction (aka Baader-Meinhof Group) in Germany attempted to destabilize and, ultimately, overturn Western governments through acts of sabotage, kidnapping, theft, and assassination. The period between 1970 to 1972 saw an explosion of political violence as separatists in Ireland struggled against British rule. And so on.

2.  Cotter, Holland. "Art's Future Meets Its Past," *New York Times*. August 13, 2013.

3.  Ibid.

4.    Ibid.

5.    Douglas, Susan. "Bad Attitudes: Harald Szeemann's Landmark Exhibition Was a Scandal in Its Day," *The Gallerist* online. June 1, 2013.

6.    Birnbaum, Daniel. "When Attitude Becomes Form: Daniel Birnbaum on Harald Szeemann," *Artforum* online, 2013.

7.    Ibid.

8.    Fanelli, Franco. "The Prada Biennale show: Creative Energy turned into Dead Fetishism: Franco Fanelli on 'When Attitudes Become Form: Bern 1969, Venice 2013,' Ca' Correr della Regina, until 24 November," *The Art Newspaper* online. June 3, 2013.

9.    Carlson, Marvin. *Performance: A Critical Introduction*. London and New York: Routledge, 2006.

10.   Kelley, Jeff. *Childsplay: The art of Allan Kaprow*. Berkeley, CA: University of California Press, 2004.

11.   A year after the class ended, Kaprow wrote, upon the death of the artist Jackson Pollock, an essay for *Artnews* called "The Legacy of Jackson Pollock." In the essay, Kaprow suggested the best distance from which to view a Pollock painting was from where the painting filled one's entire peripheral vision, giving an impression of how the painter experienced it while making it. The viewer should strive to be entangled in Pollock's paintings, experiencing the work through one's entire body. "I am convinced," Kaprow wrote, "that to grasp a Pollock's impact properly, we must be acrobats." Source: Allan Kaprow. *Essays on the Blurring of Art and Life*. Berkeley, CA: University of California Press, 1993.

12.   Kelley, Jeff. *Childsplay: The Art of Allan Kaprow*. Berkeley, CA: University of California Press, 2004.

13.   Ibid.

14.   The list eventually included Stephan von Huene, Nam June Paik, Miriam Schapiro, Lloyd Hamrol, Judy Chicago, Alison Knowles, Peter Van Riper, Allen Hacklin, and John Baldessari, among others.

15.   Kelley, Jeff. *Childsplay: The Art of Allan Kaprow*. Berkeley, CA: University of California Press, 2004.

16.   Ibid.

17.   Suzanne Lacy in conversation with Fiona Connor for "The Experimental Impulse" online, September 14, 2011. https://soundcloud.com/fiona-connor/suzanne-lacy-on-the-feminist.

18.   Ibid.

19.   Per Leslie Jones in her essay "Art Lesson: A Narrative Chronology of John Baldessari's Life and Work," from the Baldessari retrospective exhibition "True Beauty" organized by the Tate Modern and Los Angeles County Museum of Art in 2009.

20.   Drohojowska-Philp, Hunter. "I Will Not Make Any More Boring Art: A Profile of John Baldessari," *L.A. Weekly*. July 13–19, 1984.

21. Roth, Moira. "An Interview with John Baldessari (1973)," with a forward by Micol Hebron. Original interview held on January 6, 1973, at the University of California, Santa Cruz.

22. Salle, David. "The Petit Cinema of John Baldessari," in Jessica Morgan and Leslie Jones, eds. *John Baldessari: Pure Beauty*, exh. cat. Los Angeles: Los Angeles County Museum of Art; and Munich: Prestel, 2009.

23. Roth, Moira. "An Interview with John Baldessari (1973)," with a forward by Micol Hebron. Original interview held on January 6, 1973, at the University of California, Santa Cruz.

24. Suzanne Lacy in conversation with Fiona Connor for "The Experimental Impulse" online, September 14, 2011. https://soundcloud.com/fiona-connor/suzanne-lacy-on-the-feminist.

25. Gardner, Paul, "The Heirs of Mickey, Minnie, Donald, and Pluto: California Institute of Arts. Where the Muses Really Sing," *Artnews*. October, 1973.

26. Hertz, Richard. *Jack Goldstein and the CalArts Mafia*. Ojai, CA: Minneola Press, 2003.

27. Kraft, Barbara. "Art Is What Artists Do: An Interview with John Baldessari." Articles 1, no 2. December 1984–January 1985.

28. Andre, who was known for using plain lumber and metal scraps in his work, had said in an *Artforum* interview with Phyllis Tuchman in 1970: "My cliche about myself is that I'm the first of the post-studio artists . . . . My things are conceived in the world."

29. John Baldessari, "Oral history interview with John Baldessari, 1992 Apr. 4-5," interview by Christopher Knight. Archives of American Art, Smithsonian Institution online. http://www.aaa.si.edu/collections/interviews/oralhistoryinterview-john-baldessari-11806.

30. Stern, Steven. "Note to Self," *Frieze* magazine. June–August, 2005.

31. Hertz, Richard. *Jack Goldstein and the CalArts Mafia*. Ojai, CA: Minneola Press, 2003.

32. Ibid.

33. "What Ever Happened to California?" *Time*. July 19, 1977.

34. "U.S. Cycle of Business Expansions and Contractions," The National Bureau of Economic Research online. Sept. 20, 2010. http://www.nber.org/cycles.html.

35. Even as early as the late 1950s, the city of Los Angeles had more registered cars than all but six states.

36. During the recession after 1973, the unemployment rate in California rose faster than the national average and remained elevated longer than the norm. Source: Valletta, Rob. "Extended Unemployment in California," Federal Reserve Bank of San Francisco Economic Letter. February 28, 2003. http://www.frbsf.org/publications/economics/letter/2003/el2003-05.html.

37. "California History," City Data online. http://www.city-data.com/states/California-History.html.

38. Crow, Thomas. "The Art of the Fugitive," *Under the Big Black Sun*. Los Angeles: The Museum of Contemporary Art, Los Angeles. 2011.

39.  Salle, David. "The Petit Cinema of John Baldessari," in Jessica Morgan and Leslie Jones, eds. *John Baldessari: Pure Beauty*, exh. cat. Los Angeles: Los Angeles County Museum of Art; and Munich: Prestel, 2009.

40.  Video interview with the artist. "Artist John Baldessari on teaching." Hear Now Productions. 2009.

41.  Salle, David. "The Petit Cinema of John Baldessari," in Jessica Morgan and Leslie Jones, eds. *John Baldessari: Pure Beauty*, exh. cat. Los Angeles: Los Angeles County Museum of Art; and Munich: Prestel, 2009.

42.  Here's an example of one of the cards:

She: I thought Al was in New York.

He: No, not yet.

She: But he's not here.

He: No.

He: Where's Al?

She: Maybe he's staying home to read?

He: What's he been reading?

She: Joan Didion.

43.  Hertz, Richard. *Jack Goldstein and the CalArts Mafia*. Ojai, CA: Minneola Press, 2003.

44.  Crow, Thomas. "The Art of the Fugitive," *Under the Big Black Sun*. Los Angeles: The Museum of Contemporary Art, Los Angeles. 2011.

45.  Anderson, Mary Sue. "Bas Jan Ader: In Search of the Miraculous," a sit-down, online conversation with Mary Sue Anderson made by Patrick Painter Inc. Directed by Soo Jin. June, 2011.

46.  Dumbadze, Alexander. *Bas Jan Ader: Death Is Elsewhere*. Chicago: University of Chicago Press, 2013.

47.  Crow, Thomas. "The Art of the Fugitive," *Under the Big Black Sun*. Los Angeles: The Museum of Contemporary Art, Los Angeles, 2011.

48.  Ibid.

49.  It was directed by Jerry Hughes and produced by a young Taylor Hackford, who would later go on to have great success as the director of such films as *An Officer and a Gentleman*.

50.  Kaprow, Allan. "Video Art: Old Wine, New Bottle," *Artforum*. June 1974.

51.  Ibid.

52.  Ibid.

53.  Salle, David. "The Petit Cinema of John Baldessari," in Jessica Morgan and Leslie Jones, eds. *John Baldessari: Pure Beauty*, exh. cat. Los Angeles: Los Angeles County Museum of Art; and Munich: Prestel, 2009.

54.  Ibid.

55.   Hertz, Richard. *Jack Goldstein and the CalArts Mafia*. Ojai, CA: Minneola Press, 2003.

56.   Lacy interviewed by Moira Roth. Archives of American Art online, 1990.

57.   Lacy, Suzanne. "Affinities: Thoughts on an Incomplete History," *Leaving Art: Writings on Performance, Politics, and Publics 1974–2007*. Durham, NC: Duke University Press, 2010.

58.   Lacy interviewed by Moira Roth. Archives of American Art online, 1990.

59.   Chicago, Judy. *Through the Flower*. New York: Authors Choice Press, 1975.

60.   Gaulke, Cheri. "Acting Like Women: Performance Art of the Woman's Building," *High Performance* magazine. Fall/Winter 1980.

61.   Cheng, Meiling. *In Other Los Angeleses: Multicentric Performance Art*. Berkeley, CA: University of California Press, 2002.

62.   Levin, Gail. *Becoming Judy Chicago: A Biography of the Artist*. New York: Harmony Books, 2007.

63.   Built by Sophia Hayden, the Woman's Building of 1893 housed exhibitions of women's cultural contributions throughout the world.

64.   Including the L.A. Feminist Theater, Women's Improvisational Theater, and the Woman's Performance Project.

65.   Daalder, Rene, director. *Here Is Always Somewhere Else: The Story of Bas Jan Ader*. A film production of American Scenes Production Co., 2007.

66.   Kennedy, Randy. "The Balance of a Career: Chris Burden's Feats of Art Are to Fill the New Museum," *New York Times*, September 6, 2013.

67.   Ebert, Roger. "Chris Burden: The Body Artist," *Chicago Sun-Times*. April 8, 1975.

68.   Ebert, Roger. "My God, Are They Going to Leave Me Here to Die?" *Chicago Sun-Times*. May 25, 1975.

69.   Ibid.

70.   Ebert, Roger. "The Agony of the Body Artist." *Roger Ebert's Journal* online. October 15, 2009. http://www.rogerebert.com/rogers-journal/the-agony-of-the-body-artist.

71.   Ebert, Roger. "My God, Are They Going to Leave Me Here to Die?" *Chicago Sun-Times*. May 25, 1975. "During the 45 hours," Ebert wrote, "Burden had been in psychological danger, perhaps, but not in physical danger; he had urinated, but the museum staff had not noted the signs on his navy-blue dungarees. He had been thirsty and hungry, Burden said, and he had been completely conscious at all times except for some fleeting periods of sleep. He had not used a self-imposed trance, or yoga, or anything else except self-discipline to keep himself lying there."

72.   Ebert, Roger. "Chris Burden: The Body Artist," *Chicago Sun-Times*. April 8, 1975.

73.   Schjeldahl, Peter. "Performance: Chris Burden and the limits of art," *The New Yorker*. May 14, 2007.

74. In the third part, Ader was going to mount an exhibition in Amsterdam similar to the one he had in Los Angeles in the Kauffman Gallery, except the night pieces were going to be photos taken around Amsterdam.

75. Dumbadze, Alexander. *Bas Jan Ader: Death Is Elsewhere*. Chicago: University of Chicago Press, 2013.

76. Ibid.

77. Daalder, Rene, director. *Here Is Always Somewhere Else: The Story of Bas Jan Ader*. A film production of American Scenes Production Co., 2007.

78. Ader had approached Anderson while she was eating lunch and, lifting up his T-shirt, said to her, "I've got one of the five most beautiful belly buttons in the world." "And, you know," Anderson admitted, "you can't top that for an opening line. I fell in love with him immediately."

79. Dumbadze, Alexander. *Bas Jan Ader: Death Is Elsewhere*. Chicago: University of Chicago Press, 2013.

80. Though not a two-way receiver, since the battery to power such a device would have been too unwieldy for the trip.

81. Anderson, Mary Sue. "Bas Jan Ader: In Search of the Miraculous," a sit-down, online conversation with Mary Sue Anderson made by Patrick Painter Inc. Directed by Soo Jin June, 2011.

82. This is one of the reasons why Mary Sue Anderson Ader waited for three years until starting the process of having him declared dead, a process that was completed in 1979.

83. Biographers have noted that Ader himself had brought along as reading material Hegel's *The Phenomenology of Spirit*, a complex book of philosophy that grapples with the nature and development of human consciousness and all its forms before ultimately seeming to decide that reality itself is a consciousness busy trying to figure itself out.

84. Anderson, Mary Sue. "Bas Jan Ader: In Search of the Miraculous," a sit-down, online conversation with Mary Sue Anderson made by Patrick Painter Inc. Directed by Soo Jin June, 2011.

85. Dumbadze, Alexander. *Bas Jan Ader: Death Is Elsewhere*. Chicago: University of Chicago Press, 2013.

86. Anderson, Mary Sue. "Bas Jan Ader: In Search of the Miraculous," a sit-down, online conversation with Mary Sue Anderson made by Patrick Painter Inc. Directed by Soo Jin June, 2011.

87. Dumbadze, Alexander. *Bas Jan Ader: Death Is Elsewhere*. Chicago: University of Chicago Press, 2013.

88. Anderson, Mary Sue. "Bas Jan Ader: In Search of the Miraculous," a sit-down, online conversation with Mary Sue Anderson made by Patrick Painter Inc. Directed by Soo Jin June, 2011.

## CHAPTER VI.

1.  Stecyk, C.R. "Origins of a Sub-Species," *Kustom Kulture*. Laguna, CA: Laguna Art Museum, 1993.

2.  Novak, Matt. "Nobody Walks in L.A.: The Rise of Cars and the Monorails that Never Were," *Smithsonian* online. April 13, 2013. Novak would add: "In 1920 Los Angeles had about 170 gas stations. By 1930 there were over 1,500."

3.  The terms "hot rod" and "hot-rodders" didn't come into use until sometime between 1940 and 1945.

4.  Brummett, Ronald E. "Transpotation History of California (1900 to 1950)," Kern County online. Recovered October 1, 2013. http://www.kerncog.org/transportation-history-timeline.

5.  Kay, Jane Holtz. *Asphalt Nation: How the Automobile Took Over America and How We Can Take It Back*. Berkeley, CA: University of California Press, 1997.

6.  Weschler, Lawrence. *Seeing Is Forgetting the Name of the Thing One Sees: A Life of Contemporary Artist Robert Irwin*. Berkeley, CA: University of California Press, 1982.

7.  Ibid.

8.  Ibid.

9.  Allington, Edward. "Buddha Built My Hot Rod: Cars, art, and the perfect finish," *Frieze* magazine online. January–February, 1998.

10. Adcock, Craig. *James Turrell: The Art of Light and Space*. Berkeley, CA: University of California Press, 1982.

11. Allington, Edward. "Buddha Built My Hot Rod: Cars, Art, and the Perfect Finish," *Frieze*. January–February, 1998.

12. Frank, Peter. "Jacked Up: Making It Real in L.A. Art," Katherine Cone Gallery online. http://www.katherineconegallery.com/jack-brogan-forward-by-peter-frank.html. Los Angeles, April 2012.

13. Baker, Elizabeth C. "Los Angeles, 1971," *Artnews*. September, 1971.

14. Adcock, Craig. *James Turrell: The Art of Light and Space*. Berkeley, CA: University of California Press, 1982.

15. Weschler, Lawrence. *Seeing Is Forgetting the Name of the Thing One Sees: A Life of Contemporary Artist Robert Irwin*. Berkeley, CA: University of California Press, 1982.

16. Adcock, Craig. *James Turrell: The Art of Light and Space*. Berkeley, CA: The University of California Press, 1982.

17. Weschler, Lawrence. *Seeing Is Forgetting the Name of the Thing One Sees: A Life of Contemporary Artist Robert Irwin*. Berkeley, CA: University of California Press, 1982.

18. Ibid.

19. Ibid. The critic Irwin is speaking of here is most likely Max Kozloff, a onetime critic for *The Nation* and editor for *Artforum* (and husband of Joyce Kozloff), who had been hired around 1970 to be the first dean of fine arts at the California Institute of the Arts.

20. Wolfe, Tom. *The Kandy-Kolored Tangerine-Flake Steamline Baby*. New York: Farrar, Straus and Giroux, 1965.

21. Ibid.

22. Ibid.

23. Ibid.

24. Fiberglass was a material that had become popular in the 1950s (after the development of fiberglass cloth by Owens-Corning in 1941).

25. Stecyk, C.R. "Origins of a Sub-Species," *Kustom Kulture*. Laguna, CA: Laguna Art Museum, 1993.

26. Ibid.

27. "Hobbies: The Customizers," *Time* magazine. April 10, 1964.

28. Muchnic, Suzanne. "LACMA lands Ed Kienholz's 'The Illegal Operation,' " *Los Angeles Times*. August 20, 2008.

29. Auping, Michael. "Edward Kienholz/MATRIX 21," Berkeley Art Museum exhibition catalogue. Berkeley, CA: Berkeley Art Museum, 1979.

30. And though his stance against the Kienholz show was successful in gaining national and international attention, Dorn would be eventually dissuaded from running by his close friend Walt Disney, who wanted Ronald Reagan to run for the party nomination unopposed.

31. Wyatt, Edward. "In Sunny Southern California, a Sculpture Finds Its Place in the Shadows," *New York Times*. October 2, 2007.

32. Rawlinson, Mark. "Like Trading Dust for Oranges: Ed Ruscha and Things of Interest," *Various Small Books: Referencing Various Small Books by Ed Ruscha*. Cambridge, MA: MIT Press, 2013.

33. Cheng, Meiling. *In Other Los Angeleses: Multicentric Performance Art*. Berkeley, CA: University of California Press, 2002.

34. Ibid.

35. Ibid.

36. Williams, Robert with Mike LaVella. *The Hot Rod World of Robt. Williams*. Minneapolis, MN: Motorbooks Publishing Co., 2006.

37. Williams, Robert. *The Lowbrow Art of Robert Williams*. Auburn, CA: Rip Off Press, 1979.

38. Ibid.

39. Stecyk, C.R. *Kustom Kulture: Von Dutch, Ed "Big Daddy" Roth, Robert Williams and Others*. San Francisco: Last Gasp Publishing, 1993.

40. Williams, Robert. *The Lowbrow Art of Robert Williams*. Auburn, CA: Rip Off Press, 1979.

41. At the time, a local motorcycle gang was hanging around, accusing Roth of exploiting their image in his magazine *Chopper* and demanding money.

42. Williams, Robert with Mike LaVella. *The Hot Rod World of Robt. Williams*. Minneapolis, MN: Motorbooks Publishing Co., 2006.

43. Ibid.

44. Ibid.

45. Ibid.

46. Allington, Edward. "Buddha Built My Hot Rod," *Frieze*. January–February, 1998.

47. Many were included in Williams's first book, *The Lowbrow Art of Robt. Williams*, in 1979. The title of the book coined the neologism for which Williams takes full credit.

48. Williams, Robert with Mike LaVella. *The Hot Rod World of Robt. Williams*. Minneapolis, MN: Motorbooks Publishing Co., 2006.

49. Roth's publishing company put out several comic books including *Peterson's Cartoons*, *Big Daddy Roth's Comics*, and *Peter Millar's Drag Toons*. All were typical of the underground comic style of the day.

50. Stecyk, C.R. *Kustom Kulture: Von Dutch, Ed "Big Daddy" Roth, Robert Williams and Others*. San Francisco: Last Gasp Publishing, 1993.

51. Ibid.

52. Hickey, Dave. *Air Guitar*. Los Angeles: Art Issues Press, 1997.

53. Williams, Robert and Lydia Lunch. *Visual Addiction: The Art of Robert Williams*. San Francisco: Last Gasp Publishing, 1989.

54. Davidson, J. "Sport and Modern Technology: The Rise of Skateboarding, 1963–1978," *Journal of Popular Culture*. Vol. 18, no. 4, Spring 1985.

55. Stecyk. C.R. "Introduction," *Fuck You Heroes: Glen E. Friedman Photographs 1976–1991*. New York: Burning Flags Press, 1994.

56. Stecyk, C.R. *Kustom Kulture: Von Dutch, Ed "Big Daddy" Roth, Robert Williams and Others*. San Francisco: Last Gasp Publishing, 1993.

57. Cobo-Hanlon, Leila. "The Fast Track: Lowrider Magazine's Popularity Is Accelerating," *Los Angeles Times*. October 17, 1995.

58. Ibid.

59. On the occasion of the magazine's folding, Claude "Kickboy" Bessy proclaimed: "The scene was not fun anymore, so I bailed on L.A. and the USA never to return the day Ronald Reagan was elected." Mullen, Brendan. "Thees Ees Thee Reel Shit!" *L.A. Weekly*. Oct. 20, 1999.

60. Some of them—like X, Violent Femmes, The Blasters, BoDeans, Burning Spear, Fear, Misfits, Soul Coughing, and so on—eventually became quite successful.

61. Saltz, Jerry. "A Pettibon Primer," *Village Voice*. March 16, 1999.

62. Stecyk. C.R. "Introduction," *Fuck You Heroes: Glen E. Friedman Photographs 1976–1991*. New York: Burning Flags Press, 1994. Stecyk, who worked in the late 1970s at *Skateboarder*

magazine, offered Friedman, who was himself a young skateboarder, a job as contributing photographer for the magazine.

63. In the late 1970s, Vitello and Swenson had bought the company Independent Trucks, which quickly became an industry leader in innovating ball-bearing wheels that also were made of polyurethane.

64. McCormick, Carlo interviewing Robert Williams. "Cartoon Surrealism," *Grand Street* journal. No. 52, Spring 1995.

65. The Zombie Mystery Paintings were, according to Williams, "done very fast on bulky, bad canvas, so in case they were damaged there would be no problem, I could sew them back up again. They looked really punk-rock funky. I sold them as cheap as I could. The audience for these paintings was people who had just come from seeing Fear or Henry Rollins, so they were drunk and what they were after was stimulating energy in a picture. I relaxed myself and did something that I really enjoyed doing, going for the jugular vein of enjoyment . . . . I knew how lewd I could be doing underground comics and how much I could get away with and I fell right into this. These were a tremendous success, and I just shot off from this." Source: Gilstrap, Peter. "Evil Easel," *New Times Los Angeles*. March 26, 1998.

66. Gilstrap, Peter. "Evil Easel," *New Times Los Angeles*. March 26, 1998.

67. Ibid.

## CHAPTER VII.

1. Douglas Dollarhide was the first African American mayor of a major town in California since it gained statehood in 1850.

2. The exact location of this mural and date of its creation is lost; Cal State L.A.'s Calisphere online database of public art projects lists no address and suggests a range of years, 1970–76, as the date of creation; http://content.cdlib.org/ark:/13030/kt3779r020/?layout=metadata&brand=calisphere.

3. Dunitz, Robin. "The African-American Murals of Los Angeles: Putting art where people live." American Visions. December–January, 1994.

4. Ibid.

5. Ibid.

6. Dunitz, Robin J. *Street Gallery: Guide to over 1000 Los Angeles Murals*. 2nd Edition. RJD Enterprises, 1998.

7. Ibid.

8. Brodsly, David. *L.A. Freeway: An Appreciative Essay*. Berkeley, CA: University of California Press, 1981.

9. Didion, Joan. *The White Album*. New York: Simon & Schuster, 1979.

10. Banham, Reyner. *Los Angeles: The Architecture of Four Ecologies*. Berkeley, CA: University of California Press, 1971.

11. Brodsly, David. *L.A. Freeway: An Appreciative Essay*. Berkeley, CA: University of California Press, 1981.

12.  Ibid.

13.  Ibid.

14.  Wolfe, Tom. "I Drove Around Los Angeles and It's Crazy! The Art World Is Upside Down!" *Los Angeles Times*. December 1, 1968.

15.  An act that resulted in a $125,000 court settlement to the artist through the California Art Preservation Act of 1970.

16.  According to the organization's mission statement, the Mural Conservancy of Los Angeles was created by a coalition of artists, public art advocates, city of Los Angeles and state of California public officials, and restoration specialists. Its long-term programs focus on retaining mural arts as a part of Los Angeles' cultural legacy and establishing murals as a significant part of the city's cultural heritage. The MCLA also advocates for the rights of artists and public art, working with artists to support the integrity of their work, and it promotes local artist and public murals in order to sustain Los Angeles as one of the great mural capitals in the world.

17.  "Inner City Mural Program" brochure, no date; "Inner City Mural Program," by Luckman Glasgow, LAICA Journal. December 1974.

18.  Several, Michael. "Flow Inversion Project: Inverted Freeway: Background Information," Public Art in L.A. online, 2000. http://www.publicartinla.com/LA_murals/USC/flow.html#1.

19.  *Me da asco* means, colloquially, "makes me puke."

20.  Chavoya, C. Ondine and Rita Gonzales, editors. *Asco: Elite of the Obscure*. Germany: Hatje Cantz Verlag (with the Los Angeles County Museum of Art and Williams College Museum of Art), 2011.

21.  Benavidez, Max. "The World According to Gronk," *L.A. Weekly*. August 13, 1982.

22.  Chavoya, C. Ondine and Rita Gonzales, editors. *Asco: Elite of the Obscure*. Germany: Hatje Cantz Verlag (with the Los Angeles County Museum of Art and Williams College Museum of Art), 2011.

23.  Ibid.

24.  Seymour Rosen was a professional photographer whose career began in the 1950s. He was perhaps best known for his photographs of the Watts Towers and the artists associated with L.A.'s Ferus Gallery. Source: Chavoya, C. Ondine and Rita Gonzales, editors. *Asco: Elite of the Obscure*. Germany: Hatje Cantz Verlag (with the Los Angeles County Museum of Art and Williams College Museum of Art), 2011.

25.  Chavoya, C. Ondine and Rita Gonzales, editors. *Asco: Elite of the Obscure*. Germany: Hatje Cantz Verlag (with the Los Angeles County Museum of Art and Williams College Museum of Art), 2011.

26.  Ibid.

27.  Ibid.

28.  Crow, Thomas. "The Art of the Fugitive," *Under the Big Black Sun*. Los Angeles: The Museum of Contemporary Art, Los Angeles, 2011.

29.   The mural's imagery depicted events surrounding the 1970 Chicano Moratorium march, held in East Los Angeles against the Vietnam War, which was beset by police violence and the death, from the concussive impact of a military-grade tear gas canister explosion, of the prominent Mexican American journalist Rubin Salazar.

30.   Gronk, transcript of oral history interview, Los Angeles, 20 and 23 Jan., 1997, Archives of American Art, Smithsonian Institution, Washington, D.C. http://www.aaa.si.edu/collections/oralhistories/transcripts/gronk97.htm.

31.   Gamboa, Jr., Harry. "Autobiography: 1960 EOP Admissions Statement," M753, Box 2, Folder 26, East Los Angeles Walkouts and related miscellaneous/Garfield High School, c. 1968–70.

32.   Villa, Raul Homero. *Barrio-Logos: Space and Place in Urban Chicano Literature and Culture.* Austin, TX: University of Texas Press, 2000.

33.   Ibid.

34.   Suderburg, Erika, editor. *Space, Site, Intervention: Situating Installation Art.* Minneapolis, MN: University of Minnesota Press, 2000.

35.   Chavoya, C. Ondine and Rita Gonzales, editors. *Asco: Elite of the Obscure.* Germany: Hatje Cantz Verlag (with the Los Angeles County Museum of Art and Williams College Museum of Art), 2011.

36.   Ibid.

37.   Benavidez, Mark. *Gronk.* Berkeley, CA: University of California Press, 2007.

38.   Berger, Maurice. "Speaking Out: Some Distance to Go . . . ," *Art in America.* September, 1990.

39.   Hazlitt, Gordon J. "Los Angeles, Exposure to Process," *Artnews.* January, 1977.

40.   "Shopping Bag Spirits and Freeway Fetishes: Reflection on Ritual Space," a video by Barbara McCullough, 1979.

41.   Ibid.

42.   With titles such as *Ascozilla* (1975), *Fountain of Aloof* (1978), *Slasher no.9* (1975), or *À La Mode* (1976), the "No-movies" featured "montages of funny performances, theatricality, camp impersonations, cult gore, costumes and dime-store glamour," along with its deadpan urban realism. Source: Jauregui, Gabriela. "Asco: Elite of the Obscure," *Frieze.* January–February, 2012.

43.   "Judith F. Baca: Artist, Educator, Scholar/Activist, and Community Arts Pioneer." Sparc Murals online. http://www.sparcmurals.org/JB_UCLA/judybaca_ucla/Judy_Baca_Narrative_Bio.pdf.

44.   Cockcroft, Eva Sperling and Holly Barnet-Sanchez. *Signs from the Heart: California Chicano Murals.* Albuquerque, NM: University of New Mexico Press, 1990.

45.   Abbey, Cherie D. *Biography Today: Profiles of People of Interest to Young Readers.* Detroit, MI: Omnigraphics Inc, 2009.

46.   Ibid.

47.    "SPARC programs," Sparc Murals online. http://www.sparcmurals.org:16080/sparcone/index.php?option=com_content&task=view&id=13&Itemid=43.

48.    This included Baca, Charles Brown, Isabel Castro, Donna Deitch, Judithe Hernandez, Ulysses Jenkins, Luis Lopez, Kristina Lucas, Olga Muniz, Bernardo Muniz, Arnold Ramirez, Christina Schlesinger, Gary Tokumoto, and Linda Eber.

49.    Pouncing is a technique that has been used for centuries to transfer line drawings from a sheet of paper onto another surface. It usually involves laying the paper over a prepared (smoothed) surface, pricking a series of small holes along the lines of the drawing with a special tool, then forcing a powdery chalk-like substance with a small bag of thin fabric through the holes onto the transfer surface, thereby leaving an indication of the drawing's contours.

50.    Cockcroft, Eva Sperling and Holly Barnet-Sanchez. *Signs from the Heart: California Chicano Murals*. Albuquerque, NM: University of New Mexico Press, 1990.

## CHAPTER VIII.

1.    Frank, Peter. "Los Angeles Painting in the 1970s," Art Ltd. online. Sept., 2011. http://www.artltdmag.com/index.php?subaction=showfull&id=1314989016&archive=&start_from=&ucat=28&.

2.    Her posture may have been a defensive one. It was the 1960s, after all, and, as the local artist Tony Berlant would point out, at that time "women had a hard time being recognized. Vija was one of the few I can remember who was taken seriously." Source: Hertz, Richard. *The Beat and the Buzz: Inside the L.A. Art World*. Tucson, AZ: Hol Art Books, 2009.

3.    Celmins was so invested in art as a teen that she printed the school's newspaper by hand, designed and managed the high school yearbook, and made "ridiculous, bizarre drawings of happy people at school." Source: Sussler, Betsy, editor. "Interview with Vija Celmins." Museum of Modern Art Oral History Program. Oct. 18, 2011.

4.    Sussler, Betsy, editor. "Interview with Vija Celmins." Museum of Modern Art Oral History Program. Oct. 18, 2011.

5.    Ibid.

6.    McKenna, Kristine. "Art Reviews: A Rare Show by Reclusive Vija Celmins," *Los Angeles Times*. July 27, 1990.

7.    Sirmans, Franklin and Michelle White. *Vija Celmins: Television and Disaster 1964–1966*. New Haven, CT: Yale University Press, 2010.

8.    Ibid.

9.    Ibid.

10.    Bartman, William S., editor. *Vija Celmins*. New York: A.R.T. Press, 1992.

11.    Sussler, Betsy, editor. "Interview with Vija Celmins." Museum of Modern Art Oral History Program. Oct. 18, 2011.

12.    Celmins makes one major change in her depiction: She mutes the colors that would have appeared on the magazine's red "Time: The Weekly News Magazine" title and subtitle and around the edge of the cover, as well as the yellow of the "Los Angeles Riot" banner

beneath the title. The effect is a flattening of the medium of the image, the magazine, and the photographic images that appear on the cover of the magazine.

13. Vija Celmins featured in "Time." An episode of Art 21, Season 2. Produced by Art 21, 2003.

14. Ibid.

15. Sirmans, Franklin and Michelle White. *Vija Celmins: Television and Disaster 1964–1966.* New Haven, CT: Yale University Press, 2010.

16. Relyea, Lane, Robert Gober, and Briony Fer. *Vija Celmins.* New York: Phaedon, 2004.

17. Ibid.

18. Sirmans, Franklin and Michelle White. *Vija Celmins: Television and Disaster 1964–1966.* New Haven, CT: Yale University Press, 2010.

19. Relyea, Lane, Robert Gober, and Briony Fer. *Vija Celmins.* New York: Phaedon, 2004.

20. Ibid.

21. Ayres, Anne interview of Charles Garabedian. "Oral History Interview with Charles Garabedian, 2003." Smithsonian Archives of American Art online. http://www.aaa.si.edu/collections/interviews/oral-history-interview-charles-garabedian-12734.

22. Ibid.

23. Ibid.

24. Ibid.

25. Ibid.

26. Ibid.

27. Ibid.

28 Ibid.

29. Ibid.

30. Ibid.

31. Ibid.

32. Ibid.

33. Joyce, Julie, Michael Duncan and Christopher Miles. *Charles Garabedian: A Retrospective.* Santa Barbara, CA: Santa Barbara Museum of Art, 2011.

34. Ayres, Anne interview of Charles Garabedian. "Oral History Interview with Charles Garabedian, 2003." Smithsonian Archives of American Art online.

35. McKenna, Kristine. "A Late Bloomer," *Los Angeles Times.* November 27, 1994.

36. Ayres, Anne interview of Charles Garabedian. "Oral History Interview with Charles Garabedian, 2003." Smithsonian Archives of American Art online.

37.   Ibid.

38.   Belz, Carl. *Charles Garabedian: Twenty Years of Work*. Waltham, MA: Rose Art Museum, Brandeis University, 1983.

39.   Petlin, Irving. "Charles Garabedian, Ceeje Gallery," *Artforum*, June 1965.

40.   Fuller, Mary. "Charles Garabedian: One View of the Los Angeles Art Scene," *Currant*. December 1975–January 1976.

41.   Joyce, Julie, Michael Duncan and Christopher Miles. *Charles Garabedian: A Retrospective*. Santa Barbara, CA: Santa Barbara Museum of Art, 2011.

42.   Tucker, Marcia. "An Appreciation," *Just a Great Thing to Do: Selected Works by Charles Garabedian*. San Diego, CA: La Jolla Museum of Contemporary Art, 1981.

43.   Smith, Roberta. "Art View; A Remembrance of Whitney Biennials Past," *New York Times*. February 28, 1993.

44.   Belz, Carl. *Charles Garabedian: Twenty Years of Work*. Waltham, MA: Rose Art Museum, Brandeis University, 1983.

45.   Frank, Peter. "Los Angeles Painting in the 1970s," *Art Ltd*. Online. September, 2011.

46.   Ibid.

47.   Ibid.

48.   In time, Garabedian's style would be given the critically chic label "bad painting" and would prefigure a revivalist movement in the decade that followed called "Neo-Expressionism."

49.   Frank, Peter. "Los Angeles Painting in the 1970s," *Art Ltd*. Online. September, 2011.

50.   Ibid.

51.   Ibid.

52.   Bann, Stephen. "Llyn Foulkes—Comedy, Satire, Irony, and Deeper Meaning," Llyn Foulkes New Works 1976–77. New York: Gruenebaum Gallery, 1977.

53.   Knode, Marilu. *Llyn Foulkes: Between a Rock and a Hard Place*. Laguna Beach, CA: Laguna Art Museum, 1996.

54.   "The imagery [in 'Flanders']," wrote the curator Marilu Knode, "suggests ghostly mutated figures, lost spirituality, and earth as the last—albeit disturbed—refuge." Source: Knode, Marilu. *Llyn Foulkes: Between a Rock and a Hard Place*. Laguna Beach, CA: Laguna Art Museum, 1996.

55.   "Irving (Blum) and Walter (Hobbes) didn't want to kick him out," said Moses, "and to this day Llyn is bitter about it." Source: Hertz, Richard. *The Beat and the Buzz: Inside the L.A. Art World*. Ojai, CA: Minneola Press, 2009.

56.   Knode, Marilu. *Llyn Foulkes: Between a Rock and a Hard Place*. Laguna Beach, CA: Laguna Art Museum, 1996.

57.   Ibid.

58.   Ibid.

## CHAPTER IX.

1.  Brinkley, Alan and Davis Dyer, editors. *The American Presidency*. San Diego, CA: Mariner Books, 2004.

2.  Toffler, Alvin. *Future Shock*. New York: Random House, 1970.

3.  Ibid.

4.  The very first personal computer—the Datapoint 2200, built by the Computer Terminal Corporation in San Antonio, Texas—had been quietly put on the market in 1970. It operated with an internal hard drive and no floppy drive until later.

5.  A few years later, communications theorist and author Neil Postman suggested in his 1985 book *Amusing Ourselves to Death* that our media preoccupation was responsible for an "altered perception" of reality and a kind of "cultural schizophrenia."

6.  "Crisis of Confidence." Speech transcript. PBS's *American Experience* online. http://www.pbs.org/wgbh/americanexperience/features/primary-resources/carter-crisis/.

7.  "Jimmy Carter vs. Inflation," *Time*. March 24, 1980.

8.  Among the most notable and revolutionary of technological innovations in the late 1700s and early 1800s were: The mechanization of textile spinning (1764-1769); the perfection of modern iron smelting techniques (1760-1775); James Watt's steam engine (1769); the power loom (1785); the cotton gin (1793); Volta's electric battery (1800); Robert Fulton's steamship (1807); Stephenson's steam locomotive (1814); Faraday's electric dynamo (1821); and Niepce's earliest photograph (1822). Source: Johnson, Paul. *The Birth of the Modern*. New York: Harper Perennial, 1992.

9.  Johnson, Paul. *The Birth of the Modern*. New York: Harper Perennial, 1992.

10. Philips, Lisa, Marvin Heiferman, and John G. Hanhardt. *Image World: Art and Media Culture*. New York: Whitney Museum of American Art, 1989.

11. Ibid.

12. Frank, Peter. "Los Angeles Painting in the 1970s," *Art Ltd*. Online. September, 2011. http://www.artltdmag.com/index.php?subaction=showfull&id=1314989016&archive=&start_from=&ucat=28&.

13. Importantly, both Man Ray and Marcel Duchamp came to speak at the school while Allen was there, and he took to heart their messages to act out their political and social convictions and rebel against the conventions of the 1960s.

14. Forsha, Lynda, Robert McDonald, and Dave Hickey. *Rooms and Stories: Recent Works by Terry Allen*. La Jolla, CA: La Jolla Museum of Contemporary Art, 1983.

15. Hickey, Dave. *Terry Allen*. Austin, TX: University of Texas Press, 2010.

16. For instance, at the end of his song "There Otta Be A Law Against Sunny Southern California," Allen sings: "Yeah there otta be a law against sunny Southern California. There otta be a law against putting the devil behind the wheel. 'Cause as long as you people are gonna sanction such an evil, well I'm gonna turn your asphalt back Into brimstone. Yeah, you Goddamned bet I will."

17. Crary, Jonathan. "West Texas Dada," *Art in America*. September, 1983.

18.   Lewallen, Constance. "Give and Take," *Allen Ruppersberg: You and Me or The Art of Give and Take*. Santa Monica, CA: Santa Monica Museum of Art, 2009.

19.   Ibid.

20.   Winer, Helene. "Introduction," Allen Ruppersberg. Pomona College Art Gallery, 1972.

21.   Brown, Julia and Howard Singerman. *The Secret of Life and Death: Volume I 1969-1984*. Los Angeles: The Museum of Contemporary Art, Los Angeles, 1984.

22.   Lewallen, Constance. "Give and Take," *Allen Ruppersberg: You and Me or The Art of Give and Take*. Santa Monica, CA: Santa Monica Museum of Art, 2009.

23.   Several L.A. celebrities and cultural figures, including Dennis Hopper and Joni Mitchell, are also said to have stopped by the cafe while it was open.

24.   Stern, Steven. "Note to Self," *Frieze* Magazine. June–August 2005.

25.   Ibid.

26.   Ibid.

27.   Jones, Alan. "Where's Al?" *Arts*. May, 1990.

28.   Los Angeles, according to Kelley, was a "hotbed" of art-music experimentation in the 1970s. "Performance artists like the Kipper Kids and Johanna West were performing on stage alongside rock bands; the Screamers were doing a kind of expressionistic music the-ater; and members of the noise-oriented Los Angeles Free Music Society (LAFMS) were forming various splinter art rock bands . . . . Each separate scene was so tiny, and so unde-fined as of yet, that they invited border confusions." Source: Kelley, Mike. "Introduction to an Essay Which Is in the Form of Liner Notes for a CD Reissue Box Set," www.mikekelley.com. Retrieved Oct 1, 2013.

29.   Levine, Cary. *Pay for Your Pleasures: Mike Kelley, Paul McCarthy, Raymond Pettibon*. Chicago, IL: University of Chicago Press, 2013.

30.   Kelley specifically mentioned "Baldessari's humor, Anderson's folksy storytelling, Cumming's flat-footed absurdity, and Huebler's increasingly referential density," as well as the mundane imagery and dense, enigmatic, and connective narratives of Askevold, as being influential art-making models that departed from the increasingly codified Conceptual aesthetic of the time. Source: Levine, Cary. *Pay for Your Pleasures: Mike Kelley, Paul McCarthy, Raymond Pettibon*. Chicago, IL: University of Chicago Press, 2013.

31.   The list included: the Beats, especially William Burroughs; early twentieth-century avant-gardists like Tristan Tzara; Raymond Roussel, Alfred Jarry, Gertrude Stein, Raoul Hausmann, and the futurists Filippo Tommaso Marinetti and Luigi Russolo; classic American writers like Nathaniel Hawthorne and Herman Melville; William Beckford and Matthew Lewis; Modernists like Vladimir Nabokov, Günter Grass, Jean Genet, Witold Gombrowicz, and Thomas Bernhard, as well as practitioners of the "new novel" such as Thomas Pynchon and Samuel Beckett; psychology writers like R.D Laing and Wilhelm Reich; radical political writers like Abbie Hoffman and John Sinclair; theologians like Thomas Aquinas; and the ancient science in the writings of Lucretius.

32.   Welchman, John C., editor. *Mike Kelley: Foul Perfection, essays and criticism*. Cambridge, MA: Massachusetts Institute of Technology, 2003.

33. Oursler, Tony. "Mike Kelley," *Artforum*. May 1, 2012.

34. Ibid. Kelley, Oursler would add, brought a sublimely nervous sense of energy to those works: "Before performing, Mike would hang out in a bathroom, pacing, revving up for the event, running through things in his head, hitting a small whiskey flask, and running cold water into the blocked sink. He would splash his face over and over until his T-shirt was soaked, pull his pants away from his belly and shovel icy water onto his genitals, and, for good measure, dunk his head into the sink with the alarming thud of bone bouncing off porcelain. Then he would slick his hair back and be ready to go, perfectly tuned, clearheaded and in the zone. The poetry would flow, drums would beat, Mike would stomp around with some black plastic sacks attached to his feet, hide in a tent, wear a dunce cap, and lie among some cones as a white cloth rose up and down above his crotch in syncopation with a dim bulb."

35. Ibid.

36. Levine, Cary. *Pay for Your Pleasures: Mike Kelley, Paul McCarthy, Raymond Pettibon*. Chicago, IL: University of Chicago Press, 2013.

37. Welchman, John C., editor. *Mike Kelley: Foul Perfection, essays and criticism*. Cambridge, MA: Massachusetts Institute of Technology, 2003.

38. Levine, Cary. *Pay for Your Pleasures: Mike Kelley, Paul McCarthy, Raymond Pettibon*. Chicago, IL: University of Chicago Press, 2013.

39. Iles, Chrissie. *Paul McCarthy: Central Symmetrical Rotation Movement—Three Installations, Two Films*. New York: Whitney Museum of American Art, 2008.

40. Levine, Cary. *Pay for Your Pleasures: Mike Kelley, Paul McCarthy, Raymond Pettibon*. Chicago, IL: University of Chicago Press, 2013.

41. "Painting to be Stepped On" from 1961, for example, was comprised of these instructions: "Leave a piece of canvas or finished painting on the floor or in the street." For a work called "Painting for the Wind" (1961), the instructions read: "Make a hole. Leave it in the wind."

42. Having refused his induction, he was granted conscientious objector status in 1972.

43. Levine, Cary. *Pay for Your Pleasures: Mike Kelley, Paul McCarthy, Raymond Pettibon*. Chicago, IL: University of Chicago Press, 2013.

44. Ibid.

45. Drohojowka-Philp, Hunter. "It's Not Shocking to Him." *Los Angeles Times*. November 5, 2000.

46. Levine, Cary. Pay for Your Pleasures: Mike Kelley, Paul McCarthy, Raymond Pettibon. Chicago, IL: University of Chicago Press, 2013.

47. Ibid.

48. Ibid.

49. Ibid.

50. Armstrong, Richard. "Interview," *Alexis Smith*. Whitney Museum of American Art. New York: Rizzoli, 1991.

51.   Ibid.

52.   Ibid.

53.   Ibid.

54.   Caroompas, Carole. "Artist Statement," *Netropolitan* online. California/International Art Foundation. http://www.netropolitan.org/cc/ccstate.html.

55.   Howe, Katherine. "David Amico, Carole Caroompas, Mary Fish, Randall Lavender, Brian Longe," Exhibition catalogue. Main Art Gallery, Cal State Fullerton, 1984.

56.   Caroompas, Carole. "Artist Statement," *Netropolitan* online. California/International Art Foundation. http://www.netropolitan.org/cc/ccstate.html.

57.   Caroompas, Carole. Artist statement. "David Amico, Carole Caroompas, Mary Fish, Randall Lavender, Brian Longe." Exhibition catalogue. Main Art Gallery, Cal State Fullerton, 1984.

## CHAPTER X.

1.   Krull, Craig. *Photographing the L.A. Art Scene 1955–1975*. Santa Monica, CA: Smart Art Press, 1996.

2.   Video interview. "Arts advocate Lyn Kienholz talks about censorship in the L.A. art scene," Pacific Standard Time online. Getty Research Center, 2011. http://blogs.getty.edu/pacificstandardtime/explore-the-era/archives/v56/.

3.   The first work they created together, "The Middle Islands No. 1" (1972), would be the first of several ruminations on middle age, sexuality, and divorce.

4.   Ed Kienholz continued to receive sole credit for these collaborations until 1981, when he publicly announced for the first time that all works after 1972 should be retroactively credited instead to "Kienholz," in collective reference to both Ed and Nancy.

5.   Hopkins, Henry. "Introduction," The Art Show 1963–1977 Edward Kienholz and Nancy Reddin Kienholz. Rice Museum, Rice University, Houston, Texas, 1977.

6.   Hughes, Robert. "All-American Barbaric Yawp," *Time*. May 6, 1966.

7.   McDonald, Robert. *Craig Kauffman: A Comprehensive Survey 1957–1980*. La Jolla Museum of Contemporary Art, 1981.

8.   Muchnic, Suzanne. "Craig Kauffman dies at 78; artist captured the ethos of Los Angeles," *Los Angeles Times*. May 12, 2010.

9.   McDonald, Robert. *Craig Kauffman: A Comprehensive Survey 1957–1980*. La Jolla, CA: La Jolla Museum of Contemporary Art, 1981.

10.  Ibid.

11.  Ibid.

12.  Ibid.

13.  Muchnic, Suzanne. "Craig Kauffman dies at 78; artist captured the ethos of Los Angeles," *Los Angeles Times*. May 12, 2010.

14. McDonald, Robert. *Craig Kauffman: A Comprehensive Survey 1957–1980*. La Jolla, CA: La Jolla Museum of Contemporary Art, 1981.

15. As Hunter Drohojowska-Philp describes the revelation in her book on the "Cool School," the innovation came out of the blue: "One morning [artist Craig Kauffman] stopped in a doughnut shop to get a cup of coffee and noticed a sign shaped like molded plastic fruit and started wondering how it was made. He drove over to a small industrial plant in the suburb of Paramount called Planet Plastics, where he learned about molds and vacuum-form machinery." Souce: Drohojowska-Philp, Hunter. *Rebels in Paradise*. New York: Henry Holt, 2011.

16. This was an epithet that Kauffman somewhat embraced by posting, in his 1970 solo exhibition at the Pasadena Museum of California Art, a facetious "Jello Poem," which read in part: " . . . kingkong jello x-ray jello used jello supersonic jello get it on jello free jello stoned jello organ jello am-fm jello live jello f.d.r. jello five star jello muffin jello tiny rub jello cuddle jello steel wool jello drop dead jello ddt jello holy cats jello blatent jello starlet jello oh you kid jello Vietnam jello ghetto jello burn baby burn jello ac/dc jello giggling jello innocent jello fertile jello."

17. McDonald, Robert. *Craig Kauffman: A Comprehensive Survey 1957–1980*. La Jolla, CA: La Jolla Museum of Contemporary Art, 1981.

18. Auping, Michael. "Interviews with Craig Kauffman, May 21, 1976–January 27, 1977," Oral History Program, University of California, Los Angeles. Transcript pp. 71–72, 1977.

19. Ibid.

20. McDonald, Robert. *Craig Kauffman: A Comprehensive Survey 1957–1980*. La Jolla, CA: La Jolla Museum of Contemporary Art, 1981.

21. Auping, Michael. "Interviews with Craig Kauffman, May 21, 1976–January 27, 1977." Oral History Program, University of California, Los Angeles. Transcript pp. 71–72, 1977.

22. Ibid.

23. Haskell, Barbara. Larry Bell. Exhibition catalogue. Pasadena, CA: Pasadena Museum of California Art, 1972.

24. Landis, Ellen, et al. The Art of Larry Bell. Exhibition catalogue. Albuquerque, NM: The Albuquerque Museum, 1997.

25. Ibid.

26. Ibid.

27. Ibid.

28. Ibid.

29. Ibid.

30. Haskell, Barbara. *Larry Bell*. Exhibition catalogue. Pasadena, CA: Pasadena Museum of California Art, 1972.

31. Seldis, Henry J. "Viewer, Object Merge in Larry Bell Glasses," *Los Angeles Times*. April 16, 1972.

32. Called "Lush Head Woman," the Berman/Witherspoon composition exists only as a rare B-side of a 78-rpm record.

33. Between 1955 and 1964, Berman would produce nine "issues" of the "magazine" (which were actually unbound loose-leaf sheets of decorated card stock that were never formally sold or distributed, but instead mailed out to friends).

34. Duncan, Michael and Kristine McKenna. *Semina Culture*. Santa Monica, CA: DAP/Santa Monica Museum of Art, 2005.

35. Starr, Sandra Leonard. *Lost and Found in California: Four Decades of Assemblage Art*. Santa Monica, CA: Corcoran, Shoshana Wayne, and Pence Galleries, 1988.

36. Cotter, Holland. "A Return Trip to a Faraway Place Called Underground," *New York Times*. January 26, 2007.

37. Ibid.

38. According to Larry Bell's old friend and classmate, Dean Cushman, Bell idolized Bengston in the years before his connection with Ferus, "and Bengston let him." Cushman, however, was in a sizeable camp that included the likes of Judy Chicago and many others who were not fans of the abrasive Bengston. "I found him arrogant," said Cushman, "controlling and bitchy as a Sunset Boulevard queen. He frightened me, but I liked his work. I didn't understand why Larry thought he was so great, and I still don't." Source: Landis, Ellen, et al. *The Art of Larry Bell*. Exhibition catalogue. Albuquerque, NM: The Albuquerque Museum, 1997.

39. Glueck, Grace. "ART IN REVIEW; Billy Al Bengston – 'Dentos and Draculas, 1968–1973,'" *New York Times*. May 18, 2001.

40. Yau, John. *Ed Moses: A Retrospective of the Paintings and Drawings, 1951–1996*. Los Angeles: University of California Press/Museum of Contemporary Art, 1996.

41. Ibid.

42. Brougher, Kerry. "Foreward," *Ed Ruscha*. Washington, D.C.: Hirschhorn Museum and Sculpture Garden, 2000.

43. Ibid.

44. In 2001, for instance, Ruscha was elected to the American Academy of Arts and Letters as a member of its Department of Art. In 2004, he was named an Honorary Royal Academician at London's Royal Academy of Arts. In 2006, he was given the cultural prize of the German Society for Photography. In 2008, he received the Aspen Award for Art, and in 2009 he received the National Arts Award for Artistic Excellence.

45. The stature of Ruscha's art career has at least one clear numeric bit of proof: The price of his work. Because of his enduring reputation, his early works from the 1960s have been known in recent years to sell for upwards of $3 million. His personal record was set at a Christie's auction in 2011, when his painting "Strange Catch for a Fresh Water Fish" (1965) sold for $4.1 million.

46. Lacayo, Richard. "Ed Ruscha, Artist, 75," *Time*. April 18, 2013.

47. Finkel, Jori. "Artist of Light, Space, and, Now, Trees," *New York Times*. October 14, 2007.

48. Weschler, Lawrence. *Seeing Is Forgetting the Name of the Thing One Sees: A Life of Contemporary Artist Robert Irwin*. Berkeley, CA: University of California Press, 1982.

# EPILOGUE

1. Eklund, Douglas. *The Pictures Generation: 1974–1984*. New York: Yale University Press, 2009.

2. Schimmel, Paul. "California Pluralism and the Birth of the Postmodern Era," Under the Big Black Sun: California Art 1974–1981 catalogue. Los Angeles: The Museum of Contemporary Art, Los Angeles, 2011.

3. Eklund, Douglas. *The Pictures Generation: 1974–1984*. New York: Yale University Press, 2009. So important was originality to this new, Baldessarian approach to artistic development, that the professor's penchant for pointing out the derivative nature of his students' works eventually inspired a teaching assistant to create a label that read: "Nice idea, but it's been done already by _____" (the assistant would fill in the name of an artist in the blank).

4. Eklund, Douglas. *The Pictures Generation: 1974–1984*. New York: Yale University Press, 2009.

5. Other, more peripheral members of the group, who were not as closely influenced by Baldessari, included Ericka Beckman, Ross Bleckner, and Eric Fischl.

6. Hertz, Richard. *Jack Goldstein and the CalArts Mafia*. Ojai, CA: Minneola Press, 2003.

7. Ibid.

8. Eklund, Douglas. *The Pictures Generation: 1974–1984*. New York: Yale University Press, 2009.

9. Hertz, Richard. *Jack Goldstein and the CalArts Mafia*. Ojai, CA: Minneola Press, 2003.

10. Ibid.

11. Ibid.

12. Ibid.

13. Crow, Thomas. "The Art of the Fugitive," *Under the Big Black Sun*. Los Angeles: The Museum of Contemporary Art, Los Angeles, 2011.

14. Colpitt, Frances. "In and Out of the Studio," *Under the Big Black Sun*. Los Angeles: The Museum of Contemporary Art, Los Angeles, 2011.

15. Crow, Thomas. "The Art of the Fugitive," *Under the Big Black Sun*. Los Angeles: The Museum of Contemporary Art, Los Angeles, 2011.

16. Ibid.

17. Hertz, Richard. *Jack Goldstein and the CalArts Mafia*. Ojai, CA: Minneola Press, 2003.

18. Salle, David. *Jack Goldstein; Distance Equals Control*. Buffalo, NY: Hallwalls, 1978.

19. Hertz, Richard. *Jack Goldstein and the CalArts Mafia*. Ojai, CA: Minneola Press, 2003.

20. Ibid.

21. He had, according to one count, "ten shows over this time in New York, twenty-six in Europe, and only four in L.A." Source: Morgan, Jessica, and Leslie Jones. *John Baldessari: Pure Beauty*. Los Angeles: Los Angeles County Museum of Art and Prestel Press, 2010.

22.   Morgan, Jessica, and Leslie Jones. *John Baldessari: Pure Beauty*. Los Angeles: Los Angeles County Museum of Art and Prestel Press, 2010.

23.   Ibid.

24.   Levin, Kim. "Get the Big Picture?" *Village Voice*. April 22, 1981.

25.   Drohojowska-Philp, Hunter. "No More Boring Art," *Artnews*. January, 1986.

26.   Morgan, Jessica, and Leslie Jones. *John Baldessari: Pure Beauty*. Los Angeles: Los Angeles County Museum of Art and Prestel Press, 2010.

27.   The show also traveled to the Los Angeles County Museum of Art in Los Angeles, the Metropolitan Museum of Art in New York, and the Museu d'Art Contemporani de Barcelona in Spain.

28.   James Turrell featured in "Spirituality," an episode of Art 21, Season 1. Produced by Art 21, 2002.

29.   Ibid.

30.   Adcock, Craig. *James Turrell: The Art of Light and Space*. Berkeley, CA: The University of California Press, 1990.

31.   James Turrell featured in "Spirituality," an episode of Art 21, Season 1. Produced by Art 21, 2002.

32.   "They [Turrell and Chambers] spent a number of afternoons and evenings discussing the matter over whiskeys at the local cantinas," wrote Craig Adcock, "and often drove around the desert together in Chambers's specially built four-wheel-drive Cadillac." Source: Adcock, Craig. *James Turrell: The Art of Light and Space*. Berkeley, CA: The University of California Press, 1990.

33.   Since 1967, Turrell has had over 160 solo exhibitions, including a three-venue museum exhibition presented concurrently at the Guggenheim Museum in New York, the Los Angeles County Museum of Art, and the Museum of Fine Arts, Houston, in 2013. In addition to twenty-two permanent installations at institutions such as the Henry Art Gallery in Seattle, the Nasher Sculpture Center in Dallas, and P.S. 1 in Long Island City, James Turrell's work can been seen in over seventy international collections. Turrell has installed works in twenty-two countries and in fourteen U.S. states. And since 1968, when Turrell first received a grant from the National Endowment for the Arts, the artist has been the recipient of a total of twenty-two awards, including a so-called "genius grant" from the The John D. and Catherine T. MacArthur Foundation in 1984 and a Chevalier des Arts et des Lettres award by the French Government in 1991.

34.   Turrell, James, Julia Brown, and Craig Adcock. *Occluded Front, James Turrell*. Los Angeles: The Museum of Contemporary Art, Los Angeles, 1985.

35.   Wiseman, Gary. "Interview with Chris Burden," *Portland Arts* online. November 1, 2011. http://www.portlandart.net/archives/2011/11/interview_with_16.html.

36.   Loeffler, Carl E, and Darlene Tong, editors. *Performance Anthology: Source Book of California Performance Art*. San Francisco: Last Gasp Publishing and Contemporary Arts Press, 1989.

37. Burden resigned from the position because of controversy over a classroom performance by a student in which he handled a gun, allegedly referencing Burden's (in)famous performance "Shoot."

38. Author unknown. *Chris Burden: A Twenty-Year Survey.* Newport, CA: Newport Harbor Art Museum, 1988.

39. Phelan, Peggy. *Live Art in LA: Performance in Southern California, 1970–1983.* London and New York: Routledge, 2011.

40. Ibid.

41. Ibid.

42. Longhauser, Elsa. "Forward," *Allen Ruppersberg: You and Me or The Art of Give and Take.* Santa Monica, CA: Santa Monica Museum of Art, 2009.

43. Phelan, Peggy. *Live Art in LA: Performance in Southern California, 1970–1983.* London and New York: Routledge, 2011.

44. Ibid.

45. "Mission Statement," Los Angeles Poverty Department online. Retrieved Oct. 1, 2013. http://www.lapovertydept.org/about-lapd/index.php.

46. The magazine would continue publication until 1997, gradually shifting its editorial focus from art that was "formally adventurous to art that was socially and critically adventurous." Source: Description. Art in the Public Interest online. 2011. http://www.apionline.org/hp.html.

47. Phelan, Peggy. *Live Art in LA: Performance in Southern California, 1970–1983.* London and New York: Routledge, 2011.

48. Wilding, Faith. *By Our Own Hands: The Women Artist's Movement Southern California 1970–1976.* Santa Monica, CA: Double X, 1977.

49. "A Brief History of the Woman's Building," The Woman's Building online, 2013. http://www.womansbuilding.org/history.htm.

50. Gerhard, Jane F. *The Dinner Party: Judy Chicago and the Power of Popular Feminism, 1970–2007.* Athens, GA: University of Georgia Press, 2013.

51. Ibid.

52. Ibid.

53. Ibid.

54. Forty-eight feet on each side.

55. A white-tile "Heritage Floor" placed underneath the table was inscribed with the names of 999 other notable women.

56. Finkel, Jori. "Lesser-known artists are poised for a breakthrough," *Los Angeles Times.* September 18, 2011.

57. Robles, Kathleen L., and Richard Griswold del Castillo. "The History of Chicano Park." www.chicanoparksandiego.com online. Captured October 1, 2013.

58.  Dunitz, Robin J. *Street Gallery: Guide to over 1,000 Los Angeles Murals*. Revised Second Edition. Los Angeles, CA: RJD Enterprises, 1993.

59.  Ibid.

60.  Ducker, Eric. "Roadside Attractions: A Look at the Los Angeles Marathon Murals," *Grantland* online. March 18, 2013.

61.  Ibid.

62.  Gilstrap, Peter. "Evil Easel," *New Times Los Angeles*. March 26, 1998.

63.  Linton, Meg. "Introduction," *Through Prehensile Eyes: Seeing the Art of Robert Williams*. San Francisco: Last Gasp Publishing, 2005.

64.  Williams, Robert. "Volume One : Number One : Winter 1994," *Juxtapoz*. Winter, 1994.

65.  Linton, Meg. "Introduction," *Through Prehensile Eyes: Seeing the Art of Robert Williams*. San Francisco: Last Gasp Publishing, 2005.

66.  Strausbaugh, John. "Street Art That's Finding a New Address," *New York Times*. March 7, 2010.

67.  Schjeldahl, Peter. "Dark Star: The intimate grandeur of Vija Celmins," *New Yorker*. June 4, 2001.

68.  Myers, Holly. "Visions of a Late Bloomer," *Los Angeles Times*. February, 27, 2011.

69.  Joyce, Julie, Michael Duncan, and Christopher Miles. *Charles Garabedian: A Retrospective*. Santa Barbara, CA: Santa Barbara Museum of Art, 2011.

70.  "About the artist." Llyn Foulkes online. http://llynfoulkes.com/?page_id=8.

71.  Author interview with the artist, 2006.

72.  Ibid.

73.  Ibid.

74.  Schimmel, Paul. "California Pluralism and the Birth of the Postmodern Era." *Under the Big Black Sun: California Art 1974–1981* catalogue. Los Angeles: The Museum of Contemporary Art, Los Angeles, 2011.

75.  Ibid.

76.  He would appear in the Whitney Biennial seven other times during his career.

77.  Searle, Adrian. "Mike Kelley: It came from Planet Bunkum," *The Guardian*. September 7, 2011.

78.  Pener, Degen. "John Waters Opens Up About the Death of Mike Kelley," *The Hollywood Reporter*. February 3, 2012.

79.  Swanson, Carl. "Hell on Wheels," *New York* magazine. Feb. 26, 2012.

80.  Meyer-Hermann, Eva, and Lisa Gabrielle Mark, editors. *Mike Kelley*. Munich, London, New York: Prestel, 2013.

81. Swanson, Carl. "Hell on Wheels," *New York* magazine. Feb. 26, 2012.

82. Ibid.

83. Calabrese, Omar. *Neo-Baroque: A Sign of the Times*. Princeton, NJ: Princeton University Press, 1992.

# INDEX